9138

£7.50

6P

700
STE

OTHER CRITERIA

CONFRONTATIONS

NEW YORK

Other Criteria

WITH TWENTIETH-CENTURY ART

LEO STEINBERG

OXFORD UNIVERSITY PRESS 1972

To Dorothy

Preface

The eighteen pieces in this book were written intermittently over as many years and from as many motives. The earliest dates from the author's youth. It was meant as a rite of passage, a declaration of independence from formalist indoctrination. I called it "The Eye is a Part of the Mind" and spun a long argument to support the simple truth of its title.

The brief reviews that precede it in the book were done for a monthly magazine column by a truant art history student. In those days, the mid-1950's, practicing art critics were mostly artists or men of letters. Few art historians took the contemporary scene seriously enough to give it the time of day. To divert one's attention from Papal Rome to Tenth Street, New York, would have struck them as frivolous—and I respected their probity. Therefore, whenever a fellow student referred to my column, I begged him to lower his voice. He was speaking of my secret life.

With each passing month, these pieces got harder to do. Commenting on a life's work in a week's writing became a preposterous challenge. Tom Hess is right—it takes years to look at a picture. I succumbed to exhaustion after ten months and never reviewed again.

The Jasper Johns essay came five years later. It was undertaken for a number of reasons, one of which, hitherto unconfessed, had to do with the portents of middle age. That dire condition either develops inside a man, or is thrust upon him by an incomprehensible climatic change induced by a new generation. Among its symptoms is a tendency to speak of younger artists the way one speaks of juvenile delinquents, that is to say, in the plural. To me the enigma of Johns' work offered an immediate occasion to subside into middle age by

observing that painting was not what it used to be. My effort to stay with the enigma was a campaign to stave off the psychology of avoidable middle age for a while. It was seven years later that I donned the robe of an elder to write "Objectivity and the Shrinking Self."

My Picasso involvement is recent and in its nonage. The staggering corpus of Picasso's production seems still to be opening up, the familiar reappears undiscovered. I am convinced that all of Picasso's work needs rethinking in the light of the whole; that the prevailing trend to deprecate work done after the thirties is misconceived; that the significant unity of Picasso's creation will become ever clearer, so that even his Cubism will eventually come to seem more like the rest of Picasso and less like the Cubism of other men. Above all, I believe that, like the rhetoric of adulation, the professional criticism of our century has been busily shielding us from the onslaught of Picasso's imagination.

The Picasso chapters at the core of the book continue to write themselves in my mind, and I am sorry to be letting them go.

Finally, as to the name of the book: it is not so much a claim as a confident expectation. It stands for the belief that all given criteria of judgment are seasonal; that other criteria are perpetually brought into play by new forms and fresh thought.

Acknowledgments

The essays comprised in this book owe their existence largely to the help, or the helpful needling, of friends, colleagues, and students. I tell their names in affection and gratitude. Will Herberg and William Kolodney; Alfred H. Barr and Margaret Scolari Barr; Paul Brach and Miriam Shapiro; Albert E. Elsen; Mark Feldstein and Sidney Geist; Dominique de Menil and Phyllis D. Massar; and my former students Marie Tanner, Patricia Hills, and Jack Freiberg. Parts of the manuscript were read and helpfully criticized by Rosalind E. Krauss and William S. Rubin. The work owes a vast, if unspecifiable, debt to the friendship of Victor and Sally Ganz; to Mrs. Rosalie Leventritt; to Dr. Ralph M. Sussman and Dr. Arnold M. Cooper; to my sister Mita Charney and my uncle, Dr. A. Steinberg. James Raimes of Oxford University Press conceived and suggested the book and kept up the pressure required to bring it about. I am deeply grateful to Stephanie Golden of that same house for the wisdom and editorial sensitivity that saved me from many falls. The expert and indefatigable assistance of Sheila Schwartz throughout the preparation of this book is more truly described as a collaboration.

Contents

OTHER CRITERIA

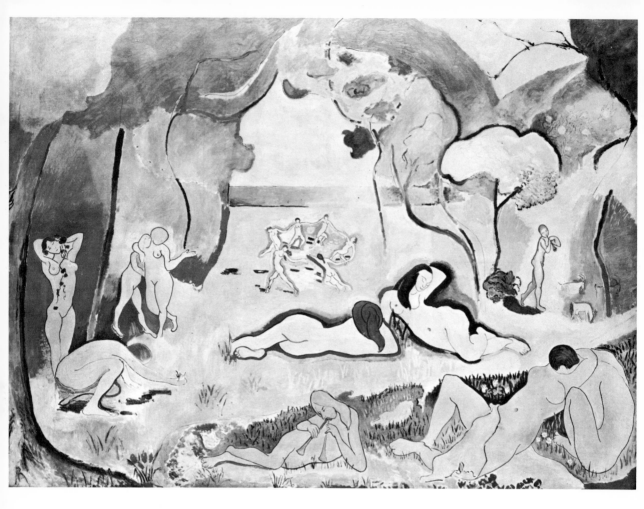

1. Henri Matisse, *Joy of Life*, 1906

1 Contemporary Art and the Plight of its Public
(1962)

A few words in defense of my topic, because some of my friends have doubted that it was worth talking about. One well-known abstract painter said to me, "Oh, the public, we're always worrying about the public." Another asked: "What is this plight they're supposed to be in? After all, art doesn't have to be for everybody. Either people get it, and then they enjoy it; or else they don't get it, and then they don't need it. So what's the predicament?"

Well, I shall try to explain what I think it is, and before that, *whose* I think it is. In other words, I shall try to explain what I mean by "the public."

In 1906, Matisse exhibited a picture which he called *The Joy of Life* (Fig. 1), now in the Barnes Foundation in Merion, Pennsylvania. It was, as we now know, one of the great breakthrough paintings of this century. The subject was an old-fashioned bacchanal—nude figures outdoors, stretched on the grass, dancing, making music or love, picking flowers, and so on. It was his most ambitious undertaking—the largest painting he had yet produced; and it made people very angry. Angriest of all was Paul Signac, a leading modern painter, who was the vice-president of the Salon des Indépendants. He would have kept the picture out, and it was hung only because that year Matisse happened to be on the hanging committee, so that his painting did not have to pass a jury. But Signac wrote to a friend: "Matisse seems to have gone to the dogs. Upon a canvas of two and a half meters, he has surrounded some strange characters with a line

Based on the first of three lectures given at the Museum of Modern Art, New York, in the spring of 1960; first published in *Harper's Magazine*, March 1962.

3

as thick as your thumb. Then he has covered the whole thing with a flat, well-defined tint, which, however pure, seems disgusting. It evokes the multicolored shop fronts of the merchants of paint, varnishes, and household goods."

I cite this affair merely to suggest that Signac, a respected modern who had been in the avant-garde for years, was at that moment a member of Matisse's public, acting typically like a member of his public.

One year later, Matisse went to Picasso's studio to look at Picasso's latest painting, the *Demoiselles d'Avignon* (Fig. 104), now in the Museum of Modern Art in New York. This, we now know, was another breakthrough for contemporary art; and this time it was Matisse who got angry. The picture, he said, was an outrage, an attempt to ridicule the whole modern movement. He swore that he would "sink Picasso" and make him regret his hoax.

It seems to me that Matisse, at that moment, was acting, typically, like a member of Picasso's public.

Such incidents are not exceptional. They illustrate a general rule that whenever there appears an art that is truly new and original, the men who denounce it first and loudest are artists. Obviously, because they are the most engaged. No critic, no outraged bourgeois, can match an artist's passion in repudiation.

The men who kept Courbet and Manet and the Impressionists and the Postimpressionists out of the salons were all painters. They were mostly academic painters. But it is not necessarily the academic painter who defends his own established manner against a novel way of making pictures or a threatened shift in taste. The leader of a revolutionary movement in art may get just as mad over a new departure, because there are few things so maddening as insubordination or betrayal in a revolutionary cause. And I think it was this sense of betrayal that made Matisse so angry in 1907 when he saw what he called "Picasso's hoax."

It serves no useful purpose to forget that Matisse's contribution to early Cubism—made at the height of his own creativity—was an attitude of absolute and arrogant incomprehension. In 1908, as juror for the avant-garde Salon d'Automne, he rejected Braque's new landscapes "with little cubes"—just as, by 1912, the triumphant Cubists were to reject Duchamp's *Nude Descending a Stair*. Therefore, instead of repeating that only academic painters spurn the new, why not reverse the charge? Any man becomes academic by virtue of, or with respect to, what he rejects.

This academization of the avant-garde is in continuous process. It has been very noticeable in New York during the past few years. May we not then drop this useless, mythical distinction between— on one side—creative, forward-looking individuals whom we call artists, and—on the other side—a sullen, anonymous, uncomprehending mass, whom we call the public?

In other words, my notion of the public is functional. The word "public" for me does not designate any particular people; it refers to a role played by people, or to a role into which people are thrust or forced by a given experience. And only those who are beyond experience should be exempt from the charge of belonging to the public.

As to the "plight"—here I mean simply the shock of discomfort, or the bewilderment or the anger or the boredom which some people always feel, and all people sometimes feel, when confronted with an unfamiliar new style. When I was younger, I was taught that this discomfort was of no importance, firstly because only philistines were said to experience it (which is a lie), and secondly because it was believed to be of short duration. This last point certainly appears to be true. No art seems to remain uncomfortable for very long. At any rate, no style of these last hundred years has long retained its early look of unacceptability. Which could lead one to suspect that the initial rejection of so many modern works was a mere historical accident.

In the early 1950's, certain spokesmen for what was then the avant-garde tried to argue differently for Abstract Expressionism. They suggested that the raw violence and the immediate action which produced these pictures put them beyond the pale of art appreciation and rendered them inherently unacceptable. And as proof they pointed out, with a satisfied gnashing of teeth, that very few people bought these pictures. Today we know that this early reluctance to buy was but the normal time lag of ten years or less. By the late 1950's, the market for Abstract Expressionist art was amazingly active. There was nothing inherently unacceptable about these paintings after all. They just looked outrageous for a season, while we of the reluctant public were coming around.

This rapid domestication of the outrageous is the most characteristic feature of our artistic life, and the time lapse between shock received and thanks returned gets progressively shorter. At the present rate of taste adaptation, it takes about seven years for a young artist with a streak of wildness in him to turn from *enfant*

terrible into elder statesman—not so much because he changes, but because the challenge he throws to the public is so quickly met.

So then the shock value of any violently new contemporary style is quickly exhausted. Before long, the new looks familiar, then normal and handsome, finally authoritative. All is well, you may say. Our initial misjudgment has been corrected; if we, or our fathers, were wrong about Cubism a half-century ago, that's all changed now.

Yes, but one thing has not changed: the relation of any new art —while it is new—to its own moment; or, to put it the other way around: every moment during the past hundred years has had an outrageous art of its own, so that every generation, from Courbet down, has had a crack at the discomfort to be had from modern art. And in this sense it is quite wrong to say that the bewilderment people feel over a new style is of no great account since it doesn't last long. Indeed it does last; it has been with us for a century. And the thrill of pain caused by modern art is like an addiction—so much of a necessity to us, that societies like Soviet Russia, without any outrageous modern art of their own, seem to us to be only half alive. They do not suffer that perpetual anxiety, or periodic frustration, or unease, which is our normal condition, and which I call "The Plight of the Public."

I therefore conclude that this plight does matter because it is both chronic and endemic. That is to say, sooner or later it is everybody's predicament, whether artist or philistine, and therefore worth taking seriously.

When a new, and apparently incomprehensible, work has appeared on the scene, we always hear of the perceptive critic who hailed it at once as a "new reality," or of the collector who recognized in it a great investment opportunity. Let me, on the other hand, put in a word for those who didn't get it.

Confronting a new work of art, they may feel excluded from something they thought they were part of—a sense of being thwarted, or deprived of something. And it is again a painter who put it best. When Georges Braque, in 1908, had his first view of the *Demoiselles d'Avignon*, he said: "It is as though we were supposed to exchange our usual diet for one of tow and paraffin." The important words here are "our usual diet." No use saying to a man, "Look, if you don't like modern painting, why don't you leave it

alone? Why do you worry about it?" There are people for whom an incomprehensible shift in art, something that really baffles or disturbs, is more like a drastic change—or better, a drastic reduction in the daily ration on which one has come to depend—as during a forced march, or while in prison. And so long as there are people who feel about art in this way, it is uninteresting to be told that there also exist certain snobs whose pretended feelings disguise a real indifference.

I know that there are people enough who are quite genuinely troubled over certain shifts as they occur in art. And this ought to give to what I call "The Plight of the Public" a certain dignity. There is a sense of loss, of sudden exile, of something willfully denied—sometimes a feeling that one's accumulated culture or experience is hopelessly devalued, leaving one exposed to spiritual destitution. And this experience can hit an artist even harder than an amateur. This sense of loss or bewilderment is too often described simply as a failure of esthetic appreciation or an inability to perceive the positive values in a novel experience. Sooner or later, we say, the man—if he has it in him—will catch on, or catch up. But there is no dignity or positive content in his resistance to the new.

But suppose you describe this resistance as a difficulty in keeping up with another man's sacrifices or another man's pace of sacrifice. Let me try to explain what I mean by the "sacrifice" in an original work of art. I think again of the *Joy of Life* by Matisse, the picture that so offended his fellow painters and critics. Matisse here disturbed certain habitual assumptions. For instance, one had always assumed that, faced with a figurative painting, one was entitled to look at the figures in it, that is, to focus on them one by one, as he wished. The painted figures, "magnets to the eye" in Vasari's phrase, offered enough seeming density to sustain the long gaze. Thus, from all his experience with art, a man felt entitled to some pleasurable reward if he focused on painted figures, especially if these figures were joyous, female, and nude. But in this picture, if one looks at the figures distinctly, there is a curious lack of reward. There is something withheld, for the figures lack coherence or structural articulation. Their outlines are traced without regard to the presence or the function of the bone within, and some of the figures are insulated by a heavy dark padding—those lines "as thick as your thumb" that Signac complained about.

In the old days, one's first reaction would have been to exclaim—

"This man can't draw." But we have the painter's preliminary studies for the individual figures of this picture—a succession of splendid drawings—and these show Matisse to have been one of the most knowing draftsmen who ever lived. Yet, after so many preparatory sketches, he arrives, in the completed painting, at a kind of draftsmanship in which his skill seems deliberately mortified or sacrificed. The heavy outlines that accost these figured nymphs prevent any materialization of bulk or density. They seem to drain energy away from the core of the figure, making it radiate into the space about them. Or perhaps it is our vision that is shunted away, so that a figure is no sooner recognized than we are forced to let it go to follow an expanding, rhythmical system. It is somewhat like watching a stone drop into water; your eye follows the expanding circles, and it takes a deliberate, almost a perverse, effort of will to keep focusing on the point of first impact—perhaps because it is so unrewarding. And perhaps Matisse was trying to make his individual figures disappear for us like that swallowed stone, so that we should be forced into recognizing a different system.

The analogue in nature to this kind of drawing is not a scene or stage on which solid forms are deployed; a truer analogue would be a circulatory system, as of a city or of the blood, where stoppage at any point implies a pathological condition, like a blood clot or traffic jam. And I think Matisse must have felt that "good drawing" in the traditional sense—that is, line and tone designating a solid form of specific character with concrete location in space—that such drawing would have tended to trap and arrest the eye, to stabilize it at a concentration of density, thereby drawing attention to the solids themselves; and this was not the kind of vision that Matisse wanted brought to his pictures.

It is lucky for us not to have been polled in 1906, because we should certainly not have been ready to discard visual habits which had been acquired in the contemplation of real masterpieces, and to toss them overboard, overnight, for one painting. Today this kind of analysis has become commonplace, because an enormous amount of this century's painting derives from Matisse's example. The free-flowing color forms of Kandinsky and of Miró, and all those paintings since, which represent reality or experience as a condition of flux, owe their parentage or their freedom to the permissions claimed in this work.

But in 1906 this could not have been foreseen. And one almost

suspects that part of the value of a painting like this accrues to it in retrospect, as its potential is gradually actualized, sometimes in the action of others. But when Matisse painted this picture, Degas was still around, with ten more years of life in him. It was surely still possible to draw with bite and precision. No wonder that few were ready to join Matisse in the kind of sacrifice that seemed implied in his waving line. And the first to acclaim the picture was no fellow painter but an amateur with time on his hands: Leo Stein, the brother of Gertrude, who began, like everyone else, by disliking it, but returned to it again and again—and then, after some weeks, announced that it was a great painting, and proceeded to buy it. He had evidently become persuaded that the sacrifice here was worthwhile in view of a novel and positive experience that could not otherwise be had.

So far as I know, the first critic to speak of a new style in art in terms of sacrifice is Baudelaire. In his essay on Ingres he mentions a "shrinkage of spiritual faculties" which Ingres imposes on himself in order to reach some cool, classic ideal—in the spirit, so he imagines, of Raphael. Baudelaire doesn't like Ingres; he feels that all imagination and movement are banished from his work. But, he says, "I have sufficient insight into Ingres' character to hold that with him this is a heroic immolation, a sacrifice upon the altar of those faculties which he sincerely believes to be nobler and more important." And then, by a remarkable leap, Baudelaire goes on to couple Ingres with Courbet, whom he also doesn't have much use for. He calls Courbet "a mighty workman, a man of fearsome, indomitable will, who has achieved results which to some minds have already more charm than those of the great masters of the Raphaelesque tradition, owing, doubtless, to their positive solidity and their unabashed indelicacy." But Baudelaire finds in Courbet the same peculiarity of mind as in Ingres, because he also massacred his faculties and silenced his imagination. "But the difference is that the heroic sacrifice offered by M. Ingres, in honor of the idea and the tradition of Raphaelesque Beauty, is performed by M. Courbet on behalf of external, positive, and immediate nature. In their war against the imagination, they are obedient to different motives; but their two opposing varieties of fanaticism lead them to the same immolation."

Baudelaire has rejected Courbet. Does this mean that his sensibility was unequal to that of the painter? Hardly, for Baudelaire's mind

was, if anything, subtler, more sensitive, more adult than that of Courbet. Nor do I think that Baudelaire, as a literary man, can be accused of being typically insensitive to visual or plastic values. His rejection of Courbet simply means that, having his own ideals, he was not prepared to sacrifice the things that Courbet had discarded. Courbet himself, like any good artist, pursued only his own positive goals; the discarded values (for example, fantasy, "ideal beauty") had long lost their positive virtue for him, and thus were no loss. But they were still felt as a loss by Baudelaire, who perhaps imagined that fantasy and ideal beauty were yet unexhausted. And I think this is what it means, or may mean, when we say that a man, faced with a work of modern art, isn't "with it." It may simply mean that, having a strong attachment to certain values, he cannot serve an unfamiliar cult in which these same values are mocked.

And this, I think, is our plight most of the time. Contemporary art is constantly inviting us to applaud the destruction of values which we still cherish, while the positive cause, for the sake of which the sacrifices are made, is rarely made clear. So that the sacrifices appear as acts of demolition, or of dismantling, without any motive—just as Courbet's work appeared to Baudelaire to be simply a revolutionary gesture for its own sake.

Let me take an example from nearer home and from my own experience. Early in 1958, a young painter named Jasper Johns had his first one-man show in New York. The pictures he showed—products of many years' work—were puzzling. Carefully painted in oil or encaustic, they were variations on four main themes:

Numbers, running in regular order, row after row all the way down the picture, either in color or white on white.

Letters, arranged in the same way.

The American Flag—not a picture of it, windblown or heroic, but stiffened, rigid, the pattern itself.

And finally, Targets, some tricolored, others all white or all green, sometimes with little boxes on top into which the artist had put plaster casts of anatomical parts, recognizably human.

A few other subjects turned up in single shots—a wire coat hanger, hung on a knob that projected from a dappled gray field. A canvas, which had a smaller stretched canvas stuck to it face to face— all you saw was its back; and the title was *Canvas*. Another, called *Drawer*, where the front panel of a wooden drawer with its two

projecting knobs had been inserted into the lower part of a canvas, painted all gray.

How did people react? Those who had to say something about it tried to fit these new works into some historical scheme. Some shrugged it off and said, "More of Dada, we've seen this before; after Expressionism comes nonsense and anti-art, just as in the twenties." One hostile New York critic saw the show as part of a sorrowful devolution, another step in the systematic emptying out of content from modern art. A French critic wrote, "We mustn't cry 'fraud' too soon." But he was merely applying the cautions of the past; his feeling was that he was being duped.

On the other hand, a great number of intelligent men and women in New York responded with intense enthusiasm, but without being able to explain the source of their fascination. A museum director suggested that perhaps it was just the relief from Abstract Expressionism, of which one had seen so much in recent years, that led him to enjoy Jasper Johns; but such negative explanations are never adequate. Some people thought that the painter chose commonplace subjects because, given our habits of overlooking life's simple things, he wanted, for the first time, to render them visible. Others thought that the charm of these paintings resided in the exquisite handling of the medium itself, and that the artist deliberately chose the most commonplace subjects so as to make them *invisible*, that is, to induce absolute concentration on the sensuous surface alone. But this didn't work for two reasons. First, because there was no agreement on whether these things were, in fact, well painted. (One New York critic of compulsive originality said that the subjects were fine, but that the painting was poor.) And, secondly, because if Johns had wanted his subject matter to become invisible through sheer banality, then he had surely failed—like a debutante who expects to remain inconspicuous by wearing blue jeans to the ball. Had reticent subject matter been his intention, he would have done better to paint a standard abstraction, where everybody knows not to question the subject. But in these new works, the subjects were overwhelmingly conspicuous, if only because of their context. Hung at general headquarters, a Jasper Johns flag might well have achieved invisibility; set up on a range, a target could well be overlooked; but carefully remade to be seen point-blank in an art gallery, these subjects struck home.

It seems that during this first encounter with Johns's work, few

people were sure of how to respond, while some of the dependable avant-garde critics applied tested avant-garde standards—which seemed suddenly to have grown old and ready for dumping.

My own first reaction was normal. I disliked the show, and would gladly have thought it a bore. Yet it depressed me and I wasn't sure why. Then I began to recognize in myself all the classical symptoms of a philistine's reaction to modern art. I was angry at the artist, as if he had invited me to a meal, only to serve something uneatable, like tow and paraffin. I was irritated at some of my friends for pretending to like it—but with an uneasy suspicion that perhaps they did like it, so that I was really mad at myself for being so dull, and at the whole situation for showing me up.

And meanwhile, the pictures remained with me—working on me and depressing me. The thought of them gave me a distinct sense of threatening loss or privation. One in particular there was, called *Target with Four Faces* (Fig. 13). It was a fairly large canvas consisting of nothing but one three-colored target—red, yellow, and blue; and above it, boxed behind a hinged wooden flap, four life casts of one face—or rather, of the lower part of a face, since the upper portion, including the eyes, had been sheared away. The picture seemed strangely rigid for a work of art and recalled Baudelaire's objection to Ingres: "No more imagination; therefore no more movement." Could any meaning be wrung from it? I thought how the human face in this picture seemed desecrated, being brutally thingified—and not in any acceptable spirit of social protest, but gratuitously, at random. At one point, I wanted the picture to give me a sickening suggestion of human sacrifice, of heads pickled or mounted as trophies. Then, I hoped, the whole thing would come to seem hypnotic and repellent, like a primitive sign of power. But when I looked again, all this romance disappeared. These faces— four of the same—were gathered there for no triumph; they were chopped up, cut away just under the eyes, but with no suggestion of cruelty, merely to make them fit into their boxes; and they were stacked on that upper shelf as a standard commodity. But was this reason enough to get so depressed? If I disliked these things, why not ignore them?

It was not that simple. For what really depressed me was what I felt these works were able to do to all other art. The pictures of de Kooning and Kline, it seemed to me, were suddenly tossed into one pot with Rembrandt and Giotto. All alike suddenly became

painters of illusion. After all, when Franz Kline lays down a swath of black paint, that paint is transfigured. You may not know what it represents, but it is at least the path of an energy or part of an object moving in or against a white space. Paint and canvas stand for more than themselves. Pigment is still the medium by which something seen, thought, or felt, something other than pigment itself, is made visible. But here, in this picture by Jasper Johns, one felt the end of illusion. No more manipulation of paint as a medium of transformation. This man, if he wants something three-dimensional, resorts to a plaster cast and builds a box to contain it. When he paints on a canvas, he can only paint what is flat—numbers, letters, a target, a flag. Everything else, it seems, would be make-believe, a childish game—"let's pretend." So, the flat is flat and the solid is three-dimensional, and these are the facts of the case, art or no art. There is no more metamorphosis, no more magic of medium. It looked to me like the death of painting, a rude stop, the end of the track.

I am not a painter myself, but I was interested in the reaction to Jasper Johns of two well-known New York abstract painters: One of them said, "If this is painting, I might as well give up." And the other said, resignedly, "Well, I am still involved with the dream." He, too, felt that an age-old dream of what painting had been, or could be, had been wantonly sacrificed—perhaps by a young man too brash or irreverent to have dreamed yet. And all this seemed much like Baudelaire's feeling about Courbet, that he had done away with imagination.

The pictures, then, kept me pondering, and I kept going back to them. And gradually something came through to me, a solitude more intense than anything I had seen in pictures of mere desolation. In *Target with Faces*, I became aware of an uncanny inversion of values. With mindless inhumanity or indifference, the organic and the inorganic had been leveled. A dismembered face, multiplied, blinded, repeats four times above the impersonal stare of a bull's-eye. Bull's-eye and blind faces—but juxtaposed as if by habit or accident, without any expressive intent. As if the values that would make a face seem more precious or eloquent had ceased to exist; as if those who could hold and impose such values just weren't around.

Then another inversion. I began to wonder what a target really

was, and concluded that a target can only exist as a point in space —"over there," at a distance. But the target of Jasper Johns is always "right here"; it is all the field there is. It has lost its definitive "Thereness." I went on to wonder about the human face, and came to the opposite conclusion. A face makes no sense unless it is "here." At a distance, you may see a man's body, a head, even a profile. But as soon as you recognize a thing as a face, it is an object no longer, but one pole in a situation of reciprocal consciousness; it has, like one's own face, absolute "Hereness." So then surely Jasper Johns's *Target with Faces* performs a strange inversion, because a target, which needs to exist at a distance, has been allotted all the available "Hereness," while the faces are shelved.

And once again, I felt that the leveling of those categories, which are the subjective markers of space, implied a totally nonhuman point of view. It was as if the subjective consciousness, which alone can give meaning to "here" and "there," had ceased to exist.

And then it dawned on me that all of Jasper Johns's pictures conveyed a sense of desolate waiting. The face-to-the-wall canvas waits to be turned; the drawer waits to be opened. That rigid flag—does it wait to be hoisted or recognized? Certainly the targets wait to be shot at. Johns made one painting using a lowered window shade which, like any window shade in the world, waits to be raised. The empty hanger waits to receive somebody's clothes. These letters, neatly set forth, wait to spell something out; and the numbers, arranged as on a tot board, wait to be scored. Even those plaster casts have the look of things temporarily shelved for some purpose. And yet, as you look at these objects, you know with absolute certainty that their time has passed, that nothing will happen, that that shade will never be lifted, those numbers will never add up again, and the coat hanger will never be clothed.

There is, in all this work, not simply an ignoring of human subject matter, as in much abstract art, but an implication of absence, and —this is what makes it most poignant—of human absence from a man-made environment. In the end, these pictures by Jasper Johns come to impress me as a dead city might—but a dead city of terrible familiarity. Only objects are left—man-made signs which, in the absence of men, have become objects. And Johns has anticipated their dereliction.

These, then, were some of my broodings as I looked at Johns's pictures. And now I'm faced with a number of questions, and a certain anxiety.

What I have said—was it *found* in the pictures or read into them? Does it accord with the painter's intention? Does it tally with other people's experience, to reassure me that my feelings are sound? I don't know. I can see that these pictures don't necessarily look like art, which has been known to solve far more difficult problems. I don't know whether they are art at all, whether they are great, or good, or likely to go up in price. And whatever experience of painting I've had in the past seems as likely to hinder me as to help. I am challenged to estimate the aesthetic value of, say, a drawer stuck into a canvas. But nothing I've ever seen can teach me how this is to be done. I am alone with this thing, and it is up to me to evaluate it in the absence of available standards. The value which I shall put on this painting tests my personal courage. Here I can discover whether I am prepared to sustain the collision with a novel experience. Am I escaping it by being overly analytical? Have I been eavesdropping on conversations? Trying to formulate certain meanings seen in this art—are they designed to demonstrate something about myself or are they authentic experience?

They are without end, these questions, and their answers are nowhere in storage. It is a kind of self-analysis that a new image can throw you into and for which I am grateful. I am left in a state of anxious uncertainty by the painting, about painting, about myself. And I suspect that this is all right. In fact, I have little confidence in people who habitually, when exposed to new works of art, know what is great and what will last.

Modern art always projects itself into a twilight zone where no values are fixed. It is always born in anxiety, at least since Cézanne. And Picasso once said that what matters most to us in Cézanne, more than his pictures, is his anxiety. It seems to me a function of modern art to transmit this anxiety to the spectator, so that his encounter with the work is—at least while the work is new—a genuine existential predicament. Like Kierkegaard's God, the work molests us with its aggressive absurdity, the way Jasper Johns presented himself to me several years ago. It demands a decision in which you discover something of your own quality; and this decision is always a "leap of faith," to use Kierkegaard's famous term. And like Kierkegaard's God, who demands a sacrifice from Abraham in violation of every moral standard; like Kierkegaard's God, the picture seems arbitrary, cruel, irrational, demanding your faith, while it makes no promise of future rewards. In other words, it is in the nature of

original contemporary art to present itself as a bad risk. And we the public, artists included, should be proud of being in this predicament, because nothing else would seem to us quite true to life; and art, after all, is supposed to be a mirror of life.

I was reading Exodus, Chapter 16, which describes the fall of manna in the desert; and found it very much to the point:

> In the morning, the dew lay round about the host, and when [it] was gone up, behold, upon the face of the wilderness there lay a small round thing, as small as the hoar-frost on the ground. And when the children of Israel saw it, . . . they wist not what it was. And Moses said unto them, This is the bread which the Lord hath given to you to eat. . . . Gather of it every man according to his eating. . . . And the children of Israel did so, and gathered, some more, some less. And when they did mete it with an omer, he that gathered much had nothing over, and he that gathered little had no lack; they gathered every man according to his eating. . . . But some of them left of it until the morning, and it bred worms and stank. . . .
>
> And the House of Israel called the name thereof Manna; . . . and the taste of it was like wafers made with honey. And Moses said, . . . Fill an omer of it to be kept for your generations; that they may see the bread [that] fed you in the wilderness. . . . So Aaron laid it up before the testimony to be kept. . . .

When I had read this much, I stopped and thought how like contemporary art this manna was; not only in that it was a God-send, or in that it was a desert food, or in that no one could quite understand it—for "they wist not what it was." Nor even because some of it was immediately put in a museum—"to be kept for your generations"; nor yet because the taste of it has remained a mystery, since the phrase here translated as "wafers made with honey" is in fact a blind guess; the Hebrew word is one that occurs nowhere else in ancient literature, and no one knows what it really means. Whence the legend that manna tasted to every man as he wished; though it came from without, its taste in the mouth was his own making.

But what clinched the modern art analogy for me was this Command—to gather of it every day, according to your eating, and not to lay it up as an insurance or investment for the future, making each day's gathering an act of faith.

2 Jasper Johns:
the First Seven Years of His Art

December 1961. Johns is exhibiting four gray paintings, recently finished. One of them is a sketch—encaustic and sculpmetal on paper; but it made its point so well that there seemed no need for elaborate execution (Fig. 2). The picture displays, on a square field, Johns's characteristic dense veil of graded gray strokes: paint that denotes nothing but painting. Hinged to the top of the square is a woodblock; and four raised letters on it which we see in a murky rectangular field, like a reflection in water, illegibly, upside down. But the block has left a fair imprint directly below, on the painting itself. It spells LIAR.

Does it mean anything?

It need not. It's a device for printing a useful word. Or just Painting with a bit of Dada provocation on top (but we are too sophisticated to be provoked by a four-letter word). Or is it an allegory about the hinge between life and art? For the woodblock, an object in actual space, is real, a piece out of life—hence illegible, topsy-turvy. Yet it is this that imprints itself on the painted field, where it is set right to become perfectly clear; such being the revelations of Art. Life's murky message is decoded by Art, and there it is, spelling

First published in *Metro*, Nos. 4/5, 1962, and, with revisions, by George Wittenborn, New York, 1963. In the present version the survey of previous critical literature (pp. 23-26) has been again somewhat revised and expanded. Otherwise the piece stands essentially as completed by the end of 1961, the terminus for all references to "recent" work. The discussion of Johns's *Target with Four Faces* (p. 54) is substantially the same as occurs in the foregoing article (pp. 12-14).

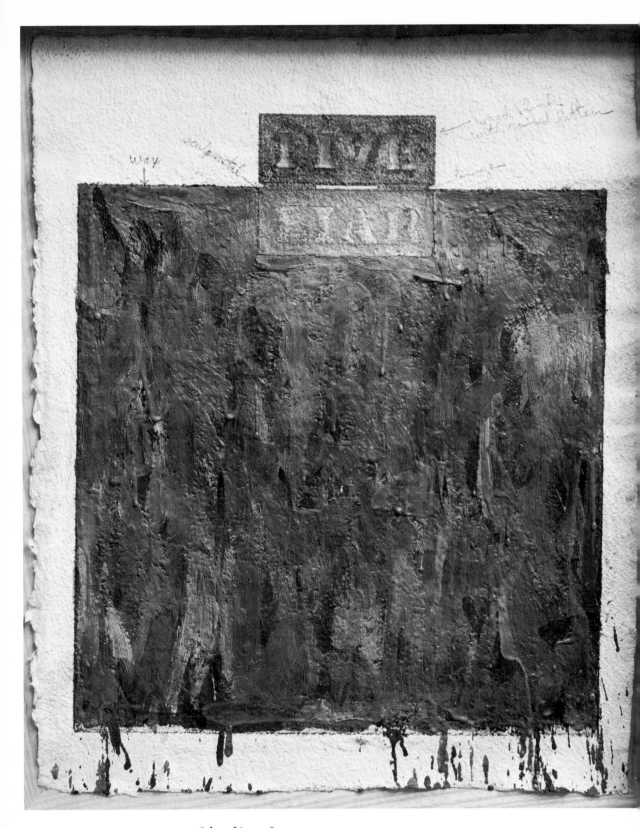

2. Johns, *Liar*, 1961

LIAR—the word cleared of every accretion of passion, a forgotten name plate that's been up since long before we moved in.

The word moves out into the room and hangs there like a frozen voice, waiting to thaw and settle. On whom? On what? Which side of the fence?

Does it mean anything?

To whom? To the schoolboy learning to read? To posterity? To the painter who made it? His friends? To the same painter who's moved on to make something else? To the critic who knows beforehand what "the needs of art" are and who can see that these needs will not be served by this sort of picture? To us who see an implacable presence and a gaping metaphor generated by crude literal means?

The elements of Johns's picture lie side by side like flint pebbles. Rubbed together they could spark a flame, and that is their meaning perhaps. But Johns does not claim to have ever heard of the invention of fire. He merely locates the pebbles.

A CRISIS

He had his first one-man show four years ago, exhibiting variations on the American flag (Figs. 3-6), and on targets, numbers, and letters. Also included were:

Book (1957), an actual book spread open, then overpainted in wax —red pages, yellow edges, blue binding—a paralyzed book in a boxed frame;

Newspaper (1957), encaustic and newsprint on canvas;

Canvas (1956), an all-gray painting in which a small canvas had been glued face down to a larger one (Fig. 7);

Drawer (1957), all-gray again, with the front panel of a plain two-knobbed drawer inserted just below center (Fig. 8).

The pictures aroused both enthusiasm and consternation, above all by their subjects. These were of such unprecedented "banality," it seemed nothing so humdrum had ever been seen before. Why had he chosen to paint subjects of such aggressive uninterest?

To be different?

The validity of this answer depends on its tone. When you hear it said with a shrug, explain to the speaker that he has made no point at all; we simply restate our question: "Why, if he wanted to be different, did he choose to be different in this particular manner?"

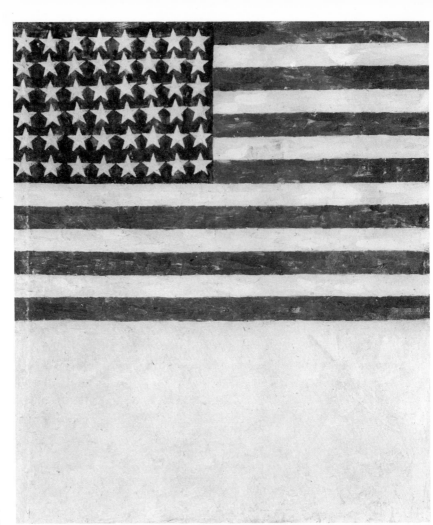

3. Johns,
Flag Above White, 1954

4. Johns,
White Flag, 1954

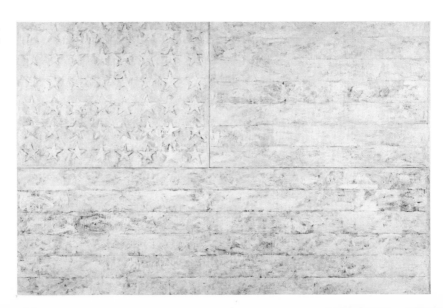

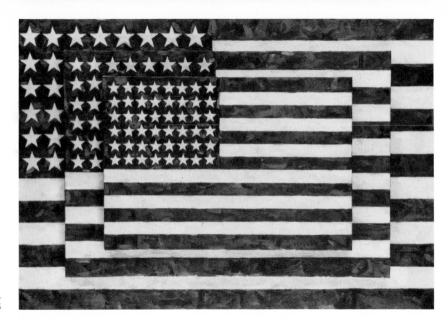

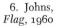
5. Johns,
Three Flags, 1958

But that same answer, returned in good will, can describe a crucial moment in a young artist's passage. For becoming a painter is like groping one's way out of a cluttered room in the dark. Beginning to walk, he tumbles over another man's couch, changes course to collide with someone's commode, then butts against a work table that can't be disturbed. Everything has its use and its user, and no need of him. When Johns was discharged from the army in 1952 and settled down in New York (he was no longer "going to be a painter," the time having come to start being one), he began to make small abstract collages from paper scraps. Being told that they looked like those of Kurt Schwitters, he went to look at Schwitters' collages and found that they did look like his own. He was trespassing, and he veered away—*to be different.*

The subject matter he displayed in January 1958 was different

6. Johns,
Flag, 1960

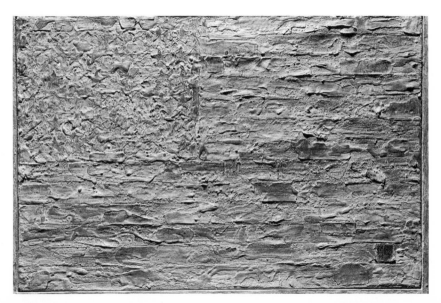

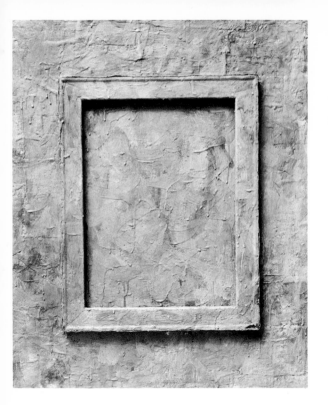

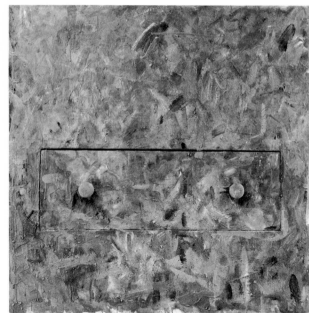

7. Johns, *The Canvas*, 1956

8. Johns, *The Drawer*, 1957

enough to precipitate a crisis in criticism. Despite a half-century of formalist indoctrination, it proved almost impossible to see the paintings for subject matter. It seemed to be the most interesting point about Johns that he managed somehow to discover uninteresting things to paint. An impasse for everyone. Even those whose long-practiced art appreciation had educated them to ignore a picture's subject as irrelevant to its quality talked and could talk about little else—though they tried. "He is a calligraphic artist of considerable stylishness," wrote Stuart Preston in the *New York Times*, (February 12, 1961), "and as for his gimmicks, you can take them or leave them."

More easily said than done; for the "gimmicks" kept gnawing away. Like all important original statements, they unbalanced the *status quo* and demanded an instant review of received notions. Since Johns's pictures showed essentially Abstract Expressionist brushwork and surface, differing from those earlier pictures only in the variable of subject matter, they seemed to accuse the strokes and drips of the de Kooning school of being after all only a subject matter of a different kind; which threatened the whole foundation of Abstract Expressionist theory. And it was the painters who resented it most.

I have elsewhere described my own sense of bewildered alarm at the first sight of these pictures (cf. p. 12f.). If I now review the response of the art world as recorded in print, it is because the situation of those four years, 1958-1961, reveals something of the essential nature of art. A work of art does not come like a penny postcard with its value stamped upon it; for all its objectness, it comes primarily as a challenge to the life of the imagination, and "correct" ways of thinking or feeling about it simply do not exist. The grooves in which thoughts and feelings will eventually run have to be excavated before anything but bewilderment or resentment is felt at all. For a long time the direction of flow remains uncertain, dammed up, or runs out all over, until, after many trial cuts by venturesome critics, certain channels are formed. In the end, that wide river which we may call the appreciation of Johns—though it will still be diverted this way and that—becomes navigable to all.

Most people—especially those who belittle a critic's work—do not know, or pretend not to know, how real the problem is. They wait it out until the channels are safely cut, then come out and enjoy the smooth sailing, saying, *who needs a critic?*

It is in the character of the critic to say no more in his best moments than what everyone in the following season repeats; he is the generator of the cliché.

The first critical reflex at the appearance of something new is usually an attempt to conserve psychic energy by assuring oneself that nothing really new has occurred. *Art News*, bold enough to fly Johns's *Target with Four Faces* (Fig. 13) on its January 1958 cover, labeled it "neo-Dada," and the word untied every tongue. Whoever had been at a loss what to say about Johns could thenceforth recite whatever was remembered of Dada.[1]

Once the Dada topic had been set up, it became itself the target of criticism. "Johns tries to use the cliché, but in the opposite way of the Dadas," wrote Tom Hess.[2] ". . . It is to be his key to the absolute. The motive is not to attack nor amuse, but to emulate Jackson Pollock and 'paint the subconscious.' The attempt is to achieve this through an art of Absolute Banality."

Hilton Kramer explained how Johns really wasn't like Dada, and not anywhere near as serious: ". . . a kind of Grandma Moses version of Dada. But . . . Dada sought to repudiate and criticize bourgeois values, whereas Johns, like Rauschenberg, aims to please and confirm the decadent periphery of bourgeois taste."[3] And John Can-

aday in the *New York Times Magazine*,[4] referring to exhibits by Rauschenberg and Johns:

> Suddenly it (Dada) is with us again and going strong. . . . At least one stuffed goat with a rubber tire around its middle has been offered for esthetic appraisal—and for sale, a far from incidental consideration. You may also buy, just now, a real wire coat hanger on a wooden peg projecting from a color-dabbed panel, if this appeals to you as something you would like to have around the house or if you think its value as an investment is likely to increase. . . . Old-time Dada could—and did, as it intended—provoke to fury. The imitators today only tease and titillate. . . .

Harold Rosenberg, endowed with a keen political sense, assumed, like Kramer and Canaday, that Johns's selection of subjects was entirely audience directed; but he arrived at the opposite judgment. The subjects were not meant to delight bourgeois taste, but to needle it. Rosenberg understood Johns's work as a derision of philistine values: "Obviously such works are intended as provocations. Instead of concentrating on art, its problems and its needs, the artist speaks to the audience about itself. . . . Johns sticks right up against the gallery goer's nose the emblem he adores."[5]

Critics who looked more searchingly into the works themselves also arrived at opposite conclusions concerning the role of the subject. Fairfield Porter (he and Robert Rosenblum were the first writers to acclaim Johns's work) thought that the paintings had to do with a way of seeing. "He looks for the first time, like a child, at things that have no meaning to the child, yet, or necessarily."[6] Objection: *Johns's unerring fidelity to the correct shape and order of numbers is surely uncharacteristic of one who knows not the meaning of what he transcribes.*

John B. Myers, calling Johns "the Surrealist of naming things," wrote: "Like a small child who holds up an egg, having discovered such an object for the first time in a hidden nest, and cries 'Egg!'— so Johns has made clear what things *are*. . . ."[7] Objection: *What child holds his breath crying "Egg!" for a year—the time it took Johns to complete his* Gray Alphabet *of 1956?*

Rosenblum wrote: "Johns first astonishes the spectator and then obliges him to examine for the first time the visual qualities of a humdrum object he had never before paused to look at."[8] Objection: *If Johns worked with any spectator in mind, is it likely that he addressed himself by preference to those who never pause to look at such things as letters? Compare Rosenblum's own earlier comment:*[9]

"*. . . The letters and numbers look as though they were uncovered in the office of a printer who so loved their shapes and mysterious symbolism that he could not commit them to everyday use.*"

According to the three writers just cited, Johns's intent in choosing a subject was either to *see it,* to *name it,* or to *show it.* But they agree that a Johns painting renders an overlooked subject suddenly recognized.

Others found the exact opposite—that Johns chose his subjects to make them disappear altogether. "Johns likes to paint objects so familiar that the spectator can cease to think about them and concentrate on the poetic qualities of the picture itself."[10] Objection: *It used to be said of Velázquez' unlovely models that they were designed "to force the public to focus its attention on the art of painting and to give less importance to its subjects" (Ortega y Gasset). May I point out that in their alleged roles as promoters of formalist art appreciation both Johns and Velázquez are failures? Velázquez because the sorry stare of his court dwarfs and idiots remains as unforgettable as his calligraphy; and Johns, because similarly not one of his subjects ever succeeded in getting itself overlooked. On the contrary.*

We thus have a critical situation in which some believe that the subjects were chosen to make them more visible, others, that they were chosen to become altogether invisible. It is the sort of discrepancy that becomes a heuristic event. It sends you back to the paintings with a more potent question: What in the work, you ask, invites such contrariness? It then turns out that the work is such as to vindicate both groups of critics. For Johns's pictures are situations wherein the subjects are constantly found and lost, submerged and recovered.[11] He regains that perpetual oscillation which characterized our looking at pre-abstract art. But whereas, in traditional art, the oscillation was between the painted surface and the subject in depth, Johns succeeds in making the pendulum swing within the flatland of post-Abstract Expressionist art. Yet the habit of dissociating "pure painting" from content is so ingrained that almost no critic wanted to see both together.[12]

Finally, a few critics struck a more open course by examining Johns's subject matter, not with respect to any anticipated spectator reaction, but for its functioning within the picture itself. Donald Judd noticed "a curious polarity and alliance of the materiality of objects and what is usually classed as the more essential qualities of paint and color. . . . 'Congruency' is a relevant description."[13] Ben

Heller observed that "the subjects limit and describe Johns's space" (see note 10). Shortly thereafter, William Rubin suggested that the "enigma" of Johns's works stemmed "from the paradoxical oneness of the picture as painting and image. Such a peculiar ambiguity," he continued, "cannot be achieved with just any subject. . . . All Johns's favorite subjects share an emblematic or 'sign' character. . . . Thus the paradox lies in Johns's reversal of the usual process of representation, by which a three-dimensional from the real world is represented as a two-dimensional illusion. Johns gives his two-dimensional signs greater substance, weight, and texture than they had in reality; in other words, he turns them into objects."[14]

Johns has built himself a personal idiom in which object and emblem, picture and subject, converge indivisibly. Subject matter is back, not as filler or adulteration, nor in some sort of partnership, but as the very condition of painting. The means and the meaning, the visible and the known, are so much one and the same, that a distinction between content and form is either not yet or no longer intelligible.

This amazing result is largely a function of his original subjects. I want to keep questioning these subjects for their common character, to see how they work for him in his paintings. If I can get some of these questions answered, I may no longer need to ask what Johns's intentions were in choosing to paint flags, targets, numbers, etc.

THE SUBJECTS

The subjects which Jasper Johns chose to paint up to 1958, the year of his first public showing, have these points in common:

1. Whether objects or signs, they are man-made things.
2. All are commonplaces of our environment.
3. All possess a ritual or conventional shape, not to be altered.
4. They are either whole entities or complete systems.
5. They tend to prescribe the picture's shape and dimensions.
6. They are flat.
7. They tend to be non-hierarchic, permitting Johns to maintain a pictorial field of leveled equality, without points of stress or privilege.
8. They are associable with sufferance rather than action.

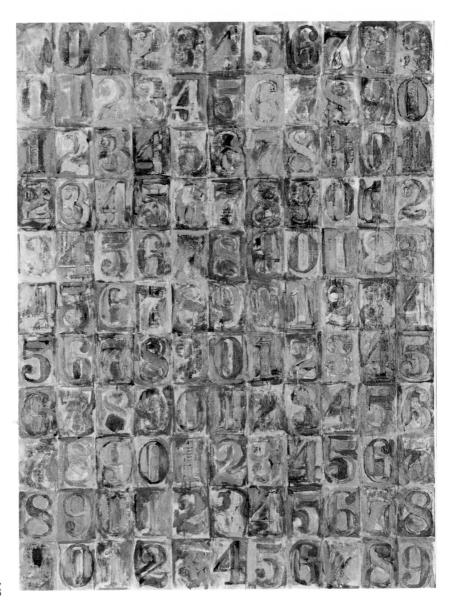

9. Johns,
Gray Numbers, 1958

I discuss each of these eight in turn.

1. *That Johns's subjects are man-made objects or signs* is apparent. The fact that they are man-made assures him that they are makable. And this is the liberating discovery for the painter whose mind is both literal and contemporary: the man-made alone can be made, whereas whatever else the environment has to show is only

imitable by make-believe. The position of modern anti-illusionism finds here its logical resting place. The street and the sky—they can only be *simulated* on canvas; but a flag, a target, a 5—these can be *made*, and the completed painting will represent no more than what it actually is. For no likeness or image of a 5 is paintable, only the thing itself.

A crucial problem of twentieth-century art—how to make the painting a firsthand reality—resolves itself when the subject matter shifts from nature to culture.

2. *The subjects are commonplaces of our environment.* So worded, Johns's preference would place him with Caravaggio, Courbet, or the American Ashcan School painters, all artists who chose lowly themes. But Johns doesn't give us the commonplace *in* a painting (transfigured by light, composition, and style), but the commonplace *as* a painting. This is different.

The choice of the commonplace does not necessarily follow from the decision to paint only man-made things: he might have chosen to paint the ground plan of the Taj Mahal. What he does choose is always a Universal: his *Coat Hanger*, for instance (Fig. 10). It is not made of wood, which would have placed it at a particular level of cost and quality; nor of some shiny plastic which would grade it on a scale of modernity. His wire hanger is of the kind nobody buys or selects. It comes free of charge from the cleaner; an object that enters everyman's house and is discarded at every back door. Similarly, his *Book, Newspaper, Hook* (1958) and flags: despite their concreteness, they are as impartial, as classless and universal as the primary numbers are, or the alphabet. His subjects are indeed commonplace, but no more "banal" than nickels and dimes.

Why did he choose them?

A woman wrote to me in June 1960: "When I saw Jasper Johns's paintings I wondered why he wasted those beautiful Chardin-like whites and greys on flags and numbers." It was the classic feminine disapproval—the familiar "I-don't-know-what-he-sees-in-her!"—of a man's love that seems misdirected. And yet so far only Rosenblum has remarked that there is a factor of love in the way Johns works with his subjects.

But love is a busy word. Perhaps the sniper who has picked his quarry from a line of uniformed enemy soldiers does the same thing. It is a matter of getting the object in focus, until it is not even one of its kind, but absolutely alone. Changing the object by a change of

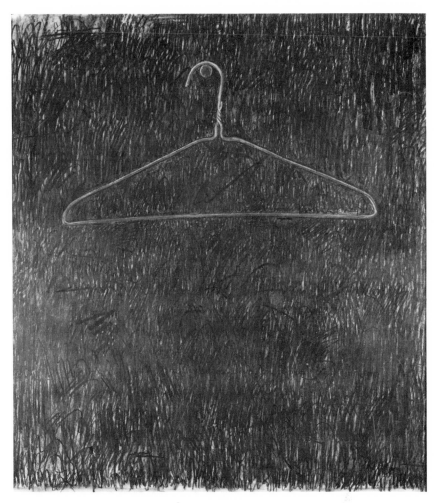

10. Johns,
Coat Hanger, 1958

attitude, the only way you can change it without violation.

Pierre Restany wrote recently[15] that Johns's essential gesture as a painter is to bestow uniqueness on the commonplace.

What happens when we see a commonplace painted by Jasper Johns? I do not believe that we experience a revelation about the design of a flag or target. Nor that we lose the subject in the delight of pure painting. But in observing these standardized things we sense an unfamiliar deceleration of their normal rate of existence. The flag stiffens, is slowly hand-painted, and—as the end stage of a process that began with the arrest of its flutter—cast in bronze (Fig. 6). The Stars and Stripes forever.

29

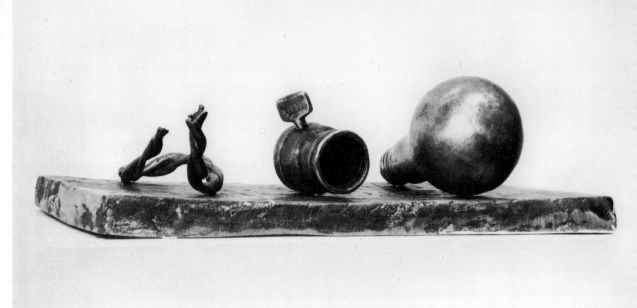

11. Johns, *Bronze,* 1960-61

All of them are slowed down. As they were not mass-produced in the outpouring of industry, so they no longer submit to the mechanical gestures of human users—the flipping of pages, the saluting of flags, opening of a drawer, computing of numbers, etc. What we see when we face a Johns commonplace is the possibility of a changed attitude; better still, the possibility of an object's lone self-existence without any human attitude whatsoever surrounding it. What Johns loves in his objects is that they are nobody's preference; not even his own. By a strange paradox, these handmade, uniquely made commonplace things are relieved of man's shadow.

If his works are disturbing at all, perhaps it is because they insinuate our absence, not from a scene of romantic desolation, nor from a universe of abstract energies, but from our own place.

3. *A Johns subject possesses a respected ritual or conventional shape.* It is never enough to say that he paints numbers; add that he paints them in proper order (i.e. not in childlike, or ignorant, or esthetic disregard of their meaning). Add that his alphabets run as prescribed, and that a ruler used in his paintings is always left whole

30

and straight, i.e. not creatively rearranged. Picabia in 1918 had incorporated a tape measure in a picture called *Les Centimètres;* but the tape had been broken and stuck down in pieces. The Cubists used to make it a practice to disrespect the true count of things: put three strings on a guitar, four or six lines on a stave of sheet music. Such departures from given facts signaled their transfiguration; they symbolized their enlistment in art. Byzantine architects sometimes ornamented a church facade with fragments of antique inscriptions, some of them upside down. The inversion, whether wilful or ignorant, was an index of alienation from the antique literary tradition. And twentieth-century art has continually made use of common objects, including numbers and clusters of letters, but modified, or freely fragmented, and in surprised combinations.

In Jasper Johns, the conventional meaning is never mocked. No attitude of anger, irony, or estheticism alters the shapes he transcribes. Nothing recalls the waywardness, the irreverence, or the untidiness of most original Dada productions. In all his subjects, Johns recognizes a prestructured form which he accepts much as artists formerly accepted the anatomy of the body. This had its practical side. "Using the design of the American flag took care of a great deal for me because I didn't have to design it," he once said. (Which reminds one that the best storytellers, such as Homer and Shakespeare, did not, like O. Henry or Somerset Maugham, invent their own plots.) "So I went on to similar things like the targets," Johns continued, "—things the mind already knows. That gave me room to work on other levels." It is as though Johns had decided to draw on both modes of non-representational painting—Geometric Abstraction and Abstract Expressionism—though their common tendency is to exclude one another. His way of realizing his subjects permits him to submit to an impersonal discipline of ruled lines, while still responding to every painterly impulse. And Johns succeeded in uniting these two disparate ways of art with yet a third, which is normally antithetical to them both; the most literal realism. It's the way things are that is the proper subject for art.

When you ask Johns why he did this or that in a painting, he answers so as to clear himself of responsibility. A given decision was made for him by the way things are, or was suggested by an accident he never invited.

Regarding the four casts of faces he placed in four oblong boxes over one of the targets (Fig. 13):

> Q: *Why did you cut them off just under the eyes?*
>
> A: *They wouldn't have fitted into the boxes if I'd left them whole.*

He was asked why his bronze sculpture of an electric bulb was broken up into bulb, socket, and cord (Fig. 11):

> A: *Because, when the parts came back from the foundry, the bulb wouldn't screw into the socket.*
>
> Q: *Could you have had it done over?*
>
> A: *I could have.*
>
> Q: *Then you liked it in fragments and you chose to leave it that way?*
>
> A: *Of course.*

The distinction I try to make between necessity and subjective preference seems unintelligible to Johns. I asked him about the type of numbers and letters he uses—coarse, standardized, unartistic—the type you associate with packing cases and grocery signs.

> Q: *You nearly always use this same type. Any particular reason?*
>
> A: *That's how the stencils come.*
>
> Q: *But if you preferred another typeface, would you think it improper to cut your own stencils?*
>
> A: *Of course not.*
>
> Q: *Then you really do like these best?*
>
> A: *Yes.*

This answer is so self-evident that I wonder why I asked the question at all; ah yes—because Johns would not see the obvious distinction between free choice and external necessity. Let me try again:

> Q: *Do you use these letter types because you like them or because that's how the stencils come?*
>
> A: *But that's what I like about them, that they come that way.*

Does this mean that it is Johns's choice to prefer given conditions —the shape of commercial stencils, inaccurate workmanship at the foundry, boxes too low to contain plaster masks, etc.? that he so wills what occurs that what comes from without becomes indistinguishable from what he chooses? The theoretic distinction I tried to impose had been fetched from elsewhere; hence its irrelevance.

I had tried to distinguish between designed lettering subject to expressive inflection, i.e. letters that exist in the world of art, and

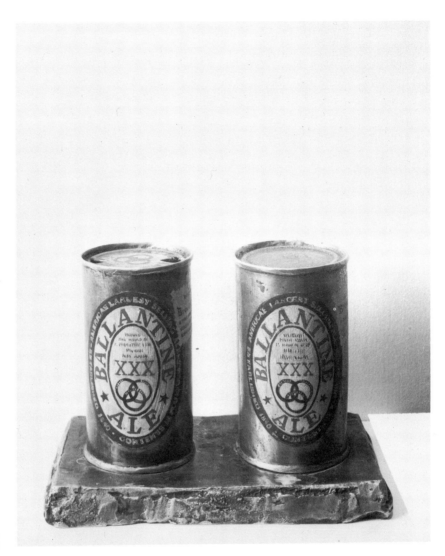

12. Johns,
Painted Bronze, 1960

those functional letters that come in mass-produced stencils to spell
THIS END UP on a crate. Proceeding by rote from this distinction be-
tween life and art, I asked whether the painter entertained an es-
thetic preference for these crude stenciled forms. Johns answers that
he will not recognize the distinction. He knows that letters of more
striking design do exist or can be made to exist. But they would be
Art. And what he likes about those stencils is that they are Art not
quite yet. He is the realist for whom preformed subject matter is a
condition of painting.

33

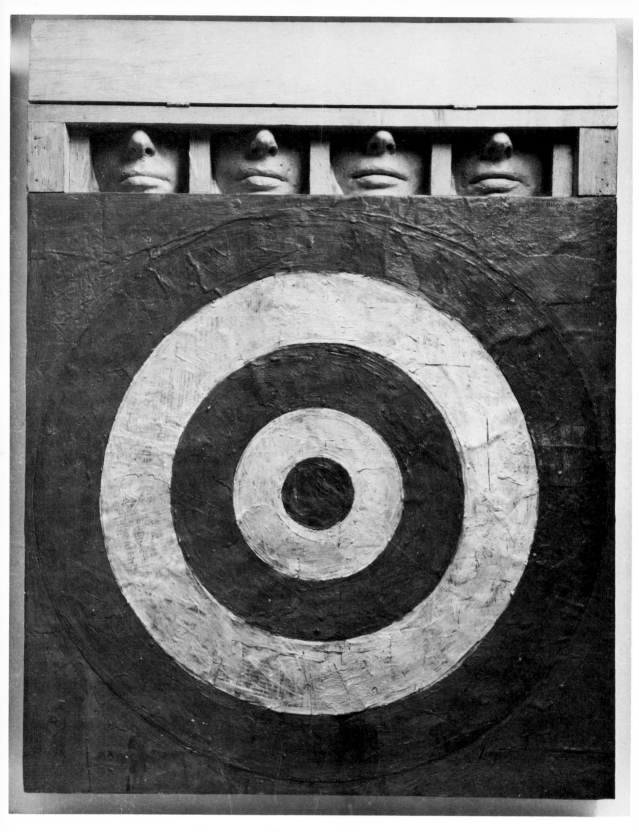

13. Johns, *Target with Four Faces,* 1955

4. *Johns's subjects are whole entities or complete systems.* Either a single thing in its entirety, a figure 5, a target, a shade; or a gamut, a span of possibilities, a full set. The first commonplace object which Johns saw as a picture, potentially, was the US flag, whose stripes stand for the sum of the original colonies and whose stars make up the full count of states; America then and now. When Johns made bronze sculptures out of two cans of ale (Fig. 12), one of them, weighing less and pierced at the top, was designated as empty, the other as full; one (with the Ballantine sign at the top) was Confederate, the other Yankee.

His numbers, when not single ciphers, run zero to nine (Fig. 9); his alphabets, from A to Z. His *Book* and his *Newspaper* are double spread; his roller *Shade* is unfurled (Fig. 20); his *Thermometer* paintings calibrate the full scale; and his various circle paintings describe complete revolutions. His latest large work (1961, about 10 feet wide) is the United States map coast-to-coast (Fig. 19). All things, whether objects or signs or series, are shown, like Egyptian shoulders, in their longest extension. And the implication here, as in Egyptian art, is the unfixed point of view.

As his objects are seen from no particular angle, so there is no intellectual position from which a significant fragment might have been singled out. No partiality. The completeness of his systems or entities implies the artist's refusal to advertise his subjective location.

It is the same with his color. When he is not painting monochromatically, his colors present a schematic abstract of the whole spectrum: Red, Yellow, Blue; or, for greater richness and with a slight turn of the wheel, the intermediate complementaries: Orange, Green, Purple.

But there are the two *Targets* of 1955 (painted when Johns was twenty-five), of which Nicolas Calas once wrote, "Oneness is killed either by repetition or by fragmentation."[16] One of these (Fig. 13) displays four truncated life casts of a face painted orange; the other (Fig. 14) is surmounted by nine boxes whose hinged flaps can be opened and shut, and which contain anatomical fragments in plaster: a near-white face segment, a near-black animal bone, a four-fingered hand painted red, a yellow heel, orange ear, green penis, purple foot and empty blue box. (I should ask Johns why the breast fragment is pink. I did once ask why he had inserted these plaster

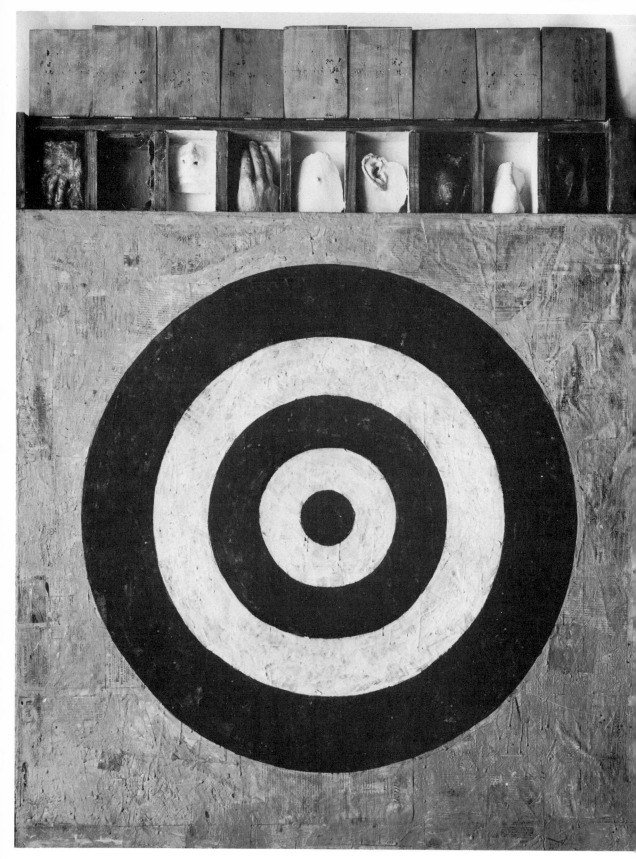

14. Johns, *Target with Plaster Casts*, 1955

casts, and his answer was, naturally, that some of the casts happened to be around in the studio.)

The fact that these anatomical parts are not whole, that only so much of them is inserted as will fit in each box, that they are clipped to size like bits of collage, indicates that the human body is not the ostensible subject. The subject remains the bull's-eye in its wholeness, for which the anatomical fragments provide the emphatic foil.

Apparently the artist wanted to know (or so he says) whether he could use life-cast fragments of body and remain as indifferent to reading their message as he was to the linage in the newspaper fragments pasted on the canvas below. Could our habit of sentimentalizing the human, even when obviously duplicated in painted plaster —could this pathetic instinct in us be deadened at sight so as to free alternative attitudes? He was tracking a dangerous possibility to its limits; and I think he miscalculated. Not that he failed to make a picture that works; but the attitude of detachment required to make it work on his stated terms is too special, too rare, and too pitilessly matter-of-fact to acquit the work of morbidity. When affective human elements are conspicuously used, and yet not used as subjects, their subjugation becomes a subject that's got out of control. At any rate, no similar fracturing of known wholes has occurred since in Johns's work.[17]

5. Since they tend to constitute the whole subject of a particular work, *Johns's objects, systems, or signs predetermine the picture's shape and dimensions.* The picture is not contained by an external frame, but is retained from within. Apollinaire had seen this coming in 1913 when he predicted a greater role in modern art for the real object, which he called the picture's "internal frame."

In Johns's work, the "internal frame" rules absolutely wherever the image depicted—flag, target, alphabet, book, canvas, or shade— remains self-sufficient. Where a physical object is included within a larger canvas it serves at least to diminish the margin of choice; the arbitrariness of where the picture ends is reduced. Thus, in *Coat Hanger* (Fig. 10) and *Drawer* (Fig. 8), the lateral span is pre-fixed; in others, e.g. *Thermometer*, the height. In *Gray Painting with a Ball* (1958; Fig. 15) the upright dimension is given by a gash in the canvas, pried and held open by an intruding ball.

In a picture of the following year (Fig. 16) the subject was to have been a circle. Johns pivoted a flat stick to trace it, then, when

15. Johns,
Gray Painting with a Ball,
1958

the tracing was done, saw that it would be false to remove it. The circle alone would have been an abstraction on canvas; with the compass stick left in evidence, the picture became an object again: a device for circle-making. Subject, title, and form suddenly coincided. The circle and the words DEVICE CIRCLE stenciled across the bottom determine, as if by necessity, the structure and shape of the work.

One of Johns's most beautiful works is the picture called *Tennyson* (1958; Fig. 17), conceived in homage to the poet who had written "The Lotos-Eaters." The poet's name—for once not stenciled but in Roman capitals—runs across the bottom, setting out the width and even, one feels, the scale of the work. The rest of his large picture (185.7 cm. high) begins in two tall upright panels on separate stretchers whose junction still shows at the top. Then the painter takes a great length of canvas and lays it over the original diptych as a folded sheet. For some reason I imagine that one can still feel the pace of these simple performances; slow, somber gestures as of an unknown, funereal rite. The canted sides of the sheet introduce the illusion of a tall upright stele. And then the gray brushwork overlays the entire field with an allover falling of grays;

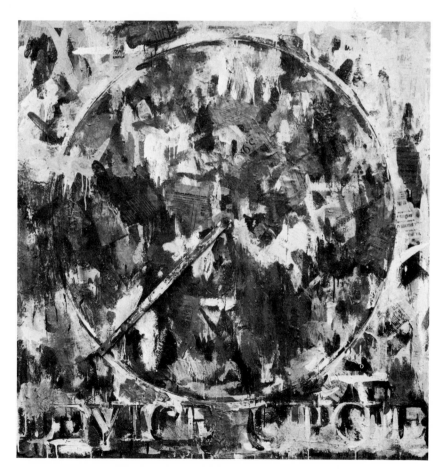

16. Johns,
Device Circle, 1959

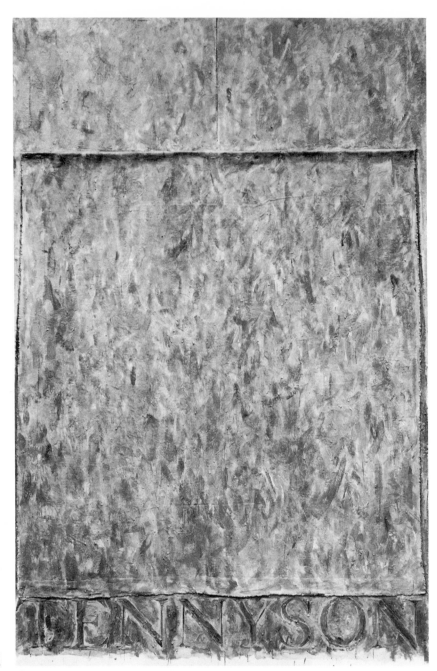

17. Johns,
Tennyson, 1958

and darker grays in the pressed density of the letters that spell Tennyson's name.

The important step in this picture was the decision to use no given reality beyond that of the poet's name, but to create, out of invented material geometries, a system equally ineluctible. The physical fashioning of this picture—the separation of the two panels and the folded tapering overlay—these in relation to the paint activity now furnish the preconditions of material necessity. A fiction, of course, since these acts of cutting and pasting were free decisions. But their wilfulness operated against another kind of material resistance and bespeaks action earlier in time. At the moment of painting, the system of three visible strata and four fields of canvas was as surely ordained as was, in previous paintings, the design of the American flag.

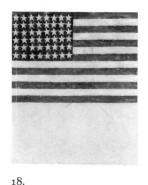

18.

But what of the arbitrary variations Johns has played on the Stars and Stripes? The *Flag Above White*, for example, (1954; Fig. 18), is a picture in which the flag's horizontal design sits incongruously in a tall canvas. It seems to me that the uncanniness of the picture derives precisely from this, that a known rule of logic and precedent is here visibly broken. When the flag ceases to be all there is; when its perfect anatomy enters into any kind of combination—it becomes fabulous: a modern realist's counterpart to the chimeras of antique realism.

The *Flag Above White:* Does the flag rest on a white plinth? Impossible since the white of the plinth and that of the stripes is identical; you can taste it.

Is the picture unfinished, as if in expectation of more of those horizontal red stripes? Such finishing might be good for the picture, but it would ruin the flag.

But then, is the lower white an excess to be pared away? This might be good for the flag, but it would cut up the picture which is visibly indivisible.

In transgressing the design of the American flag, the picture demonstrates its own impossibility.

6. *Johns's subjects are flat.* Under an enormous literal representation of an unmistakable pipe Magritte wrote *Ceci n'est pas une pipe.* And to the puzzled spectator who mistakes the image for the reality, he would have said—*Try to smoke it.*

Johns's images do not seek this immunity of the unreal. You can't smoke Magritte's painted pipe, but you could throw a dart at a Johns target, or use his painted alphabets for testing myopia. If you don't put his targets and letters to use, is it perhaps because you regard them as art? But that's your decision. You are free to spare his targets, or anyone's targets; for, as noted above, Johns renders visible the possibility of an alternative attitude. The point is, however, that it is an alternative; that the posture of aiming at a Johns target is no less sane than was genuflection before an icon. Because the subject in Johns's art has regained real presence.

In his home-grown morality, which makes it unethical to turn things away from themselves, a painting must be what it represents. Paint is paint, and numbers are numbers, and you can have a painted number in which each term is only itself. You can also have objects with paint on them. What you cannot have is a painted landscape, where the landscape is counterfeit and the paint is disguised.

Was it, I wonder, a painful decision, that paint was to be no longer a medium of transformation? Probably not; for the painter it must have been merely the taking of the next step. But once taken, it placed him at a point outside the crowded room, whence one suddenly saw how Franz Kline bundles with Watteau and Giotto. For they were all artists who use paint and surface to suggest existences other than surface and paint.

The degree of non-figurative abstraction has nothing to do with it. Existences other than those of paint are implied when Kline's imminent blacks block out the openness of a white space; when pure color patches are allowed to locate themselves at varying distances from the picture plane; when painted canvas permits the illusion that form and space, figure and ground are not of one stuff. Johns eliminates this residue of double dealing in modern painting. Since his picture plane is to be flat, nothing is paintable without make-believe but what is flat by nature. And if for some reason he wants something 3-D, let the artist insert the thing, or a cast of it.

Does all this mean that Johns is a respecter of what used to be called "the integrity of the picture plane?" On the contrary. Such is his sovereign disrespect for it that he lets his subjects take care of the matter.

Have you noticed how his paint is laid on? The brushstrokes

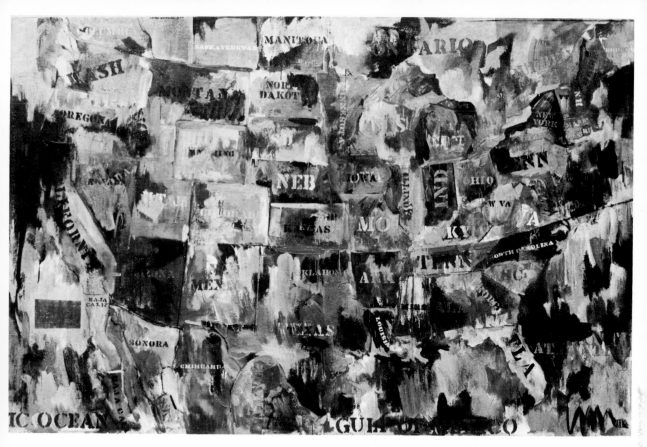

19. Johns, *Map,* 1962

don't blend; each dab is a short shape, distinct in tone from its neighbor. This is the way Cézanne used to paint, in broken planes composed of adjacent values; imparting pictorial flatness to things which the mind knows to be atmospheric and spatial. Johns, with that same type of brushwork that hovers midway between opaque canvas and spatial illusion, does the reverse: allowing an atmospheric suggestion to things which the mind knows to be flat. In fact, he relies on his subject matter to find and retain the picture plane for him, leaving him free to work, as he put it, *on other levels.*

Not for a generation has subject matter been of such radical formal importance as in his *Map* (1961; Fig. 19).[18] In reading maps, we are used to seeing blue waters against earth-colored landmasses. But Johns's picture disperses Blue, Yellow, Red, and some new derivatives in even quantities all over the map. If this were a quilt of pure color relations, the blues that now ride most of Texas and Iowa would sink unfathomably. Johns counts on our knowledge that this is a map to maintain surface tension against the natural spatial pressures of colors; just as Poussin, clothing a girl's skiey thigh in the

43

foreground in blue, relies on our understanding of foregrounds and thighs to hold the recessive color in place.

Is it not now apparent how far from arbitrary, how far from the spirit of Dada, or from any desire to provoke some uncaring bourgeois, Johns is in the choice of his themes?

Look at the flag again, the first of his found subjects and, in its natural state, almost a preformed Johnsian system. The red and white stripes do not—as in a normal striped pattern—form a figure-ground hierarchy. They are, in their familiar symbolic role, wholly equivalent. In other words, the alternation of red and white stripes in the American flag is much flatter than similar stripes on a T-shirt would be. As for the stars on blue ground: here, as in all situations that threaten a figure–ground differential, Johns employs all his techniques as a painter to cancel the difference:

The ceaseless overlap-interlace of figure and ground; a paint surface like knitting or basketry. Not a shallow space but the quickened density of a film.

An M-W brushstroke that looks and functions like the corrugated staples carpenters use.

The unpainted lower edge of most of his canvasses.

The drip, familiar mark of New York School painting, defining the canvas ground as rain streamers define the transparent window pane.

Collage fragments, newspaper or a patch of fresh canvas, to recall the painting to its materiality wherever color or tone values overreach into illusory space.

I keep looking at his black-and-white painting called *Shade* (Fig. 20). But for a narrow margin all around, its entire surface is taken up by an actual window shade—the cheap kind; Johns had to fortify it to keep it flat. It's been pulled down as if for the night, and obviously for the last time. Over all the visible surface, shade and ground canvas together, spreads the paint itself, paint unusually atmospheric and permissive of depth. It makes a nocturnal space with bursts in it of white lights that radiate from suspended points, like bursting and falling fireworks misted over.

An abstracted nightscape? You stare at and into a field whose darkness is absolute, whose whites brighten nothing, but make darkness visible, as Milton said of infernal shade.

20. Johns,
Shade, 1959

Or a scene of nightfall: far lights flaring and fading move into focus and out, like rainy lights passed on a road. Are we out inside the night or indoors? A window, with its cheap shade pulled down, is within reach, shutting me out, keeping me in? Look again. On a canvas shade lowered against the outside we are given to see outdoor darkness; like the hollow shade our closed eyes project upon lowered lids. Alberti compared the perspective diaphanes of the

45

Renaissance to open windows. Johns's *Shade* compares the adiaphane of his canvas to a window whose shade is down.

7. *Johns's subjects are non-hierarchic.* When Johns paints in color his effort is to maintain each of his colors in a state of allover dispersion and in similar quantities. There is to be no predominance.

When he paints figures, such as numbers or letters, the negative spaces are given just enough occasional overlap to cancel any hierarchic distinction between figure and ground.

The objects he incorporates in his pictures are those that are equally uninteresting to tramp and tycoon.

Instruments of differentiation—a ruler or a thermometer attached to the canvas—may interrupt the paint surface, but they cannot alter its character, whose homogeneity overrules their calibrations.

Within Johns's pictorial fields, all the members abide in a state of democratic equality. No part swells at the expense of another. Every part of the image tends toward the picture plane as water tends to sea level. The paint surface, waved and incidented but leveled and leveling like the surface of water; and one imagines that any part could replace any other at any point.

In other words, no one is pointing at anything in particular, perhaps because no one's around.

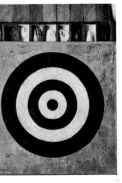

21.

What of the Targets, however? As objects of use they are designed to feature one center; systems of total convergence upon a privileged point. But Johns's treatment of targets neutralizes their native emphasis, chiefly by the strong decentralized red in the spandrels. And it must have been partly to offset the look of centralization that Johns topped two of his targets with boxed anatomical casts (Fig. 21). They form an aimless procession to and fro on a shelved horizontal, and invite the vertical up-and-down motion of raising and closing the flaps. One good reason for their inclusion was surely the determination to bring this most centralizing of all possible forms down to a state of homogeneous de-emphasis. Hence also his target paintings that are all-green and all-white. Johns unfocuses even the target so that, being seen not with a marksman's eye, it is seen with an alternative attitude.

It is characteristic of Johns that having by certain means achieved a certain desired appearance, he goes on to see whether he may not

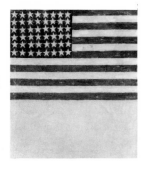

18.

get the same result by the opposite means: whether he can make a target look as decentralized as a flag; whether he can make the upright *Flag Above White* (Fig. 18) look as indivisible as a flag alone; and, in his two Targets with plaster casts, whether the effect of randomness, procured by anatomical fragments from all over the body, can be attained also by a fourfold repetition of the same single face; and whether male privates in plaster may be made to seem as indifferently public as the cast of a heel; and whether, having aroused the spectator's sense of participation by means of hinged flaps which he can open at will, the spectator may not be stirred to the same sense of participation by means of a drawer which remains shut.

Moral: Nothing in art is so true that its opposite cannot be made even truer.

8. *Johns's subjects are associable with sufferance rather than action.* All objects are passive and Johns's pictures are objects. But objects get themselves associated with specific actions and, accordingly, with degrees of doing and suffering. Everyone knows what it means when a warlike king identifies himself with a hammer, or a Michelangelo with an anvil. Johns's symbolism may not be so explicit, but to ignore the variable of symbolic pressure in his iconography is either negligent or doctrinaire. For the objects he chooses show a distinct preference for letting things happen. A flag has nothing to do but be recognized; a target is aimed at; a book is opened, letters and numbers are shuffled, shades are pulled, drawers are filled and closed. Even the *Hook* Johns once drew puts out no prehensile claw, but curls up on itself.

Along with his manner of painting, his subjects tend to create areas of uneventful persistence; the subjects themselves yielding patterns of continuity that stay inert against the erosive activity of the paint.

It seems to hold for the early work. Then, by 1958, Johns introduced elements of assertive action into his pictures, which thereafter became readable as polarities of doing and suffering. Things that acted and things acted upon appeared in conjunction. In the *Gray Painting with Ball* (1958, Fig. 15) the ball works as a forceful intrusion, a foreign body in the gashed canvas. The compass arm that remained behind in *Device Circle* (1959, Fig. 16) is an efficient agent that makes its mark wherever it touches. Such changes deserve to be noticed; they indicate how Johns's repertory of objects grows responsive to life.

His subject matter is the sensitive vehicle of his intentions as person and painter. It is not there by default, nor to provoke honest Babbitts into a rage of incomprehension. His themes were not chosen to educate our blunt sensibilities, nor indeed for any reason having to do with you and me. Johns chose his subjects because they were the ones that best let him live his painter's life. That is to say, they alone would convey him and his hand—in the way they both wished to be traveling—from edge to edge of the day's canvas.

WHAT IS A PAINTING?

You don't just ask; you advance a hypothesis. The question is, What is a Picture? or What sort of presence is the Picture Plane? And the hypothesis takes the form of a painting.

It is part of the fascination of Johns's work that many of his inventions are interpretable as meditations on the nature of painting, pursued as if in dialogue with a questioner of ideal innocence and congenital blindness.

A picture, you see, is a piece of cotton duck nailed to a stretcher.

Like this? says the blindman, holding it up with its face to the wall. Then Johns makes a picture of that kind of picture to see whether it will make a picture (Fig. 7).

Or: *A picture is what a painter puts whatever he has into.*

You mean like a drawer?

Not quite; remember it's flat.

Like the front of a drawer?

The thought takes form as a picture (Fig. 22)—and let's not ask whether this is what the artist had thought while he made it. It's what the picture gives you to think that counts.

But if pictures are flat, says the blindman, *why do they always speak of things IN pictures?*

Why, what's wrong with it?

Things ON pictures, it should be; like things on trays or on walls.

That's right.

Well then, when something is IN a picture, where is it? In a fold of the canvas? Behind it, a concealed music box?

Johns painted just such a picture in 1955, calling it *Tango;* canvases with secret folds are the subject of *Tennyson* and of two pictures (1960 and 1961) called *Disappearance.*

What would happen if you dropped one of Cézanne's apples into

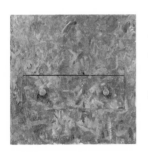

22.

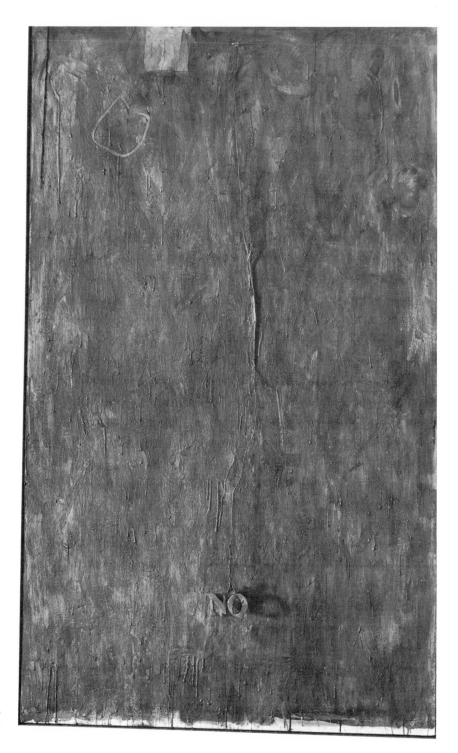

23. Johns,
NO, 1961

24. Johns,
0 Through 9, 1960

a Still Life by Renoir? Would the weight of it sink it right through the table? Would the table itself pulverize like disturbed dust or down from a torn pillow? Yet this is the standard anomaly of conceiving an alien solid quartered upon a pictorial field. The blindman refused to believe that it could be done.

Show me, he said; and Johns painted *Gray Painting with Ball.*

He has worked valiantly to keep him informed, this blindman who believes nothing that cannot be touched. *Green Target* was a special donation; a target in Braille, so to speak.

And the logic of it is overwhelming. If a painting is truly an object—repeat: if that which is painted is truly an object—then that which is painted cannot be a purely optic phenomenon. It must have a visible tangibility. And in that case any painting can be rehearsed with either its visual or its tactual modality played up or played down. A Johns painting may be flattened into a drawing, or relieved in sculpmetal and bronze. A drawing (which Johns usually makes *after* a painting) abstracts from the picture its visibility. Green targets, flags bleached or brazen, all effaced tricolor emblems reduced to texture alone, approach pure palpability.

50

Among Johns's December 1961 paintings, and in the same group with LIAR (Fig. 2), is a larger picture called *NO* (Fig. 23). Its painted field is made up of soft mottled grays. Fastened to a hook near the top is a long straggling wire hung loose and free. From its lower end dangle two letters, an N and an O, cut out of aluminum foil and casting a vagrant shadow. The shadow writes NO near a place that's already big with the same message—the word NO raised on the canvas in sculpmetal relief.

Both this picture and *LIAR* seem to me to write a new role for the picture plane: not a window, nor an uprighted tray, nor yet an object with active projections into actual space; but a surface observed during impregnation, observed as it receives a message or imprint from real space.

Johns has painted and drawn a series of pictures (Figs. 24 and 25) which he called *Zero Through Nine*. Not "zero *to* nine," like the white painting of the previous year; but *through*—to intimate that succession had given way to transparency and superposition. As if the progression of cardinal numbers had suddenly become faintly

51

improper for implying a prearranged pecking order. It accords well
with his moral position that Johns should have hit on the idea of
annulling the seniority rule among numbers. Now all ten ciphers,
drawn to one scale, are superimposed in one place.

But "superimposed" is the wrong word; it suggests stratification.
And the point about these numbers is that they exist in simultane-
ity in the same single stratum.

But "same" too is the wrong word. The same river cannot be
stepped into twice, and just so, no cipher here steps into the same
situation, since each entering form alters it for the next, while
changing the place for all previous tenants.

What sort of a place is this that can hold ten simultaneous pres-
ences in solution? Is it anything like that scholastic pinhead that
supports untold numbers of angels? Or a movie screen with a mem-
ory? . . . Some years ago Johns was asked at a party what he
would do if he were not a painter. He said he would run a lending
collection of paintings to tour the country by air. The distributing
aircraft, he said, would be labeled: "The Picture Plane."

HOW IMPROPER IS IT TO FIND POETIC, METAPHORICAL,
OR EMOTIONAL CONTENT IN JOHNS'S WORK?

I remember how, in 1957, my initial dismay over Johns's work was
overcome by the pictures themselves. A suspicion of their destruc-
tive or unserious intention was dissipated not only by their com-
manding presence and workmanlike quality, but by something that
impressed me as the intensity of their solitude. And this despite
their deadpan materiality, and despite the artist's assurance that
emotional content was neither overtly nor implicitly present. When
I said to him recently that his early works seemed to me to be "about
human absence," he replied that this would mean their failure for
him; for it would imply that he had "been there," whereas he wants
his pictures to be objects alone.

Well then I think he fails; not as a painter, but as theorist. For the
assumption of a realism of absolute impersonality always does fail—
if taken literally. That assumption is itself a way of feeling; it is the
ascetic passion which sustains the drive of a youthful Velázquez, or
a Courbet, while they shake the emotional slop from themselves and
their models.

Johns's earliest surviving picture—he destroyed many—has a ro-
mantic melancholy about it, even a hint of self-pity. It is the lovely

26. Johns,
Construction with a Piano,
1954

small *Construction with a Piano* (1954; Fig. 26). Compared with such a piece, the symbolism of his 1961 paintings—*LIAR, NO, Good Time Charley, In Memory of My Feelings*—is both more overt and more impenetrable. The painter past thirty dares to be frankly autobiographical because his sense of self is objectified, and because he feels secure in the strength of his idiom.

Between that early muted lament and these latest tough-minded personal symbols lie the paintings I have chiefly discussed, works that were to have been of the most uncompromising impersonal objectivity.

53

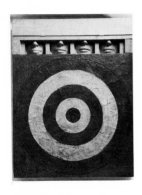

27.

Target with Four Faces (1955, Fig. 27) was to have been just that and no more. And it is indeed without content, if content implies the artist in attendance pumping it in. But that's not what's implied at all. The content in Johns's work gives the impression of being self-generated—so potent are his juxtapositions. Here in this work the rigid stare of the bull's-eye is surmounted by four eyeless life casts of one face. Suppose the juxtaposition performed without expressive purpose. Then, within the world-frame of this picture, the values that would make a face seem more articulate than a target are not being held anymore. And this is neither a logical inference nor a sentimental projection. It is something one sees.

But the things one knows also come in. Thus the target appears in its known true colors; but the face is orange all over. The target is whole; but the face is cut down. The target, of which one tends to have many, is single; the face, of which one has one alone, has been multiplied. In common experience, targets are known at a distance; a target so close that it cannot be missed is deprived of its functional identity—as is a face on a shelf four times repeated. So then, if target and facial casts had no correlative meaning when the artist first put them together, the life they now lead in his picture gives them a common constraint. They seem to have traded their respective holdings in space. For the target that belongs out there at a distance has acquired absolute hereness. And the human face, which is experienced as here, has been dismissed to *up there*. As if the subjective space consciousness that gives meaning to the words "here" and "there" had ceased operation.

And then I saw that all of Johns's early pictures, in the passivity of their subjects and their slow lasting through time, imply a perpetual waiting—like the canvas face-to-the-wall that waits to be turned, or the empty coat hanger. But it is a waiting for nothing, since the objects, as Johns presents them, acknowledge no living presence; they are tokens of human absence from a man-made environment. Only man's chattels remain, overgrown by paint as by indifferent vegetation. Familiar objects, but Johns has anticipated their dereliction.

And is this finally what the picture means?
No, not that at all. Who would need pictures if they were that translatable? What I am saying is that Johns puts two flinty things in a picture and makes them work against one another so hard that the mind is sparked. Seeing them becomes thinking.

3 Other Criteria

Twice within ten years—eventful years for American painting—
Fortune, the magazine "for those who must think and act in terms of
the long run," addressed itself to the business of art. Both pieces are
now sadly dated, but both were articles of faith, and what remains
of interest is the change of style, the shift in tone partly subcon-
scious from the first to the second, from September 1946 to Decem-
ber 1955.[1]

The writer of the earlier piece, embarrassed by a subject which he
deems outlandish, hits upon the travelogue as the appropriate sty-
listic model. Describing New York's 57th Street, he writes like one
who has been visiting in foreign parts and now returns with a bag of
exotic stories. "There are many curious customs to be observed
among the inhabitants of the art districts," he begins. He concludes
with a warning to beware of what is "one of the world's slyest and
subtlest bazaars."

The stylistic model for the second piece is the stock market re-
port. The writers' language applies itself not to the psychic distance
of the subject but to bringing it home. The metaphor throughout is
"the hard coin of art"; the goal, to rise above softheaded sentiment,
to cut the trite associations of Fine Art with culture, foreigners,
philanthropy, and ladies' clubs. Over a given period, we learn, "Gen-
eral Motors has done a little better than Cézanne, but not so well as
Renoir." A Vermeer recently sold turns out to be worth "$1,252 per
square inch," as against the land on which the House of Morgan on
Wall Street stands—valued at only $2.10 per square inch.

Based on a lecture given at the Museum of Modern Art, New York, March 1968. The
latter portion of the present piece appeared in *Artforum,* March 1972.

The authors distinguish between three types of investment oppor-
tunities: gilt-edged securities—the old masters, of whom there are
perhaps two hundred and fifty; blue-chip stock, i.e. paintings that
rank beneath the old masters—here, as within a group of industrial
stocks, "there are performers that have their ups and downs"; and,
thirdly, the speculative or "growth" issues. But as not all growth
companies grow, so, we are reminded, at this level the art market
and the stock market are equally chancy. A list follows of forty-four
artists currently working; their "eventual historical position cannot
be foretold. . . . But out of such material, given a growing unity of
taste and acceptance of their aims, *investments for the future are
made*" (italics original).

A heartening change! Where the first article had been aloof and
retrospective (". . . the days of the fabulous collectors are gone,"
etc.), the second looks ahead to profit and enterprise: "The owner-
ship of art offers a unique combination of financial attractions. . . .
From the broadest point of view art is an investment."

Insofar as such exhortations concern avant-garde art, the new
attitude marks a historic turn in modern culture. Avant-garde art,
lately Americanized, is for the first time associated with big money.
And this because its occult aims and uncertain future have been suc-
cessfully translated into homely terms. For far-out modernism, we
can now read "speculative growth stock"; for apparent quality,
"market attractiveness"; and for an adverse change of taste, "techni-
cal obsolescence." A feat of language to absolve a change of attitude.
Art is not, after all, what we thought it was; in the broadest sense it
is hard cash. The whole of art, its growing tip included, is assimilated
to familiar values. Another decade, and we shall have mutual funds
based on securities in the form of pictures held in bank vaults.

But this is only the practical man's amiable way of assimilating
what had long been forbidden. He may or may not like the art—the
problem is to have it without guilt. Americans have always felt
suspicious and uneasy about art. Traditionally, the idea of art has
had too many untoward associations—with High Culture and High
Church religion, with aristocracy and snob appeal, with pleasure,
wickedness, finesse. To American minds, the word "art" is the guilty
root from which derive "artful," "arty," and "artificial." Whence the
perpetual need to call art by some other name. "Investment"—the
euphemism for the financier—is but a special case, and in some ways
the least significant. More interesting, because creatively involved,

are those Americans who assimilate art by actively changing it, by moving it from where they find it onto home ground and adapting it to native criteria. Theirs is the opposite of the investor's game. The latter, seeking to make art acceptable, takes the finished product and declares it to be something else. The artist's dream is to intend something else and still come up with art. But the pervasive character of American artistic culture, whether for good or ill, for sport or for real, derives from an initial posture of repudiation.

NOT ART BUT WORK

Thomas Eakins (1844-1916) is the type of the American artist.[2] In his acceptance of America's disinterest in art (John Sloan described the American artist as the unwanted cockroach in the kitchen of a frontier society), Eakins tried "to convince his conscience that painting was work."[3] Compare his picture *William Rush Carving His Allegorical Figure of the Schuylkill River* with the *Pygmalion* by his former teacher in Paris, Léon Gérome (Figs. 28 and 29). Both pictures idealize the artist in his studio and his handling a female nude. And both involve the painter in self-projection. As Gérome inscribes his name on the base of Pygmalion's statue, so Eakins signs on one of Rush's architectural ornaments.

Gérome's picture (after 1881) illustrates an ancient myth of art. It arrests that moment of miraculous change when the sculptor's creation, responding to his appeal, turns into flesh. Though the statue's lower half is still cold white marble, its blushing top is already woman enough to restrain his over-eager advances. And the third living presence is a Cupid on the wing aiming his dart. The picture —a fantasy of the artist's reward—links art with desire.

Gérome's American pupil reverses all Pygmalion attitudes. His picture links art with Work, and with work conceived as its own reward.[4] The subject is the self-taught early American sculptor William Rush (1756-1836), best known for his masterpiece of 1812, the *Nymph of the Schuylkill River*. Eakins admired Rush's simplified naturalism and idealized him in several paintings. A first version of *William Rush Carving . . .* (1877; Philadelphia Museum) presented the hero in period costume. But in the definitive version of 1908 (Brooklyn Museum) the sculptor is given plain workman's clothes, and the reward of his labor is the skill of his nervy hands and his leathery face.

28. Jean Léon Gérome,
Pygmalion and Galatea

29. Thomas Eakins,
*William Rush Carving
His Allegorical Figure
of the Schuylkill River*

The nude in Eakins' picture is one of the finest in American paint-ing. But one observes that the allegory for which the model is posing is draped; ergo, the model's nakedness is not there to be relished, but for science's sake; nudity, we perceive, is the structure that underlies draperies. And as the sculptor chisels away at the side of a wooden knee, everything turns from the naked woman—even the third party present—a chaperone of mature years bent on her knitting. All activ-ity, the model's patience as well as the sculptor's craft, is redeemed by the absorption in work. Its ennobling effect overcomes the most entrenched prejudice. Eakins' *William Rush* is a manful attempt to silence the American objection to art and undress by assimilating both to the ethic of work. That is why everything in his picture is preoccupied—whereas in the Gérome everything turns to the nude; that is why the upright format of Gérome's painting is scaled to her figure, while Eakins' oblong picture is scaled to the shop.

Of the two images, the Eakins seems more sincerely romantic. Its sentiment and covert symbolism are personal, whereas Gérome ex-presses a notorious fantasy long since externalized. But in the end, both pictures are equally culture-bound. Eakins' celebration of honest work springs from the puritanism of the society in which he tried to practice his art. And his expressions, whether spoken or painted, are haunted by the idea of professional discipline as the absolute value. What he detests in Rubens ("the nastiest most vul-gar noisy painter that ever lived") is the man's counter-productive excess. Rubens' people, he observes, "must all be in the most violent action, must use the strength of Hercules if a little watch is to be wound up."[5] Upon arriving in Paris to study in Gérome's atelier at the Ecole des Beaux Arts, he writes to his father (November 11, 1866): "It is an incalculable advantage to have all around you better workmen than yourself." Thereafter, when Eakins feels in a confi-dent mood, he speaks of producing "solid, heavy work." The idealism and the yearning for sensuality that run through his art remain un-acknowledged in his protestations. He projects an image of himself which later critics, such as James T. Flexner, transmit obligingly: "During four years of study in France and Spain, he had sought neither grace nor inspiration, but had amassed technical skill like an engineer learning to build a bridge."[6] And of Eakins' *The Agnew Clinic* (1898), Flexner observes: "He did not soften the impact with sentiment; he expressed neither horror nor pity. We are shown the workroom of men who have a job to do and who do it efficiently."

Neither grace nor inspiration, neither horror nor pity. Noble senti-

ments of that kind may be relative values, commendable in the limited spheres of art and the moral life. But to be workmanlike is an absolute good. Efficiency is self-justifying; it exonerates any activity whatsoever. It is the active man's formalism—a value independent of content. As the marine captain said after a battle near Conthien in South Vietnam—"It was definitely a good night's work. I don't know how many gooks we got really but we got plenty. We counted 140 on the ground this morning."[7] Or the *Life* correspondent reporting on sniping operations around Khe San: "They work in three-man teams. When they drop an enemy, each man of the team is credited with a kill."[8]

No need to assume that captain and correspondent were abnormally callous. The evidence of their remarks indicates only that they subscribe to an etiquette of tough he-man talk which prohibits heroic rhetoric no less than compassion. Their taste in manliness holds to the ideal of a good man getting his job done without fuss. And those activities which, like bloodshed and art, sometimes seem dubious on moral grounds—they more than any need the higher ideal of efficiency to shelter under.

There is a strikingly prophetic passage in *The Art Spirit* (1923), by Robert Henri, leader of the "New York Eight," the first group of self-conscious nativists in American painting. It confesses to a visionary taste which far outruns the late impressionism of his paintings: "I love the tools made for mechanics. . . . They are so beautiful, so simple and plain and straight to their meaning. There is no 'Art' about them, they have not been *made* beautiful, they *are* beautiful. Someone has defined a work of art as a 'thing beautifully done.' I like it better if we cut away the adverb and preserve the word 'done,' and let it stand alone in its fullest meaning. Things are not done beautifully. The beauty is an integral part of their being done."[9]

The fulfillment of this vision is still a motive force in American art. Think of Robert Morris' *Box with the Sound of Its Own Making*, shown at the Green Gallery in 1963. A plain wooden box and a tape recording of the sawing and hammering that put it together. The work strips the adverb from the definition of art. A thing done—period.

All honest work, from hammering to engineering, is preferable to *facture* and *cuisine*, or whatever it is the French put in their painting. Not art but industry and enterprise. "Work today is the greatest thing in the world," wrote Whistler's American disciple Joseph Pen-

nell in 1912, describing the building of the Panama Canal—that "most wonderful Wonder of Work," where "there are no architects, no designers, no decorators—just engineers and organizers."[10] The ideal demiurge is no longer the artist. "John Marin used to feel put down by taxi-cabs," says Claes Oldenburg. "He said to himself: what is my painting worth next to a taxi-cab? A taxi-cab is so much more powerful and beautiful and so much more expressive of the present time. I feel sometimes the same way about machinery when I see it."[11] New York artists ardently admire Buckminster Fuller and love hearing him say that the greatest artist of the twentieth century is Henry Ford.

NOT ART BUT ACTION

Back in 1931 the popular art writer Thomas Craven published a volume of artists' biographies called *Men of Art*, an honorific title meant to evoke the phrase "men of action." A generation later, Harold Rosenberg Americanized the esthetics of the Abstract Expressionists in a more sophisticated but not wholly dissimilar spirit. His famous article "The American Action Painters"[12] was again intended to relieve artists of the ignominy of art. "At a certain moment," he wrote, "the canvas began to appear to one American painter after another as an arena in which to act. What was to go on the canvas was not a picture but an event." And: "The painter was no longer concerned with producing a certain kind of object, the work of art, but with living on the canvas."

It is important to remember that these statements were never true. Kline and de Kooning made their paintings with deliberation, worked and reworked them towards "spontaneity," and were as much concerned with producing art as every good painter is. And as for "living on the canvas"—a *façon de parler*, applicable to all real art or to none. Michelangelo said that his blood flowed in his works. The aged Titian, we are told, attacked a half-finished canvas as though it were his mortal enemy. And James Joyce spoke for them all when, on receiving the first printed copy of *Ulysses*, he weighed the tome in his hand and said: "Hoc est corpus meum." But these are historical examples, and to wrong the past is part of the action. Each generation sloughs that knowledge of history which interferes with its own sense of a fresh start.

Taken literally, as a proposition of fact, Rosenberg's special claim

for the New York School was mistaken. But it was and remains important for its appeal to the artists involved. It appealed once again to the American disdain for art conceived as something too carefully plotted, too cosmetic, too French. The problem on New York's 10th Street in the early fifties was how to be painters without ceasing to be American. And if Rosenberg's article failed to make logical sense, judged by other criteria it made better than sense: it made history. His achievement was to have armed a generation of artists with a vocabulary of self-respect. "The painter," he wrote in that article, "gets away from art through his act of painting." Exactly what was needed. Away from art into a glory of activism, where a man making a painting acts in an arena, undergoes encounters, and creates events.

American art since World War II is unthinkable without this liberating impulse towards something other than art. And it persists. "Getting away from Art" not only assures individual artists that their work is worth doing, it is the condition of vital change. There have been artists before who were tempted to abandon their art for something that promised greater reality—science or public service, commerce or religious experience (among Renaissance men alone one may cite Piero della Francesca, Fra Bartolommeo, Leonardo, and Michelangelo). But what was once an exceptional manifestation has now become institutional within the field. Nowhere else, at no other time, could an artist with eleven one-man exhibitions behind him declare that he is "not aiming for a particular look"; that he wants neither "awe-inspiring symbolism nor perceptual titillation" but "real socio-political energy"—and yet be speaking out of and back to the world of art.[13]

Not art but industry. Not to be handicrafting, but to produce a series, a line. Telephone specifications to a steel mill and achieve art untouched by an artist's hand. To transcend the debility of manual gesture is one ideal of recent American art, whether in choice of materials or application of pigment. But the ideal was already formed in 1840 when "the American Leonardo da Vinci," Samuel F. B. Morse, then a prominent portrait painter, hailed the daguerreotype as "Rembrandt perfected," because no longer dependent on "the uncertain hand of the artist."

Not art but technological research. Nothing is prouder than an artist's boast that the concept he submitted to a corporation strained their technology.

Not art but objects, and these objects touted as things beyond art, though they were conceived with a legitimate esthetic objective: to keep the thing made unarticulated, its internal relations so minimized that nothing remains but an immediate relation to its external environment. At which point rhetoric enters. The reduced art object, now fully subsumed by its environment, is declared to be at last a real thing, possessed of more "reality" than mere art ever had.

The process of courting non-art is continuous. Not art but happenings; not art but social action; not art but transaction—or situation, experiment, behavioral stimulus. Like the practical man with his arid not-art-but-investment rationalization, American artists seek to immerse the things they make or do in the redeeming otherness of non-art. Hence the instability of the modern experience. The game is to maintain invention and creativity with an anti-art attitude.

It's a heady predicament for anyone interested in the field. Not art but outrage. Every generation of American artists subverts the given art situation. Each brings on a new wave of radicals to shake off ageing admirers. Put another way—American art lovers come with built-in obsolescence. I think we all do.

COPING

One way to cope with the provocations of novel art is to rest firm and maintain solid standards. The standards are set by the critic's long-practised taste and by his conviction that only those innovations will be significant which promote the established direction of advanced art. All else is irrelevant. Judged for "quality" and for an "advancedness" measurable by given criteria, each work is then graded on a comparative scale.

A second way is more yielding. The critic interested in a novel manifestation holds his criteria and taste in reserve. Since they were formed upon yesterday's art, he does not assume that they are ready-made for today. While he seeks to comprehend the objectives behind the new art produced, nothing is *a priori* excluded or judged irrelevant. Since he is not passing out grades, he suspends judgment until the work's intention has come into focus and his response to it is—in the literal sense of the word—sym-pathetic; not necessarily to approve, but to feel along with it as with a thing that is like no other.

I am aware that this second mode tends to be expatiating and slow. It offers neither certitude nor precise quality ratings. But I believe that both ways—the will to empathize and the will to appraise

—have their use. There must be an ideal combination of them, and perhaps most critics strive to achieve it. But that achievement lies beyond individual sensibility; the capacity to experience all works in accord with their inward objectives and at the same time against external standards belongs rather to the collective judgment of a generation, a judgment within which many kinds of critical insights have been absorbed.

Since mine is the second mode, I find myself constantly in opposition to what is called formalism; not because I doubt the necessity of formal analysis, or the positive value of work done by serious formalist critics. But because I mistrust their certainties, their apparatus of quantification, their self-righteous indifference to that part of artistic utterance which their tools do not measure. I dislike above all their interdictory stance—the attitude that tells an artist what he ought not to do, and the spectator what he ought not to see.

PREVENTIVE ESTHETICS

When was it that formalist art criticism first conceived of itself as a cautionary and prohibitive function? At a certain point, we begin to be told that there is only one thing, one alone, to be looked for in art. Thus Baudelaire in his 1863 essay on Delacroix:

> A well-drawn figure fills you with a pleasure that is quite alien to the theme. Voluptuous or terrible, this figure owes its charm solely to the arabesque it describes in space. The limbs of a flayed martyr, the body of a swooning nymph, if they are skillfully drawn, connote a type of pleasure in which the theme plays no part, and if you believe otherwise, I shall be forced to think that you are an executioner or a rake.[14]

No one will want to argue the opposite—that you savor a Delacroix for the tang of massacre only. But earlier critics, and I suspect the painter himself, might have allowed one to see a coincidence, a magic identity of pathos and arabesque. Now, at the risk of Baudelaire's disapproval, this will no longer do: short of confessing that you look to art to gratify prurient or sadistic appetites, you had better see those nude limbs *solely* as arabesques described in space.[15]

Or compare this from Roger Fry's *Last Lectures*:

> The sensuality of Indian artists is exceedingly erotic—the *leitmotif* of much of their sculpture is taken from the more relaxed and abandoned poses of the female figure. A great deal of their art, even their religious art, is definitely pornographic, and although I have

no moral prejudices against that form of expression, it generally interferes with aesthetic considerations by interposing a strong irrelevant interest which tends to distract both the artist and spectator from the essential purpose of a work of art.[16]

The provincialism of this passage is characteristic. Indifferent to the intent of the art he condemned, Fry could not see that erotic sculptures on Indian temples are "pornographic" only to the extent that Western images of Crucifixion and martyrdom are "sadistic." If Fry found the love of Shiva and Parvati more distracting than the agony of Christ, this tells us something of his personal background, but very little about "the essential purpose of art."

Similar warnings against distracting interference with esthetic form come from most formalist writers. They deplore the tendency artists have of trying to make pictures move you in illegitimate ways —as when Albert C. Barnes says of Michelangelo's *Fall of Man* on the Sistine Ceiling that "the effect of movement is vigorous and powerful but tends to be overdramatic."[17] An artist who "overdramatizes" his representations has wrong-headed values and must pay the price. *Serves him right* is the implicit moral of Clement Greenberg's contention that Picasso began at one definable moment to lose his certainty as an artist:

> A painting done in 1925, the striking *Three Dancers*, where the will to illustrative expressiveness appears ambitiously for the first time since the Blue Period, is the first evidence of a lessening of this certainty. . . . The *Three Dancers* goes wrong, not just because it is literary . . . , but because the theatrical placing and rendering of the head and arms of the center figure cause the upper third of the picture to wobble.[18]

My purpose is not to argue whether the *Three Dancers* (Tate Gallery, London) goes wrong. What matters is that an alleged fault of unstable design is blamed upon interference from a "theatrical," i.e. alien, intention—"the will to expressiveness." This is pure prejudice. Another critic, assuming he found the same fault, might feel that this upper portion had failed through overconcern with formal arrangement. If the artist "went wrong," who decides which lobe of his Manichaean brain was responsible, the bright half whence pure design is distilled, or that darker side where illustrative expressiveness lurks?

Reducing the range of reference has always been the appointed task of formalist thought, but there has been much hard, serious

thinking in it. Given the complexity and infinite resonance of works of art, the stripping down of artistic value to the single determinant of formal organization was once—in the nineteenth century—a remarkable cultural achievement. The attempt was to discipline art criticism in the manner of scientific experiment, through the isolation of a single variable. Art's "essential purpose"—call it abstract unity of design or whatever prevents buckling and wobbling—was presumed to be abstractable from all works of art. And the whole range of meaning was ruled to be disposable "subject matter," which at best did no harm but which more commonly burdened the form. In the formalist ethic, the ideal critic remains unmoved by the artist's expressive intention, uninfluenced by his culture, deaf to his irony or iconography, and so proceeds undistracted, programmed like an Orpheus making his way out of Hell.

It does not seem to me that the esthetic quality of works of art was ever more than a notional fiction, that it can be experienced as an independent variable, or that it is really isolated by critical judgment. Our experience indicates rather that quality rides the crest of a style, and that when a movement or style as such is resisted, the qualitative differences within that style become unavailable. Ten years ago, all American formalist critics spurned Pop Art *in toto*, and their wholesale rejection admitted no consideration of individual quality or distinction. Whatever merit a Claes Oldenburg may have had remained imperceptible, while the names "Lichtenstein, Rosenquist, Warhol" were run off like the firm name Carson, Pirie, Scott & Co. What interests me here is not to what extent those early denunciations of Pop might need readjustment. The point is that formalist critics could not even confront the question of quality; or were loth to do so lest the exercise of esthetic judgment bestow undue dignity on an aberration. There was to be no voting across party lines.

THE STRAIGHT AND NARROW MAINSTREAM

Contemporary American formalism owes its strength and enormous influence to the professionalism of its approach. It analyzes specific stylistic changes within a linear conception of historic development. Its theoretical justification was furnished by Clement Greenberg, whose essay "Modernist Painting" (1965) reduces the art of a hundred years to an elegant one-dimensional sweep. Following is a

brief summary, given as far as possible in the author's own words.[19]

"The essence of Modernism lies . . . in the use of the . . . methods of a discipline to criticize the discipline itself—not in order to subvert it, but to entrench it more firmly in its area of competence." As Kant used logic to establish the limits of logic, so, argues Greenberg, "Modernism criticizes from the inside, through the procedures themselves of that which is being criticized." How then does this self-criticism proceed? "The task of self-criticism became to eliminate from the effects of each art any . . . effect that might conceivably be borrowed from . . . any other art. Thereby each art would be rendered 'pure.' . . ." This purity, Greenberg continues, "meant self-definition, and the enterprise of self-criticism in the arts became one of self-definition with a vengeance." How did this process of self-definition find expression in painting? Pictorial art, Greenberg explains, "criticized and defined itself under Modernism" by "stressing the ineluctable flatness of the support (i.e. the stretched canvas or panel). . . . Flatness alone was unique and exclusive to that art. . . . and so, Modernist painting oriented itself to flatness as it did to nothing else."

We may take it for granted that in this system all narrative and symbolic content had to drain out of painting because that kind of content was held in common with literature. The depiction of solid forms was abandoned because "three-dimensionality is the province of sculpture, and for the sake of its own autonomy painting has had above all to divest itself of everything it might share with sculpture." Recognizable entities had to go because they "exist in three-dimensional space and the barest suggestion of a recognizable entity suffices to call up associations of that kind of space. . . . and by doing so, alienates pictorial space from the two-dimensionality which is the guarantee of painting's independence as an art."

Whatever else one may think of Greenberg's construction, its overwhelming effect is to put all painting in series. The progressive flattening of the pictorial stage since Manet "until its backdrop has become the same as its curtain"[20]—the approximation of the depicted field to the plane of its material support—this was the great Kantian process of self-definition in which all serious Modernist painting was willy-nilly engaged. The one thing which painting can call its own is color coincident with the flat ground, and its drive towards independence demands withdrawal from anything outside itself and single-minded insistence on its unique property. Even

now, two hundred years after Kant, any striving for other goals becomes deviationist. Despite the continual emergence in our culture of cross-border disciplines (ecology, cybernetics, psycho-linguistics, biochemical engineering, etc.), the self-definition of advanced painting is still said to require retreat. It is surely cause for suspicion when the drift of third-quarter twentieth-century American painting is made to depend on eighteenth-century German epistemology. Are there no contractionist impulses nearer at hand? Was it Kantian self-definition which led the American woman into what Betty Friedan calls the "Feminine Mystique," wherein "the only commitment for women is the fulfilment of their own femininity"?[21]

ILLUSIONISM NEW AND OLD

A graver objection concerns Greenberg's management of pre-modern art, and this needs discussion because Greenberg's Modernism defines itself in opposition to the Old Masters. If that opposition becomes unstable, Modernism may have to be redefined—by other criteria.

The problem, it seems, hinges on the illusionism of Old Master paintings—the supposed intent of their art to deceive and dissemble. Now, there can be no doubt that there are, and that there have always been, people who look at realistic images as though they were real—but what kind of people? On August 13, 1971, the cover of *Life* magazine featured a nude *Eve* by Albrecht Dürer side by side with the photograph of a modern young woman in dungarees. In the weeks following, close to 3000 Middle American readers cancelled their subscriptions to *Life*, protesting the shamelessness of the nude. Many took her for real and thought she had stripped for the photographer. But these people, whatever their moral standards, are not the definers of art.

Yet Greenberg's contrasting definition of Old Master art relies on just this sort of reading. "Realistic, illusionist art had dissembled the medium, using art to conceal art"; whereas "Modernism used art to call attention to art."[22] It is as though we were told that modern poetry for the first time draws attention to its own process, whereas Dante, Shakespeare, and Keats had merely used meter and rhyme to tell stories. Has Greenberg been taken in by the illusionism of the Old Masters? Obviously not, for he has a good eye for painting. And in fact his actual observations continually overturn the polarity he

seeks to establish. Thus: "The Old Masters always took into account the tension between surface and illusion, between the physical facts of the medium and its figurative content—but in their need to conceal art with art, the last thing they had wanted was to make an explicit point of this tension."[23] The defining contrast then is not a matter of essence, but only of emphasis; the Old Masters do acknowledge the physical facts of the medium—but not "explicitly." On closer inspection the difference between their goals and those of Modernist painting becomes even more elusive:

> The Old Masters had sensed that it was necessary to preserve what is called the integrity of the picture plane: that is, to signify the enduring presence of flatness under the most vivid illusion of three-dimensional space. The apparent contradiction involved—the dialectical tension, to use a fashionable but apt phrase—was essential to the success of their art, as it is indeed to the success of all pictorial art. The Modernists have neither avoided nor resolved this contradiction; rather, they have reversed its terms. One is made aware of the flatness of their pictures before, instead of after, being made aware of what the flatness contains. Whereas one tends to see what is *in* an Old Master before seeing it as a picture, one sees a Modernist painting as a picture first. This is, of course, the best way of seeing any kind of picture, Old Master or Modernist, but Modernism imposes it as the only and necessary way, and Modernism's success in doing so is a success of self-criticism.[24]

Are we still on firm factual ground? The "objective" difference between Old Master and Modernist reduces itself to subjective tendencies in the viewer. It is he who in looking at an Old Master painting *tends* to see the illusion "before seeing it as a picture." But what if he doesn't? What if he sees a Giotto, a Poussin, or a Fragonard as a picture first, habitually screening out the deep space indications until he has seen the surface disposition of its formal elements? Does an Old Master painting forego its Old Master status if it is seen in primary flatness and only secondly as a vivid illusion? Consider that typical Old Master expression, the rapid sketch (Fig. 30). Does Rembrandt's drawing become Modernist if its pen strokes and bister washes emerge for us before, or along with, the old lady's image? It seems to me that the last thing this draughtsman wants is to dissemble his medium, or conceal his art; what he wants, and gets, is precisely a tension, made fully explicit, between the figure evoked and the physicality of paper, pen stroke, and ink. And yet, in terms of style, such a sketch as this is integral to Old Master art. It

30. Rembrandt,
A Woman Reading,
ca. 1639-40

merely dramatizes the quality that enables Baudelaire to see a Delacroix as nothing but arabesques.

And, contrariwise, what if the viewer tends to see Modernist paintings as spatial abstractions of landscape? The sculptor Don Judd complains that New York School paintings of the 1950's keep him intensely aware of what their flatness contains—"airiness" and "illusionistic space." He said recently: "Rothko's whole way of working depended on a good deal of illusionism. It's very aerial. The whole thing is about areas floating in space. Compared to Newman there is distinctly a certain depth. But I finally thought that all painting was spatially illusionistic."[25]

Where does this leave us? The difference between Old Master and Modernist is not, after all, between illusion and flatness; it turns out that both are present in each. But if the difference is in the *order* in which these two presences are perceived, then do the subjective approaches of Baudelaire and Judd reverse the distinction between historic and modern art?

Greenberg is fully conscious of the airy illusionism observed by Judd in Modernist painting. But though open atmospheric effects, such as are found in Rothko or Jules Olitski, clearly deny and dissemble the picture's material surface, he nevertheless finds them congruent with Painting's self-definition because the illusion conveyed is visual, rather than tactile or kinesthetic. And visual art

70

should, to conform with Kantian self-criticism and scientific consist-
ency, "confine itself exclusively to what is given in visual experi-
ence." "Where the Old Masters created an illusion of space into
which one could imagine oneself walking, the illusion created by a
Modernist is one into which one can look, can travel through, only
with the eye."[26]

The difference, then, reduces itself to distinct *kinds* of spatial illu-
sion, but this last saving distinction is one which defines "Modern-
ism" by pre-industrial standards of locomotion. How, in what kind
of painted space, do you let yourself roam? Greenberg apparently
can imagine himself trudging through a Rembrandtesque gloom,
but he cannot conceive journeying through an Olitski. Do we need
to be reminded that in an age of space travel a pictorial semblance
of open void is just as inviting to imaginary penetration as the pic-
torial semblance of a receding landscape was formerly to a man on
foot? Are we now to define Modernist painting against a Kantian
concept of transportation? Greenberg's theoretical schema keeps
breaking down because it insists on defining modern art without
acknowledgment of its content, and historical art without recog-
nizing its formal self-consciousness.

All major painting, at least of the last six hundred years, has as-
siduously "called attention to art." Except for *tour de force* demon-
strations and special effects, and before their tradition collapsed in
nineteenth-century academicism, the Old Masters always took pains
to neutralize the effect of reality, presenting their make-believe
worlds, as it were, between quotation marks. The means they chose
were, of course, those of their day, not of ours; and often their care-
ful controls are annulled by our habit of lifting a partial work from
its setting—transposing a detached fresco or predella panel into the
category of easel painting. But a dramatic narrative painted by
Giotto resembles neither nineteenth-century easel painting nor a
movie screen. When it is not wrenched from its context (as in most
art history books), it works within a wall system, each wall support-
ing multiple scenes set between elaborate framing bands, within
which, in turn, other scenes on different scales are descried. You are
shown simultaneous and incompatible systems whose juxtaposition
cancels or checks the illusion. Similarly, the Sistine Ceiling when
seen in its entirety: the work is a battleground for local illusion,
counter-illusion, and emphasized architectural surface—art turning
constantly back on itself.

This is a functional multiplicity, and it occurs even in apparently

single works. Look at those cornered, diminutive prophets in our Figure 31, leaning out of the picture plane: their eager demonstrative gestures towards the Christ turn the illusionist scene of the Crucifixion back into a picture of it—complete with its own patterned frame. The artist here does exactly what Greenberg admires as a significant find in a crucial Cubist picture by Braque: "(Braque) discovered that *trompe-l'œil* could be used to undeceive as well as to deceive the eye. It could be used, that is, to declare as well as to deny the actual surface."[27]

Where the Old Masters do seem to dissolve the picture plane to gain an unambiguous illusion of depth, they usually have a special objective in mind, an objective understood and shared by the viewer. Michelangelo's *Last Judgment,* unlike the Ceiling, obliterates the supporting wall plane so that the vision of a Christ "come to judge the quick and the dead" gives immediate urgency to the words of the Creed. Caravaggio's pictures, whether erotic or religious in their address, were similarly intended to induce a penetrating experience. But their relentless, surface-dissolving illusionism was largely repudiated by the Old Masters. Until the nineteenth century, the kind of painting which utterly broke the consistency of the surface remained a special, even exceptional resource of Old Master art.

The more realistic the art of the Old Masters became, the more they raised internal safeguards against illusion, ensuring at every point that attention would remain focused upon the art.

They did it by radical color economies, or by eerie proportional attenuation; by multiplication of detail, or by preternatural beauty. They did it—as modern films do with spliced footage taken from older movies—by quotations and references to other art; quotation being a surefire means of shunting the ostensible realism of a depicted scene back into art.

They did it by abrupt internal changes of scale; or by shifting reality levels—as when Raphael's *Expulsion of Heliodorus* inserts a group of contemporaries in modern dress as observers of the Biblical scene; or by overlapping reality levels, as when a frescoed battle scene on a Vatican wall curls up at the edges to become a fake tapestry—two self-confounding illusions which call both into question and recall both to art.

The "recall to art" may be engineered by the subject matter itself. In a Dutch interior, the backview of a personage who draws a cur-

31. Niccolò di Pietro
Gerini (?),
Crucifixion

tain aside to look at a painting on the far wall acts as my *alter ego*,
doing what I am doing and reminding me (in case I missed the
point of the picture's immense ebony frame) that I too am looking
at a flat object. Better still, such seventeenth-century interiors as
Velázquez' *Ladies in Waiting* often juxtapose a doorway or window
view with a framed painting, and, next to that, a mirror filled with
a reflection. These three kinds of image serve as an inventory of the

73

three possible roles assignable to a picture plane. The window pane or proscenium effect refers to what lies behind it, the looking glass refers to what lies before, while the pigmented surface asserts itself; and all three are paraded in sequence. Such pictures soliloquize about the capacities of the surface and the nature of illusion itself.

Again and again, in so-called illusionist art, it is illusionism that is under discussion, the art "calling attention to art" in perfect self-critical consciousness. And this is why the Old Masters are forever inventing interferences with spatial recession. They do not merely "take account" of the tension between surface and depth, as if for the sake of decorative coherence, while reserving their thrust for the depiction of depth. Rather, they maintain an explicit, controlled, ever-visible dualism. Fifteenth-century perspective was not a surface-denying illusion of space, but the symbolic form of space as an intelligible coordinate surface pattern. Good illusionist painting not only anchors depth to the plane; it is almost never without built-in devices designed to suspend the illusion, and the potency of these devices depends—like the appreciation of counterpoint or of puns—on the spectator's ability to register two things in concert, to receive both the illusion and the means of illusion at once.

Some of the Old Masters overruled the apparent perspective by dispersing identical color patches as an allover carpet spread (Pieter Bruegel, for instance). Some worked with chromatic dissonances to weave a continuous surface shimmer like mother-of-pearl. Many—from Titian onward—insured their art against realism by the obtrusive calligraphy of the brush—laying a welter of brush-strokes upon the surface to call attention to process. Some contrived implausible contradictions within the field, as when the swelling bulk of a foreshortened form is collapsed and denied the spatial ambience to house it. All of them counted on elaborate framing as an integral part of the work ("advertising the literal nature of the support," as Greenberg says of Collage)—so that the picture, no matter how deep its illusionism, turned back into a thing mounted there like a gem. It was Michelangelo himself who designed the frame of the *Doni Madonna*, an element essential to the precious-mirror effect of its surface (Fig. 32).

Greenberg wants all Old Master and Modernist painters to reduce their differences to a single criterion, and that criterion as mechanistic as possible—either illusionistic or flat. But what significant art is that simple? Have you ever asked how deep the thrones

32. Michelangelo,
Doni Madonna

of the Sistine Prophets and Sibyls are? Perfectly shallow if you glance across the whole sequence; but they run ten to twenty feet deep as soon as you focus on one alone. Perspective illusionism and anatomic foreshortening sustain a ceaseless optical oscillation.

"The abiding effect is a constant shuttling between surface and depth, in which the depicted flatness is 'infected' by the undepicted. Rather than being deceived, the eye is puzzled; instead of seeing objects in space, it sees nothing more than—a picture."[28] These words, in which Greenberg describes Cubist collage, apply as well to Michelangelo's Ceiling, and to thousands of Old Master works. They describe the effect of a not untypical early-fifteenth-century manuscript page (Fig. 33): *Missus est Gabriel angelus.* Three reality levels oscillate in and compete for that capital *M:* an arcade opening on a bedchamber; a trellis for ivy ornament; and a letter at the head of a word. All three at once. The eye is puzzled; instead of seeing objects in space it sees a picture.[29]

The notion that Old Master paintings in contrast to modern dissemble the medium, conceal the art, deny the surface, deceive the eye, etc., is only true for a viewer who looks at the art like those ex-subscribers to *Life* magazine. The distinction a critic makes between Modern–self-analytical and Old Master–representational re-

33. Early fifteenth-century
Florentine (?) manuscript

fers less to the works compared than to his own chosen stance—to
be analytic about the one and polemically naive about the other.

It is poor practice, when modern art is under discussion, to pre-
sent the Old Masters as naively concerned with eye-fooling trickery,
while reserving for modern art both the superior honesty of dealing
with the flat plane of painting and the maturer intellectual disci-
pline of self-analysis. All important art, at least since the Trecento,
is preoccupied with self-criticism. Whatever else it may be about,
all art is about art. All original art searches its limits, and the differ-
ence between the old and the modernist is not in the fact of self-
definition but in the direction which this self-definition takes. This
direction being part of the content.

At this point Greenberg might answer that self-definition does not
deserve its name unless it aims at purity, and that this in turn requires
stripping painting down to its irreducible essence, i.e. the coinci-

dence of flattened color with its material support. I reply that this mistakes a special case for a necessity. The process of Painting's self-realization can go either way. For Jan van Eyck, for example, the self-realization of painting is not reductive but expansive. He turns to the sculptor and says, "Anything you can do I can do better"; then to the goldsmith—"Anything *you* can do I can do better"; and so to the architect. He redesigns everything in the flat and even banishes metallic gold to create the effect of it—like Manet—in pure color and light. Anything anybody can do, painting does better—and that's where, for van Eyck, painting realizes itself—discovering its autonomy literally in its ability to do without external aid.

Art's perpetual need to redefine the area of its competence by testing its limits takes many forms. Not always does it probe in the same direction. Jacques Louis David's ambition to make art a force of national moral leadership is as surely a challenge to the limits of art as is Matisse's elimination of tonal values. At one historical moment painters get interested in finding out just how much their art can annex, into how much non-art it can venture and still remain art. At other times they explore the opposite end to discover how much they can renounce and still stay in business. What is constant is art's concern with itself, the interest painters have in questioning their operation. It is a provincialism to make the self-critical turn of mind the sufficient distinction of Modernism; and once it is understood as not its peculiar distinction, then the specific look of contemporary abstract art—its object quality, its blankness and secrecy, its impersonal or industrial look, its simplicity and tendency to project a stark minimum of decisions, its radiance and power and scale—these become recognizable as a kind of content—expressive, communicative, eloquent in their own way.[30]

THE CORPORATE MODEL OF DEVELOPING ART

It is astonishing how often recent Abstract American painting is defined and described almost exclusively in terms of internal problem-solving. As though the strength of a particular artist expressed itself only in his choice to conform with a set of existent professional needs and his inventiveness in producing the answers. The dominant formalist critics today tend to treat modern painting as an evolving technology wherein at any one moment specific tasks require solution—tasks set for the artist as problems are set for researchers in the big

corporations. The artist as engineer and research technician becomes important insofar as he comes up with solutions to the right problem. How the choice of that problem coincides with any personal impulse, psychological predisposition, or social ideal is immaterial; the solution matters because it answers a problem set forth by a governing technocracy.

In America this corporate model of artistic evolution appears full-blown by the mid-1920's. It inhabits the formalist doctrine that Painting aspires towards an ever-tightening synthesis of its design elements. The theory in its beginnings was fairly simple. Suppose a given painting represents a reclining nude; and suppose the figure outlined with a perceptible contour. Within that contour lies a distinct shape. That shape is of a certain color, and the color—modulated from light to dark or from warm to cool—reflects a specific quantity or kind of light. We have then four formal elements—line, shape, color, and light —which can be experienced and thought of as separate and distinct. Now, it is argued, the test of significantly advanced painting will be the progressive obliteration of these distinctions. The most successful picture will so synthesize the means of design that line will be no longer separable from shape, nor shape from color, nor color from light. A working criterion, easily memorized and applied. It tells you not necessarily which picture is best, but which is in line to promote the overall aspiration of Painting—this alignment being a *sine qua non* of historic importance. By this criterion, the painter of the Sistine Ceiling is, with due respect, relegated to one of the byways of Painting since his inventions, for all their immediate interest, do not ultimately promote the direction in which Painting must go; Michelangelo's forms are "realized in a sculptural rather than a pictorial manner" (Albert C. Barnes).[31] Indeed, the elements of Michelangelo's depictions are remarkable for separability—specific shapes sharply delineated by bounding lines, tinted by local color, modulated by chiaroscuro. Though Michelangelo will (I am convinced) be emerging within the next several years as one of the most original colorists of all time, by the criteria enunciated above he fails to contribute—as did Titian's coloristic diffusion—to the synthesis of the means of design. For the critic-collector Albert C. Barnes he remains a dead end, whereas the course initiated by Titian leads irresistibly to its culmination in Renoir and William Glackens.

This single criterion for important progressive art, moving as by predestination towards utter homogeneity of the elements of design,

is still with us, now considerably more analytical, more prestigious than ever, and celebrating its latest historical denouement in the triumph of color field painting.

In formalist criticism, the criterion for significant progress remains a kind of design technology subject to one compulsive direction: the treatment of "the whole surface as a single undifferentiated field of interest." The goal is to merge figure with ground, integrate shape and field, eliminate foreground-background discontinuities; to restrict pattern to those elements (horizontals or verticals) that suggest a symbiotic relationship of image and frame; to collapse painting and drawing in a single gesture, and equate design and process (as Pollock's drip-paintings do, or Morris Louis's *Veils*, Fig. 36); in short, to achieve the synthesis of all separable elements of painting, preferably—but this is a secondary consideration—without that loss of incident or detail which diminishes visual interest.

There is, it seems to me, a more thoroughgoing kind of synthesis involved in this set of descriptions—the leveling of end and means. In the criticism of the relevant paintings there is rarely a hint of expressive purpose, or recognition that pictures function in human experience. The painter's industry is a closed loop. The search for the holistic design is simply self-justified and self-perpetuating. Whether this search is still the exalted Kantian process of self-criticism seems questionable; the claim strikes me rather as a remote intellectual analogy. And other analogies suggest themselves, less intellectual, but closer to home. It is probably no chance coincidence that the descriptive terms which have dominated American formalist criticism these past fifty years run parallel to the contemporaneous evolution of the Detroit automobile. Its ever-increasing symbiosis of parts—the ingestion of doors, running boards, wheels, fenders, spare tires, signals, etc., in a one-piece fuselage—suggests, with no need for Kant, a similar drift towards synthesizing its design elements. It is not that the cars look like the paintings. What I am saying here relates less to the pictures themselves than to the critical apparatus that deals with them. Pollock, Louis, and Noland are vastly different from each other; but the reductive terms of discussion that continually run them in series are remarkably close to the ideals that govern the packaging of the all-American engine. It is the critics' criterion far more than the painters' works which is ruled by a streamlined efficiency image.

But the reference to industrial ideals can serve to focus on certain

34. Kenneth Noland,
Coarse Shadow and *Stria*

distinctions within art itself. If, for instance, we question the work of the three painters just mentioned from the viewpoint of expressive content, they immediately separate out. There is obviously no affinity for industrialism in Pollock or Louis, but it does characterize an important aspect of the younger man's work. His thirty-foot-long stripe paintings, consisting of parallel color bands, embody, beyond the subtlety of their color, principles of efficiency, speed, and machine-tooled precision which, in the imagination to which they appeal, tend to associate themselves with the output of industry more than of art (Fig. 34). Noland's pictures of the late sixties are the fastest I know.

The painter Vlaminck used to say that he wished to make pictures which would be readable to a motorist speeding by in an automobile. But Vlaminck's belated expressionism could no more incorporate such an ideal than Robert Henri's impressionist portraits incorporated his admiration for mechanical tools. Vlaminck's palette-knifed snowscapes lacked every access to his ostensible goal. They possessed neither the scale, the format, the color radiance, nor even

the appropriate subject matter: good motorists look for signals and signs, not at messages from a painter's easel. Vlaminck's statement remains naive because it is essentially idle. But there is nothing naive in Noland's determination to produce, as he put it, " 'one-shot' paintings perceptible at a single glance." I quote from a recent article by Barbara Rose, who continues: "To achieve maximum immediacy, Noland was ready to jettison anything interfering with the most instantaneous communication of the image."[32]

Noland's stated objective during the 1960's confirms what his pictures reveal—an idealization of efficient speed and, implicitly, a conception of the humanity at whom his "one-shots" are aimed. The instantaneity which his pictures convey implies a different psychic orientation, a revised relationship with the spectator. Like all art that ostensibly thinks only about itself, they create their own viewer, project their peculiar conception of who, what, and where he is.

Is he a man in a hurry? Is he at rest or in motion? Is he one who construes or one who reacts? Is he a man alone—or a crowd? Is he a human being at all—or a function, a specialized function or instrumentality, such as the one to which Rauschenberg's *Chairs* (1968) reduced the human agent. (A room-size transparent screen whose illumination was electronically activated by sound; the visibility of the chairs which constituted the image depending on the noises made by the spectator—his footsteps when entering, his coughing or speaking voice. One felt reduced to the commodity of a switch.) I suspect that all works of art or stylistic cycles are definable by their built-in idea of the spectator. Thus, returning once more to the Pollock-Louis-Noland procession, the younger man, who separates himself from his elders by the criterion of industrial affinity, parts from them again by his distinct view of the viewer.

Considerations of "human interest" belong in the criticism of modernist art not because we are incurably sentimental about humanity, but because it is art we are talking about. And it appears to me that even such professional technicalities as "orientation to flatness" yield to other criteria as soon as the picture is questioned not for its internal coherence, but for its orientation to human posture.

What is "pictorial flatness" about? Obviously it does not refer to the zero curvature of the physical plane—a cat walking over pictures by Tiepolo and Barnett Newman gets the same support from each one. What is meant of course is an ideated flatness, the sensation of flatness experienced in imagination. But if that's what is meant, is

there anything flatter than the *Olympia* (1950) of Dubuffet (Fig. 35)? If flatness in painting indicates an imaginative experience, then the pressed-leaf effect, the graffito effect, the scratched-gravel or fossil-impression effect of Dubuffet's image dramatizes the sensation of flatness far beyond the capacity, or the intention, of most color field painting. But in fact, these different "flatnesses" are not even comparable. And the word "flat" is too stale and remote for the respective sensations touched off by the visionary color *Veils* of Morris Louis (Fig. 36) and the bedrock pictographs of Dubuffet. Nor need flatness be an end product at all—as Jasper Johns demonstrated in the mid-1950's, when his first *Flags* and *Targets* relegated the whole maintenance problem of flatness to "subject matter." However atmospheric his brushwork or play of tonalities, the depicted subject ensured that the image stayed flat. So then one discovers that there are recognizable entities, from flags even to female nudes, which can actually promote the sensation of flatness.

This discovery is still fairly recent, and it is not intelligible in terms of design technology. It demands consideration of subject and content, and, above all, of how the artist's pictorial surface tilts into the space of the viewer's imagination.

THE FLATBED PICTURE PLANE

I borrow the term from the flatbed printing press—"a horizontal bed on which a horizontal printing surface rests" (Webster). And I propose to use the word to describe the characteristic picture plane of the 1960's—a pictorial surface whose angulation with respect to the human posture is the precondition of its changed content.

It was suggested earlier (pp. 73-74) that the Old Masters had three ways of conceiving the picture plane. But one axiom was shared by all three interpretations, and it remained operative in the succeeding centuries, even through Cubism and Abstract Expressionism: the conception of the picture as representing a world, some sort of worldspace which reads on the picture plane in correspondence with the erect human posture. The top of the picture corresponds to where we hold our heads aloft; while its lower edge gravitates to where we place our feet. Even in Picasso's Cubist collages, where the Renaissance worldspace concept almost breaks down, there is still a harking back to implied acts of vision, to something that was once actually seen.

35. Dubuffet,
Olympia, 1950

36. Morris Louis,
White Series II, 1960.

A picture that harks back to the natural world evokes sense data which are experienced in the normal erect posture. Therefore the Renaissance picture plane affirms verticality as its essential condition. And the concept of the picture plane as an upright surface survives the most drastic changes of style. Pictures by Rothko, Still, Newman, de Kooning, and Kline are still addressed to us head to foot—as are those of Matisse and Miró. They are revelations to which we relate visually as from the top of a columnar body; and this applies no less to Pollock's drip paintings and the poured *Veils* and *Unfurls* of Morris Louis. Pollock indeed poured and dripped his pigment upon canvases laid on the ground, but this was an expedient. After the first color skeins had gone down, he would tack the canvas on to a wall—to get acquainted with it, he used to say; to see where it wanted to go. He lived with the painting in its uprighted state, as with a world confronting his human posture. It is in this sense, I think, that the Abstract Expressionists were still nature painters. Pollock's drip paintings cannot escape being read as thickets; Louis' *Veils* acknowledge the same gravitational force to which our being in nature is subject.[33]

But something happened in painting around 1950—most conspicuously (at least within my experience) in the work of Robert Rauschenberg and Dubuffet. We can still hang their pictures—just as we tack up maps and architectural plans, or nail a horseshoe to the wall for good luck. Yet these pictures no longer simulate vertical fields, but opaque flatbed horizontals. They no more depend on a head-to-toe correspondence with human posture than a newspaper does. The flatbed picture plane makes its symbolic allusion to hard surfaces such as tabletops, studio floors, charts, bulletin boards—any receptor surface on which objects are scattered, on which data is entered, on which information may be received, printed, impressed —whether coherently or in confusion. The pictures of the last fifteen to twenty years insist on a radically new orientation, in which the painted surface is no longer the analogue of a visual experience of nature but of operational processes.

To repeat: it is not the actual physical placement of the image that counts. There is no law against hanging a rug on a wall, or reproducing a narrative picture as a mosaic floor. What I have in mind is the psychic address of the image, its special mode of imaginative confrontation, and I tend to regard the tilt of the picture plane from vertical to horizontal as expressive of the most radical shift in the subject matter of art, the shift from nature to culture.

A shift of such magnitude does not come overnight, nor as the feat of one artist alone. Portents and antecedents become increasingly recognizable in retrospect—Monet's *Nymphéas* (Fig. 163), or Mondrian's transmutation of sea and sky into signs plus and minus. And the picture planes of a Synthetic Cubist still life or a Schwitters collage suggest like-minded reorientations. But these last were small objects; the "thingness" of them was appropriate to their size. Whereas the event of the 1950's was the expansion of the work-surface picture plane to the man-sized environmental scale of Abstract Expressionism. Perhaps Duchamp was the most vital source. His *Large Glass* begun in 1915, or his *Tu m'* of 1918, is no longer the analogue of a world perceived from an upright position, but a matrix of information conveniently placed in a vertical situation. And one detects a sense of the significance of a ninety-degree shift in relation to a man's posture even in some of those Duchamp "works" that once seemed no more than provocative gestures: the *Coatrack* nailed to the floor and the famous *Urinal* tilted up like a monument.

But on the New York art scene the great shift came in Rauschenberg's work of the early 1950's. Even as Abstract Expressionism was celebrating its triumphs, he proposed the flatbed or work-surface picture plane as the foundation of an artistic language that would deal with a different order of experience. The earliest work which Rauschenberg admits into his canon—*White Painting with Numbers* (Fig. 37)—was painted in 1949 in a life class at the Art Students' League, the young painter turning his back on the model. Rauschenberg's picture, with its cryptic meander of lines and numbers, is a work surface that cannot be construed into anything else. Up and down are as subtly confounded as positive-negative space or figure-ground differential. You cannot read it as masonry, nor as a system of chains or quoins, and the written ciphers read every way. Scratched into wet paint, the picture ends up as a verification of its own opaque surface.

In the year following, Rauschenberg began to experiment with objects placed on blueprint paper and exposed to sunlight. Already then he was involved with the physical material of plans; and in the early 1950's used newsprint to prime his canvas—to activate the ground, as he put it—so that his first brush-stroke upon it took place in a gray map of words.

In retrospect the most clownish of Rauschenberg's youthful pranks take on a kind of stylistic consistency. Back in the fifties, he was in-

37. Rauschenberg,
White Painting with Numbers,
1949

vited to participate in an exhibition on the nostalgic subject of "nature in art"—the organizers hoping perhaps to promote an alternative to the new abstract painting. Rauschenberg's entry was a square patch of growing grass held down with chicken wire, placed in a box suitable for framing and hung on the wall. The artist visited the show periodically to water his piece—a transposition from nature to culture through a shift of ninety degrees. When he erased a de Kooning drawing, exhibiting it as "Drawing by Willem de Kooning erased by Robert Rauschenberg," he was making more than a multifaceted psychological gesture; he was changing—for the viewer no less than for himself—the angle of imaginative confrontation; tilting de Koon-

ing's evocation of a worldspace into a thing produced by pressing down on a desk.

The paintings he made towards the end of that decade included intrusive non-art attachments: a pillow suspended horizontally from the lower frame (*Canyon*, 1959); a grounded ladder inserted between the painted panels which made up the picture (*Winter Pool*, 1959–60; Fig. 38); a chair standing against a wall but ingrown with the painting behind (*Pilgrim*, 1960). Though they hung on the wall, the pictures kept referring back to the horizontals on which we walk and sit, work and sleep.

When in the early 1960's he worked with photographic transfers, the images—each in itself illusionistic—kept interfering with one another; intimations of spatial meaning forever canceling out to sub-

38. Rauschenberg,
Winter Pool, 1959

side in a kind of optical noise. The waste and detritus of communi-
cation—like radio transmission with interference; noise and meaning
on the same wavelength, visually on the same flatbed plane.

This picture plane, as in the enormous canvas called *Overdraw*
(1963), could look like some garbled conflation of controls system
and cityscape, suggesting the ceaseless inflow of urban message,
stimulus, and impediment. To hold all this together, Rauschenberg's
picture plane had to become a surface to which anything reachable-
thinkable would adhere. It had to be whatever a billboard or dash-
board is, and everything a projection screen is, with further affinities
for anything that is flat and worked over—palimpsest, canceled plate,
printer's proof, trial blank, chart, map, aerial view. Any flat docu-
mentary surface that tabulates information is a relevant analogue of
his picture plane—radically different from the transparent projec-
tion plane with its optical correspondence to man's visual field. And
it seemed at times that Rauschenberg's work surface stood for the
mind itself—dump, reservoir, switching center, abundant with con-
crete references freely associated as in an internal monologue—the
outward symbol of the mind as a running transformer of the external
world, constantly ingesting incoming unprocessed data to be mapped
in an overcharged field.

To cope with his symbolic program, the available types of pictorial
surface seemed inadequate; they were too exclusive and too homo-
geneous. Rauschenberg found that his imagery needed bedrock as
hard and tolerant as a workbench. If some collage element, such as
a pasted-down photograph, threatened to evoke a topical illusion of
depth, the surface was casually stained or smeared with paint to re-
call its irreducible flatness. The "integrity of the picture plane"—once
the accomplishment of good design—was to become that which is
given. The picture's "flatness" was to be no more of a problem than
the flatness of a disordered desk or an unswept floor. Against Rau-
schenberg's picture plane you can pin or project any image because
it will not work as the glimpse of a world, but as a scrap of printed
material. And you can attach any object, so long as it beds itself
down on the work surface. The old clock in Rauschenberg's 1961
Third Time Painting (Fig. 39) lies with the number 12 on the left,
because the clock face properly uprighted would have illusionized
the whole system into a real vertical plane—like the wall of a room,
part of the given world. Or, in the same picture the flattened shirt
with its sleeves outstretched—not like wash on a line, but—with paint

39. Rauschenberg,
Third Time Painting, 1961

stains and drips holding it down—like laundry laid out for pressing. The consistent horizontality is called upon to maintain a symbolic continuum of litter, workbench, and data-ingesting mind.

Perhaps Rauschenberg's profoundest symbolic gesture came in 1955 when he seized his own bed, smeared paint on its pillow and

quilt coverlet, and uprighted it against the wall. There, in the vertical posture of "art," it continues to work in the imagination as the eternal companion of our other resource, our horizontality, the flat bedding in which we do our begetting, conceiving, and dreaming. The horizontality of the bed relates to "making" as the vertical of the Renaissance picture plane related to seeing.

I once heard Jasper Johns say that Rauschenberg was the man who in this century had invented the most since Picasso. What he invented above all was, I think, a pictorial surface that let the world in again. Not the world of the Renaissance man who looked for his weather clues out of the window; but the world of men who turn knobs to hear a taped message, "precipitation probability ten percent tonight," electronically transmitted from some windowless booth. Rauschenberg's picture plane is for the consciousness immersed in the brain of the city.

The flatbed picture plane lends itself to any content that does not evoke a prior optical event. As a criterion of classification it cuts across the terms "abstract" and "representational," Pop and Modernist. Color field painters such as Noland, Frank Stella, and Ellsworth Kelly, whenever their works suggest a reproducible image, seem to work with the flatbed picture plane, i.e. one which is manmade and stops short at the pigmented surface; whereas Pollock's and Louis's pictures remain visionary, and Frankenthaler's abstractions, for all their immediate modernism, are—as Lawrence Alloway recently put it—"a celebration of human pleasure in what is not manmade."[34]

Insofar as the flatbed picture plane accommodates recognizable objects, it presents them as man-made things of universally familiar character. The emblematic images of the early Johns belong in this class; so, I think, does most of Pop Art. When Roy Lichtenstein in the early sixties painted an Air Force officer kissing his girl goodbye, the actual subject matter was the mass-produced comic-book image; ben-day dots and stereotyped drawing ensured that the image was understood as a representation of printed matter. The pathetic humanity that populate Dubuffet's pictures are rude manmade graffiti, and their reality derives both from the material density of the surface and from the emotional pressure that guided the hand. Claes Oldenburg's drawing, to quote his own words, "takes on an 'ugliness' which is a mimicry of the scrawls and patterns of street

graffiti. It celebrates irrationality, disconnection, violence, and stunted expression—the damaged life forces of the city street."[35]

And about Andy Warhol, David Antin once wrote a paragraph which I wish I had written:

> In the Warhol canvases, the image can be said to barely exist. On the one hand this is part of his overriding interest in the "deteriorated image," the consequence of a series of regressions from some initial image of the real world. Here there is actually a series of images of images, beginning from the translation of the light reflectivity of a human face into the precipitation of silver from a photosensitive emulsion, this negative image developed, re-photographed into a positive image with reversal of light and shadow, and consequent blurring, further translated by telegraphy, engraved on a plate and printed through a crude screen with low-grade ink on newsprint, and this final blurring and silkscreening in an imposed lilac color on canvas. What is left? The sense that there is something out there one recognizes and yet can't see. Before the Warhol canvases we are trapped in a ghastly embarrassment. This sense of the arbitrary coloring, the nearly obliterated image and the persistently intrusive feeling. Somewhere in the image there is a proposition. It is unclear.[36]

The picture conceived as the image of an image. It's a conception which guarantees that the presentation will not be directly that of a worldspace, and that it will nevertheless admit any experience as the matter of representation. And it readmits the artist in the fullness of his human interests, as well as the artist-technician.

The all-purpose picture plane underlying this post-Modernist painting has made the course of art once again non-linear and unpredictable. What I have called the flatbed is more than a surface distinction if it is understood as a change within painting that changed the relationship between artist and image, image and viewer. Yet this internal change is no more than a symptom of changes which go far beyond questions of picture planes, or of painting as such. It is part of a shakeup which contaminates all purified categories. The deepening inroads of art into non-art continue to alienate the connoisseur as art defects and departs into strange territories leaving the old stand-by criteria to rule an eroding plain.

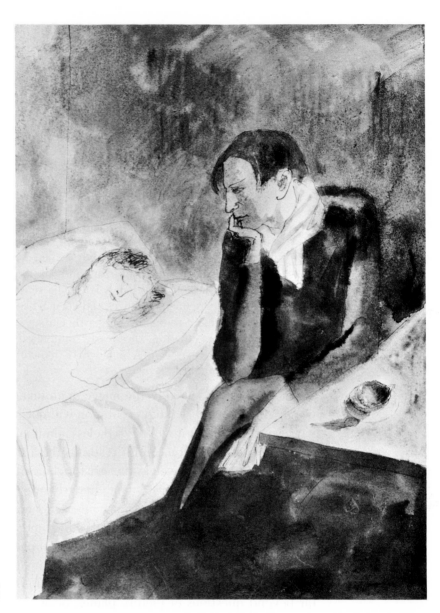

40. Picasso,
Contemplation, 1904

4 Picasso's Sleepwatchers

A Picasso watercolor of the Blue Period (Fig. 40) presents the artist at twenty-three. He is doing none of the things self-portrayed artists usually do. He is not searching his mirror reflection, nor staring defiance, nor eyeing a model. He appears neither at work nor at ease but deeply engaged in inaction: watching a girl asleep.

The girl lies in a pool of light, one raised arm cradling her head. She lies within arm's reach, yet almost glides away, and her wall-papered corner dissolves in the warm glow of noonday sleep. It is the painter's figure that conveys an oppressive awareness of circumstance. Dusky blues ink even his cup and hair. His cold shadow contrasts with her brightness; his sitting up with her lying down; his solid frame with the tremulous trace of her skin. Their opposition is total. And as her radiance suggests the pure bliss of the body, his perplexed consciousness becomes a condition of exile.

In that same year, 1904, Picasso produced a more frankly allegorical variant of the theme (Fig. 41). Again a male watcher, this time a hunger-bitten wraith of a man; he stares at a girl sleeping in a low bed—at his feet, but at a distance which his inordinate height makes seem inaccessible. The contrast is again between gloom of mind and the light of the body. And though the woman's recumbent pose set off against an upright male posture seems somehow familiar and fitting, there is no satisfactory meeting of opposites here, only mutual exclusion: he standing in darkness, in modern dress, exhausted, irresolute; while the girl's naked sleep leaves her simple and whole.

First published in *Life* magazine, December 27, 1968.

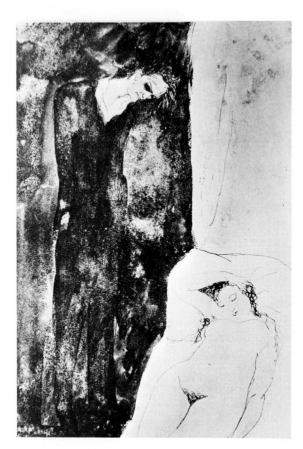

41. Picasso,
Sleeping Nude, 1904

42. Picasso,
Reclining Nude with Figures,
1908

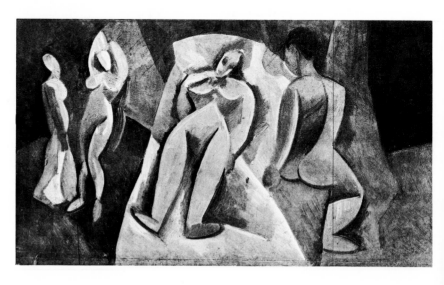

Is the male watcher still the artist himself? He has withheld his own likeness—a discreet evasion which frees him to project a symbolic self in a burst of self-pity.[1]

These early pictures are curtain raisers. They introduce the subject of the watched sleeper which was to become one of the haunted themes that recur continually in Picasso's work and give it constancy. The artist must have known from the beginning that the subject was old. Scenes of sleeping nymphs observed by alerted males —scenes concerned with looking and longing—are part of the grand tradition of art, in antiquity and again since the Renaissance. But the young Picasso appropriates the universal theme as though he had found it within closed doors in his own private depths. So that the watch-sleep confrontation enters his work almost like a confession. And this may be why his further explorations of the subject were long postponed; the Cubist enterprise then being launched had no use for its sentiment. But before putting the subject away, Picasso stripped it of its private emotional connotations: in a powerful painting of 1908 (Fig. 42) the wake-slumber theme is depersonalized.

Picasso was in a heroic phase then—a campaign of self-conquest designed to subdue his own technical brilliance and to restrain his irresistible sentimental appeal. A facile artist by inclination and talent, he was turning himself into an awkward one. For years he had been visiting available styles, finding them easy to emulate and adapt. He was now putting forth greater effort to produce work less ingratiating. In the work of 1907–8, Picasso's subtle line has no place. The whole surface, whether descriptive of solid or void, hardens into a crust, and the illusion of space is impaired—but not from ineptitude. Picasso, the boy wonder, had always known how to make objects look three-dimensional and how to breathe in the spaces between. Such magic feats were the routine of competent students in every accredited school of art. Picasso now asks—and with a gathering momentum of innocence—how this thing which everyone knows how to do can be done at all.

In the 1908 picture the supine central figure has little feminine charm, no sentimental appeal, no personality traits. With emphatic simplicity she declares herself to be a figure laid on a bias and instructed to proceed into depth, while the crusty picture plane, resisting, keeps her propped up. The commonplace of a reclining

nude is made to dramatize the absurdity of simultaneous surface and depth.

It is part of the artist's game that the female figures as well as the youth sitting by should read as "quotations." The reclining pose derives from a common Renaissance type of foreshortened figure; the young man's posture, rotated through 180 degrees to display a continuous contour from top to toe, is an antique invention. And Picasso uses it precisely for its original purpose—to get a plausible accommodation of solid body in a flat ground.

The subject of this anonymous grouping remains unspecified. But as it centers on a recumbent woman watched by an alert male, a sensitive private theme becomes neutralized; the faceless youth turning his back has no name. It is as though Picasso had repeated the theme only to take himself out of it. Before abandoning it—for during the Cubist years it does not crop up again—he separates it from himself. In exactly this spirit Joyce's young Stephen Dedalus described the perfected dramatic form as one in which "the personality of the artist . . . finally refines itself out of existence, impersonalizes itself, so to speak."[2]

Picasso's watcher-and-sleeper theme returns briefly around 1920 in a few lightly sketched scenes of stranded bathers, mythical female figures sometimes sleeping and waking together. The motif reappears in a family scene of 1923 (Fig. 43), in which a weary youth turns away from a young mother and child. The date of the drawing suggests that it refers to Picasso's deteriorating marriage to Olga, who had borne him a son less than two years before and from whom he was straining away. But if this boyish sleeper identifies the 42-year-old Picasso, then the master is masked again, this time by blunt, classical features.

From 1931 onward, the wake-slumber theme moves into dominance and becomes one of Picasso's perennial preoccupations. Watched sleepers now loll in hundreds of drawings and paintings and in some of the finest etchings of the *Suite Vollard*. Since Picasso was now passing fifty, and the wake-slumber theme had lain dormant so long, he was retrieving it from his youth, just as the actors within these etchings seemed retrieved from the mythical youth of the race; for they are all classical figures, nude as the gods, with immortal lives lived in midsummer heat—a fellowship of Jovian sculptors, monsters, compliant models; the artist working, watching, or

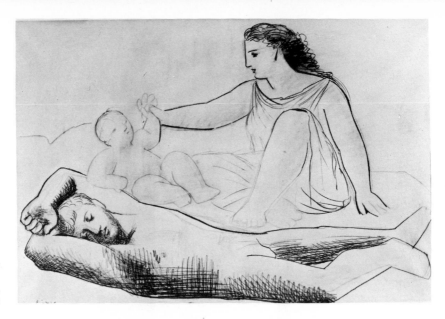

43. Picasso,
The Family, 1923

resting, the women embraced by the minotaur or gazing in hypno-
tized fascination at what the sculptor has wrought. Sometimes, hav-
ing fallen asleep, they join in the mating of oblivion and vigilance.

Numerous drawings, both exploratory and retrospective, surround
the etchings of the *Suite Vollard.* In one of them (Fig. 44), a vigilant
youth sits low against a couch which supports a nude girl asleep. He
is a statuesque figure of frank Grecian features, while the immense
sleeper behind him recalls the full-blown women of Ingres, and be-
yond Ingres, the stony survivors of antique dreamlands, such as the
Barberini *Faun* and the Vatican *Ariadne.* As never before in these
confrontations, the opposites of slumber and wakefulness are recon-
ciled. The boy and the sleeping girl share a single long contour: a

44. Picasso,
Youth and Sleeping Girl,
September 24, 1931

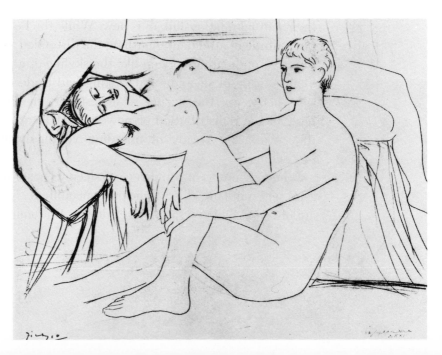

45. Jan Saenredam,
Jael Slaying Sisera

line that begins as hers becomes his from his knee to the pit of his
neck. Her arms, rising and falling, direct their abundant power to his
folded hands; and the conjunction of their right hands signals an
imminent critical contact, recalling a more famous creation of man.

Almost everything in their features seems long familiar, yet in
their mutual relationship all is new. While the boy holds the floor in
the attitude of attendant guardian, the distended sleeper behind him
forms an undulating horizon like the skyline of a plateau. In no pre-
vious pairing of sleeping and waking had pride of place and supe-
rior energy put the sleeper so majestically in the ascendant. It is
here, in the redistribution of powers, that Picasso's figures—though
they evoke an Arcady of unfading youth—depart from classical
precedents.

Where meetings of watchers and sleepers occur in ancient art they
represent unplanned or delicious encounters. Somnolent nymphs
are unveiled by lewd satyrs; ever-dozing Endymion is visited by the

98

46. Boldrini after Titian,
Satyr and Sleeping Nymph

47. Annibale Carracci,
Jupiter and Antiope

lovesick moon goddess Selene; Dionysus comes upon Ariadne asleep
and decides to get married. Invariably the encounter with sleep im-
plies opportunity. And with a few rare exceptions this principle
holds again in post-Renaissance art.

But Renaissance artists complicated the fortunes of sleep. They
showed dreamers harangued by dream visions, and they dwelled
with fascination on stories in which gods or Old Testament heroines
take advantage of an enemy's slumber to cut him down. Mercury
and Argus, Judith and Holofernes, Jael and Sisera are the best
known of these fell encounters (Fig. 45). But whether the intrusion
is tender or murderous, the one caught napping, victim or benefi-
ciary, is the butt of the action. Sleep is the opportunity of the in-
truder (Figs. 46 and 47).

A narrative painter with a true-to-life story to tell may have little
choice here; real sleepers, being in no position to offer resistance,
must always seem passive and vulnerable. The same applies to genre

99

48. Picasso,
Minotaur and Woman Asleep,
June 18, 1933

49. Jacob Matham,
Cimon and Iphigenia

scenes that involve people asleep. To think of a sleeper dominating a life situation is difficult not only because defenselessness keeps him in jeopardy, but because sleep itself is a fragile condition. In post-Renaissance art the satyr theme was often modernized and domesticated: we observe a young spark as he lights on a catnapping maid or peeks through a bedroom door left ajar. Inevitably in these situations a helpless sleeper is exposed to the relative omnipotence of an intruder; and the imbalance of power provides the whole plot.

When this imbalance no longer obtains, whenever a confrontation of watcher and sleeper suggests matching powers, the chances are that the scene has shifted from the narrative and the literal level to a symbolic plane.

Hence the patience of Picasso's sleepwatchers. Their wake at a slumberer's side is never an opportune moment. Nor are Picasso's sleepers ever awakened, startled, or taken advantage of. They nod in daylight and incur no intrusions. And even when the visitant is a monster, their sleep is safe. Picasso's sleep-watching encounters are not accidents but juxtaposed states of being.

Picasso's minotaur, his familiar, a bull-headed yearner; like the sculptor with whom he consorts, he stands for the artist himself. He lusts and carouses and dies before wide-eyed women in the arena. In the *Suite Vollard* he appears more than once as a tender-eyed melancholic, searching the face of a sleeping girl (Fig. 48). The brute is tame.

Such taming is not unheard of. Boccaccio, for instance, tells a tale that was often depicted in art (Fig. 49): a rude rustic, Cimon by name, stumbles upon the sleeping Iphigenia and, through the mere sight of her revealed beauty, converts into a gentleman—a piece of transparent propaganda intended to counter the monkish view that a female exposed necessarily brings out the beast in a man.

Picasso's theme is more subtle, and his own words, as reported by Françoise Gilot, suggest one of its meanings. He was showing her the prints of the *Suite Vollard*; coming upon the intruding minotaur, he described the curious monster as seeking a kind of emotional knowledge: "He is studying her, trying to read her thoughts, trying to decide whether she loves him *because* he is a monster."[3] Again, as in the watercolors of 1904, the wakeful male, unable to share her thoughts, feels shut out. It is her sleep that precludes the knowledge of her. Her sleep, so far from offering a main chance or licentious

occasion, awakens the minotaur to his banishment. The sleeper's withdrawal is recognized as a desertion. Which leaves the nymph newly empowered; no longer defenseless game, she holds the power of the kept secret, the power of the safe and the lock.

The theme of the hybrid visitor takes final form in one of the last and most elaborate prints of the *Suite Vollard* (Fig. 50): an open loggia—a nymph asleep, a faun entering with the noonday sun. He has the horns and tail but not the disfiguring hooves of his breed. And his left hand unveiling the woman's face is raised as if in a solemn rite of erotic sanctification. This is no forward fantasy of voyeurism and female complaisance. This hybrid lover, genuflecting as he uncovers his nymph, is not lifting a secret but offering homage to a mystery.

Sleep, the interior privacy of the *sueño*—the state of sleeping and dreaming which in Spanish goes by a single name—may be Picasso's symbol of the innermost self. Once, when challenging the presumption of would-be interpreters of his art, he asked, "How can anyone enter into my dreams?"[4] He was protecting the self in its solitude, but also in its secret inward fertility. The word "dreams" he used as did his Mediterranean ancestors who named the god of dreams Morpheus for the "forms" (*morphai*) spawned in the imagination of sleep.[5]

The naive image of inactive sleep is clearly too mechanistic for Picasso's art. Even in common experience, where wakefulness is a running down and sleep a renewal of forces, the advantage in the power balance is not all on the side of vigilance. And inside a picture, where real motion is stilled, the contrast between sleeping and waking may be so conceived as to beggar the state of waking. Then the sleeper's repose, being self-contained and replete, will discredit the waking state as a condition condemned to the avid intake of experience and data, a restlessness which in its need to be continually feeding betrays incompleteness; and the other's quiescence will appear the more puissant, because less dependent on perpetual maintenance. Even in common American speech a "sleeper" is a potential winner; while the Spanish *sueño* implies nothing less than the power to dispel facts. Every Spanish child knows the passage in *Don Quixote* that celebrates sleep for the capacities inherent in dreaming: "Now blessings light on him that first invented this same sleep!" says Sancho Panza. "It covers a man all over, thoughts and all, like a cloak. . . . 'Tis the current coin that purchases all the pleasures

50. Picasso, *Faun and Sleeping Woman*, 1936

of the world cheap; and the balance that sets the king and the shepherd, the fool and the wise man even."[6]

Picasso's interest in the wake-slumber theme derives from at least three distinct impulses: from his private life, from the psychic concerns of his generation, and from his native culture.

In his homes, Picasso has always kept what decent folk call "irregular hours," working nights and sleeping the mornings away. Throughout his life he has seen others sleep and, when asleep, has known himself watched.

But sleep itself was being observed with new interest during Picasso's formative years. It was then that much of Western scientific and artistic energy turned to the study of marginal states of consciousness, sleep and dreaming included. Titles such as *The*

103

51. Picasso, *Girl Seated by a Sleeping Minotaur*, May 18, 1933

Sleepers and One That Watcheth (this from an English painting of about 1900[7]) have a distinct period character. So has Proust's long-drawn description of a girl sleeping—"La regarder dormir"—which he built into his novel *La Prisonnière* (1923). One feels that Picasso read this book and perhaps absorbed some of Proust's spirit: "I found her asleep and did not rouse her. . . . She reminded me of a long blossoming stem that had been laid there . . . her sleep, on the margin of which I remained musing . . . was to me an undiscovered country. . . ." And again: ". . . those drooping lids introduced into her face a perfect continuity, unbroken by any intrusion of eyes."

But Picasso's sleep-watching has a Hispanic flavor. It recalls the poet Quevedo "posing wakeful questions to the dream-life" and Spain's national drama, Calderón's *La vida es sueño*, whose complex plot demonstrates that "each man dreams what he is"; and it brings to mind Picasso's younger contemporary, the Spanish-educated Ar-

104

gentine Jorge Luis Borges, who declares that we dream the world, that the dreamer is dreamed in his turn, that "while we sleep here, we are awake elsewhere and that in this way every man is two men."[8]

At any moment Picasso's imagery may require one to read his characters not as persons engaged in watching and being watched, but as a figuration of sleeping and waking—dependent states that exclude and presuppose one another, nourish and infect one another, each lacking some richness the other has. In their alternation and reciprocity, we recognize the half-lives our lives are. Hence their interchangeability in Picasso's art. The familiar personifications trade roles and places. The man or the minotaur watching the girl is followed in the *Suite Vollard* by a demure Kore watching over the huge hairy minotaur drowsing behind a silk curtain (Fig. 51). And throughout the late thirties and forties, drawings in which satyrs watch sleeping nymphs alternate with others in which a man's sleep is watched.

The conciliation of sleeper and watcher is variously symbolized, sometimes by substitution, the transfer or sharing of parts, sometimes by the action of light. In the 1904 watercolors, the confronted parties occupied distinct zones of brightness and gloom. In a noble aquatint of the *Suite Vollard* (Fig. 52), one candle placed between the nude girl and the Picasso boy at her side illuminates both together, so that they join in defining one orbit of light.

Sometimes both figures are female. Instead of confirming the distinctness of the two states by distinction of sex, the exponents of vigil and sleep blend into sisters. When the drawing of 1931 (Fig. 44) was reworked as an etching, its alert youth was replaced by a watcher of the same gender as the sleeper herself. In scores of later drawings and prints, wherever these persons share a coincident nature, they become readable as alternate states, twin phases of a single existence, wary and weary by turns.

But the opposite is equally true—that they are never abstractions alone, nor mere symbols of watch and sleep. On one day, February 10, 1946, Picasso made seventeen drawings—airy, whimsical variations on an old theme (Figs. 53–60). Their technique is a pencil line; their mode—metamorphosis; their manifest subject—two women. They look as if almost anyone could have drawn them.

Sitting up on the left is the sleepless one, an odalisque of ripened plant forms, of swollen pods, lobes, parted fruit. At her side, or behind her, lies another. This other woman (for she has, in the first drawing, between her raised arms, a small head on a stalk and breasts like twin berries) becomes progressively dehumanized—into a creeping vine or a ground beetle with sprouting antennas—then devolves further into approximations of vulva, pupa, and leaf. While her burgeoning companion remains erectile and statuesque, she regresses through the most primitive stages of vegetative and insect existence. And yet, throughout seventeen variations, the precise, intimate contact between the two is never broken; their lower bodies remain tangent or interlaced.

One could not ask for more radical transformations, for female figures more depersonalized by abstraction. But Picasso's symbols are so manifold and allusive that apparent abstraction never rules out its opposite—the specific reference to one person, or to a particular thing. In fact, these Picasso drawings portray two women whose identities will be remembered as men remember Rembrandt's Saskia and Hendrikje. They are Françoise Gilot, who was then coming to live with Picasso, and Dora Maar, the most tragic of his rejected mistresses, just then passing out of his life. For the February 10 series of drawings was merely a day's by-product of a long winter's work on one lithographic stone which Picasso carried through eighteen progressive states (Figs. 61–64). In the comparison with these prints, every detail of the more abstract drawings becomes legible as a direct transformation of screen or couch, of raised arms into cocoon and curtain folds into feelers. And the lithographs are evidence for the identity of the entwined females of whom one is supplanting the other.

This is how Françoise Gilot describes her first acquaintance with the lithograph known as *Les Deux Femmes nues:*

> There was a portrait of two women, one sleeping, the other sitting beside her. The one sitting was obviously me. The other I wasn't sure about. When I asked Pablo who it was, he told me he wasn't sure, either. It was either Dora Maar or my friend Geneviève, he said. When I first saw the lithograph, he had made six states of it. He continued to make changes in it through the winter and by the time it reached the definitive state—there were 18 in all—its character had changed radically from highly representational to unrecognizably abstract. But in losing her pictorial identity, the sleeping

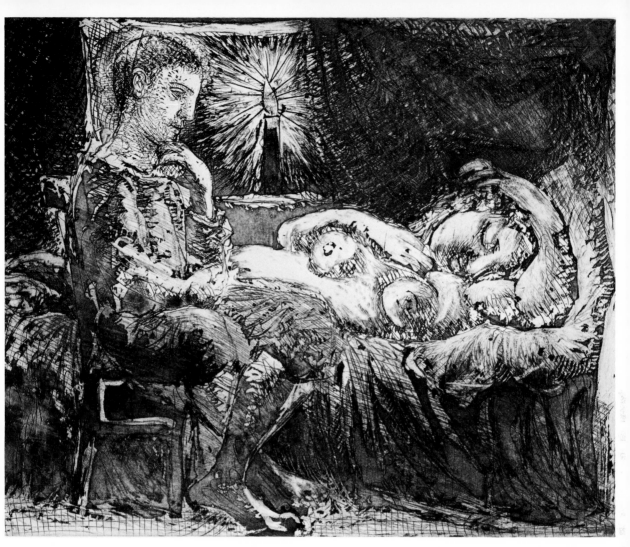

52. Picasso, *Vigil*, 1936

woman had regained her actual one. Pablo had come to realize that
she was, after all, Dora Maar, he told me. And as though to prove
it he pointed, in the margins of the paper, to a number of *re-marques*: there were little birds of various kinds and two insects
drawn in minute detail. He said he had always considered Dora
had such a Kafkaesque personality [a reference to Kafka's "Meta-morphosis," whose hero awakens one morning to find himself
changed into a beetle] that whenever he noted a spot or a stain on
the wall of her apartment, he would work at it with his pen until
it became a small but very lifelike insect. The fact that he had been
led to make the same kind of 'comment' in the margins of the
stone made him realize that the sleeping woman was, indeed,
Dora. The birds in the upper and lower margins were for me, he
said.[9]

107

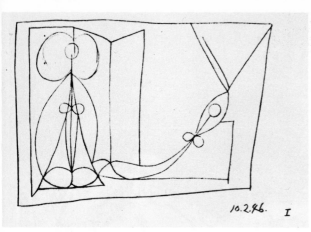

53. Picasso, Study, February 10, 1946

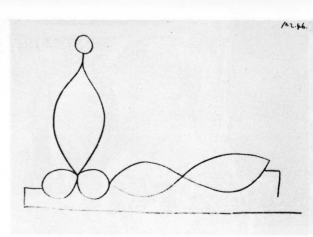

54. Picasso, Study, February 10, 1946

57. Picasso, Study, February 10, 1946

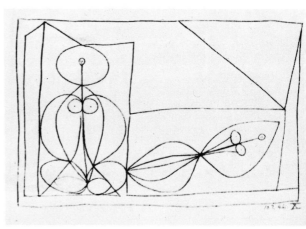

58. Picasso, Study, February 10, 1946

61. Picasso, *Two Nude Women*, November 1945–March 1946

62. Picasso, *Two Nude Women*, November 1945–March 1946

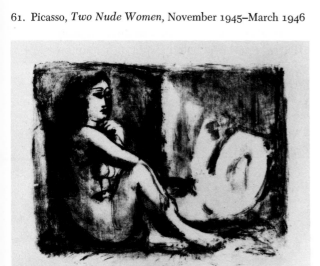

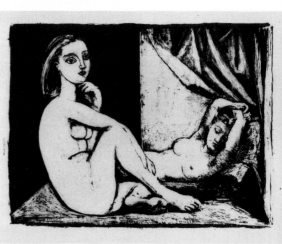

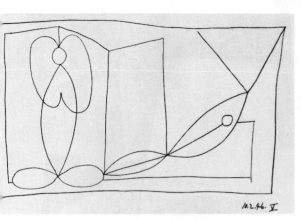

Picasso, Study, February 10, 1946

56. Picasso, Study, February 10, 1946

Picasso, Study, February 10, 1946

60. Picasso, Study, February 10, 1946

Picasso, *Two Nude Women,* November 1945–March 1946

64. Picasso, *Two Nude Women,* November 1945–March 1946

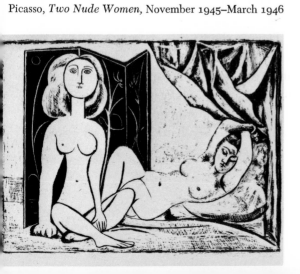

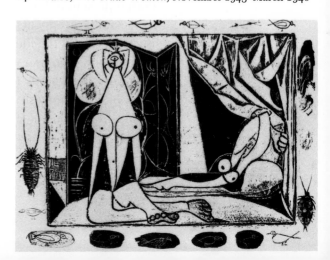

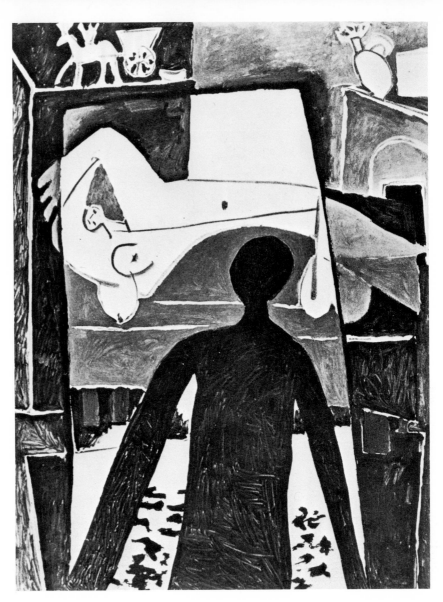

It is a revealing passage. Firstly, because the writer, herself a painter and in close touch with Picasso's ideas, takes it for granted that two figures in a Picasso lithograph, recognizable or not, must both represent definite persons.

Secondly, it appears that Picasso shares this assumption. He too is curious about the identity of his figures, as a man might be curious about who's who in a recent dream, welcoming any small clue.

Thirdly, as regards the internal sources of Picasso's imagery: the Gilot passage suggests that they flow unpredictably from intercommunicating levels of personality: they involve capacities of which

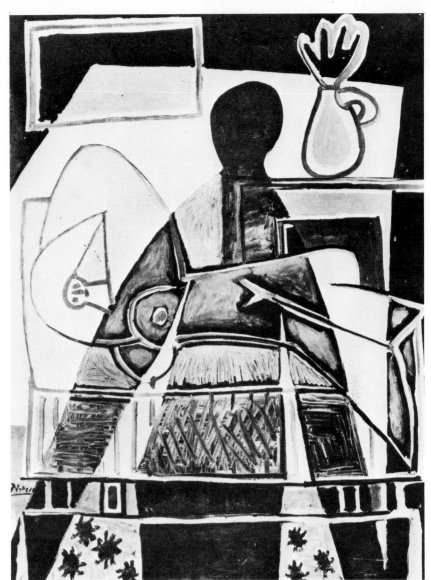

66. Picasso,
The Artist's Bedroom,
December 29, 1953

some are awake, others subliminal. Even Françoise did not apparently observe that in the first state of the lithograph the sitting woman is not yet Françoise but Dora Maar—who then yields her upright place to the successor, while her own identity enters the sleeper. The identities of Picasso's watchers and sleepers, oscillating between portraiture and abstraction, may at any moment become simultaneous or interchangeable. One can never assume for a given work that specifiable references of this kind must exist in it. Picasso may repeat a sleep-watching scene because it contains a potential for variation which wants exploring. But even if a wake-sleep con-

111

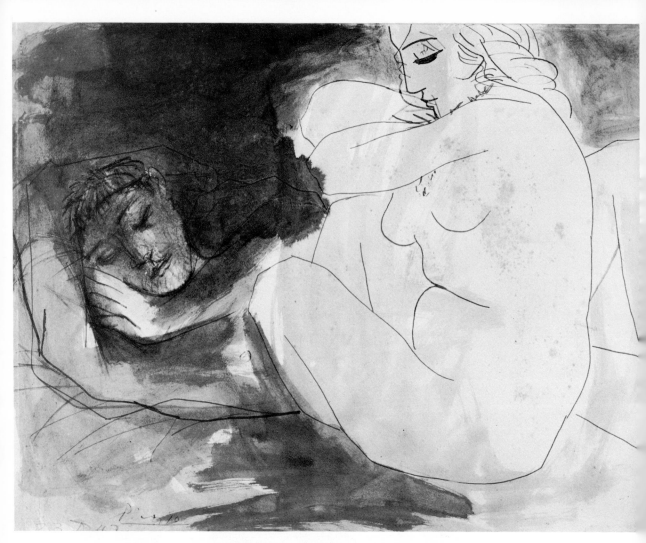

67. Picasso, *The Dream*, 1942

frontation began as a purely formal polarity, it grows in Picasso's hands into a pattern of opposites that attracts meanings. His most formal schemes remain or become receptive to autobiographical and expressive content. Thus in our series of drawings, even where the two female figures are most schematized, their mutual relation still describes something of their comparative personalities, their respective standing in Picasso's favor, their fates. Ultimately, in these drawings, the upright form rising over the horizontal describes a pattern of supercession.

Seven years later (1953), when Françoise left Picasso, the artist acknowledged his desolation in two similar paintings (Figs. 65 and 66): a man's shadow falls into a room where a nude woman is sleeping. "It was our bedroom," Picasso explained. "My shadow and the

sunlight fall onto the bed and across the floor."[10] The pictures are full of reminiscences, not of his personal life only, but of his art. As in the watercolor drawings done a half-century earlier, the man's deprivation and loneliness are carried by the color of shadow. As in the beautiful drawing of 1931, the high place of the sleeper's body (Fig. 65) forms a canopy for the man. And as in many drawings of the preceding decade, most conspicuously in one of 1942 entitled *The Dream* (Fig. 67) the reality of one or both figures recedes. In the painting, a man's shadow mourns the white ghost of a departed woman. In *The Dream,* an all-white crouched woman looms with closed eye over a dark boyish sleeper, and we cannot tell where the reality is and where the dream.

At Antibes on October 13, 1946, Picasso drew a male figure lying face down, asleep (Fig. 68). The figure is generated by seven lines that define it in compact angular shapes, suggesting an incompressible substance. It contrasts with the buoyancy of the woman—an apparition, a volatile Eve born of the sleep of Adam; he is probably dreaming her.

Another drawing (Fig. 69), done a month later: a woman sleeping, only her upper parts showing, one raised arm supporting her head. Indication of place limited, as before, to a horizontal line; not enough for a meadow or beach, but rather a minimal statement of horizontality—which is all the ground that sleep needs; it can dream the rest. Indeed, she may well have dreamed her horned satyr into

68. Picasso,
*Sleeping Man and
Standing Woman,*
October 13, 1946 (VII)

existence. On the other hand, she may herself be the projection of his satyr's lust. Lusting with imagination, he could even project her particular kind, who would dream just such a satyr as he. Perhaps in the drawing they engender each other? Then each is the other's created fantasy; then desire and dream alike anticipate art in the operation of image-making.

Such drawings are reveries. Their function is maintenance. They help to keep a lifetime's brooding uninterrupted—a brooding on the interplay of substance and fantasy, working and dreaming. They are materialized thoughts in which desire and form intersect.

In another sense their function for Picasso may be even more rudimentary. His upright watchers and reclined sleepers serve him as means of constantly charting and redefining the ground of his canvas, his paper, or etcher's plate. For whether his couples are cast as lovers, or as fateful sisters, or in the roles of artist and model, they stake out an elemental geometry. Perpendicular to each other and parallel to the margins, they span and they scale the pictorial plane, so that horizontal and vertical materialize in ever-new personifications. The artist's will to lay down and erect the forms that perpetually reembody the conditions of his two-dimensional plane— this is more than a technical matter. For the flat picture surface is his whole working world, and Picasso reclaims it continually by projecting watchers and sleepers as the living coordinates of his realm.

69. Picasso,
Satyr and Sleeping Woman,
November 1, 1946

5 The Skulls of Picasso

Skull and Pitcher, painted on March 10, 1945 (Fig. 70). A rectangular table having five, six, maybe seven sides (counting is not encouraged). It stands at a window or porch, an ambiguous outside-in station, an interior that inhales the outdoors. The reticulate backdrop may be a tiled wall, or a plaid hanging, or coincident grids out of register. On the table, skull faces pitcher; between them—a spread of white light, either cast by the window or the negative of a shadow thrown by the skull. The glazed earthenware jug shows five facets; that means every aspect accounted for, to say nothing of lip, handle, and corrugated inside. The orientation of its lighted and shaded planes is reversed. The slender segments facing the incoming yellow light do not brighten up, but show sunless violet, so that we recognize them despite their precession for what they are—averted planes, tokens of other aspects. The light's character is consistently altered, as in the bar of white light standing up under the table. And above board, the light enters not softly, like the spiritual substance it ought to be, but like a sharpened ax-blade whose contact causes instantaneous recoil. The situation is tense; skull and pitcher in confrontation.

In one of the eight similar subjects painted during the ensuing week—*Skull and Leeks* (Fig. 71; March 18)—the pathetic anxiety of the still life objects is even more pressing. Surrounded by lean

First published in Art News, October 1971.

To Dominique and Jean de Menil, who own the Houston still life, I offer my sincere appreciation for their friendship and kindness to me as to thousands of others who care about art.

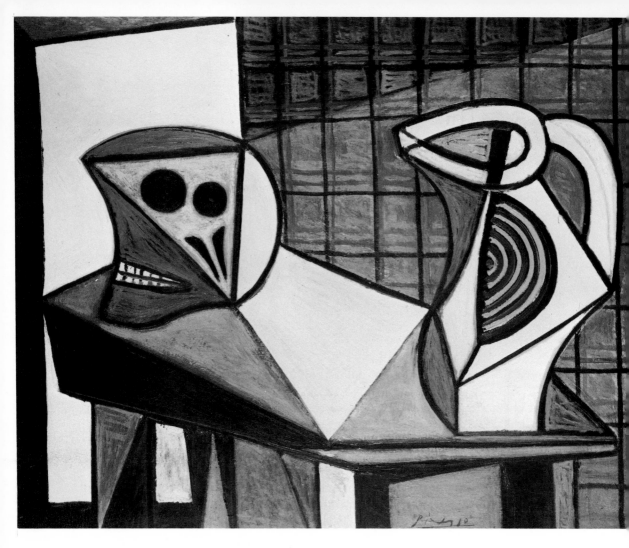

70. Picasso, *Skull and Pitcher*, 1945

vegetables, two of which reach out like arms, the skull screams amain while a buxom pitcher looks on. It appears to be a matter of fact that the pitcher is feminine, whereas the skull, poor death, spurned and uneatable, looks very sorry.

But in the earlier picture the skull is mean and hard as a bullet. The thrust of its cranium reverberates at the pitcher's throat. And the curvaceous vessel, as befits the responsive sex, reels. Shrinking back, timorous, yielding, belonging—its caving gorge, you remember, attuned to the death's head—it plays the receiving role in a Satanic annunciation.[1]

Like the pitcher, the skull too enrolls all its facets—top, occiput, profile, and hollowface. Its impending mass sits flat and full against the sunlight. No tenuous fragility here of human bone, no openwork

hinging of jaws; it is all solid matter, obdurate substance, a fossil in its absolute prime. "One way to master the fear of death is to become its embodiment," reports a psychiatrist.[2] And since this picture is laden with passionate metaphor, I cannot unthink the possibility that Picasso, who during the 1930's had projected himself into the Minotaur monster, is self-projecting again.

The pressure of emphasis contained in this sentient skull accords with its density. Despite the flat planes of the painter's idiom, it is made to seem indestructibly solid—but by what means? Of course, the heavy black boundary holds the parts down like a steel hoop, and such secure casing must be assumed to enclose an incumbent mass—the more so since the border thins out against the light and thickens below as on any three-dimensional object properly rendered. Then again, the segmental shapes at top and back suggest partial views in perspective. And the suggested planes, changing color from dark tones to light—from violet to a heightened turquoise —tend to read as tonal gradations on a spherical body. Furthermore, the skull lies in the path of an entering light, whence its bulk emerges by implication; it has to be volumetric to block all that light. Then there is the effect of the larger stark-staring eye which looks straight out and at the same time to left so that it rivets front-

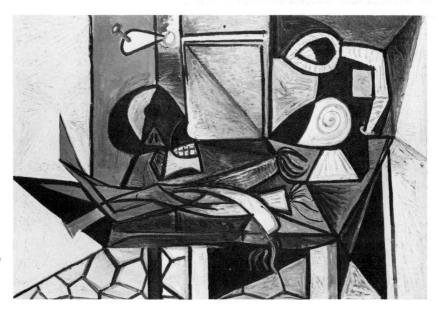

71. Picasso,
Skull and Leeks, 1945

face and profile together. More important, the wedged-in triangular centerpiece: though it tips on one corner, it maintains the most rigid of geometric forms—a right triangle, its hypotenuse running from ten o'clock to five on the dial. And finally, the sides of this interned triangle—three chords of a circle—discharge (with refracted break of direction) into the surrounding field. Reading centerward, these fielded lines impinge from without to form planar ridges. Thus every internal division of the cranial orb claims its remote anchorage far afield; each side of its face is steered into place and held fast. It is the most redoubtable skull he ever painted.

The skulls in Picasso's earlier works were never that serious. There is one in the powerful *Still Life* of 1907 in Leningrad; but it is used like a common *vanitas* symbol, and a Cézannesque prop. In the same year Picasso discarded the motif of a symbolic skull from his *Demoiselles d'Avignon* project. And where a skull appears in a Synthetic Cubist still life, it is flimsy, lightweight, no more than a paper mask, a matter of make-believe.

Much later, after the mid-1940's, the skull will turn up again as a fake object—a bogey, a silly thing to be frightened of—taking form as a mask, or a harmless owl, or as a punning resemblance in the soft muzzle of a horseface.[3] But in 1940, the moment of World War II, skulls entered his art in earnest. Real death was outside, real fear grounded within, and Picasso's iconography narrowed upon it.

To continue working, the artist, then nearing sixty, had moved to the small harbor town of Royan on the Gironde. The Royan sketchbooks for June-July 1940 are strewn with pen drawings of skulls; endlessly repeated studies of the same subject—the kind of ceaseless rehearsal Picasso makes of a thing until he has it like his own signature, until he knows it from inside out, so that he can dispatch its parts several ways at once. Paris was in the hands of the Nazis and the painter of *Guernica*, their outstanding exponent of "degenerate" art, was inventing a type of head which a young woman shares with a bare skull, death and the maiden faceting a single core.

At the height of the war, back in his Paris studio and entering his sixty-third year, Picasso began work on an overlifesize bronze of a *Death's Head*. Loyal friends had kept up a clandestine flow of scrap metal to his atelier, and Picasso trembled for the fate of his bronzes when German officers called. "They won't help you make your big guns," he said nervously. "No," replied one, "but they could make little ones."[4]

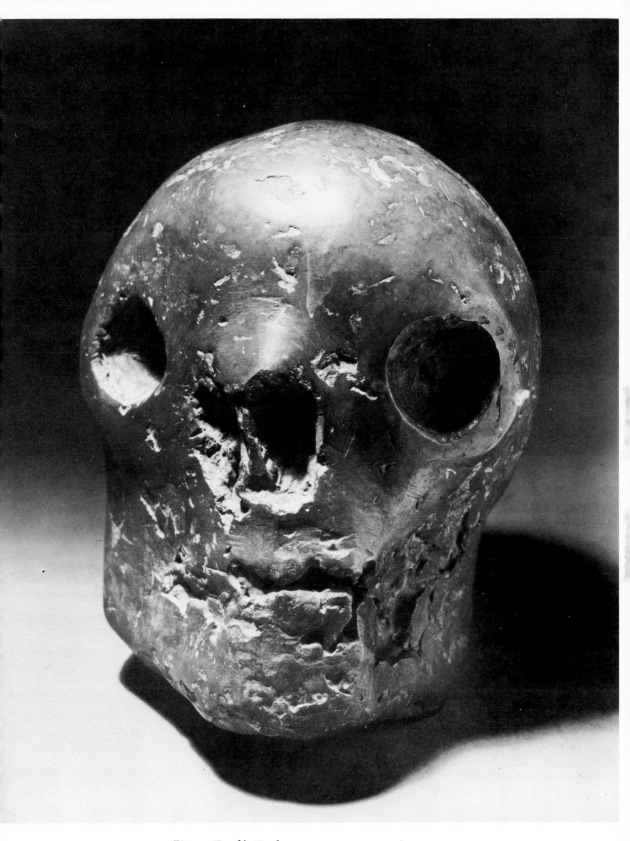

72. Picasso, *Death's Head*, 1944

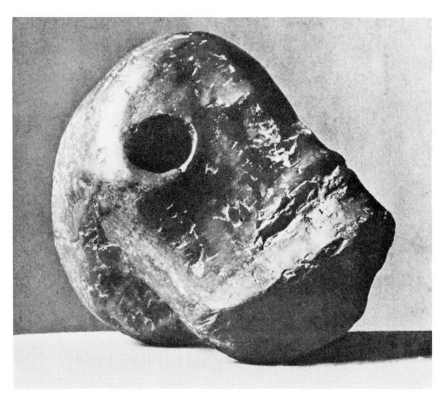

73. Picasso,
Death's Head, 1944

The bronze *Skull* survived (Figs. 72 and 73). It is probably the most powerful single-mass sculpture in twentieth-century art. Irrespective of its timing and its symbolic charge, it constitutes a landmark in Picasso's artistic history, the most determined attack of his sculptor's career on the problem of giving new life to the monolith.

The skull is all mass in pure homogeneity, mass conveyed by avoiding every concession to planimetric surface organization. Picasso returns to one of his earliest intuitions about the relation of internal volume to surface: that the familiar planes of a man's head are not given in nature but imposed by convention, so that even the forehead, the pre-eminent bonewall of the face, a fronting plane *par excellence—front* in French, *frente* in Spanish—need present no flat frontage, but rather a continuously swelling ascent towards some lifted summit—as in the *Mask of a Picador with Broken Nose* of 1903-5. Think of the human head in conventional planes, and you may as well think empty boxes; whether cubiform and hard-edge, or

with bevelled turns, these planes might still house a hollow—a conclusion which Picasso demonstrated when, in the fragmentations of Cubism, he disassembled the head's component facets and found no resistance within. But suppose the objective were to deny every vacancy, to allow no thinkable internal slack, to make surface the visible symptom of unsurpassable density down to the inmost core; this requires the obliteration of all pre-framed planar articulations, and the form's aboriginal mass in perpetual expansion to realize its outside.

Picasso's bronze skull is indestructible ore, all core and no crust. Like Egyptian sculpture, it has the granitic cohesion which makes other substances look loose and porous. There are no parts to this skull: the mandible fused with the cranium is a single impacted monolith. The wall-eyed sockets sliding away on oblique slopes leave no plane of imaginable frontality; and the wide eye holes, not framed or contained by their sockets but, on the contrary, staring them into place, as if the glance tunneled its way out from within. Fashioned during the critical battles of World War II, Picasso's *Skull* is resurgent vitality in the midst of death. It affirms the indestructibility of the center.

Perhaps the war and the siege of Paris were the sufficient occasion, but I hardly think so. No external event, no matter how overwhelming its scope, engenders a work of art unless it becomes an inward occasion. And there is evidence that Picasso, as the 1940's progressed, had cause to brood on the timing of his own death; it had been foretold. The collection of unpublished works from his earliest Paris years which recently passed to the Picasso Museum in Barcelona includes a penciled chart of his own palm, datable *ca.* 1903-4, its lines carefully plotted for divination. Readings of Picasso's fate surround the drawing, written and signed by the friend of his youth, Max Jacob: ". . . *ligne de vie—jusqu'à 68 ans/ faiblesse et maladie grave à la fin de ses jours.*" Picasso's death, following debilitation and sickness, is predicted for the end of the forties.[5]

Picasso is not a man to let that kind of oracle slip his mind, nor is Max Jacob a poet whose words one forgets. Jacob had been interned as a Jew in the concentration camp at Drancy, where he died soon after. Picasso, at some risk to himself, attended the funeral.[6]

It was 1944, the climactic year of the war, the battle for Paris, and the death of his soothsayer. And before the year's end, Picasso has completed that huge brazen *Death's Head* which, in a great news

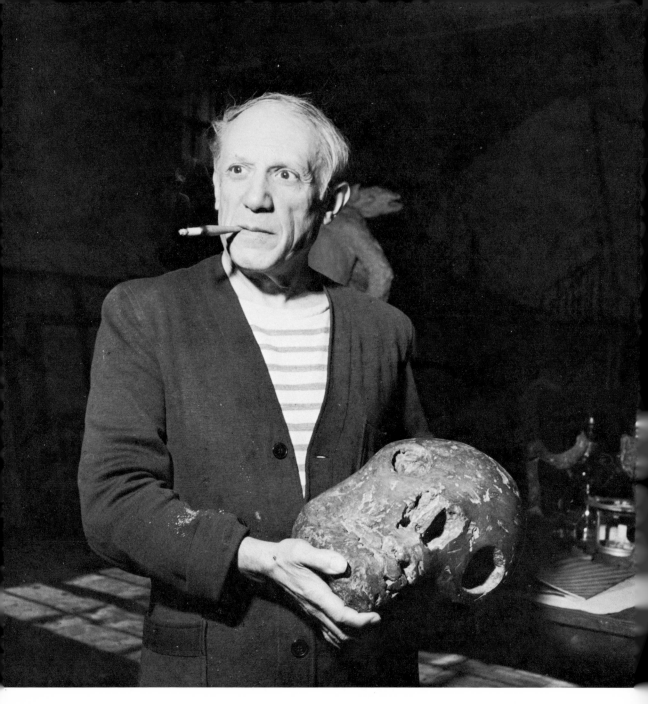

74. Pablo Picasso, 1944

photo of that year taken by Robert Capa, he holds in his hands with a look of irrepressible triumph (Fig. 74). Thereafter the skull becomes part of his household, the lively protagonist of his domestic still lifes.

The graph of Picasso's life work traces a pattern of periodic Descents ever deepening. In his first significant body of work, produced after 1901, when he was barely twenty, Picasso identified himself with society's derelicts. His cast of characters were outcasts and vagabonds, beggars and harlots, the blind and the crippled, and the pale acrobats of the circus. Their company constitutes Picasso's first Descent into the Underworld, the "descent" being a search for authentic humanity at the base level. But the plunge taken in 1907-8 is a going down so much deeper that it makes the first in retrospect appear sentimental and shallow. The descent now is anthropological rather than sociological, that is to say, down to the primitive roots of awareness, where the symbolic environment is the jungle and the earth-given body is stirred by a lumbering pre-consciousness. Picasso's pictures of 1908, the *Dryad*, the *Nude with Draperies*, and the *Three Women* (all in Leningrad), are his private creation myth, a probing of the origins of the race and the roots of the psyche. This metaphor of devolution towards primitive states is Picasso's second Descent.

A third, more precipitous, plunge came with Picasso's metamorphic or Surrealist period of the late twenties and early thirties, when the metaphor of submergence became biological. Tumescent, reptilian monsters peopled his imagery to enact a human existence in steep descent down the ladder of evolution.[7]

These, before World War II, were Picasso's three Descents into the Underworld—as fellow outcast, fellow savage, and fellow brute. But his fellowship with death in the forties reached deeper still. For there is no fall so steep as that which, in the *Charnel House* (1945; New York, Museum of Modern Art), levels the painter's eye with the slaughtered cadavers heaped under the kitchen table. Picasso abandoned the picture, making it one of the world's great unfinished works. His next major painting, dated 1946, was the *Joie de vivre*.

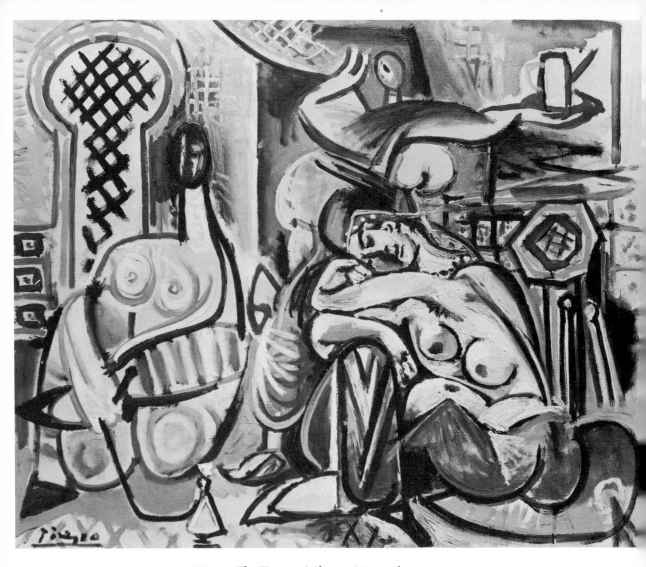

75. Picasso, *The Women of Algiers, A,* December 13, 1954

6 The Algerian Women and Picasso At Large

I FROM A TO M

Early afternoon December 13, 1954, Picasso, aged seventy-three and still in his Paris studio, delivered his first variation on Delacroix's *Femmes d'Alger* (Fig. 75). They are three women in an oriental interior; one is coiled up and asleep; another alert, sitting up with a hookah; a third—the light-footed, full-bosomed servant backstage—drags a curtain, while promoting a coffeepot to the upper right corner. Props include one small polygonal table, a tasseled cushion rounding the lower right, and—transfixing the Smoker's hand—the hookah, bottle and snake. On the tiled background wall, openwork lattice crosshatching a Moorish niche; finally, at far center, a dark entrance exposed.

The picture—marked "A" in the official alphabetical designation—is small, 60 by 73 centimeters. First of two canvases covered before the end of the day, it seems hastily painted and muddy in color. But judging it in isolation misses its point since Picasso's idiom refers backward and forward, each shape in transit between where he found it and where he is taking it. Picasso has said of his later pictures that they are pages in a diary which he has no time to be editing. The picture then is an intention, a bid to get the Algerian project at last under way. He is prospecting the field, as it were, exploring a place which he proposes to settle.

According to Françoise Gilot, the project was of long standing. Writing in 1964, some twelve years after her decade of life with Picasso had come to an end, she recalled: "He had often spoken to me of making his own version of the *Women of Algiers* and had taken me to the Louvre on an average of once a month to study it."[1]

125

It may well be true, but it is also good writing. Gilot's memoir is enhanced with dramatic anticipation as the genesis of a great series of paintings is made to fall within her incumbency. If the memoir is faintly suspect, it is because, apart from glamorizing the parties involved, it romanticizes the effect of Delacroix's original in the Louvre—but more of this later.

Of Delacroix's four *Algériennes* (Fig. 77), Canvas A recruits three —the three on the right—and regroups them. The departing servant is posted behind the two sitters, the wave of her hand being applied to the curtain. Delacroix's dreamy croucher—her hookah resigned to a friend—dozes off. A marginal niche moves into prominence— giant keyhole adjoining an uncurtained door, giving Picasso's version two openings in the rear.

The perfunctory figure drawing in Canvas A is of the kind that flatters neither his models nor the artist's reputation as draughtsman. It serves two immediate functions: to stake out the plot assignable to each figure, and within the plot assigned, to assemble the parts needed to put a woman together—twin balloons, pointed shoes, flexible piping for arms, and so forth. Picasso's main interest was clearly in the somnolent one, the one most fully realized. Spine, breasts, and shoulder are bunched in the upper quarters without transitions. Their concentration sets off the prolixity of the undercarriage, splayed out across half the picture, and the right buttock reappears at each end—like New Zealand in a Mercator projection.[2]

The principle of anatomy by assemblage extends more loosely to the whole group—assembled in a rough pyramid, beyond which everything wanes and slackens. Picasso could not wait to repeat the picture, and one can see why. He apparently did not think the main figure worked, and he felt for the servant girl who, with so much ground to cover, had received little more than a trajectory for her labors.

So Picasso painted the scene again, with the three women's roles reassessed (Fig. 76). She who was last is now foremost and the Sleeper edged to the right. The concern is less with assembling the solid forms than with adjusting relationships on the surface. Servant and Sleeper get out of each other's way. Body landmarks adopt a uniform module. As foreground and background begin corresponding together, the erected head of the Smoker assimilates to the round-headed niche behind. That niche has grown phallic, and its

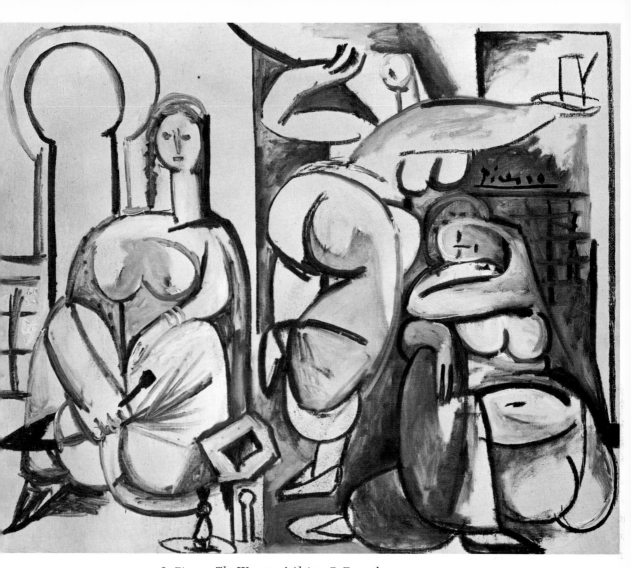

76. Picasso, *The Women of Algiers, B,* December 13, 1954

hidden base is rediscovered sustaining the woman. Even the eroticism is now more responsibly diagrammed.

In these two paintings then, and in one afternoon, Picasso's intent oscillates between the professional and the erotic. Conventional sex symbols, forthright as a schoolboy's graffiti, become the material of sophisticated coordination. The artist moves from the evocation of female forms blown by desire, to the overall order within which all forms, anatomic and otherwise, serve to articulate surface tension; from the projection of women heaped and proffered like fruit, to stretching the field clear and taut for the charting of information.

The tension between these requirements was given from the

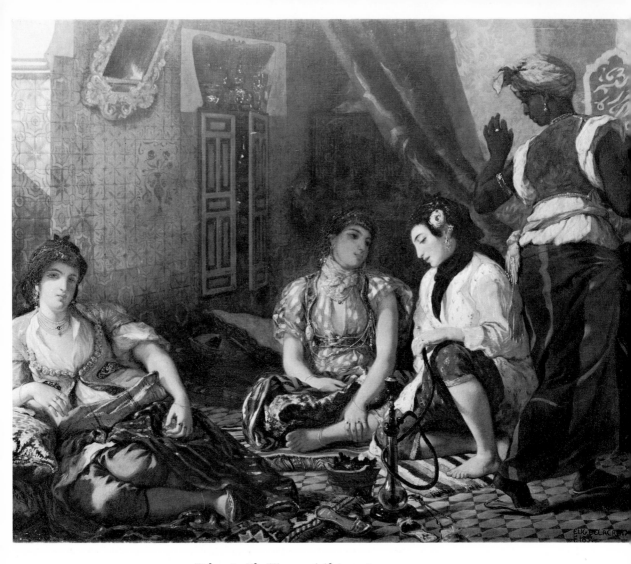

77. Delacroix, *The Women of Algiers*, 1834

beginning; for what roused Picasso to emulate Delacroix was not the
harem subject itself, but a peculiar manoeuverability which he
found built into the task. It is demonstrable that the inspiration
came to him not from one picture alone, the Louvre *Women of Al-
giers* of 1834 (Fig. 77), but no less from Delacroix's later revision of
1849 in the Musée Fabre at Montpellier (Fig. 78). The Montpellier
picture supplied the table and the action of the drawn curtain, but
Picasso did not go to it merely for the additional props. He saw a
relationship between the two pictures and took off at once from
both versions. What he took from the pair of them was their dia-
logue, the liberating awareness that their confrontation makes every
compositional decision seem again tentative. Delacroix's revision of
1849 reduces the scale of the figures, brings up the curtain, throws

in the table, makes a woman stretch out, and so on. Seeing repro-
ductions of the two pictures together, the process of finishing is re-
versed, and Delacroix's *Femmes d'Alger* becomes a reopened project.

The differences between the two pictures are more than scenery
shifts and manipulations. They are changes which radically alter the
spectator's position with respect to the scene. And this alteration
too, implicit in the pairing of the two pictures, must have attracted
Picasso. In the Louvre version it is not only that the four women
loom larger within their house; they are so near, and the framing
edge is so provisional, as to suggest an approaching close-up; a
view taken by someone already there.

By comparison, the Montpellier version is classicized. Servant and
curtain, niche and odalisque, present a proscenium stage; they be-
come repoussoirs, setting the scene off as a removed spatial unit.
Withdrawn from the spectator, the room becomes theater, and the
arras, brought forward for the servant to pull away, reveals the

78. Delacroix, *The Women of Algiers,* 1849

interior to an audience of watchers. The spectator shut out is now
peering in—and from a lowered eye level. One looked down in the
Louvre picture, and the women were at one's feet. In the Montpel-
lier version one looks up at a stage. The rights of possession or ha-
bitual companionship implied by the Louvre picture become a
voyeur's privilege.

All this if the two works are read in the order in which they were
painted. But why not in reverse? What prevents the sensation of
moving in? The inversion of the historical sequence is a step into
the women's quarter.

Bold fantasies are released by confronting the two Delacroix
paintings. And that Picasso relished the contrast between them is
indicated by his continual struggle in the *Femmes d'Alger* series
to reconcile distance with presence, possessing and watching, the
data of vision and the carnal knowledge attained in an embrace.
Sight, which needs distance, is out of touch with its aim. Whereas
the embrace, having lost distance, is blind. These Delacroix pictures
were meditated on by a man who, endowed with the most penetrant
sight of his century, chose to portray himself as a blind Minotaur
led by his groping hand.

From December 13, 1954, to April 14, 1955, Picasso stayed with
his task. During these four months he made fifteen pictures and
numerous drawings (eight have been published) and carried a set
of lithographs through four states.[3] Of the paintings the first six are
small, two are separate figure studies, and seven are large (the larg-
est, 130 x 195 cm.).

After that first December day which dates versions A and B, Pi-
casso did not pick up the brush for a fortnight. He was letting his
dissatisfactions accumulate before trying again. On December 21
he jotted the scene down in a drawing (Z. XVI, 344) filled with
premonition of scrambled styles—and his wife-to-be Jacqueline
Rocque, crouched at right, supervising. Canvas C (Fig. 79) came on
December 28, a picture so packed and turbulent that it makes the
fine clarity of B look slack and vacant. The whole field is electrified.
The shapes at right swerve and plunge as a new-burgeoning pres-
ence shoots up at the center, a white *Algérienne* soaring on dotted
silk pants, a Delacroix odalisque brought in from the Montpellier
version but transposed into primordial Mediterranean morphology—

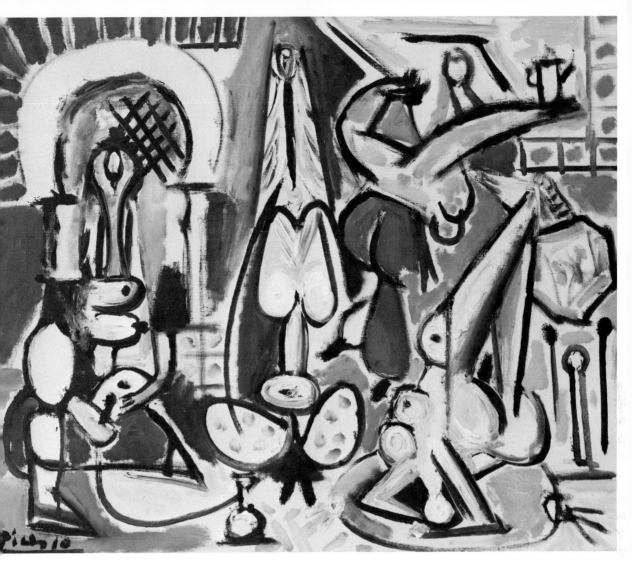

79. Picasso, *The Women of Algiers, C,* December 28, 1954

half Cycladic figment, half cactus plant. For the second time the
hookah is passed. Picasso hands it to Delacroix's fourth figure, the
one at far left. But the humanity of the left-hand figure is kept in abey-
ance; she looks engineered, rigid, solidified, her efficient parts
mounted like traffic signals, and her mace head socketed in the
round niche behind.

The servant is galvanized and the lunge of her arm wrenches her
head away. Or else the painter was so determined to allow no slack
anywhere that he has thrown her head where a void needed filling.
Every edge is remargined, every corner recharged. Even the inter-
stices between the legs of the polygonal table act up like rockets

131

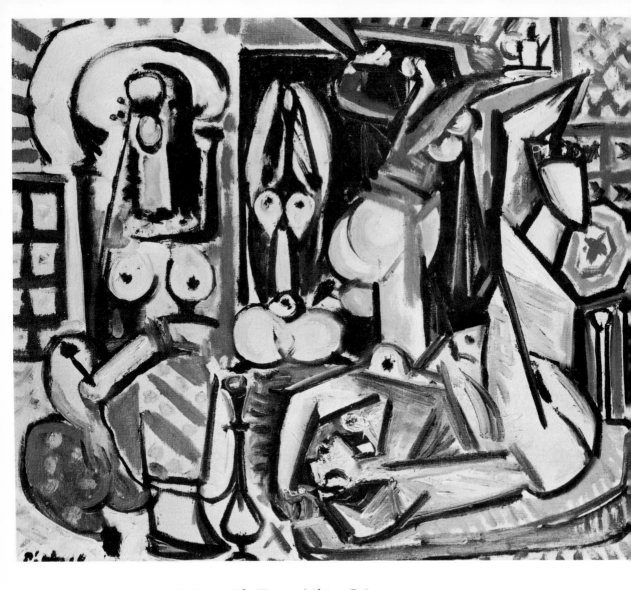

80. Picasso, *The Women of Algiers, D,* January 1, 1955

81. Picasso,
Studies of reclining nudes,
1905

whose concerted boost topples the tabletop so that only the weight of the Sleeper's feet holds it down. And this is the most astonishing change—the Sleeper turned over, head down, legs up, arms overhead. It is a bold move away from Delacroix's models, a reclamation of freedom. The Sleeper capsized reopens the situation. She becomes manipulable again, whereas the packing of her component parts in Canvas B threatened finality.

January 1, 1955: Canvas D (Fig. 80). The Odalisque now reduced to size, framed in the distant door as the Smoker is framed by the niche. Space is deep, the depth under pressure. Differentiations appear: the eight arms in the picture point systematically downward and upward, outward and inward. And no two women's breasts grow alike. The recumbent Sleeper settles in her definitive pose, a pose of long memory—one that Picasso never abandoned since he first found it a thousand pictures ago (Fig. 81). Her crescent eye, sinking like a reflected moon, establishes the theme of deep sleep.

But the Odalisque at far center came from elsewhere. Through the last six canvases of the series she remains at her post. Her axial location still recalls Delacroix. But the ceremony of her lifted arms and her nude torso indicate a source nearer home. In Canvas D she appears for the first time as a watchful presence, seeing everything we can see, but seeing it from the rear, and ineluctably associated with Matisse (Fig. 82).

Designing an odalisque, Picasso was clearly pressed by his old rivalry with Matisse, the man twelve years his senior and his single acknowledged peer. Françoise Gilot has some interesting recollections of these two men as fighting cocks. She recalls Matisse's visit to Picasso's Museum at Antibes:

> One day in 1948, Matisse came over with his secretary, Lydia, to look at the museum. He was particularly puzzled by the long plywood panel of the *Reclining Woman*. "I understand the way you've done the head," Matisse said, "but not what you've done with her bottom. The two parts of it turn in a strange way. They don't follow the other planes of the body." It seemed to bother him. He took out a notebook and made a sketch of the painting to take home with him for further study.[4]

If the recollection is accurate, then Matisse's incomprehension in 1948 of a familiar Picasso device should perhaps be understood as a bantering provocation. And perhaps he was simply repaying in kind, since a similar situation had arisen in March 1946 when Pi-

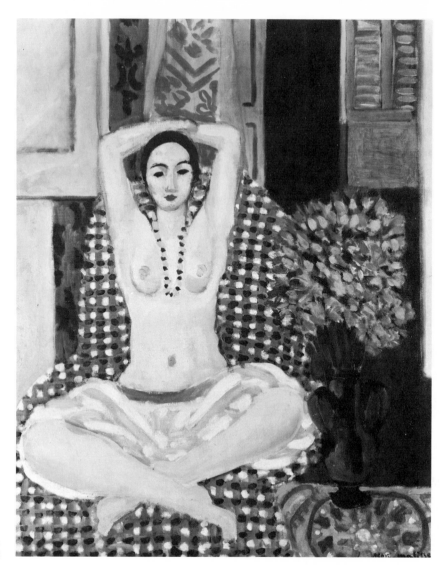

82. Henri Matisse,
Hindu Pose, 1923

casso, according to Françoise Gilot who records the event, called on Matisse:

> We saw several of a series of paintings he had been working on: among them there were variations on two women in an interior. One was nude, rather naturalistic and painted in blue. . . . Pablo said to Matisse, "It seems to me that in a composition like that the color can't be blue because the color that kind of drawing suggests is pink. In a more transposed drawing, perhaps, the local color of the nude could be blue, but here the drawing is still that of a pink nude." Matisse thought that this was quite true and said he would change it.[5]

That promise Matisse neglected to keep, and scores of his sky-dipped nudes survive in immortal blue. If Gilot's memory did not

fail, then his pledge to correct the "wrong" color is a devastating *re-vanche*. Picasso meanwhile astonishes us by choosing to talk Philistine. Obviously he no more meant what he said than did his antagonist. His admiration of Matisse's superior command of color is documented. It may be that the two rivals were exacerbating each other to the point where each operated below his own intelligence level. More likely, they were merely needling each other with make-believe incomprehension. In the end, perhaps, Picasso's objection was not to the impropriety of blue nudes; rather it vexed him to see Matisse exercising the kind of freedom which he liked to reserve as his own. And it is no surprise to find that Picasso's fifth version of the *Women of Algiers*—Canvas E (Fig. 83)—is built entirely around a nude of

83. Picasso, *The Women of Algiers, E,* January 16, 1955

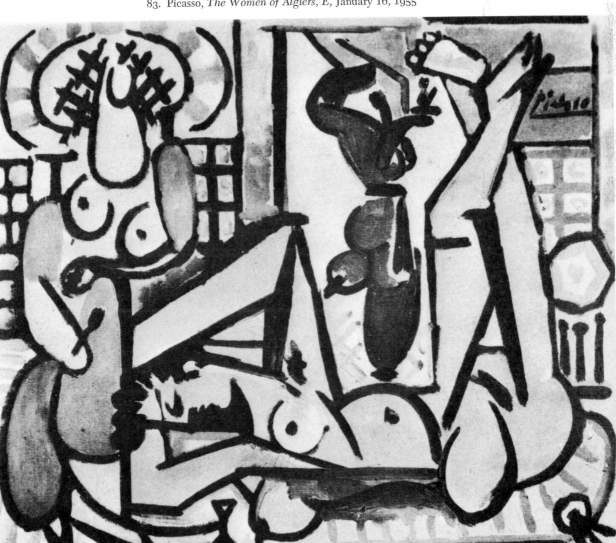

"pink shape" painted blue. It is as though the Matisse Odalisque of the previous version had induced the next association—and with it the reflex: if he could, so can I.

But that's frivolous. Matisse had died shortly before. "Oui, il est mort," said Picasso when a new resemblance to the dead master's motifs appeared in his work—"Il est mort, et moi, je continue son travail." Picasso was both paying homage and taking possession of an inheritance. He told Roland Penrose: "When Matisse died, he left me his Odalisques."[6]

Canvas E (January 16) returns to the simplified three-figure type. The blue nude moves across stage to become the main topic, converting the scene to Picasso's beloved vision of a sleeping woman watched by a woman awake. The mix becomes denser. Ingredients of his own iconography blend with those of Delacroix and Matisse and more to come. The Odalisque of the dark middle door gives way to a new impersonal presence—the brightness revealed by the Servant's drawn curtain. Is Velázquez being invoked? The background of *Las Meninas* (to which Picasso devoted a subsequent series of variations) centers similarly on the light of a distant door unveiled by a drawn curtain; and there a man halts on a flight of steps, glancing back, so that we see him survey from behind what we see from in front. His glance rounds out the scene; thanks to him our visual knowledge seems less confined to the perspective of aspects.

The likelihood of an allusion to the Velázquez motif is confirmed in the next canvas (January 17; Fig. 84). Here, as if again by immediate association, the far flashing doorway is suddenly filled with a flight of steps, much as in *Las Meninas*. No man is there; but the bright terraced opening unveiled in the distance renders the room accessible and potentially visible from the back. This potentiality is actualized whenever thereafter the Matisse Odalisque resumes her post here as witness. Her presence personifies the incoming light.

Canvas F, last of the small compositional studies, was followed by the sketch of a single figure, that of the Servant, to whom Picasso had been giving the most strenuous assignments throughout. The genetic origins of this figure are magnificently complex. Cézanne's *L'Après-midi à Naples*[7] offers so close a prototype that it seems almost to have dislodged the memory of the corresponding handmaid in Delacroix. Yet both are immediate sources, while the peculiar

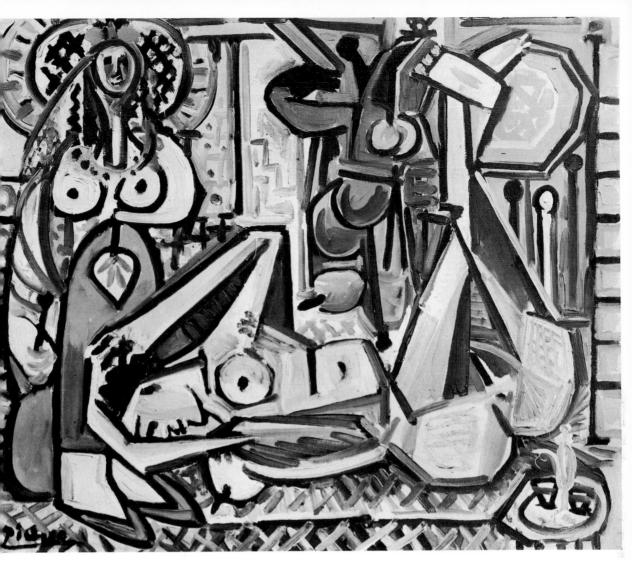

84. Picasso, *The Women of Algiers, F,* January 17, 1955

gyration of Picasso's figure betrays a kinship of greater antiquity.
His Servant remains throughout the exponent of motion. Assigned
to a hothouse of indolent waiting and sleep, she jumps, kicks up a
foot, pulls at a curtain, and propels tray and pot with such haste
that the rest of her barely keeps up. Nor is this all, for she must also
be twisting to counterpoint her direction. In Canvas A—and in B,
where she briefly takes pride of place—her eye and hand at the cur-
tain point backward, and though she runs to the right, the foot she
has on the ground advances the other way. Such ambivalence in a
running figure has ancient roots. It is a common manifestation of
Greek runners on Archaic reliefs—as though their creators had
sensed the absurdity of representing an action which, if continued,

137

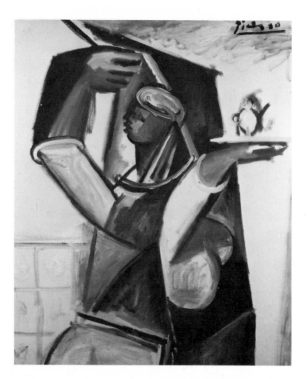

would empty the field. They preferred the absurdity of a running posture whose capacious, frame-filling motion maintains position and surrenders no ground.[8]

It is this capacity which Picasso expects of his Servant. In Canvases A and B he was scheming to dispatch her in opposing directions at equal speeds—an impossible venture, abandoned in the four following pictures. But Canvas G, the one with the Servant alone (Fig. 85; January 18, 1955), proclaims that he was not ready yet to give up. G is her heroic moment—a scurrying maid grown to a woman of valor, a monument. And her direction equivocates, since, turning to left, she appears to sprout breasts on her back. Picasso, however, is not thinking anatomy, but thinking motion, still hoping to make the body move two ways at once. In Canvas H (Fig. 86) his design is spelled out. The defeating irrationality of the task—all parts of the body to proceed either right or left on a straight axis— adjusts to a rational compromise. We learn that buttocks alone, properly squared in the picture plane, establish a stable backview, a position from which every other part of the body may diverge at ninety degrees. Here then we have an all-purpose servant, coming

and going, with changeable hands black and white, one that can move briskly off stage while sending a helpful arm, a profile, and one wagging foot back to stage center.

Hellenistic art had a type and a word for her kind of action—*Venus respiciens*, "she who looks back." In ancient art, as it was considered unmanly, so it was felt to be adorably feminine to cast backward glances. Picasso's servant girl is conceived in and from art. Her ancestry includes both the *Venus Callipyge* (Fig. 123) and Poussin's smiling nymph who dances the Bacchanalian round while pressing grape juice for the child at her back.[9] In the succeeding canvases, the Servant's motion remains forked and complex, though the radical solutions attempted in B and G were abandoned. What was retained was the dance.

H (Fig. 86), the eighth in the series, dated January 24, 1955, is the first of the big canvases and partly funny. The comic part is the

86. Picasso, *The Women of Algiers, H,* January 24, 1955

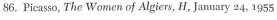

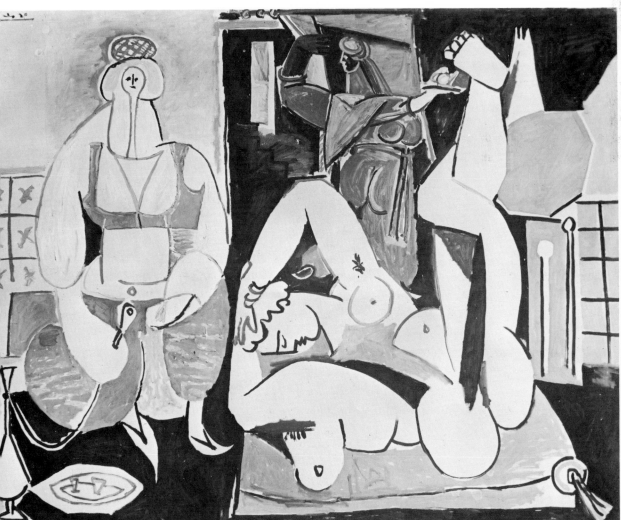

upper left portion where lady and latticed niche have been upstaging each other since the plot began. Introduced as solemn architecture in Canvas A, the niche (phallicized) sidles up to the Smoker in B, then expands (C) to absorb her head into its top. Thereafter, as its monumental pretensions decline, it hangs on as a halo, or at least a straw hat; finally (H to J), shrinks to a pompon. It is millinery versus architecture—and the former prevails. In the duel between figure and ground, the figure, as is appropriate for Picasso, wins out. The lady takes over and the artist, watching it happen, must have felt fairly amused. Since H is also the picture in which the Servant problem was solved, Picasso may be relaxing and celebrating. Hence the decorative application of color, the smoothed planes of cerulean, coral, and celadon which convert large tracts of the picture into peaceable ground.

Yet the main character, the woman asleep, is an ugly thing. Half her trunk separates as from a carcass, the rest is a carving, slashing, and twisting such as no flesh endures. The rendering of the figure is of the kind that has always encouraged Picasso's detractors, and not only those naive unwitting voodooists who imagine that the dismemberment of a human image is a cruelty wished on its original. Critics who regret the deformities in Picasso's late work are not necessarily wanting in esthetic sophistication. They include insiders—idealists, artists, and laymen—those who, disdainful of market values, remark that Picasso's vein of true genius dried up long ago—after *Guernica*, surely, if not before. Looking at Canvas H, they may fault it on formal grounds, and deplore the perversity of the drawing. Observe how these uncouth contours are laid on in clumsy, gratuitous gestures—Picasso's notorious impatience at its most infelicitous. When was it he last spent more than a day on a painting? Here, in the Sleeper's figure, having nothing to say—forgive me, I am trying to write like a New York art critic—he is marking time with anatomic and graphic clichés, hoping perhaps that their very crudity will offend; and these clichés cleverly disarrayed so as to make them harder to read, uningratiating and "difficult," as high art should be. Except that such pretentiousness is no cover-up for bad drawing; unquote.

It turns out, however, that the question is not whether good or bad, whether pretentious or otherwise, but whether it works. And that question—since an engine cannot be judged in ignorance of its function—is answerable only if one knows what the image sets out

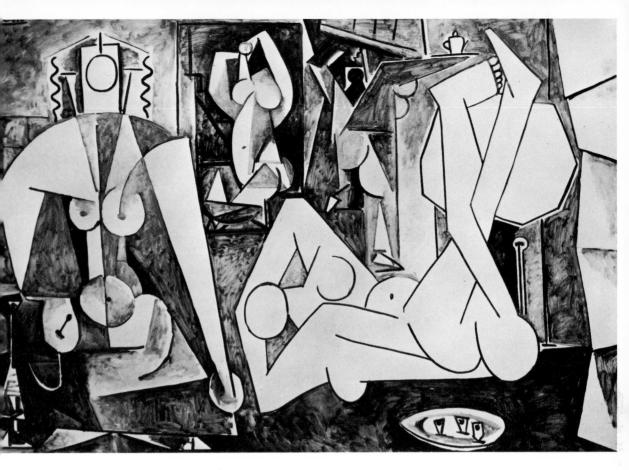

87. Picasso, *The Women of Algiers, M*, February 11, 1955

to do. An immediate reaction to Picasso's nude Sleeper, judging from given standards of plausibility, eloquence, animation, coherence, etc., is likely to be as wide of the mark as was Picasso's reported response to Matisse's blue nude. It ignores the objectives. To recognize Picasso's objectives for the recumbent figure it is best to contemplate their fulfillment in the masterpiece of the series—Canvas M (Fig. 87). Comparing the Sleeper in H and M, it becomes suddenly clear what it was that Picasso was after—what he had been trying to do from the start.

The problem was squarely representational—not new to Picasso, but one which, as he kept posing it, admitted only *ad hoc* solutions; a problem in rendering as marvelous as any feat of anatomic foreshortening seemed five hundred years ago. And it involved Picasso in one of his most private pursuits, where neither close observation, nor conventional skill, nor, strangely enough, the lessons of Cubism offered a guide. The problem was to pose the Sleeper

simultaneously prone and supine; put another way, to have her seen both front and back, yet—and this is where Cubist examples were no help whatsoever—without physical dismemberment, without separation of facets, but as a compact close-contoured body which denies itself neither as an object of vision nor as self-centered presence.

Not an absurdity but an observed fact: the Sleeper's torso in Canvas M has two left sides and no right. But how on earth is this done? The question is worth asking because the phenomenon to be analyzed may well be the last of its kind, the last attempt in post-Renaissance art to render a complex of experienced three-dimensional knowledge on a flat ground, the last time perhaps that the

7.

power of painting sought to define itself not in paring down to an essence, but in the enormity of its reach.

Repeat: the Sleeper in Canvas M shows only left sides—one reaching upward, and the same again folded over. Belly and upper breast represent her supine on her back, presumably seen from her right—arms overhead, blank head cradled in folded hands (recto). The underside represents a girl prone, seen from her left, showing the back of her head resting on folded hands (verso). The girl's neck in backview is correctly overlapped by the near shoulder, and the shoulder bends into spine; but as this bend nears the breast it jumps track to pick up a lower parallel, descending to right; the abandoned track meanwhile becoming front median. As for her long rigid base—one end of it, where it laps over a breast, defines the heart side; its other end, before going under, borders the lower back, but viewed once again from the right. How are these shifts engineered? Can such a straight edge as her lower contour be secretly turning like a rotating shaft?

The ambiguities in Canvas M depend on certain decisions which thereafter remain constant. In the head: reduction to a wide faceless circle that can double-function for front and back. At the neck: tapering contours to suggest the trapezius brought up from the back. From the shoulder down: a hooked line initiating a spinal groove, but with vicinities that convert it to a front axis—a trajectory passing so near the umbilical orbit can be nothing else.

The figure conflates two canonic positions of sleep—both antique types which recur in Picasso's work almost from the beginning (Fig. 88).[10] Sometimes they surface jointly, as in a drypoint etching from the Suite Vollard (Fig. 89), where lower and middle registers float two somnolent nudes, prone and supine in supercession. Their drift leaves it uncertain whether they are in fact two; they may be one woman in successive positions. And if so, the energy that divided them can also reverse itself to rejoin two motor phases in one agent body.

In 1950, four years before the Delacroix project, Picasso appropriated the theme of Courbet's *Young Women on the Banks of the Seine*.[11] In his metamorphosis, Courbet's reclining figures, respectively prone and supine, melt in a single organic melée. But there the synthetic idiom, proceeding from a prior atomization of form, allowed for a kaleidoscopic shake-up of small random units. Picasso's broken-down "Courbetiennes" could be blended almost by

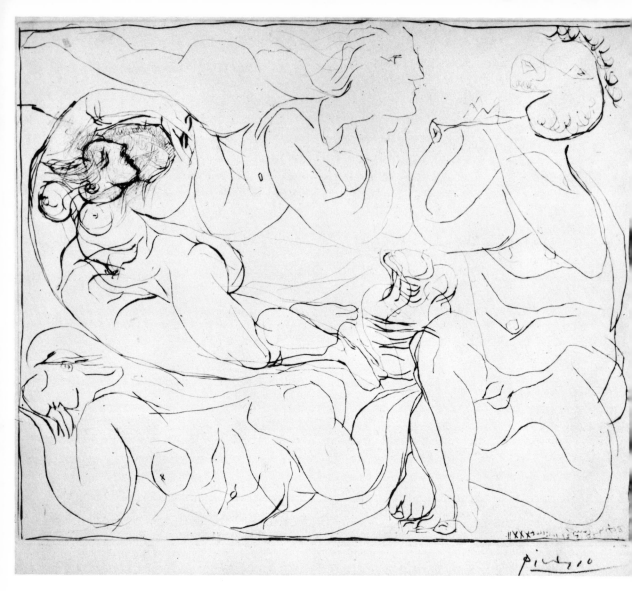

89. Picasso, *Three Nudes and a Satyr Playing the Flute*, July 21, 1932

improvisation. In his Algerian series, the ground rules posed this severer task: to compound large, recognizably divergent aspects in one convergent form.

A backward glance at Canvas A (Fig. 75) reveals how that task was first formulated. The Sleeper there was already compounded of disparate views, three-quarter front and three-quarter backviews sliding into each other. (Figures 90 and 91 demonstrate how these component aspects may be disengaged by deliberate masking.) But because these component aspects—like the foreshortened sides of a cube—are imaginable from viewpoints separated by less than 90 degrees on an arc, their simultaneity still suggests a single impacted

90. Picasso,
The Women of Algiers, A,
with overlay

91. Picasso,
The Women of Algiers, A,
with overlay

form. The torso embodies a slight motor contraction, presenting a solidified monolith detached from surrounding space. It was this monolith character engendered by the conflation of nearly contiguous aspects that Picasso rejected as he worked towards the more radical simultaneity of front and back, aspects separated by 180 degrees. In Canvas M the Sleeper's anatomy is compiled of exact opposites, and it admits only those decisions, those adjustments minutely hinged, which at every point sustain ambiguity.

Regarding the girl's upper body, most of the drawing expresses the prone position; while a fair portion, including head, neck, and arms, is kept precisely ambivalent. In fact, only two arcs—one breast and a belly—remain unambiguously supine. If, upon first acquaintance, the figure looks supine nevertheless, the effect is wholly due to the legs, which admit no other reading. Elevated and crossed, they can have been hoisted only by one flat on her back (cf. Fig. 81). They seem simple: two legs launched from a butt tilted into full view.

Yet the girl's lower body is enigmatic. You would think that her blatant exposure leaves no room for confusing such elementals as left and right. There should be no question but that the straight leg, shot from the right buttock and passing under, is the right leg—despite its gauche foot elevation which is clearly the left. But then the other limb, the articulate one folded over and fringed with adroitly diminishing toes, is a right leg again. Ascend once more from the outer buttock: somewhere in mid-course, a twice-jointed knee becomes a convertor zone, and by the time the kneebend is left behind the original setup of right and left is upset. Reading from the top down, you find the right buttock on the supine Sleeper's left side. Put another way—the straight leg is the right by virtue of its origin at the right buttock; but the adjoining buttock, since it launches a right foot, must be right again. One concludes that, as Picasso used two left breasts for one chest, so he now brings two right buttocks forward for one behind. A complementarity principle: distinct sets of observations—depending on whether you read from the top down or from the bottom up—yield contradictory descriptions of a single phenomenon.

Going back now to Canvas H, one understands the Sleeper's unlovely legs—one of them double-twined like dry rubber tubing. The right-left interchange was already being attempted, and indeed was continually attempted in D, F, H, I, J, and K. (See foldout follow-

92. Picasso,
dy for *The Three Women*,
1908

ing p. 234). And the "ugliness" of that whole figure in Canvas H—
so far from being a gratuitous deformation, either from carelessness
or for effect—results rather from a determination to incorporate the
simultaneity principle at all costs. Canvas M brings it off, and with
elegance. It recalls Picasso's comment to Françoise Gilot about one
of his etchings: "When he [the artist] succeeds in doing something
with one pure line, he's sure then that he's found something."[12]

There is no ready answer to the question why Picasso chose to
invent such games. The right-left exchange, for example—lending a
right foot to a left leg, or a right leg to the left side—is obviously no
joke for Picasso. He began to pursue it many years earlier with a
stubborn determination to make it work (cf. p. 219 below). And he
had first ventured it in the *Dryad* and in a study (Fig. 92) for the awe-
some so-called *Three Women*, both in the Hermitage, dated 1908.
One suspects a sexual connotation, for the notion that the right side is

male and the left female is almost a universal myth. It runs as strong in the human unconscious as in medical history and the symbolism of heraldry.[13] Picasso's interchange of dexter and sinister—reserved chiefly for shut-eyed female nudes sleeping—may be a fantasy of sexual fusion. But not necessarily. It is perhaps merely an outward sign of the inward disorientation attendant on a sleeper's withdrawal from actual space. Or again, is the sleeper's body crossed by memories of past motion? Or perhaps dreaming? Dream imagery, pursued by rapid eye motion, does not respect the fixities of anatomy and perspective. In all these alternatives, the anatomical perturbations point inward to the sleeper's condition of self-awareness.

Nor can one pin down the representational reference of Picasso's front/back simultaneities. What range of experience, visual or otherwise, is tapped in such figures as the Algerian Sleeper? That they represent the Sleeper's motion in contracted time is one possible reading—one in a constellation of possibilities. The disparate aspects then stand for duration perceived, referring to the views one rolling body presents at different moments. But they could as well represent antipodal points of vantage trained upon a body at rest. In some earlier Picasso nudes, such as those etched in Figure 89, the simultaneous showing of spine and belly suggests a convergence upon the figured form of sight, touch, and thought. The sidelong aspects are either pulled in by a wide-angle awareness or extended from a relaxed center out. The loosened contours lose hold of their substance because they have become enveloped in sight. One may think of an ambulating or periscopic curiosity, of a lens on a circular rail moving about its target; one's fixed point of view stretched into an arc. Or else the draughtsman's trace, trespassing beyond the strict contour, becomes a continuous caress, an unwillingness to let go. Or is it in the end merely the thought of the body's form that brings up all sides of it? One looks back to Picasso's early study sheets of female nudes, such as our Figure 88; again and again the obverse of a pose is paired with its reverse aspect: the compulsive juxtaposition means either-or. Later on, these mutually exclusive alternatives are forced back into that single body of information from which they fell. The Sleeper in Canvas M of the *Femmes d'Alger* is perhaps a diagrammed abbreviation of aspects to contain maximum density of information.

"*Rien n'est exclu*," as Picasso remarks when discussing the interpretation of his past works.[14] Nothing excluded—except poverty of

imagination. We will not be fobbed off by non-explanations that cite the sufficiency of pictorial form, the abstract requirements of arrangement and pattern, etc.—evasions which formalist criticism projects upon the mind of a genius at work. Picasso's anatomies of ambiguity are too well structured, too subtly pondered to allow such critical abdication.

The investment of his simultaneity images is unlimited. Proceeding from the perceived instability of sense data—from the experienced inrush of nature and art—they constitute a last outpost in Western art of the commitment to verisimilitude. Only the passion to transmute and transmit experience at a new level of richness accounts for the exacting precision of Picasso's ambiguous Sleepers.

In Canvas M, the rendering of that figure has become so apt and effortless that it belies the burden of the attempt. It accords with Picasso's oft-quoted remark—"I don't seek, I find." But such euphoric statements must be read against the more frequent kind: "One never stops seeking because one never finds anything." Or: "I never do a painting as a work of art. All of them are researches. I search constantly, and there is a logical sequence in all this research. It's an experiment in time." In the Algiers series, the stages antecedent to Canvas M, available for comparison step by step, trace the protracted search—the tries, the inventions, the ironies and repeated failures by which Picasso hacked and worked his way to a solution. The pictures document the consistency of his purpose from the day he began and the long struggle for spontaneity.

RETROSPECT

Canvas A: the Sleeper's torso already two-faced (Figs. 90 and 91) —a simultaneity of diverse three-quarter aspects in one palpable cluster.

Canvas B: the Sleeper reshuffled. One detail points the direction of thought. A wishbone shape near the bottom double-functions for front and back, sacrum and pubis. Reading from the belly down, it is the sex; from the buttocks up, the base of the spine.[15]

Canvas C: the problem more clearly stated. Foreparts and hinder parts surface together. Whether the pommelhead tossed down on her arms shows front or back nobody knows; nor whether the blatant orifice between the thighs refers to anterior or posterior position. The intended disorientation is already in hand, and if the

present form failed to survive, it was because it came as a raw em-branglement of female flesh which allows of no femininity, and no tenderness. Hence the fine-faced Sleeper flat on her back in Can-vas D.

On her back; yet most of her visible frontage features the back itself. She presents the very spine she would have to be lying on. Absolute visibility? Not effectively, since the elements tumble with-out effective cohesion; they resist integration. And the figure, though redeemed by the beauty of a profile and arm, remains jagged and brittle.

Canvas E: the blue Sleeper as dominant form is a further attempt to eroticize. Her curves somewhat smoother. The idea of two left breasts: half the chest is itself again upside down. Against her fixed profile and her give-away hands wisely hidden, the body rotates in full ambiguity. Gifted with hindsight, we now recognize the emer-gent principle of left sides successively prone and supine, but their

93. Picasso, *The Women of Algiers, I,* January 25, 1955

simultaneity is not yet eloquent. In Both E and F the Sleepers register as supine; their slim undersides—as if you could peel them off—have not substance enough to hold the contrasting aspects in balance. It would need a massive correction to make the prone/supine simultaneity work.

Canvas H: massive correction. The Sleeper's prone torso 'has grown abundant, large enough now to hold its own—but at the cost of coherence. The proportional gain sacrifices the body's integrity. Upper and lower breasts, the supine view and the prone, are separated by no-man's land, where the color is murky and a black wedge concedes the impossibility of the task. The parts sunder like a trunk split down the middle. Separated by 180 degrees, the contrasting aspects refuse to incorporate. This is what makes H the moment of crisis. The harsh drawing here is that of an artist trying too much, forcing the means of representation beyond the possible.

Canvases I and J (Figs. 93 and 94): both criticize the late dis-

94. Picasso, *The Women of Algiers, J,* January 26, 1955

95. Picasso, *The Women of Algiers, K,* February 6, 1955

membering of the Sleeper; they reintegrate, one emphasizing the
supine position, the other the prone. In the correction process, the
erotic appeal of the figure is lost. The Sleepers in I and J become
inflexible clods, and the artist decides that his objective is incom-
patible with the degree of naturalism on which he had been insisting.

Canvas K is important (Fig. 95): a radical idiomatic change to-
wards stylization, flattening, and dissolution of facets in the manner
of Synthetic Cubism. Descriptive contours separate in broken curves
—straight dashes long and short, like pick-up sticks on the surface.
The field reforms as a network or grille, flat in technique, transpar-
ently deep by implication. A determined effort to create a space at-
tuned to that principle of absolute visibility, which Picasso had pre-
viously embodied in the Sleeper alone. He now seeks to evoke a

space in which all appearance will seem co-determined by antipodal points of view. The women in Canvas K are ostensibly roomed in a compressed post-Cubist space. Yet the upstaged Odalisque—scaled down for distance, bosom clairvoyant, framed in the open door—is watchful enough to suggest that the forms placed before her possess an alternative aspect. And the Smoker, whose open pelvis flips around, head-on and tails, almost blocks the path of her vision, as though to offer equivalent revelations before and behind. In Canvas K it is only this tireless background watcher, the alert Matisse Odalisque, who retains a monolithic solidity. Meanwhile the besetting problem of the recumbent Sleeper in the right foreground is temporarily laid to rest. The specificity of the profile head is abandoned in favor of the blank token of Canvas C. Locked hands and armpits are quickly marked—tic-tac-toe. And the breasts are left out —proof absolute that Picasso has put her on ice; she is merely laid in, assigned to maintain her plot in the field while other problems are being attended.

In one sense, Canvas K, dated February 6, 1955, is a digression, for it defuses much of the sensuality of the Algerian women. The detachment lasted three days; Canvas L (Fig. 96; February 9) is a noble abstraction of the Smoker alone.

Two days later (February 11), Picasso produced Canvas M (Fig.

96. Picasso,
The Women of Algiers, L,
February 9, 1955

87)—a picture of renewed sensuality and austere formal beauty, its color held down in grays, nearly monochrome.[16] The Sleeper's figure, in its concentrated precision of line and interval, emerges as the easy solution to problems which every attempt for two months past had shown to be beyond reach. A woman's recumbent form as an interlace of inwoven aspects. Despite their perfect surface coherence, their consubstantiality with the flat plane, the symbolic complicity of these aspects engenders the form of a woman who possesses both front and back, as though the fullness of her were on display.

II WHAT ABOUT CUBISM?

"Cubist simultaneity of point of view" is a phrase so familiar, and in one sense so well founded, that it seems to cover whatever else in that line there was to invent. If Cubism had done it all in the teens

97. Picasso, *The Women of Algiers, N,* February 13, 1955 (see note 16)

of the century, why fuss about Picasso still doing it forty years later?

Cubism had not done it all. Its simultaneities—imagine a bottle in elevation poised against the plan of a tabletop—are of a special order. Their function is always disjunctive. Their purpose is not the integration of forms but, on the contrary, the fragmentation of solid structures for insertion in a relief-like space where no hint of reverse aspects survives.

Within the Cubist style, the ideas of corporeal integrity and aspect-simultaneity are antagonistic; designedly incompatible. The faceted objects that appear in the first Cubist phase (late 1908 to 1910) retain a good deal of density, but they suggest little interest in simultaneous point of view. And by the time that interest develops in Cubism's later phases, objects are drained of mass and the picture is flat.

The effect of Cubism on the imaging of familiar bodies was to unsolder their structure and scatter their parts. Cubism was still a transformation of remembered solids into a two-dimensional system. Its inheritance was the *theatrum mundi* spaced out with objects. Whereas two World Wars later, the flat Cubist space is taken for granted. It is where its creator has been at home for a generation. And the task he now sets his art is to renew the stereometry of the body without regressing to pre-Cubist illusionism, to restore sensuous presence to objects conceived and maintained in the flatlands of post-Cubist space. Simultaneity of aspects aiming at consolidation becomes a new structural mode.

Meanwhile, the notion that Cubism was a release from fixed viewpoint, intended to analyze objects from all sides at once, has blinded us to the goals and inventions of Picasso's post-Cubist years. Wherever in the nineteen thirties, or forties, or fifties, Picasso achieves an unheard-of visualization of simultaneity, the result is checked off as a "characteristic Cubist device," implying, sometimes unintentionally, that the old genius is living off his early investment.

If, therefore, the effects observed in the *Algerian Women* seem less than revolutionary in the telling, it is because just such effects have been wrongly claimed for Cubism from the beginning. And the failure of claims to stand up under examination has yet to shake a literary tradition established in large part by the artists themselves and their friends. It was they who laid down certain

tenets of orthodoxy for all who thereafter aligned themselves with the cause of modern art.

The visual evidence is overwhelmingly negative. Cubism never sought to confirm the structure of depicted objects, and claims of this sort made for "Analytical" Cubism by its first champions were plainly wrong. But as Meyer Schapiro remarked in his essay on Fromentin, "to perceive the aims of the art of one's own time and to judge them rightly is so unusual as to constitute an act of genius."[17] We do not fault people for lacking genius. And to observe in retrospect that the early champions of Cubism were misguided is no disparagement. Their defense of the new painting was not dispassionate but a historic bid for special status—as when Raphael, in the *School of Athens*, placed the exponents of what was then modern painting among the arts of precise measurement and at the furthest remove from the arts of inspiration.

The earliest supporters of Cubism—their writings are assembled in a luminous little book by Edward Fry[18]—searched for terms that would ennoble and justify the new art. Their achievement was to have respected it even though it resembled nothing that then looked respectable in the halls of good art. Hence the militancy of their criticism; hence their persistent attempts to refer the pictorial transformations of Cubism to such redoubtable values as objectivity, realism, science, analysis, and so forth.

"The art that must give the structure of things, . . . their structure, substructure and superstructure . . ." wrote Léon Werth of Picasso's new works in 1910.

In "the clever mixing of the successive and the simultaneous," wrote the Cubist painter Jean Metzinger in 1910, ". . . Picasso confesses himself a realist."

"What is Cubism?" asks Roger Allard. "First and foremost the conscious determination to re-establish in painting the knowledge of mass, volume and weight."

"The Cubists are . . . going to give back to painting its true aim, which is to reproduce, with asperity and with respect, objects as they are. . . ."—Jacques Rivière, 1912.

And Picasso's friend, the poet André Salmon: "Painting, from now on, was becoming a science, and not one of the less austere."

The new painting was said to have freed the representation of objects from the limitations inherent both in the single instant and

in the spectator's subjectively fixed point of view. An object appearing in a Cubist painting is "a synthesis situated in the passage of time" (Roger Allard, 1910). And again: "[The Cubists] move round the object, in order to give, under the control of intelligence, a concrete representation of it, made up of several successive aspects" (Metzinger, 1911).[19]

The whole Cubist enterprise was thus raised to the status of "scientific analysis." And "scientific" it seemed to the degree that it allegedly replaced the anthropocentric fixed-point perspective of academic art by a mode of representation independent of where someone happened to stand. The transcendence of human reference was after all the keynote of the progress of science. "The characteristic of the entire development of theoretical physics to date," said Max Planck in 1908, "is a unification of its system, achieved through a certain emancipation from anthropomorphic elements, especially from the specific sense impressions."[20] It was a noble impulse to want to see the new art marching in step with so emancipated a science.

But what need to repeat those early pleas half a century later? Indeed, given the visual evidence and the further course taken by Cubist painting, the early hypothesis about the analytical objectivity of Cubism was gradually dropped. It no longer appears in the writing of thoughtful observers.[21]

But familiar ideas about difficult things tend to hang on; they are economical, and sharing them becomes a kind of companionship. Thus we still hear pronouncements that Cubism was "a movement among painters toward the sculptor's three-dimensional problems"; or that its concern was "the solid tangible reality of things."[22] The Cubist painter André Lhote even argued the case in the form of a diagram, showing how the image of a drinking glass is conflated from various aspects to become Cubist (Fig. 98). But the date of Lhote's diagram is 1952, whereas authentic Cubist tableware resists all such demonstrations. And no human figures in Cubist pictures ever came near such a program. Had comprehensive all-sidedness been the operational principle of Cubism, we would have to conclude that the true Cubist nude appears only in such late inventions as Picasso's *Grand Nu de femme* (Fig. 99). Here indeed is a systematic conflation of a half dozen disparate aspects—its date,

98. André Lhote,
Cubist drinking glass, 1952

99. Picasso,
Grand Nu de femme, 1962

however, is not pre-World War I, but—like Lhote's diagram—post-World War II.

It is now apparent that Cubism sought neither a three-dimensional nor a "scientific" grasp of depicted form. Whatever objects or portions of objects remained recognizable during its "Analytical" phase (1909-12) were not faceted to demonstrate real structures, but the better to absorb their dismembered parts in the field. In the maturity of Cubism, human figures and implements, having crystallized into angular planes, began to break up; the facets disengaged, tipped and quivered in the thickening ground. The old hollowspace of narrative painting closed in. Pictorial space became a vibrating shallow of uncertain density, the equal footing of solid and void. The perceptual possessiveness which demands the illusion of solids was mocked. "In Cubist painting," writes Harold Rosenberg, "the object is grasped in tiny spurts of perception . . . a pile of clues submitted to an intuitive sense of order . . . it never reveals a 'tangible reality.' "[23]

Picasso's *Woman with Mandolin* (Fig. 100; 1910) is like an allegory of Cubist process. A woman is there—well centered within the frame, and seen head-on as in any Renaissance portrait. A few telling clues indicate that she is nude, and the instrument in her hands is no secret. But the space behind, smooth at the upper left, is subtly mystified. Stacked rectangles nest in each other and cascade down the left margin. Those near the top read as stretchers and picture frames—a recessional of other art, somewhat as in the background of Poussin's Louvre *Self-Portrait,* except that Picasso makes his hard Cubist quoins fade in a dappled mist. Multipled downward, they seem to fill out as prismatic solids, their substance visibly interchangeable with that of the nude. Incomplete as they are, and never concretely localized, these prisms are the exchange medium between segments of body and geometric right angles. All pictorial action, all rhythmic movement depends upon transience and convertibility—back and forth between the modeled rotundities of the nude and the flats of the "background." In this reciprocation, the depicted objects disintegrate beyond grasping, the disintegration accelerating in the "Analytical" Cubist works of the years following. The material elements of the painting become ever more palpable on the surface, the objects to which they allude ever more evanescent.

This withdrawal from tangibility is an essential feature of Cubist rendering. And the tendency is not reversed by such "simultaneities" as a circlet hovering at the brim of a bottle, or the minute glimpse of a short sidelong plane. A Cubist glass may erect its rim as a circle rather than as the ellipse actually seen; and a rocking dice cube may show more of its triple planes than is allowed in fixed-point perspective. But such details have no bearing on the "objective reality" status of Cubist objects, being subject to three conditions:

First—they are episodic, they lurk here and there, without sustaining the general program. The pictorial space and its fill remain squarely confronted from one position, like a relief.

Second: the few doubling facets that do occur belong to objects of the most predictable familiarity. Instead of specific shapes fetched from around top or corner, we get schematic tokens, so that the information delivered is invariably such as the viewer already has; everyone knows that the top of a tumbler is round. Similarly, a profile nose placed on a frontal mask does not advance objective knowledge if it suppresses the knowledge of its front aspect in favor of a schematic hook—André Salmon's "noses in the form of isosceles triangles."[24]

Third: the splaying-out of foreshortened facets, though derived from Cézanne, comes to serve a new purpose: not to fortify the masonry of interlocked forms, but on the contrary, to disassemble their thinkable parts, so that conceptual disjunction parallels the visual fragmentation of the whole field. In other words, in a Cubist picture the here and there of divergent aspects is not designed to consolidate body surfaces, but to impress the theme of discontinuity upon every level of consciousness. Never is a Cubist object apprehendable from several sides at once, never is the reverse aspect of it conceivable, and no object in a work of "Analytical" Cubism by Picasso or Braque appears as a summation of disparate views.

In the succeeding phase of Synthetic Cubism, the decade after 1913, the surfacing of averted facets becomes more frequent. But these facets, along with other object reminiscences and material scraps, are admitted as weightless fragments. A broken outline, a label, the shape of a shadow, two floated facets and a length of contour adrift—whatever is nameable can be sprung loose and moved on the board. Again, the process is not a study or symbolization of structures, but a pictorial dispersion of random parts. And it puts

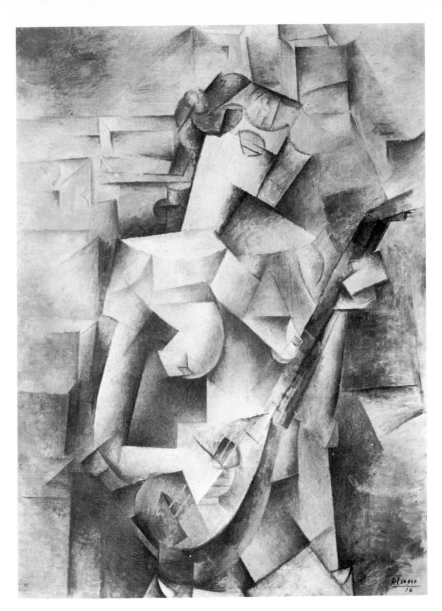

100. Picasso,
Woman with Mandolin, 1910

Cubism further than ever from that possessive vision which Picasso reclaims in the *Femmes d'Alger*.

But if the source of that vision is not in Cubist painting, is it perhaps to be found in Cubist theory? Picasso knew all along what was being argued and written. The early champions of Cubism were or became his friends, and no artist was ever more closely surrounded by master wordsmen.[25] If the critical claims for the representational powers of Cubism outstripped its performance, is it possible that Picasso subsequently sought to make up what his in-

terpreters had already argued on his behalf? Or that, stung by their championship, he determined at last to invent what had been already described? A retroactive validation of critical apologetics! Or a challenge accepted—"I, Pablo, can paint anything you can say!"

The answer is No, for the sources of Picasso's preoccupation with simultaneity lie deeper than talk, and deeper than Cubism, which they precede. It was rather during the Cubist phase that some of Picasso's inmost obsessions were temporarily rested—among them, the fantasy of an Argus-voyeur whose eyes see from a hundred points.

There is insanity in such a program, and resistance to it was bred in the bone of anyone who knew how to draw. Take a simple syntactic problem in rendering: you are line-drawing a human head in three-quarter: where does the ear go? Anxious life class beginners invariably put it too close to the eye—to diminish the uncertain pause between the familiar landmarks of eye and ear. Then they learn—as Picasso, to judge from his earliest surviving painting, had learned before he was eight—that this measured interval must be kept open at the proper span, since the whole architecture of the skull depends on it. The correct spacing of ear and eye is the feature which implies the intervening formations of zygomatic arch, orbit, and temple. And in any competent nineteenth-century draughtsman the feeling for the firm substrate of such blank intervals was second nature.

Now observe Picasso from 1907 onward, moving against these intervals till he has crushed them down. It is not a matter of distortion simply, which implies liberties taken with a canonic proportion. What Picasso does is more radical. By means of features loosed from their structural context, he achieves a wholesale obliteration of supporting structure. To stay with the example of ear and eye: in numerous three-quarter heads of Picasso's so-called Negro period, the enlarged ear inches closer and closer till it abuts the eye. Eye, ear, and forced adjacency are seen together. No more zygomatic arch, orbit, or temple; the ground is dissolved, the substructure dismantled (Figs. 101 and 102).

Similar surface pressures initiate a perpetual re-zoning of features—first in the face, which remains from beginning to end Picasso's chief battleground, then, with increasing assurance, through-

101. Picasso,
Head of a Man, 1907

102. Picasso,
Head of a Woman, 1907

out the body. More startling than the reshaping of the facial features themselves—huge animal eyes, the mouth an inferior orifice under an inert nose projected as rigid blade—more disturbing than the melancholy of these alterations is the way they overwhelm their terrain. It is as though they had swelled beyond continence. Eyes out of sockets hang on to the edge of the mask; the shadow that descends the side of a nose, meeting no change of plane to contain it, glides unchecked down to the jaw. The status of every anatomic transition is overruled, and it is characteristic that the neck, the very type of a link form, disappears. The mask simply settles down on the collar bones—as in Picasso's *Self-Portrait* of 1906 (Philadelphia) and, more emphatically, in numerous drawings and paintings of the two following years. The whole fabric of measured spans, slopes, and hollows which keep features in place is giving way.

Speaking teleologically, this obliteration of a given system of three-dimensional structural intervals accomplished in 1907 appears as the crucial act of Picasso's creative life. Most of his later inventions rest, not on the foundation he then laid, but on the freedom he then won for himself. Certainly his abrogation of pre-structured intervals in the human anatomy—an abrogation imposed exactly where these intervals seemed most inviolate—became the first precondition for whatever simultaneity effects were to follow. The same principle after all is at work when the shell of an ear, encountering no resistance, moves in on the nearest eye, or when—half a century later in Canvas A of the *Femmes d'Alger*—an entire three-quarter backview moves in on a woman's chest. It took half a century to extend the applicability of the principle from one sub-facial particle to an entire flank, but underlying both instances is the same resolution. For it was never a matter of contemplating a hidden feature in its normal position through a medium transparent to the mind's eye—like the design of a house in the thought of its architect; nor of wrenching a whole side into view around a solid corner. Picasso's sensuous vision acknowledges the materiality of the house and the fact that you cannot see its front, side, and back parts at the same time while the masonry stands. But if the connecting walls go and all material energy is discharged upon the articulating organs alone —why, then, nothing will bar the rear entrance from entering the same field of vision as the front porch. And the mobility of these features becomes the prerequisite of simultaneity.

All this in retrospect, following many harvests. Yet even at this remove, Picasso's activity during those pre-Cubist years impresses one with its reckless courage. When he made paintings and drawings such as Figure 101, he had not seen the as yet uncreated work which now enables us to applaud his early decisions. He was abandoning his professional skill, his understanding of three-dimensional structure, his long acquaintance with human beauty. Leaving all this behind for the absurdity of hanging an ear on an eye, where did he think such solecisms would take him?

I believe that Picasso's visionary emancipation of features from syntax helps to explain both his receptivity to Negro art and the fact (frustrating to art historians) that nothing Picasso made during those years looks like anything actually African. Had he followed a specific African model he would have been bartering one syntax for another; whereas the charter he drew from all African art—transpos-

ing sculptural stylizations into flat fields—was the principle of features wayward enough to be treated like movable signs. Between these signs, landmarks of face and body, the intervals would have to be constantly re-invented and justified by effective cohesion.

What determines the choice of those features which Picasso in 1907 retains from the wreck of classic anatomy? It is no accident that they are for the most part predictably obvious. They are clichés, pictographs in the mind, the closest things in the human image to common counters. It is as if Picasso's choices were governed by hierarchies of banality; his faces pared down to the features you knew the names of when you first learned to talk. Isn't the eye in the human face more banal than, say, the cut of its socket? And conversely, is there anything more unnamable and exotic than the pass from zygoma to gonion? It is these learned exoticisms which have to go. In the end, the materials of Picasso's gerrymandering are not heads as such, since these come with their proper structure of slopes and planes, but those remembered signs that stand for eye, mouth, oval perimeter, and so forth. Designing a face becomes a positioning of movable pieces.

And so in the nude. Within its outline—itself a commonplace and therefore preserved—the anatomical surface dissolves. What is left is not a topographic continuum, like a city plan, but a pilgrim's chart, designed for points of interest. The landmarks are bunched together at the expense of those nameless inter-relations which the popular image of the female nude neglects to conceptualize.

Like no artist of his generation, Picasso seized upon the expressive and structural power of the cliché. Where most nineteenth-century painting pretends that every female figure in art has been freshly observed for its every appearance, Picasso takes the image for what it is—a formula readymade, an art school routine, the commonplace of a million graffiti and the daily refill of libidinous thought balloons. As if he knew that the female body exists not only inside a woman's dress, but, like the alphabet or any known signal, inside everyman's head. The parts of it can be parsed grammatically, or vulgarized into *argot*. As Picasso finally draws them, the featured banalities of the nude—its double pomes, buttons, and clefts—are the common stock of erotic fantasy. And if their redisposition contradicts real appearances, their consonance with real feeling more than makes up. Picasso's nudes are mapped around their erogenous

zones. Just as his naked faces, with their perceptive organs crowded and amplified, seem over-exposed to experience.

The brutality and erotic charge of Picasso's works of 1907-8 accord with their formal power. And their symbolic energy flows from his total being. The works of this immediate pre-Cubist period testify to a vast deepening of his inspirational sources. They include the *Demoiselles d'Avignon* (Fig. 104) and the three great Leningrad pictures—the *Dryad,* the *Nude with Draperies,* and the *Three Women.*[26] The latter has been so called since Alice B. Toklas first saw it (and found it "frightening") in 1908. But are all three of them women? The differences between the two foreground figures suggest an inward struggle of incipient sexual differentiation. They look like a private creation myth.

Formalist criticism has tended to insulate the discussion of Cubism and its antecedents against the symbolic content of Picasso's imagination. Accordingly, the pictures of 1907-8 have been noted chiefly for their proto-Cubist reforms. But the work of those years created a reservoir which Cubism tapped without exhausting. The volcanic physical forces, the savagery, and the heated eroticism—all these energies which erupt again and again in Picasso's subsequent work—remained underground. So did the problem of simultaneity, broached in 1907, shelved for the Cubist interlude.

Make recto and verso cohabit in the same contoured shape . . . Impossible. Try to symbolize or insinuate corporeality through an intelligible coincidence of front and back. The idea first appears in Picasso's work as an elaborate pun. His earliest figure in two-way orientation is the *Standing Nude,* a drawing of 1907 (Fig. 103). The figure is rendered in line and each line sustains a conspiracy of double functions.

Will anyone bet on which aspect the lady is showing? Is it her front or her back with head turned to look over the shoulder? Faint traces in the zone of the pelvis may once have referred to the rump, but Picasso has let them fade out; their precise reference would have destroyed ambiguity. Waist, thorax, and singlebreast transmit no specific clue; nor does the cylindrical neck, or the flat falling arm. The head, of course, can be read both of two ways—either turned back over the shoulder or as a three-quarter front view. This leaves only the upraised hand which, as an open palm with ex-

103. Picasso,
Standing Nude, 1907

tended thumb, would stand unequivocally for the right hand of a
figure seen from the rear. And this is precisely why the thumb is
removed by one slashing curve continuous from elbow to index.
The rest of the hand is no problem. The cross-stroke at the roots of
the four fingers defines the back of the hand as readily as the palm.
Thus every anatomical portion ends up at the same ambivalence
level. The most exacting draughtsmanship serves a thoroughgoing
duplicity.

Inside its bounded planes the drawing is flat; it shuns the tradi-
tional indications of bulk, such as shading and overlap. But it recre-
ates the idea of "body," of something more than its silhouette,
through the cunning of sustained front/back ambiguity. Not a body
in the sense of spatial displacement, but the embodiment of a two-
way visibility, a form seen from both sides. The principle of visual
ambiguity in the interest of symbolic concretion is here laid down
for the first time.[27] And it is vastly significant for the history of twen-

tieth-century art that this figure was drawn on the back of a study sheet for the *Demoiselles d'Avignon*. It springs from the same mold of thought which produced one of the epic works of our time. And it compels us to look again at the *Demoiselles* and its preliminary studies (Figs. 104 and 105).[28]

The three earliest drawings (Z. II, 643, 19 and 20) showed a man entering the salon of a brothel. As Picasso remembered him more than thirty years later, he carried a (never recognizable) skull,

104. Picasso, *Les Demoiselles d'Avignon*, 1907

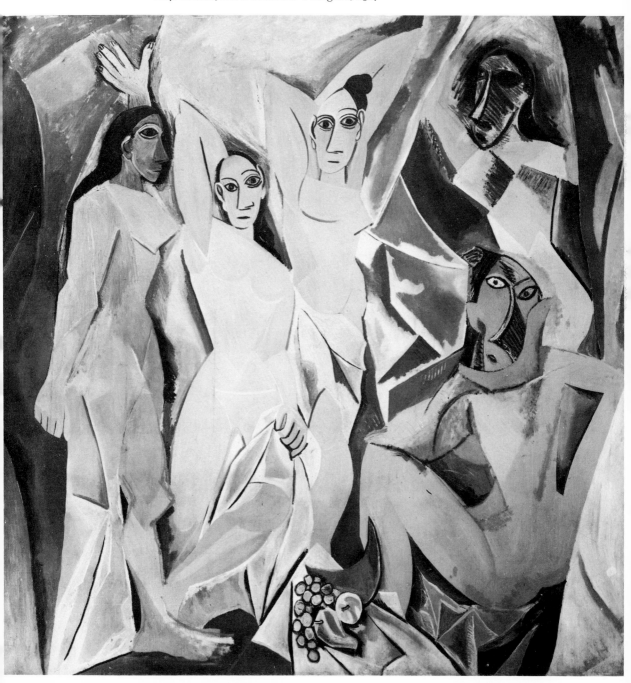

whence Alfred Barr concludes that the project began as "a kind of *memento mori.*"[29] The center showed a timid sailor, seated at a table with still life, surrounded by five disrobed prostitutes: one at his side, one squatting before, and three more in the background, the one in the upper right peering in through parted curtains.

As the studies evolved, the two male presences disappeared. "All implications of moralistic contrast between virtue (the man with skull) and vice (the man surrounded by food and women) have been eliminated in favor of a purely formal figure composition, which as it develops becomes more and more dehumanized and abstract. . . ." wrote Alfred Barr.[30] Picasso's close friend, André Salmon, had written similarly in 1912: "For the first time in Picasso's work the expression of the faces is neither tragic nor passionate. These are masks almost entirely freed from humanity. Yet these people are not gods, nor are they Titans or heroes; not even allegorical or symbolic figures. They are naked problems, white numbers on the blackboard."[31]

Can we be looking at the same canvas? A "purely formal figure composition"—"white numbers on a blackboard"—this picture which to us looks like a tidal wave of female aggression? Has the work changed . . . or has it changed us? André Salmon saw the *Demoiselles* driven so far towards abstraction that he could liken them to "white numbers on a blackboard." We, having seen real white numbers on a board by Jasper Johns, no longer accept his description. The more recent experience unflattens the work of 1907.

The older literature was so preoccupied with this giant step in the direction of Cubism that in discussing the picture's space only its innovating flatness was noted. But now that post-Cubist flatness in painting has been long assured, it is safe to observe what else is given. What exactly was flattened out? Two things above all, two quasi-baroque features which Picasso preserved through eighteen surviving sketches; a diagonal swing inward from left to right; and, at the bottom, the iceberg tip of a table whose main body must be presumed to continue beyond the frame. This last is an effect beloved by the Impressionists, and Picasso himself had used it in a painting of 1901 called *On the Upper Deck* (Chicago). Since, in this small canvas, most of the picture surface is taken up by the bow of the vessel seen from amidships, we, the spectators, are assumed to be fellow travelers on the same deck. It is exactly this fiction

105. Picasso,
Study for
Les Demoiselles d'Avignon,
1907

which, however attenuated, underlies the motif of the tipped table in the *Demoiselles*. Most of it is presumed to extend from the picture out to seat visiting clientèle—you and me. Indeed, one early sketch, which may well be a first thought for the picture, shows a group of men, half-length, at just such a table, watching the exhibition of two Demoiselles (Fig. 105). The final version then dollies in on the scene while retaining all the evidence of the stage.

The whole theatrical spectacle of the *Demoiselles* is exposed between proscenium flats. It begins at the left with a drawn curtain. And it converges on narrowly parted curtains at the upper right where the savage looks in. These are no minor features; at least the artist never thought them expendable. Between the early sketches and the final painting a lot was abandoned—the symbolism, the actuality of the setting conveyed by the middle table, two of the seven figures that made up the original team. What was never sur-

rendered was the space-ruling function of near and far curtains. The result, of course, is not the clear, layered depth of a Renaissance stage, but neither is the space flat or shallow. The spatial cues are given in contradiction, but they are given. They are both deployed and collapsed. And much of the violence of the picture is the conflict between crush and expansion maintained by its material and spatial sequences: a lifted still life at center and a white flat at the right; then a nude squatted down on an ottoman, followed by the sudden chill of blue draperies falling; and at last the figure upstage looking inward as from the mouth of a cave. No terms taken from other styles describe the disquiet of so much depth under stress. The surfacing spaces of Cubism are as irrelevant here as the perspectives of academic art. This is an interior space in compression —like the inside of pleated bellows—and the pressure is hitherward, towards the spectator, one arm's length from the proffered fruit. The whole picture is an oncoming space charged with heat and urgency by the massed human presence.

The compression of space is greatest along the right margin, precisely where the rearward extension is deepest. And it is here, in the lower right corner, that the wild Squatter becomes the focus of intensified realization. In the development of this figure through its progressive stages, one discovers how Picasso gradually worked a straightforward backview, pigtail and all, towards ambiguity. While the end result is flat as a paper cutout, Picasso convokes alternate visibilities, relying in part on the punning scheme of the *Standing Nude* (Fig. 103). In the final picture, an arm akimbo and one rising thigh fuse flat against a convenient curtain. Had these limbs been omitted, the rest of the figure might have been readable as a three-quarter backview with head jerked over the shoulder. But with these limbs retained, all three-quarter logic is thwarted. The figure becomes a full-splayed backview, in flat contradiction to the abrupt frontality of its head. And the violent wrench of her simultaneities more than makes up for abstraction and flattening. It gives her pink flesh an aggressive immediacy, brought nearer still by the shameless impudence of the pose and the proximity of an implicated observer who knows every side of her.

It must have become known very early that some sort of all-round vision was being tried. When Georges Braque early in 1908 produced his first artistic response to the *Demoiselles* in a pen drawing of three angular nudes, he explained: "To portray every physical

aspect of such a subject required three figures, much as the representation of a house requires a plan, an elevation and a section."[32] But against Picasso's chimera, Braque's rationalism seems naive, for Picasso had not been concerned with any expository succession. The Squatter in *Les Demoiselles* is reflective and restive, a never-averted, all-in-one apparition, a hard-staring backview regardless of a man's station.

More than any other element in the picture, the Squatter stares down three founding rules of Western art: the rule of idealization, which justifies picture-making as an ennobling pursuit; the rule of a viewpoint fixed at a measured optical distance; and the correlative requirement of psychic-detachment in the representation of nudes —tradition having made the kept distance mandatory for the posture of art. Renaissance figure painting would not have flourished in Christendom as it did had the sex appeal of the painted nude been confessed. The justification of art depended on the profession of erotic disinterest, on the distinction between engaged prurience and the contemplation of formal beauty whereby the erotic will to possess was assumed into admiration.

It was into this noble tradition that Picasso entered his *Demoiselles*. It remains an uncanny event, the moment of art's devenustation—a fateful word derived from Venus, whence the Latin *venustas*, beauty, whence *venustare*, to make beautiful, whence its obsolete English opposite, "to devenustate."

For the role Picasso assigns to simultaneity it is significant that its first major trial comes in a context of provocative sensuality, and in a pictorial space whose blatant abstraction imposes itself on a near-baroque concatenation of spaces, complete with baroque devices for the spatial involvement of the observer. The observer's presence, any man's presence, is understood without any man being painted in. Everybody can see that the ladies are having company. And even at our distance of sixty-odd years, the immediacy of the revelation appals. Curtains are pulled away on a catastrophic regression, parlor reverting to jungle and one flat brazen strumpet of simultaneous aspects regarding her clientèle. In their absolute presence Picasso's ominous whores stage a terrifying desublimation of art. The picture breaks the triple spell of tradition—idealization, emotional distance, and fixed-focus perspective—the tradition of high-craft illusionism which conducts the spectator-voyeur unobserved to his privileged seat.

106. Picasso, *The Sculptor*, August 4, 1931

107. Gonzales Cocx, *The Sense of Sight*, ca. 1650

III DRAWING AS IF TO POSSESS[33]

In a drawing of 1931 in the Seattle Museum, Picasso presents a bearded sculptor at work on a statuette. I compare it with a small painting of a similar subject by the seventeenth-century Fleming Gonzales Cocx (Figs. 106 and 107). In the earlier picture, the artist's gaze and his delicate operation converge upon one patch of surface—one patch at a time. In Picasso's drawing, the sculptor's wide angle vision circles the figure, and the statue turns at the touch of his hand; hence its double exposure, the lineaments of a near-frontal anatomy imprinted on a three-quarter backview. We are assured that the figure is understood in the round.

Shortly thereafter, Picasso launched a series of erotic drawings and prints—again the female body fully possessed (Fig. 108).[34] But whereas, in the statuette, possession by understanding was symbolized in the overlay of a distinct other aspect, no distinctness is allowed in the "Embrace." The possessed woman, downed and en-

gulfed, clings too close for seeing. Blind grappling overwhelms every aspect so that the viewer, rather than receiving multiplied visual data, experiences some of the visual disorientation which attends carnal knowledge.[35] The differences between the subjects of artist and ravisher are plain enough. In Picasso's aspiration of total envelopment, they are opposites. But they share their reference to a single compulsion. Both reach for that knowing intimacy which Picasso's iconography confounds in a twofold expression of creation and love.[36]

But the will to possess the full knowledge of what is depicted, this refusal to be confined to an aspect, is not Picasso's alone. It pervades Western art, fed by multiple impulses, to all of which Picasso responds. The impulse may be sensual, springing from dreams of erotic fulfilment; or cognitive, an intellectual passion for complete information—like wanting a picture of the backface of the moon; or

108. Picasso,
The Embrace, 1933

109. Ivory bead from a rosary, French or Flemish, *ca.* 1500 110. Ivory bead from a rosary, French or Flemish, *ca.* 1500

moralistic, derived from the preacher's warning to remain unde-ceived by the fair face of the world.

In the late Middle Ages the moralistic impulse gave rise to such images as the "Prince of the World" on the facade of Strasbourg Cathedral. The figure stands at the inner jamb of the southwestern portal—a fat-witted fop warmed by the smiles of Five Foolish Virgins; what they don't see is the open back of his garment and his arse and spine crawling with toads.

Or: a late fifteenth-century ivory carving in the Boston Museum—a pendant detached from its rosary (Figs. 109 and 110). The obverse of this macabre contrivance represents a young couple embraced, but being worked in the round and designed for handling, you could not finger the lovers without feeling the carved Death behind.[37] Taking the bridal pair at face value you would miss their love's future tense and God's plan for the whole—which is why the Museum installs the object against a small mirror. Scaled to a lady's hand, it was designed to transmit that surpassing knowledge which is not stayed by the facade of romantic love.[38]

176

Such rhetoric seems at first sight remote from Picasso's mentality. Yet a personal version even of this allegorical mode does appear in his work. The theme may be that of death ingrown with life (as in some woman-skull images of 1940, Fig. 111), or, more often, of an animal nature impaled with the human, both natures faceting a single core.[39] These images of the 1940's are one more manifestation of Picasso's lifelong obsession with the problem of all-sided present-ment—an obsession so keen that, whatever means Western art may have found to display front and back simultaneously, Picasso appro-priates all those which he came too late to invent.

Four such means developed within the Renaissance system of focused perspective. They are: front and back in succession; the averted back revealed to a mirror; the same shown to a responsive watcher upstage; and the *figura serpentinata*. Evolved within the canons of naturalism, they are techniques of harmonizing an ideal of omnispection with the logic of a fixed point of view.

ABOUT-FACE IN SEQUENCE

"Because the *Danae,* previously sent to Your Majesty, had appeared entirely from the front, I wished [in the present *Venus and Adonis*] to show the opposite side [*la contraria parte*], to the end that the chamber where [these pictures] will hang, may become more de-lightful to see [*riesca più grazioso alla vista*]." Thus Titian to his client Philip II of Spain in a letter of 1554.[40] He adds that an *An-dromeda* currently under contract "will display yet another view." Titian was doing more than pandering to the salacious taste of his patron. As his theme was the female nude, he would render it from all sides and, with a painter's pride, yield nothing to the superiority claims advanced by the sculptors. Like any Renaissance artist he would have known Pliny's notorious account of Praxiteles' Cnidian Venus, placed in a shrine with entrances fore and aft.[41] And, like Giorgione before him (assuming that Vasari's tale may be be-lieved[42]), Titian was silencing the sculptor's taunt that painting, being one-sided, was the weaker of the two arts. In even more overt rivalry with the pretensions of sculpture, another mid-sixteenth-century painter, Daniele da Volterra, painted a *David and Goliath* on panel (Louvre)—then, on the reverse of the panel, the same group again seen from the rear.[43]

But these situations were special. The normal procedure for co-

111.

112. Picasso,
La Lola, 1905

exhibiting frontal and dorsal aspects of otherwise similar figures was juxtaposition within the same field. The idea was rooted in antique compositional principles, observable from late Archaic reliefs to such Hellenistic baroque groups as the *Farnese Bull*. And if Renaissance masters thought the device too predictable, they knew how to disguise it, the game being to maintain hidden identities in variation.

113. Master P. M.,
The Women's Bath

In Pollaiuolo's *Martyrdom of St. Sebastian* (London), the foreground archers are inversions of one another: as one loads a crossbow, his comrade nearby is only himself again seen from behind. And Pollaiuolo surely did not mean their identity to pass unobserved. Examples of such procedure abound at every level of sophistication. The adjoined verso is the common means of conveying, or holding on to, full information about three-dimensional objects. You find it in modern coin catalogues and documentary photographs (e.g. Figs. 109-110), and you find it again and again among Picasso's early study sheets of female nudes. At first glance the deliberate expository arrangement of his "La Lola," for instance (Fig. 112), looks like the Master P. M.'s engraving, *The Women's Bath* (Fig. 113); the same sequence in both of front, back, and side, plus one figure in flexion. Yet they are worlds apart. One sees at once how the abstraction of Picasso's line prevents his successive images from dispersing. The fifteenth-century German engraver models each insulate aspect in order to know. Picasso, knowing each aspect, wants to have them in simultaneity. He will, if necessary, spend the next fifty years learning how.

The paradigm of the sequential mode is the Three Graces—a cool, deliberate exposition of anterior and posterior aspects (Fig. 114).[44] Endlessly copied in Roman times, the group was enthusiastically revived in the Renaissance and remained a staple of official art. It comes as a surprise to discover that this late Hellenistic invention survives into the twentieth century as no other antique has been able to do. The Three Graces inspire Gauguin, Matisse, Delaunay, Maillol, and Braque. And they are a constant in Picasso's own *œuvre*

114. Antonio Federighi,
The Three Graces

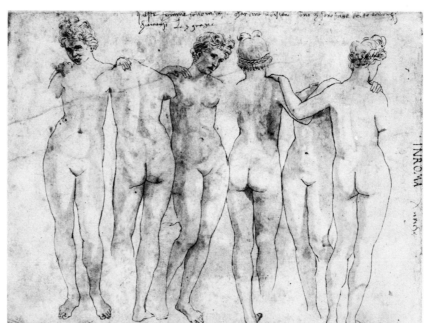

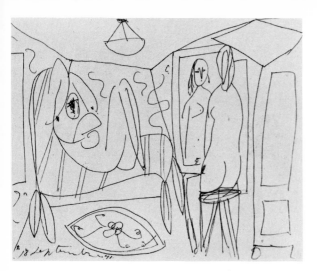
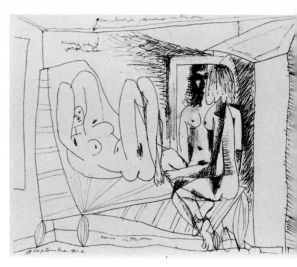

115. Picasso, *Nudes in an Interior*, September 18, 1941 116. Picasso, *Nudes in an Interior*, September 18, 1941

where, from 1905 onward,[45] they reappear in almost every period. It was their two-dimensional about-face routine which allowed the Three Graces to survive the flattening of twentieth-century art.

THE REFLECTED REVERSE

A fifteenth-century account of a lost Jan van Eyck picture describes women bathing, ". . . the reverse of their bodies being visible in a mirror, so that their backs as well as their breasts could be seen."[46]

This is one mode of simultaneity which Picasso disdains. Not that he avoids mirrors as such—only their prosaic fidelity. As in allegories and fairy tales, Picasso's mirrors are oracular instruments; they transmute and surprise and tell secrets. His catoptrics are magical. The plain mirror's capacity to throw back the dependable image of an alternate aspect—though it delighted van Eyck, Titian, Ingres, Lautrec, and Matisse—leaves Picasso unmoved.[47]

During 1940–41 he made drawings involving multiple mirror reflections; of these more will be said below. Before that late date, he had used mirroring only once—during a three-day spell which produced two famous paintings. On March 12, 1932, he painted *The Mirror*—a girl asleep, her posterior assigned to the looking glass (Gustav Stern Foundation, U.S.A.). Two days later came the *Girl Before Mirror* (Museum of Modern Art, New York), this time turned face-to-face. Both pictures remain unique; instances of those rare motifs which Picasso abandoned.

But their rejection confirms the seriousness with which he regards

Picasso, *Nudes in an Interior,* September 19, 1941

simultaneity as a way of consolidating the body. A mirror reflection, after all, is always elsewhere. Its identity with the thing mirrored is not grasped by intuition, but inferred from relational clues. Whether addorsed or confronted, a girl's mirror image widens the gap between her knowable aspects. Object and image repel one another. Even if carefully hyphened by means of proximity and obvious likeness, they do not cohere. They want to diverge from each other like one's own two hands back to back.

Picasso seems to regard this as a fault that requires correction. In a series of drawings dated September 18-19, 1941, he includes a nude seated at a three-quarter-length mirror. And the progress of the series (Figs. 115-117) plots a gradual *rapprochement,* until the woman and her reflection have coalesced, the two facing aspects at once simultaneous and indivisible. Compare such pictures as Bedoli's *Portrait of a Girl* (Parma), Velázquez' *Venus* (London), Ingres's *Comtesse d'Aussonville* (Frick, New York), or Matisse's numerous paintings and drawings with posed models reflected: the effect is a dispersion of aspects rather than palpable continuity; the form is fielded but not embraced. And though the volume of information delivered is doubled, the cost in sensuality is, for Picasso, the wrong price to pay.

IMPLIED REARWARD ASPECT

Delacroix's *Journal* for September 14, 1854, describes hearing mass in the Church of St. Jacques at Dieppe. After a brief account of the ceremony, which ends with the Kiss of Peace, he concludes: "On

ferait un joli tableau de ce dernier moment, pris de derrière l'autel."[48] Delacroix—like the heir of Baroque art he aspires to be—sees in depth and imagines his physical vision rebounding from its own vanishing point, so as to visualize the scene in reverse.

The pictorial stage of Renaissance and Baroque art makes frequent appeal to a character whose function it is to personify such rebounding vision. You find him in the recesses of depicted space, focusing on the inturned aspect of some powerful foreground form of which we are not shown enough. The recessed watcher, a painted figment, becomes our functioning double. In collaboration with our own seeing, he rounds out the protagonist form in its fullness.

In the most moving early examples of such functional vision, the watched protagonist is a Christ whom we only see from the back—as in Mantegna's *Descent into Limbo;* or in H. S. Beham's engraving of the Man of Sorrows appearing to Mary (B. 9, s.v. Altdorfer), where the dramatic action gathers in one searching gaze aimed at what we cannot see. Later, in the hands of the Baroque masters, such dramatized lines of sight are stretched to the full depth of the scene. In Rembrandt's *Denial of St. Peter* (Amsterdam) the group about the Apostle is staged near the picture plane; as Peter puts off the questioning maid, Christ, placed deep in space, turns his head looking, so that Peter's lapse is observed, as it had been foreseen, *de profundis.*

Or else the foreground motif is a canvas in progress—as in Rembrandt's *Painter Before His Easel* (Boston), and in Velázquez' *Las Meninas.* In both pictures, our attention turns on the glance of the painter; behind the reverse of the canvas, we see its obverse observed.

And even this pure baroque mode of suggestion Picasso retains. In some pre-Cubist works, and again in the 1930's, he had allowed eye witnesses in the remote or middle distance to function dramatically—though with no intent to promote a stereometric illusion.[49] But just this is unmistakably the effect of the couped head on the horizon in *Girls with a Toy Boat,* 1937 (Fig. 118). The two huge little heroines in the foreground, remarkable for developed feminine charm and wholly preoccupied with their toy, are spied upon from afar. Someone in earnest is eyeing them, an immense rock with a face in it, yet clearly one of their kind and, I think, masculine. Who else looks so avid watching from across the divide? He studies the seaward aspect of what we watch from the shore. The all-sidedness

118. Picasso, *Girls with a Toy Boat*, February 12, 1937

of the foreground figures depends not on their modeled openwork fabric alone, but almost as much on the inquisitive rover peering from beyond the high sea.[50]

SERPENTINATION

In a note to Vasari acknowledging the gift of a drawing, Aretino (1540) praises a certain nude which, "bending down to the ground, shows both the back and the front."[51] He was describing a figure of hairpin design, a variant of the *figura serpentinata*. Its elastic anatomy serves Mannerist art for the simultaneous display of front and back without recourse to repetition, external props, or the aid of witnesses. It incorporates both views at once on a jack-knifing spine lengthened only by one or two extra vertebrae. In sixteenth-century pictures, such jack-knife figures tend to approach on the run, like homing engines, then double over so fast that their backs show before one can miss their diminished frontality. Indeed, in the best

183

119. Paolo Farinati,
Perseus and Andromeda

120. Jan van Hemessen,
Judith, ca. 1560

. Picasso, Study of a nude, 1939-40

122. Picasso, Study of a nude, 1939-40

jack-knifing figures, the torso swerves aside as it folds over so as to leave the most possible frontage in view.[52]

Thematically, such Mannerist figures draw their justification from the narrative context. It needs a catastrophe to discharge the requisite speed and the conflicting emotions—fear and solicitude, curiosity and panic flight, and so forth. Hence the splendid complexity of rotation in a figure such as Paolo Farinati's *Andromeda* (Fig. 119).

The more common variety of serpentination, which requires no strenuous pretext, is the standing or lying figure rotating on its main axis. Its motivation is sensual; it suggests well-being, self-admiration, or erotic enticement. You would not believe the amount of enticing frontage which a Mannerist backview can show. As in Jan van Hemessen's *Judith*, for instance (Fig. 120)—and in Picassos galore (Figs. 121 and 122). The understanding of this motif in our culture is immediate and universal. Pin-up models posing for calendar art tend to

185

123. Picasso, *La Puce*, 1942; *Venus Callipyge*

work up a *figura serpentinata*, and their photographer, if he has a sense of his craft, knows just how much expository rotation is wanted to meet the terms of an "eyeful."

Picasso's draughtsmanship, which habitually wrings women's bodies to ensure that all breasts and buttocks show, impounds every known form of serpentination from the stores of the past.[53] The *Bathers* (Fogg, Cambridge, Mass.), a drawing of 1918 famous for its classical reminiscences, exhibits both Mannerist types—one woman atwist on a spiral waist, and a jack-knife figure capping the composition. Sometimes the source is mocked, as in the aquatint entitled *La Puce* (Bloch 359). Dated 1942, it was produced for the Vollard edition of Buffon's *Natural History* to illustrate "The Flea." For reasons unstated but not far to seek, the etching was excluded from the published edition. It is of course based on the Late Hellenistic *Aphrodite Callipyge*—the "Venus of the handsome behind" who turns about to acknowledge her other aspect (Fig. 123). I know that Picasso's conception seems trifling; but the frivolous virtuosity of his adaptation is that of a passionate, possessive eye. Since the statue's pose, seen from the normal front view, amounts to a promise —the promise, that is, of its implied rearward aspect—Picasso synchronizes promise and actuality by flipping half of the torso around, and makes it work without seeming discontinuity.

Frivolous subject matter is no serious deterrent to work. Picasso made a beautiful line drawing on December 6, 1953, a drawing which visualizes an imposing measure of three-dimensionality, in spatial depth as well as volumetric displacement (Fig. 124). The

subject is a roundelay of six frisky nudes holding hands. It is a bravura performance, like a Chinese brush painting—thinking and ceaseless practice precede, and no fumbling thereafter. The success is especially remarkable at the two ends, where the projecting of a round dance poses its greatest challenge: how to sustain the continuity of the circular motion through the foreshortened depths of the turns. Picasso meets the challenge with two brilliant solutions. At the left the dancers are stacked three deep, showing—like his many Three Graces—front, side and back in succession; at the right, one frolicking nude alone incorporates all phases in one. I suggest tilting the drawing ninety degrees to appreciate the cunning of her serpentination. But serpentination here is mere pretense. Such gyrations as hers, or as those of the girl with the flea, entail a disjunctive manoeuver far beyond anatomical elasticity. And this principle of disjunction situates Picasso's figures outside the strained limits of Mannerism in a world of his own.

For most of Picasso's twisting anatomies serpentination is in fact a misnomer. The apparent versations of his serpentine poses are not athletically self-induced, but rather the pretext for his own impulsive visualization of three-dimensional form. Picasso's line traps a hidden dimension—like a horizon, at every point of which the mind can zoom in. He draws like the style on a kymograph. While his stylus pretends to pan along the straight edge of a cylinder, his imagination makes that cylinder turn like a spit, so that even a seeming straight

124. Picasso,
La Ronde,
December 6, 1953

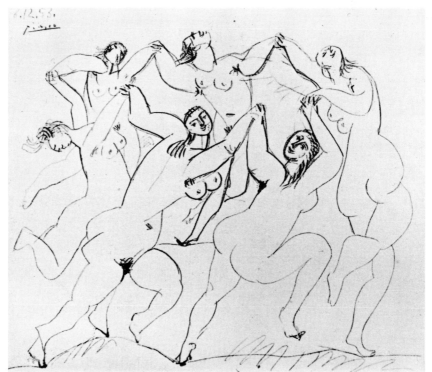

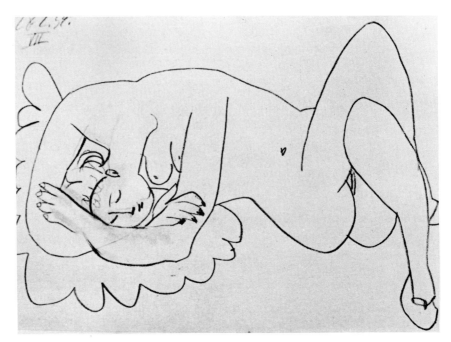

125. Picasso,
Nude Girl Asleep,
February 28, 1954 (VII)

126. Picasso,
Nessus and Dejaneira, 1920

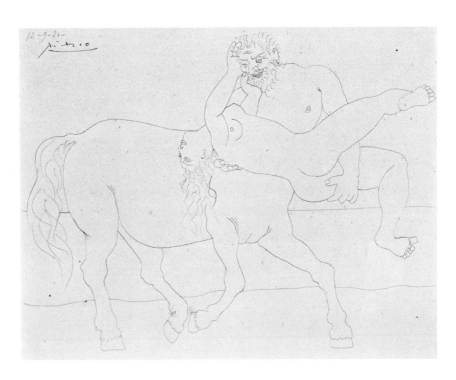

line ends up as a history of spiral motion. And the apparent agility of his gyrating figures resembles that drum rotation; it is part gesture, but in complicity with his own zooming eye. When he traces the innocent flank of a body, he seems not to be thinking a margin but a continuous hither and thither. A meander of three-dimensional reference collapses into a one-dimensional line.

Is it not astonishing that the figure of the *Nude Girl Asleep* (Fig. 125; 1954) can register as a front view even though no less than one third of her back shows at the top, and another third at the bottom? The power behind the conception (and the laborious fieldwork still visible in the studies[54]) is belied by the winsomeness of the subject. Yet the internal strain and the body's verve disguised as sweet rest are of a Michelangelesque quality of imagination. And a half-century of Picasso's art supports that upper contour which rides in such smooth ambiguity from nape to hip.

The principle was well in hand by 1920. Already then a bland contour that seems merely to sail at the edge of a volume could engender that volume as a revolving form. In the *Nessus and Dejaneira* drawing (Fig. 126), the linear trace of the bride's torso from breast to groin is rendered as if on a turning shaft; it describes a hithering transverse, and the rotation enclosed can no longer be rationalized as a posture of serpentination. The writhing of a nymph in distress merely cooperates with a linear symbol which foreshortens the receding plane.

But Picasso's impulse to possess the delineated form in a simultaneity of all aspects runs even deeper. Its earliest monumental expression takes us back once again to the pre-Cubist moment. A new bid for symbolic solidity is made in the large *Bather* of 1908 (Fig. 127)—a standing nude on which some of Picasso's most famous distortions appear for the first time. Carefully synthesized and conscientiously transferred from its preparatory drawing (Z. II, 110), the painted figure shows both pubis and rump, and a good deal more backbone than a frontal perspective allows. The splay-out principle, by which Cézanne had bonded inanimate objects into the painted field, is applied—at the cost of devenustation—to the female anatomy, and with a contrary purpose: to confirm a known fulness of body by wrenching its averted sides into view.

Unlike the four modes of simultaneity which respect the fixed viewpoint, the implication of Picasso's *Bather* is a vision cut loose. Here emerge those effects which encourage talk of circumspicuous

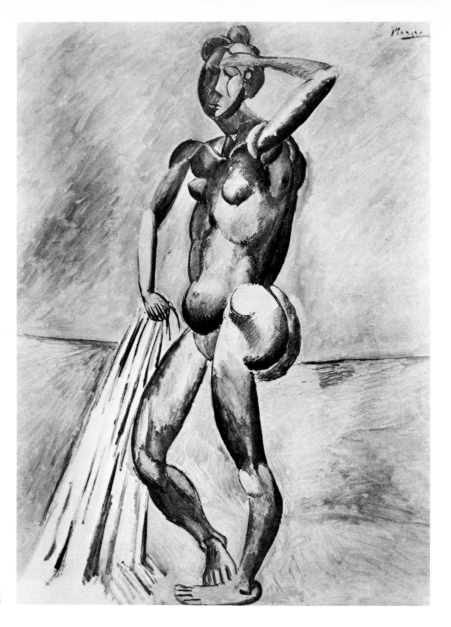

127. Picasso,
The Bather, 1908

or circumambient sight, of visual rays bent around corners, etc. The
early literature of Cubism gave currency to the notion that Picasso
paints a figure as though he had toured it to collect impressions of its
various aspects. But such descriptions tend to be overly rationalistic;
who has not had the experience—especially with Picasso's Cubism—
of seeing the work confound its interpreters? The liberties Picasso
takes in the *Bather*'s figure by transgressing its contours seem simple,
but every explanation is doomed that remains unilateral. I have sug-
gested (p. 148) that any one explanation must take its place in a con-
stellation of possibilities. In the *Bather,* for instance, the excess

visibility at spine and buttocks may record the artist's bent vision; it may equally well stand for the object itself revolving, as though the Bather's torso had ceded its boundaries to the directions of motion. The thought of the body turned, or of the body signalling its capability for such turning, is as rational an explanation as the restlessness of an ambulant viewer. And then again, is not touch involved—the pencil as delegate of the exploring hand? And beyond all these mythologies lies a simpler hypothesis, that we are dealing merely with a diagrammatic symbolization of volume, a graphic device for maximum density of information. Ambiguous simultaneity is part of Picasso's essential approach to the rendering of the external world.

In the *Bather*, where the overspill from the optical silhouette makes its first dramatic appearance, any single description remains superficial if it ignores the figure's physical action, and the impacted solidity which it achieves. The far side of the Bather's face, her pronated right arm and twisted right leg—not obviously pigeon-toed but in-turned—all promote one massed involution, so that the aspect of the body's entire right side grinds inward upon the fixed left. Once again, the suggestion of aspects interlocking and fused is generated by the figure's gestural energy in complicity with the artist's eye.

It is essential to Picasso's multi-aspected vision that the object he draws meet his encompassing vision halfway. His marvelous evocation of gesture interlocks with the process of circumspection. Picasso's subjects always cooperate. The gestures he invents abet the grasp of his sight, as when, thirty-three years after the *Bather*, he draws a cross-legged nude seated, with buttocks showing and both knees seen from the front (Z. XI, 332); and the very action of the crossed legs, the energy of their involution, seems to induce the corresponding overlap of antipodal aspects. The image is a symbiosis of world and vision, an emphatic visualization of substantial form.

Surveying Picasso's lifelong commitment to the theme of woman as solid reality—a commitment relaxed only during the Cubist episode—one arrives at a disturbing conclusion. That Picasso, the great flattener of twentieth-century painting, has had to cope in himself with the most uncompromising three-dimensional imagination that ever possessed a great painter. And that he flattened the language of painting in the years just before World War I because the traditional means of 3-D rendering inherited from the past were for him too one-

sided, too lamely content with the exclusive aspect. In other words—not 3-D enough. Though his innovations could be misunderstood and were often mistaken for literal flatness, in Picasso's own work they served to appropriate for his art what he knew to be solid and real.

IV THE WEAVE OF ASPECTS

In the *Sleeping Nude* of 1954 (Fig. 125), as in the *Bather* of 1908 (Fig. 127), Picasso's disturbance of conventional contours could still register as a momentary displacement. Whether it was the seeing eye that displaced itself in rounding a bend, or the draughtsman's hand mentally strafing the object, or the turning object itself—the rationale for the distortion lies so close to common experience that it becomes acceptable as soon as the most rigid insistence on focused perspective has been relaxed. But Picasso's more radical simultaneities are of another order. They cannot be rationalized by appeals to tactile or durational modes of perception. And their antecedents, or parallels, exist not in narrative representational art but in techniques of demonstration, in those graphic devices which never intended to simulate the appearance or sensation of bodies, whose purpose is rather to marshal a full body of information about three-dimensional data on a plane surface. As when a textbook illustration develops the running ornament of a Greek vase in a strip—as though the vessel had been zipped down the back and pressed flat. Closer still are those splendid projections whereby geodesists, cosmographers, and mathematicians have for centuries rendered the world's sphere on a plane surface—gnomonic, quincuncial, and homolographic projections, discontinuous and kidney-shaped map projections with their distortions, repeats, and disjunctions. These ingenious summaries of the sphere on the plane are the natural analogue for Picasso's manipulations of the human image. Granted that Picasso's heuristic impulses are not pure but entwined with his passions, he treats the body as those maps treat the globe: treats it like a cartographer processing data, and again like the global ruler in the Age of Discovery whose *mappa mundi* unfurls a circumnavigated world.

SCHEMATIC ASSEMBLAGE

The dissociation of facets which Picasso accomplished during the phases of Cubist dismemberment had equipped him with new con-

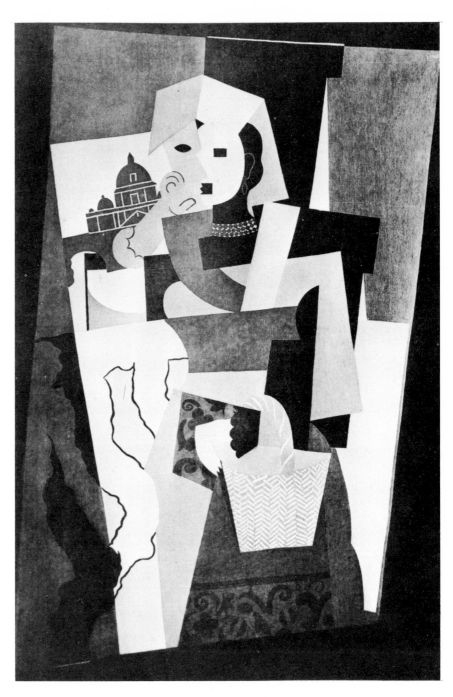

128. *Picasso,*
L'Italienne, 1917

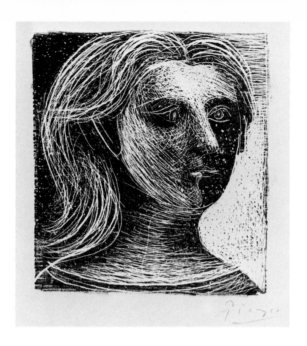

129. Picasso,
Head of a Woman, 1925

structive techniques. And they enabled him to invent images exactly equivalent to certain findings in contemporaneous epistemology. Thus Bertrand Russell argued that what we call solid bodies are in fact mental constructs, built up of our composite experience of aspects, which alone come to us from without. "All the aspects of a thing are real, whereas the thing is a mere logical construction."[55]

There is a precise analogy in Picasso's twin-aspect faces—constructs of disparate views fetched from separate vantage points. The idea was broached in the 1908 *Bather* and survives without significant emphasis during Cubism.[56] But there is something new in the conflations that emerge in Picasso's work during World War I. They are unlike the portrait heads of Analytical Cubism, whose native substantiality is perversely acknowledged in their very proneness to flake and splinter. These newer heads were never beheld at all. They were conceived in collage, from the union of prefabricated flat elements, recalling that fusion of "real" aspects of which Russell's philosophy constructs a "thing." In a painting of 1917, *L'Italienne* (Fig. 128), the head of the figure is assembled from two preformed poster-like units: one sees a mask, salmon-pink, accosted by a gray profile, but as the two end up sharing an eye the match seems a success. A curious idea: one person compounded of two different natures.[57]

During the next several years, the two-in-one face motif is stretched, tested, deployed. Sometimes the perplexity behind the new image is spelled out—as in a drawing of 1926 in the San Fran-

cisco Museum: it shows an artist facing his model; the model shows a fine profile, but shows it to us—not to him; he has to draw her portrait full-face. Where then do these two entities coexist? Are front and side views mere signals received by different observers, each at his separate station? Picasso wants them rejoined. Increasingly, they are meshed and fused, and, by the mid-1920's, they interpenetrate in a single construction (Fig. 129).[58] In scores of invented heads, and in portrait heads of the 1930's, the side and front aspects are marshalled together to compose not only the semblance of a full head, but of multifaceted personality. And the sensation is less of graft and assemblage than of a facing head which internally accommodates its own profile (Fig. 130).

The accommodation takes place on the median, where the arris formed by the nose offers the profile a natural site. After all, the shadow of a strong raking light fretting the human face already prefigures its view from the side—whence those numerous sixteenth-

130. Picasso, *Nude Woman in an Armchair*, 1932

131. Agnolo Bronzino, *Panciatichi Madonna*

132. Picasso,
Portrait of a Lady, 1937

century images that almost anticipate Picasso's design. The darkened half of the face of Bronzino's *Panciatichi Madonna* (Fig. 131) foreshadows the potential side view without exceeding the Renaissance quota of one aspect per point of sight.

In a wilder alternative for making profilation coincident with frontality, Picasso bypasses the median. We seem still to be shown facing portraits, but then one cheek's contour erupts and the profile pushes out from within (Fig. 132). The orientation of the whole head becomes equivocal. There is no longer a *prima facie* case for

frontality, since the excrescent profile proposes a simultaneous alternative: that the head is a profile primarily, but a profile overplussed with "frontality paraphernalia"—that is to say, with two eyes, paired nostrils, lips nearly full, hair center-parted, etc. These heads—they emerge in the early thirties—constitute one of Picasso's most audacious decisions, more daring than the well-centered profiles mentioned above, and more shocking to anyone made in God's image. For while a profile identified with the median leans on the given architecture of the human head, the newer conflations depend entirely on the set of a few wayward organs. All connective tissue becomes pure invention—magnetized intervals to hold straying features in place.[59] The potential of the new image is forced to the utmost during 1937–39, especially in the Dora Maar portraits. Their disruptive pressure is fierce and disturbing, in the later versions often repellent, or suggestive of unendurable psychological stress.

133. Picasso,
Femme assise,
April 23, 1943

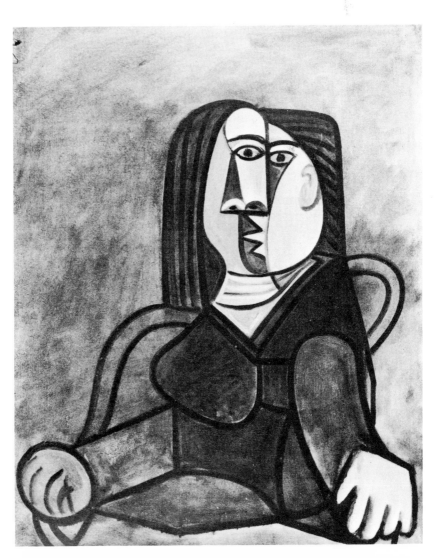

Later on—as almost invariably happens in Picasso's career—what had been hard-won turns into play. By 1943 Picasso could juggle even more than two aspects in one portrait head. A real head, of course, has many faces, but how many can balance on one point of space at the same time? To elicit the answer, the question is posed in scores of prints, drawings, and paintings—as in Fig. 133. Or the *Faun*—a large linear ink drawing of 1946 (Fig. 134). The head presents itself as a bust portrait, with redundant evidence of frontality —squared neck and shoulders, two each of eyes and ears, and a pair of horns. But within the space of the face the economy is so stringent that a dozen internal lines perform triple functions. All the lines, like a magician's props, are laid out for inspection, yet inside the face two interpenetrant profiles sharing a single eye stare past each other.

Speaking of eyes, Picasso is the first artist perhaps in a thousand years to reopen the problem of number. When Dickens observed that "the popular prejudice runs in favor of two," it was normal anatomy he had in mind. But with painting in mind, how many eyes pertain to a profile? Again, the popular prejudice recognizes no problem, for though human profiles show but one eye in action, the collaboration of a transnasal twin is assumed. Still, Picasso decides otherwise, and his decision comes in response to an ancient challenge —how to impart active sight to the picture of an averted face.

Archaic Greek painters, like their Egyptian forerunners, made the

134. Picasso, *The Faun*, August 30, 1946

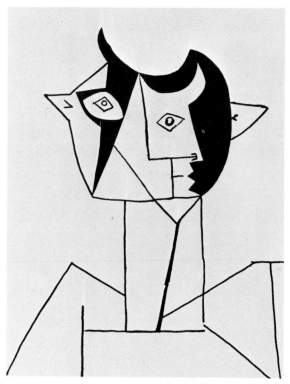

profile shine with one full seeing eye—an emblem having no conceivable sides. Then, with reluctance, but in obedience to classical naturalism, the Greek eye turned aside, relaxing its hold on the viewer the better to participate in its own illusionist space. But the problem returns when pictorial space becomes depthless again. It returns in Byzantium a thousand years later, when the strict profile, the form inherited from Hellenistic art, comes again to seem ineffectual and blind. In the flattened mosaic field, an averted eye in an averted head seemed to lack the effective emanation of sight. Accordingly, the actors in Middle Byzantine narrative scenes display either the full face or the three-quarter view. Only the wicked in their unseeing half-life have profile faces.[60]

For Picasso, repossessed of a flat, post-Cubist space, the problem becomes real again,[61] and is solved in a manner which, in its disregard of man's God-framed symmetry, was inconceivable for the Byzantines. Consider the two-in-one faces discussed above, for example: read as primary profiles, they bear both eyes on one side. In fact, by 1932, Picasso was treating twin-sighted profiles like an anatomical norm.[62] In the *Guernica* mural, 1937, all heads in side view, human and animal, are binocular. In such works as *Combat* (drypoint, October 1937; B. 301), the optical capability of the contestants—two eyes in tandem on the same flank—looks so efficient that one forgets the preposterous insolence of Picasso's solution.

Whether the trajectory of a human life traces a teleological pattern remains to be seen, but an artist's work can console us by making it seem so. There is a beautiful fitness in the fact that the twenty-one-year-old Picasso, depicting, say, a young couple in a café, was already turning the eye's orientation on the face into a topical issue. The Egyptianized eye which his characters affect as early as 1902, and thereafter insistently, must have struck his contemporaries as a notable feature. Douanier Rousseau may have had it in mind in his quaint reference to Picasso's "Egyptian manner."[63] And when Marie Laurencin in 1908 painted Picasso's portrait into her *Group of Artists* (Cone Collection, Baltimore), she drew him like a visitant from a mastaba relief. It is as though Picasso had, from the beginning, made the eye responsible for the whole problem of three-dimensionality on the surface. The willful perspective of that single organ throws the first challenge to perspectival homogeneity in representation. Shortly thereafter, Picasso's full-faces display profile noses. They

seem like small items; but only as rudders and hinges seem small in proportion to what they turn. Eyes and noses are Picasso's first warnings that the consistency of the old system is to be shaken up by the intrusion of alternate aspects.

In another sense too these early details are prophetic. Picasso begins by confounding the two archetypal aspects of eyes—front and side separated by ninety degrees. When he later proceeds to build twin-aspect heads—the ingredients of his conflations, we remember, being not visual records but conceptual schemas—they are again, like photos in a rogue's gallery, precise front and profile, separated by the right angle.

To repeat: Picasso's economy of simultaneity begins with a limited incidence of depicted planes. In heads and figures the conjured aspects refer to cardinal points separated by a precise quadrant. In the head, the quadrant runs from full-face to profile; in the nude, from three-quarter frontality to the nearest three-quarter backview (cf. Figs. 127 and 106); in glasses, bottles, and pitchers, from base or brim to elevation. The divergence of aspects is controlled throughout by the prototypical angle, the right angle. And here again the successful functioning of Picasso's inventions depends on the recognizability of foreknown relational patterns. The elements of conflation are prescribed like a drillmaster's repertory—eyes-left, right-face, and so on.

The consistent appeal to a narrow conceptual frame ensures legibility, and it anchors the image once more in memories of visual-kinesthetic experience. Picasso's early success in making disc-face and profile cohere was due not only to their recognizable character as conventional signs, but as well to the assurance that the relation between them could still be read as a time shift, a rotation through ninety degrees of which the image registered the terminal moments. In the face, as in the nude, the disparity of the views synchronized was narrow enough to remain thinkable in terms of perception—the warped shape and the double exposure symbolizing the range of a limited turn. In the implied rotation of viewer or object through ninety degrees, the object's aboriginal structure did not need to be abrogated, might even be emphasized.

But none of this holds when the arc implied in the joining of disparate aspects approaches 180 degrees. Whether these aspects be whole or partial, the image of an object showing diametrically opposed aspects implies a schematic disjunction to which no kines-

thetic experience can be attached. The omission of all intermediacy between front and back defeats the sense of transition, of orbiting on an arc. There is no feeling of sequence or motion, hence no recognition of mass. When recto and verso are juxtaposed, they register as an ideated notation with no illusion of physical presence. Any simultaneous exposition of obverse and reverse localized in one frame becomes at once diagrammatic, like certain anatomical illustrations—an operation performed on paper upon paper elements, as when a Baroque architect's elevation changes midway from street to garden facade; or when half of a torn dollar bill is re-glued back to front; or when, in the rendering of a painter's canvas, Picasso flips the other half of the canvas around (*The Studio*, 1934; University of Indiana, Bloomington).

Thus the inclusion of a 180-degree turn within stable contours—even if the subject recalls an originally three-dimensional nude—remains or becomes a paper manipulation. The complete turnabout, the coincidence of recto and verso without intervening duration, is no longer referable to experience. It implies a prior translation into schema and diagram, like the conceptual analysis of an architectural body into plan, section, and elevation. Which explains why, for almost three decades, Picasso's exercise of simultaneity left the body's full turn unattempted.[64]

But was it even imaginable or, for that matter, worth trying? For not only was the idea of a simultaneous fore-and-aft image absurd and irrational; even if it succeeded, its effect would be either illegible or else a reduction to flat processed data—departing further than ever from its goal, the total grasp.

Yet Picasso persisted, insisting that front and back would emerge in his image simultaneously without sacrifice of real presence—the thing to be known as a sculptor knows his creation before he withdraws his hand; or as an orbiting, all-seeing eye might apprehend it; or as the thing knows itself from within—or is known to an embrace gifted with sight. The quest was for the form that would be at the same time a diagram and an embrace.

It is a new world he makes in the 1940's. World War II; Paris in German hands and Picasso, approaching his seventh decade, in his studio on the rue des Grands Augustins; the consequent isolation bestowed a gift upon him which normally only unwilling young artists receive—a boon season of hidden years.

Picasso's entwined double faces of the late thirties included a variant which cannot be regarded as simply conflating a front and side. They are the images that feature the human head with a canine or bovine snout—a long muzzle curling in fleshy nostrils where we expect the blade of a nose. The hybridization begins around 1937. It is the period which follows the incursion of the Minotaur in Picasso's affairs, the period of the increasingly therianthropic Dora Maar portraits and, above all, the period of *Guernica*. By 1938 the ox muzzle is on the faces of children, and on coarse peasants ingesting sunlight and food; it is the dominant trait of the terrifying *Nude Dressing Her Hair* (1940; Figs. 135 and 158). In a hundred multi-faced heads of the period that combine the now-familiar side and *en face*,

135. Picasso,
Nude Dressing Her Hair,
June 19, 1940
(postscript to Fig. 158)

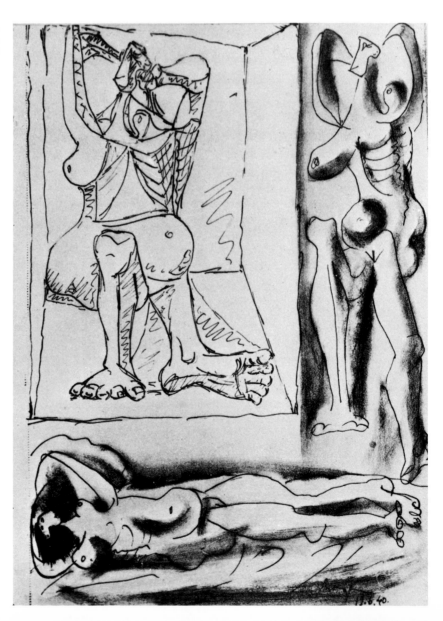

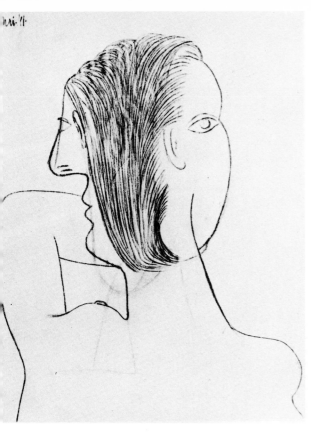

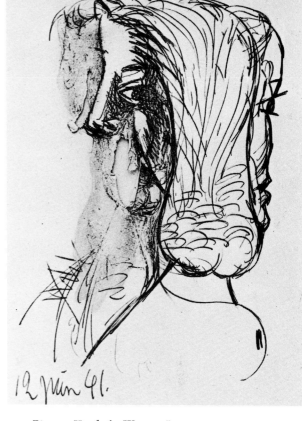

136. Picasso, *Head of a Woman,* May 20, 1941

137. Picasso, *Head of a Woman,* June 12, 1941

138. Picasso,
Reclining Woman,
May 19, 1941

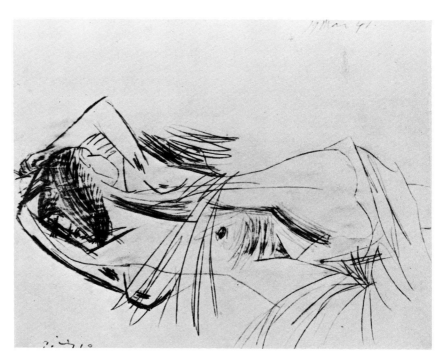

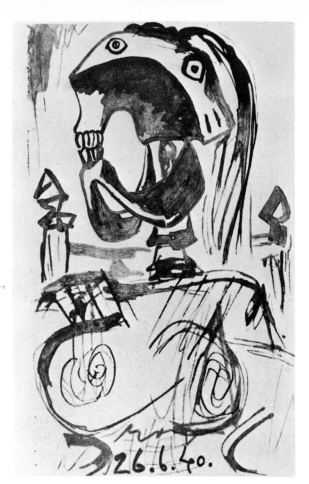

139. Picasso,
Head of a Woman,
June 26, 1940

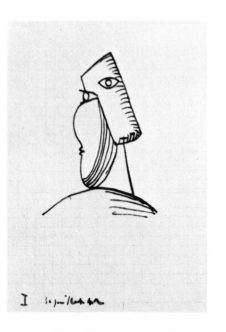
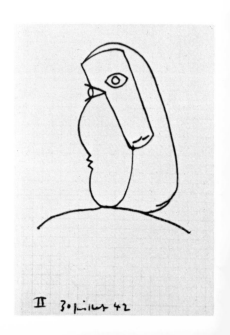

140. Picasso,
Heads,
July 30–August 9, 1942

the thick, breathy snout incorporated with the human face suggests a lowered, brute plane of existence. We shall return to these images presently.

By 1939 he had broached a new possibility in the conflation of aspects, one which at its beginning has nothing to do with the beast. It is concerned again with simultaneity, but passes beyond the banal ninety-degree dichotomy of front and side. The image takes off from the *profil perdu* of a young woman with long falling hair; another profile, divergent, is then hinged to the three-quarter backview, so that the angle between the hinged aspects expands to 120 degrees (Figs. 136-38 and 99).

Only one final wrench needed to establish the simultaneity image as a conjunction of diametric opposites. And it comes, beginning in mid-1940—women's heads as instant convergences of front and back. These are extremity situations, and something of the psychic energy that engendered them is suggested by their symbolic charge. The extremes that are being conflated are lady and animal; the front of a bovine snout ingrown as a single visage with the lost profile of a beautiful woman; and sometimes a feminine head shared with a bare skull (Fig. 139). Chronologically these works coincide with the Spanish Civil War in its final phase and the beginning of World War II.

The boldest thinking is again done in the drawings, where the idea gestates. It appears distilled in seven studies of a woman's head, begun July 30, 1942 (Fig. 140). Their left halves show a gentle feminine contour—a frank eye in profile, full cheek, firm mouth and round chin. No nose is in sight, so that we must interpret the facial

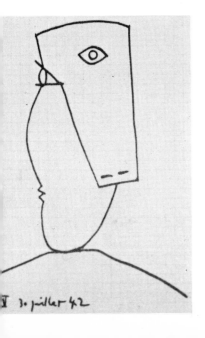

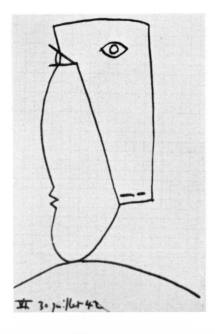

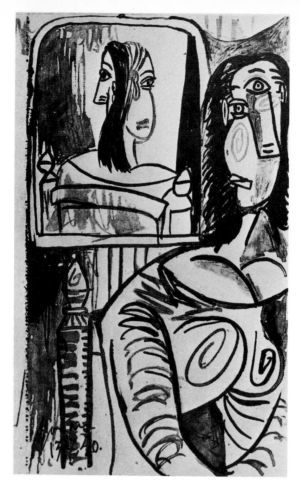

141. Picasso,
Woman in a Mirror,
July 13, 1940

edge as a *profil perdu*. The interpretation is binding; it is confirmed
by the snood (in No. 98) and by the constant base line which reads
as a back view of shoulders. But the right half is the woman's head
humped with ox-eye and heifer's snout—not an imposed alien graft,
but flesh of her flesh. The whole context of Picasso's work demon-
strates that he thinks of these organs as featuring one indivisible
core. Before and behind are impaled together, much as in the old
seventeenth-century broadsheets Lady Worldliness was impaled
with a Death's head as her sinister aspect. These drawings, and the
many related oils of the period, plow the animal back into the
human, constituent both of the same stock. The beast in the lady is
the back of her head refaced as her animal aspect, and both aspects
are viewed from the primitive side.

The problem of front and back simultaneity is thus turned back-
to-front. Instead of starting with the conceptually familiar frontface
and wrenching the sides into view, Picasso now starts at the rear,

which we tend to regard as provisionally averted, then brings the more readily welcomed elements of the facade around. Henceforth the full diametric span, the simultaneity of antipodal aspects, is the minimum program.

And as usual—presumably for his own clarification—Picasso makes didactic drawings, drawings in which a reflective looking-glass mirrors his own circumspection (Fig. 141).[65] The half-length of a seated girl posing; the head conflated as in the 1942 drawings described above, but here posed against a mirror which throws back, not the mere back of her head, nor any single optic phenomenon, but two further aspects again. We are reminded of Joyce's defense of *Finnegans Wake*: "Yes. Some of the means I use are trivial—and some are quadrivial."[66]

The female body undergoes new kinds of revision. Its "commonplaces" serve as exponents of vagrant aspects. A dotted bosom becomes the prefix to any aspect soever, so that frontal figures as they bend over sprout breasts at the shoulder blades.[67] A *Sleeping Nude*, prone on her stomach, shows her top sunny-side up, and her face facing both ways, like the covers of a dropped book splayed out (Figs. 142, 138). Yet the body coheres; there is neither Cubist dismemberment nor schematic disjunction. These figures work, and Picasso's draughtsmanship makes their irrational translocations

142. Picasso,
Sleeping Nude, 1941

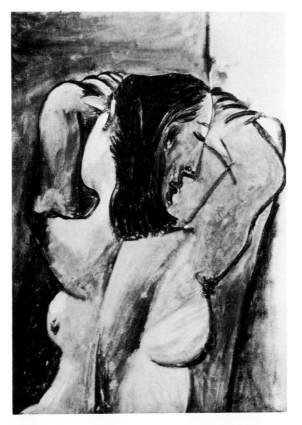

seem genuinely informative about the rotundity of the object ob-
served. Could a cartographer do it? Could he make the world's other
side present to the imagination by entering Pacific islands on the
Atlantic? Picasso's feat is to have created a syntax of inventible inter-
vals within which such transpositions do not simply register as jokes
or mistakes. The displacements themselves are not hard to make;
making them work, making them human, required the better part of
Picasso's life.

These images are no flat diagrammed expositions of aspects. And
they are a far cry from Cubism. Picasso is wholly in earnest about
his embodiments, about their debt to the kind of three-dimensional
space that confers reverse aspects; or rather about the role of these
aspects as the epitomes of that space. Their task is to make exiled
space present in effigy.

From 1940 onward Picasso's faces and nudes insist again on firm
structure. But their solidity hardly relies on such tried devices as
chiaroscuro. It rests in the interlocking or inweaving of aspects—
partial aspects summoned from different compass points, and their
interpenetrating convergence creating the anatomical body.

Throughout the early 1940's, Picasso made his astonishing studies
of sleeping nudes—compact in substance, in position both prone and
supine, every viewpoint produced and retained (Figs. 135, 143).
The scrambling of aspects continues, the figures repeatedly harsh
and ugly but always centripetal, always generating coherence; and
one looks and keeps looking, marveling how these impossible contra-
dictions seem to grow normal and necessary, until you wonder how
we ever put up with the poor showing of one-sided representation.[68]

In these newer images the simultaneity effects involve the whole
form. In works before the late 1930's, simultaneity rarely engages
more than one item per picture. If that item is a double-faced head,
the doubling stops short at the trunk. Complex heads tend to rest on
plain bodies, while multiplex torsos support simple heads. Rarely,
if ever, do these amplifications appear together, but rather each
singly plays off against normalcy. Picasso practices an economy of
persuasion. Because they operate against normal expectancy, his
own as much as ours, his simultaneities must come one at a time, or
defeat comprehension through overload.

There are other economies. One perceives in retrospect that Pi-
casso's studies in simultaneity had for thirty years remained tied to

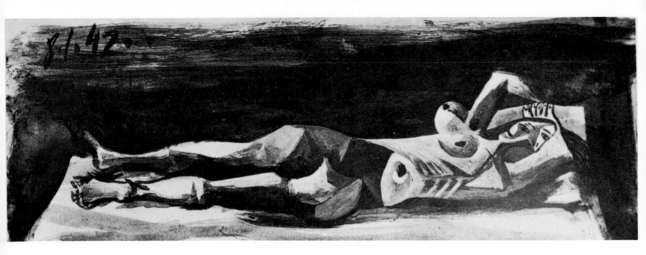

143. Picasso, *Three Nudes*, detail of lower figure, January 8, 1942

a select subject matter of special forms. Exercised only on faces and figures—and not even on these simultaneously—his conflations did not recast the entire pictorial language into an alternative system. Hence, from the viewpoint of one whose criteria derive from Cubism, the limited incidence of Picasso's conflations can appear episodic, a marginal idiosyncrasy in representation—unlike Cubism, which digests still life and portraiture, interiors and exterior spaces, landscapes and atmosphere. But Cubism could assimilate all natural forms largely by leveling the distinctions between them, or neutralizing the value of their distinctions. Whatever detectable difference existed in 1911 between, say, an art dealer and a bottle of rum, was incidental to their digestibility in the pictorial metabolism. In this apparent subjugation of content, Cubism has always been "modern," whereas Picasso's persistent engagement in special subjects was not. And precisely because Picasso's simultaneity effects were subject-bound, localizing an intensified realization in "significant" things, such as human faces, the primacy of these things within the whole seemed constantly reaffirmed. One can look at a hundred Picasso paintings of seated figures with conflated faces; the near-neutral backgrounds suggest that the artist does not consider backgrounds important. To a modern esthetic concerned with the "field," this can look like an obsolete academic attitude.

Equally anachronistic is Picasso's sustained interest in problems of rendering, that is to say, in reproducing the difficult likeness of something experienced in nature. Again, from the viewpoint of normative twentieth-century esthetics, inclined as it is towards abstraction and formalism, all problems of rendering belong to art schools. Even the rendering of a periscopic glimpse of a model's behind can be written

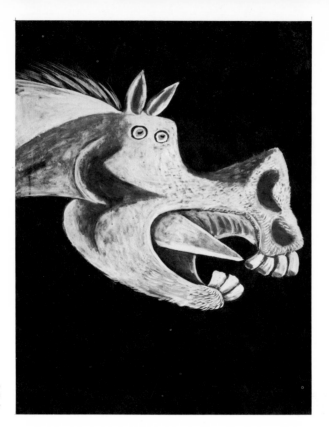

144. Picasso,
Study for head of a horse
(*Guernica*), May 2, 1937

off as an exercise of the how-to variety—like how to draw elephants. No solution to that kind of problem constitutes what in Modernism will pass as a change of vision, or stylistic shift, or transformation of pictorial structure. Yet until the late 1930's, Picasso's multi-aspected imagery confined itself almost exclusively to objects of absolute familiarity. They had to be objects divisible into simple conceptual units which remained recognizable under shift and distortion, and which were at the same time the focus of personal, psychological, or sexual interest. In short, Picasso's simultaneities devolved mainly upon women's faces and female nudes. Hence, from the viewpoint of most recent American painting, for instance, Picasso's pursuit of simultaneity seems essentially marginal.

But it is central to Picasso's progressive vision. One by one, from the late 1930's through the war years, the restrictions which for decades had checked his simultaneities fall away. A process begun with the dislocation of a few migrant organs, and which gradually embraced the whole human anatomy, finally moves out beyond.

Animals first. In the *Bullfight*, an oil of 1934 (Collection of Henry P. McIlhenny), the distorted head of the dying *toro* is already a *front-de-bœuf* continuous with its profile; contours simply don't terminate where they should. The tossed heads of the gored horses

in related Boisgeloup bullfight scenes are more complex still. And the trend culminates in the *Guernica* studies. In one painting especially—the side view of a horse's head screaming (Fig. 144)—the look-up perspective of the jawbones is simultaneous with a frontal view of ears, eyes, and nostrils, as well as with the exterior face and the inside of the mouth. The systematic delivery of all conceivable aspects is accomplished by the translocation of organs and the splaying out of averted planes.

The most radical solution is found in the studies, dated August 26, 1942, for the lamb borne by the shepherd in the great bronze executed in the following year (Fig. 145). Here the artist attacks that single element on which the very notion of axial frontality rests, i.e. the main vertical axis from the chin down. Instead of descending towards the belly, the line swerves into backbone, yielding a perfect simultaneity of front and back views.

At the same time Picasso tackled the furniture.[69] The enterprise of such large oils as *Chair with Gladiolas* (September 17, 1943; Z.

145. Picasso,
Study of a lamb,
August 26, 1942

XIII, 123), begins in a series of powerful drawings of chairs (November–December 1942; Z. XII, 170-78): cane chairs of massive structure and bulk, which yet avoid the illusion of irrevocable spatial displacement. For they are precisely distorted to equivocate between contradictory clues: a foreleg ends up behind, parallel struts keep crossing over, and a tipping seat, traumatized by previous perspectives, strikes crazy angles. Picasso can fill a single sheet, fourteen by twenty inches, with a pullulation of little chairs—the same item in thirty-five variations—an exercise of infinite facetry which ends only because the sheet is used up (Fig. 146). What Picasso brings to the chair is a sense of its real presence, a conviction of the provisional nature of aspects, and the usual overrun of imagination.

The chair continues as subject and by January 1943 serves as a perch for a breed of multi-faceted doves. They too enter Picasso's widening world of plural perspectives (Z. XII, 199-201 and 266-71). There is a new discipline in his determination that even familiar silhouettes, such as birds, be visualized as convocations of aspects.

The word "discipline," at this time, was Picasso's own. Shortly after the liberation of Paris in August 1944, he told an English visitor that "a more disciplined art, less unconstrained freedom in a time like this, is the artist's defense and guard."[70] No one can know

the exact connotation these words had for Picasso. But anybody can see that it was a controlled program which developed what had long been episodic into a thoroughgoing modality. Dove, lamb, and wicker chair; dry trees with their flat-limned branches faceted, folded, and twisted like paper streamers (cf. *The Tree*, January 4, 1944; Z. XIII, 214); and landscapes—some produced at Royan as early as August 1940 (Z. XI, 84-90)—whose remote reaches are roped into the foreground, yet insistent on mass and depth: they are steps in a systematic extension of the simultaneity principle—from humans and animals to the objects and ambience of their environment.

The change in the style of Picasso's wartime production was recognized by his outstanding critic as soon as it came to the world's attention. In the *Nude with a Musician* (also known as *L'Aubade*, May 4, 1942; Z. XII, 69, Paris), Alfred H. Barr noted that "the figures preserve their integrity of form. Very rarely do they merge with background or accessories as in cubism of the analytical period." Of the *First Steps* (May 21, 1943; Z. XIII, 36, Yale): "the effect is ambiguous for the distortions seem to enhance the original subject rather than destroy it." Of the *Chair with Gladiolas:* "As in most of his recent still lifes the characteristic shapes of objects are not disintegrated as in cubism, but are fortified by the use of heavy dark contours."[71]

The departure from Cubism is not superficial, but radical enough to constitute a major turn of intention. It represents a new will to consolidation, reflected alike in the powerful monolithic sculpture of 1943-44 and in the *Charnel House* (Museum of Modern Art, New York), Picasso's masterpiece of 1945, a picture of such densities and spatial depths that *Guernica* by comparison looks like a dance of shadows.

Picasso's still lifes of the early 1940's are extraordinary—craggy and stark, and the few edibles on the table assembled under powerful stresses. Perhaps they owe some of their stridency to the hunger of the war years; Picasso's wartime play, *Desire Caught by the Tail* (1941) is obsessed by the want of food. These dire pictures (Figs. 147-150) profess none of the noble delights Picasso spread forth in the still lifes of the 1920's; none of the spirited elegance that distinguished those of Synthetic Cubism. The fare on his wartime tables is not rhythmically patterned within the picture plane, but trapped

in an unbreakable web, held down as if to forestall resistance. The objects within these spaces—a small roasted bird, lean vegetables, spiked flowers or ears of wheat, baskets of eggs, and green pellets of fruit—one can sense that they matter.

What gives these objects their strength? Their angular shape, of course, and the geometric rigidity of the triangle which is their pervasive module. And in the larger elements, the baskets especially, an internal rezoning of planes to accommodate a surcharge of aspects. More is involved here than a splaying out of hidden facets. In some of these works, such as the *Still Life* of August 12, 1942 (Fig. 149), all objects seem braced or contained by an iron grid of black rods. Sometimes these are omitted or painted over, but their exerted pressure continues to be felt in the reactive distortions of containers and tabletops. As these black spokes traverse the pictorial space, each in passing edges some inner or outer contour, so that an object's component planes end up being defined by far-traveled energies impinging on it from without. A basket's constituent planes lie zoned within spatial tracks, or in the intersections of overlapping space lanes. These inflexible trails confer a visual ne-

cessity on irregular facets that could otherwise look like arbitrary deformations. At the same time, the planes of the basket, say in Figures 147 and 148, are unmistakable as actual aspects, each seen from a different angle, yielding not the predictable stereotypes of front and side, elevation and plan, but real perspectives, optical data, an overplus of foreshortened, distorted planes. And the space tracks by which these planes are defined become symbols of sight and vantage.

There is reason, then, to regard these black tracks as more than fortified pattern. They seem to be concretions of sight lines, pathways of multiple simultaneous vision—not wholly unlike the structural lines of a Renaissance perspective grid, which also serve to lock the depicted forms in position. As those orthogonals of fixed-point perspective converge on a lone vanishing point, they too distort every object within their path, squeezing it towards the horizon. But in Picasso's still lifes of the 1940's, vanishing points are multiple, and one at least seems reflexive—it implies sight lines rebounding out of the perceived depth towards the viewer's position. Accordingly, certain lines that read as divergent on the plane surface seem

149. Picasso,
Still Life, August 12, 1942

actually to converge hitherward from far corners, their transit inflecting the shapes of tables and baskets, much as did the schematized lines of classic perspective—but in reverse. It is as though the artist, imagining a normal perspective grid, had managed to freeze its convergences, while projecting himself to the vanishing point to look back at his objects from their diminishing ends—like a nimble photographer looking back at his delayed-shutter camera. They give the impression, these baskets, not of distorted structures, but of being seen simultaneously from many poles.

Such an interpretation of the complicity of space in Picasso's still lifes of the early forties is supported by the evidence of certain drawings which systematically explore the spatial environment of things to be seen in simultaneity. The problem is stated in a series that begins August 18, 1941, with a study of a scrambled nude resting in a small room (Z. XI, 249). One week goes by and Picasso questions her setting. His next drawing (Fig. 151) shows a furnished room which contains—with apparent difficulty—a ceiling, a couch, one or two windows, and an open armoire. The ceiling, made the more literal by a central light fixture, sets out from the upper

216

150. Picasso,
Still Life with Thorns,
August 13, 1943

margin and proceeds in well-behaved perspective recession: it diminishes as a trapezoid towards the narrowed part of the room—where rationality stops. The perpendiculars that ought to run down the far corners to define the end wall, become instead two converging obliques that return at once to the foreground; misguided verticals that turn the whole ceiling into a flying trapeze. The room inverts like a pocket.

In four drawings immediately following (August 25-28; Z. XI, 251-54), the setting is temporarily stilled to await amplification of content. The nude on the couch is joined by another woman, either nude or dressed, standing before the mirror door of the armoire. There is a hanging lamp, a tall tripod flowerstand behind the couch, and an assortment of rectangular panels that suggest doors, windows, and frames. The nude is the main focus of simultaneity; her unfolded superficies are refurled and crumpled like a serviette. And the trained mirror amplifies its received signal.

But then, on September 1, the question returns—what sort of architecture houses simultaneous aspects (Fig. 152)? Is the room itself seen, or is it to be merely the shell within which seeing takes

217

151. Picasso,
Furnished Room,
August 25, 1941

152. Picasso,
Furnished Room
with Sleeping Nude,
September 1, 1941

153. Picasso,
Furnished Room,
September 1, 1941

place? What of the furniture? Inactive, like a laboratory bench which stays outside the chemistry of the experiment? The couch, for example; what steadies it if the nude on it is unstable? Is all this structure held in place by mere force of convention?

The last three drawings (Fig. 153 and Z. XI, 275, 276) lead to the furthest outpost of Picasso's thought about the staging of ubiquitous vision. A depth of field is apparent, but within it all relative intervals become incommensurate—near and far interchangeable, tripod and couch interpenetrant and emplaced together. The artist's sight, his successive acts of focusing, seem to project indelible vanishing lines, leaving the room traversed by an irregular network of intersections. The deep space funneled by complementary perspectives becomes collapsible. As when a child playing cat's cradle loops a finger about the farthest-out string and pulls it forward—so the sightlines tracking these spaces undergo instant inversion. A brace of vanishing points receding, but "receding" from both near and far vantages simultaneously; the space defined as a scaffolding of visual rays, wavetrains of imagined eyereach projected towards foci whence sight always turns home again.

The theme of the occupied room is resumed continually—culminating in the famous large oil *L'Aubade* of May 4, 1942 (Musée de l'Art Moderne, Paris). In some ways, the five published studies for this interior are even more interesting, since more was broached in them than the painted version absorbed. And three of the drawings post-date the painting, Picasso evidently continuing to ponder its space. The first (Fig. 154) shows again the familiar nude reclining supine. Her disposition, which exposes both rump and pubis without our having to move, is by now an inherited trait. Her pose—arms overhead and feet crossed—is likewise expected. More interesting, the right leg, crossed by its mate, terminates in a left foot, while the other leg, drawn with studied precision, is the entire left limb flipped over to show from the back (cf. Fig. 143). Moreover, her arms and head begin to read ambiguously as those of a prone figure (as in Canvas M of the *Femmes d'Alger*; cf. for corroboration, Z. XII, 67).

In the elaborate full-picture drawing of the same day (Fig. 155) the nude is somewhat simplified, though her legs—obeying the right/left reciprocation—still cross into uncrossed feet, and her torso is splayed. But there is more—her restive bed grows responsive and doubles sympathetically with her own double portions, and the

154. Picasso,
Reclining Nude,
study for *L'Aubade,*
May 3, 1942

whole room heaves like a house of dreams. For all its tectonic carpentry, the armature of floorboards and panels allows no averted planes, not even thinkable ones, so that the environment of both solid form and spatial containment becomes resistless like the limitless diaphane of outdoors.

155. Picasso,
*Reclining Nude
and Seated Woman,*
study for *L'Aubade,*
May 4, 1942

156. Picasso,
Study for *L'Aubade*,
May 5, 1942

Overhead floats one of Picasso's most famous puns, famous since
Guernica: the shaded electric light as an all-seeing eye.[72] The an-
cient symbol of the sun's eye is acknowledged, but as inadequate.
For the sun breeds shadows which itself does not know, and a light
that breeds shadows admits the existence of inaccessible planes. But
the ambience Picasso wants for his multi-aspected figures must be,
like themselves, a space without unpossessed surfaces, an illumi-
nated, eternally shadowless chamber, all-apparent in the glare of
the lantern eye, signature of omnispection.

The final abstraction (Fig. 156) can only be understood as the
end point of these penetrations. It is a controlled grid of multiple spa-
tial directives. The lines moving in parallels define intersecting
space lanes—like star trails, directions for indoor galaxies. But each
single line also converges somewhere with another—the sets of con-
vergences being programmed to convey vanishing points to dis-
persed destinations. A counterpoint, then, of two merging themes—
indoor space lanes and lines of sight, criss-crossing in a kind of
charted ubiquity. It is this space, with its invertible depths and its

221

linear events generated by optical capabilities, which ideally enfolds Picasso's simultaneity images. It is a space inside a cat's cradle, every tensor in readiness for instant transfer; a contractile, expansive, collapsible space. It is this space which is monumentalized in major works of the 1940's, the still lifes, *L'Aubade* and the *Charnel House*.

Where—imagining these simultaneities—does the artist imagine himself? The answer is inescapable that he is always both here and elsewhere, as though he possessed double presence. His mind looks at the natural world with fixed, focused vision and, at the same time, with a meta-physiological sight which can roam, orbit, embrace, and return with a harvest of portable aspects. What he receives from the vantage of his physical eye is constantly amplified or disturbed by gifts from his other seeing. Hence throughout Picasso's work, the insistence on both—on the vision of the natural man and the magician.

To use an ancient metaphor—it makes of Picasso what used to be called a *natura duplex*. For the man who sees sharply from where he is and from elsewhere at the same time is like a twinned person in whom contradictory natures concur. Prototypes of two-natured beings are common in religion, law, politics, and economics, and always their meaning is power. The theology of incarnate godhead has its secular counterpart in the definition of sovereignty—the legal fiction of the King's Two Bodies, his body natural and his indestructible, mystical body which is everywhere; the fiction being designed as a legitimization of kingship.[73] Just so, an individual "incorporates" himself to enhance his economic potential, to become literally his own superbody, that is to say, one not subject to the liabilities of his mere self.

For Picasso too it is a matter of power, but of a power which, as it resides in the evidence of his dual vision, constantly innovates and renews its claims. The other nature which the king has by grace of succession and the one-man corporation by contract law, the artist must wring from the visual world, win again and again by means of the images he creates. The imagery that falls from Picasso's hand must continually demonstrate that he sees in simultaneity. There is no resting in it; once a specific multiplication of aspects has been achieved, the new image becomes a repeatable graphic device. To maintain his sense of sovereignty over what he beholds demands the unceasing invention of simultaneities—just as his sense of physi-

cal confrontation with the world requires a constant renewal of his fixed-focus vision. He needs his imagery to attest both his manhood and his power to transcend its physical limitations. And he needs the representation of natural forms in ever-new simultaneities for the perpetual reconfirmation of a power which exists only as it expands.

V ARRIVAL

Everything comes together in Canvas O (Fig. 162), the last of the Algiers series, a synthesis on many levels. It reunites the exercise of simultaneity with its erotic impulse, and the multi-aspected figure with a responsive space. And it makes both these forms of union dependent upon a third: the billeting of incompatible presences— i.e. divergent "styles"—under one roof.

Begin, on the level of figurative representation, with the conflicting calls of aspect-scrambling and beauty. The subject may seem impertinent, since feminine charm is no criterion of judgment in twentieth-century art. But since it is of surpassing interest to the artist under discussion (he and Matisse being the only major painters of their time to make the celebration of beautiful women a concern of their art), it deserves passing attention.

Throughout the early 1940's, Picasso soldered female images out of disparate aspects but, in his characteristic way, never ceased to draw "normally"—that is to say, from the vantage of his own physique, confined to one point of sight. Perhaps for this reason his attacks on the problem of simultaneity often look like fresh starts, as if undertaken again and again from the old position—the position of a sensuality which enjoys its embodiment and rejoices in what it sees. And the attacks were aimed over and over at the same enticement, the same naked evidence.

Now, in the human female, that which perpetually stimulates consciousness of its otherness is the quality which ancient authors call "smooth and shining." "A woman's body," I read in Macrobius, "is full of moisture, as appears from the smoothness and sheen of her skin."

Picasso may have missed reading Macrobius, but he kept informed on the subject. And he must have seen that his harsh female constructs of the early 1940's brought on continuing devenustation: that success in compounding one body from interpenetrant aspects

157. Picasso,
Women on the Beach, 1934

was gained at the cost of delight. But this price, and Picasso's eagerness to be paying it, indicates perhaps how profoundly his interest in women extends beyond beauty and sexual appeal.

From the late twenties and through the thirties, the monstrous and the comical had been part of Picasso's expressive purpose; invented or hybrid anatomies were the constituent metaphors of his idiom, and dislocations of sensitive organs induced no painful sense of cruelty to human flesh (Fig. 157). But in the late thirties, and continuing through the early war years, Picasso's image of woman was both rehumanized and embittered—sufficiently like a woman to register as a negation of femininity. The most repellent of Picasso's females date from these years, the violence of their distortion again largely due to the forcing of antithetical aspects. Figures such as the *Nude Dressing Her Hair* (Figs. 135 and 158) or the gouache of a woman asleep (Fig. 143) seem unbearably ugly.

But who knows the meaning of ugliness; or why a painter will choose to reward the expectation of beauty with horror; or why Picasso would scar and mangle his nudes in the process of mating their disjointed sides. These questions may not seem relevant to current high-art considerations, but most of the answers exist ready-made as prejudices; they should be flushed out:

224

Perhaps these images of the early 1940's have no psychological function at all. Their clamorous ugliness may be the indifferent side-effect of the artist's simultaneity explorations to which questions of sex appeal are irrelevant.

Are these distortions something which Picasso's work does to women, or which he, like a witch doctor, would do if he could? A sadistic streak has indeed been laid to his charge.[74]

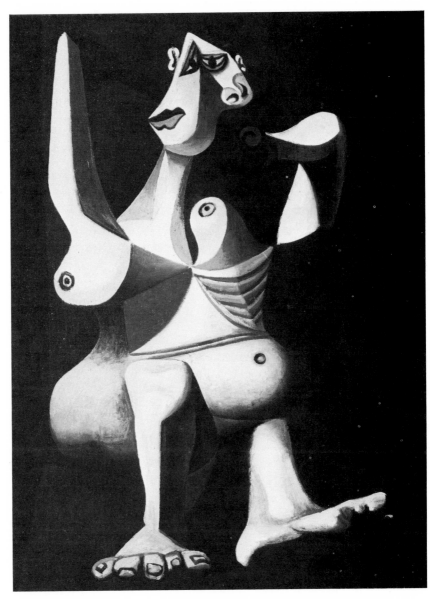

158. Picasso,
Nude Dressing Her Hair,
1940

Are they an exercise of power over the female, continually re-experienced in manipulating her image?

Or a boast of the potency of his art in making that which the vulgar think ugly acceptable?

Do they express a self-irony—as if to say, look, this is what keeps turning my head.

Or do these distortions expose a seamy side in the subject—symbolic statements designed as revelations of hidden truths about women?

But, at the risk of sounding sophistical, could they not be the opposite? Suppose that the image of woman nude is what Picasso admires above all things on earth; then to accuse the atrocity of a warring world he holds up to it the brutalization of what was made to be loved. The degradation of a cherished perfection becomes an index of the general sink. We recall the answer Picasso is said to have given the German officer who asked, pointing to a reproduction of *Guernica* in Picasso's studio—"Did you do that?" "No, you did that."[75] His quip placed responsibility for the image on the destroyer. And so perhaps in his wartime nudes. The measure of the world's evil is the disfigurement of its flower—whom Picasso in a happier moment would call *la femme fleur*. Some such interpretation has at least the advantage of referring the stateliest and the most abject of Picasso's women to a common emotional ground.[76] For it seems hard to deny that his brutalized women of 1940-42 were meant to repel. They are uncompanionable.

But this last observation points to a significant difference between the monsters of Picasso's Surrealist-metamorphic period and the non-seducers of the early forties. The former appear nearly always in action, usually in a predatory sexual encounter; the latter represent woman alone. She is sleeping, waiting, or dressing, often seated with her legs crossed—the classical posture that seals off the body against the outside. The singleness of these figures, and the palpable evidence of all their sides, lead to another intuition about their state of being. They seem explored in their self-existence, in a condition of involuntary pre-consciousness, unappealing only because not yet the cynosure of men's eyes, the woman alone with her body, unobserved, before beauty is born.

And then again, Picasso may not think they are ugly at all—not if he can make them real. I suspect that Picasso does not "distort," but seeks only to realize. In the last analysis, realization is what they are about.

Whatever intent accompanies the conception of these female fig-
ures, they seem victimized by the packing of disparate aspects. Even
in the 1931 drawing of the sculptor at work (Fig. 106), the statu-
ette's twin-aspect torso looks scarified. On the female anatomies of
the early 1940's, the colliding aspects make jagged and brittle joints.
The consolidate parts, though successfully rolled up from ulterior
vantage points, yield a sort of hideousness which blocks out normal
erotic considerations.

A change of mood sets in toward the mid-forties. The tender
young mother in *First Steps* (Yale) dates from May 1943. Most of
the female heads of this and the following year indicate other con-
cerns—thoughts about sculpture, where the parts of the face will be
bent metal sheets intersecting in space (Z. XIII, 21, 28-33, etc.).
Images of explicit anger and brutality become rarer. And where
the multi-face figure persists, it suggests neither primitive menace
nor inflicted mayhem; the transposed aspects impressed on the body
look less like pitiless operations. In fact, there is increasingly less
insistence on simultaneity as Picasso's women, for whatever private
or public reasons, begin again to delight. The evolution of Picasso's
work in the late forties shows a thematic divergence which was soon
to pose a fresh task—the task of rendering the figure all-round but
without detriment, i.e. without mortifying the impulse of desire
and admiration which first proposed the woman's body as a subject
of representation. The problem so postulated rules out any diagram-
matic superposition of front and back and any misfitting of dis-
jointed limbs. Freaks and diagrams have this in common—they dis-
courage embrace.

But if the graphic means developed for the expression of simul-
taneity keep diverting the image away from the joy of its inspira-
tion; if teratogeny, the production of monsters, punishes every de-
sire to project the caressing impulse on canvas and paper—then is
simultaneity still worth pursuing? Or is it adaptable only to tragic
and moralizing expression—and, for the rest, let painting stick to one
view at a time.

Ever since the *Standing Nude* of 1907 (Fig. 103), the *Demoiselles*
(Fig. 104), and the 1908 *Bather* (Fig. 127), the graphic devices
Picasso invented to express simultaneity had produced temporary
devenustation. But invariably the new device would end up har-
monized with his conceptions of beauty in face and body. Again and
again, Picasso's disjunctive-reconstructive technique is assimilated
to the lovable image—the two impulses sometimes in conflict, some-

160. Picasso,
Nude Dressing Her Hair,
March 7, 1954

159.

times unrelated to one another, in the end reconciled. Indeed, Picasso's hard-won techniques of all-seeing representation could not have sustained his creative goals had they remained inapplicable to a theme central to his manhood and art.

Delight and a spirit of celebration re-enter his art in the late forties and early fifties (cf. Figs. 159 and 125). In the spring of 1954 Picasso produced a series of drawings (Fig. 160) and two paintings (Z. XVI, 258 and Fig. 161) of women at their coiffure. Once again, after a decade's pause, the body is built up of inwoven aspects, but the body is happy and prepared to charm. The problem of simultaneity links up with a process of re-venustation—a process that was to culminate at the end of that year in the *Algerian Women.*

228

161. Picasso,
La Coiffure, March 7, 1954

How is a manifold anatomy housed? The drawings and paintings of 1953-54 had succeeded in harmonizing difficult circumplications with a spirited eroticism; but they showed figures in isolation, forms afloat on the neutral ground upon which the draughtsman Picasso likes to work out his rendering of a subject. This detachment from space is Picasso's native predisposition. Already in the 1908 *Bather* (Fig. 127), his bent vision was aimed at the figure's contours alone; there was no attempt to visualize a corresponding space warp, no transformation of the rudimentary beach. And ever thereafter, the inventor of Cubism chose periodically not to encompass his figures in spaces of like-minded consistency. One is struck once again by the polar character of Picasso's Cubist involvement. Within the range of his interests, the integration of figure and ground in an overall system remains—as it did for Michelangelo—one particular enterprise; not the painter's problem *par excellence*, but one task

among many; no more absorbing or valid than the invention of emblems, the projection of emotional states, or the mastering of representational problems, such as the problem of foreshortened motion for Michelangelo, or, for Picasso, the simultaneous showing of front and back.

Simultaneity had long been Picasso's outstanding problem in rendering. In the Algerian series, but most especially in the final climactic canvas, it unites with the problem of space integration.

Sleeper and Smoker in Canvas O (Fig. 162) do not really differ in style—they are both in Picasso's style of 1955. But they differ in representational mode, one faceless, schematic, the other comparatively naturalistic. They differ too with respect to their housing; if this were the inside of an accordion, I could imagine it compressed on the right, pulled out at the left. And they differ in the kind of claim they make on the beholder. While the slumbering one heaps her limbs about her unconscious center, the other stares back at the spectator as if to match his curiosity; his opposite pole. One could call them iconic and narrative, but with the narrative mode paradoxically the more abstract. Which of the two is the more solidly rendered is hard to say. The alert Smoker offers a single perspective, all frontage and no turns permitted, as enjoined by the fixed point of view. And she is drawn without tonal gradations, all contour and local color. Whereas the Sleeper's colors function as tonal values, making forceful suggestions of turning planes, like a folded construction. The two figures define one another in their distinctness, but also in their affinity. One is all aspect—the other, all aspects in one. Yet we know them to be interchangeable.

It is clearly more than a matter of juxtaposing "representational" and "Cubist" styles, or abstract and realistic. For the schematic Sleeper, who looks at first sight like the shook fragments in a kaleidoscope, is at least as stereometric in structure as a Japanese origami; and the Smoker is after all a painted emblem in the style of a playing card. Which has more volume—a paper sculpture or a Queen of Hearts? The variables which for us define truth to appearance are infinite, and Picasso learned long ago that they could be separated and shuffled.

For instance: in a classical work such as the *Three Graces*, all the figures are understood to be exactly or nearly alike; in terms of style, all are brought up to the same level of finish and anatomical specificity. They are distinguished only by orientation, i.e. in showing either their fronts or their backs. But their likeness to one another

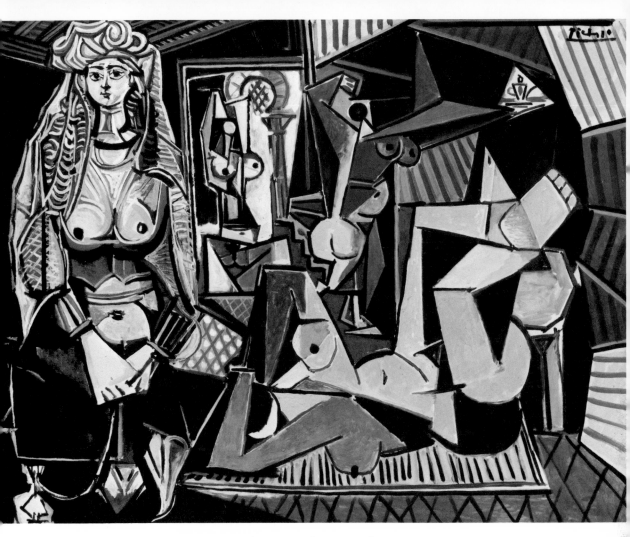

162. Picasso, *The Women of Algiers, O,* February 14, 1955

assures us that each figure actually possesses both a front and a back view, whether she shows it or not. The depicted figure is, as it were, endowed with two variables—a given anatomical character and a given orientation in space. Now Picasso reshuffles the mix. Having compounded both orientations in one, he feels free to vary the figures in anatomical specificity, leaving one of two interchangeable women in a schematic mode. The one with the pretty face has no other aspect; while her sister of many aspects has no particular face. Yet they are understood to belong, like the Graces, to one sisterhood. Picasso's anatomic "clichés," his repetitive body landmarks, guarantee the continuance of the family likeness under changing modalities.

And now each of the two has her appropriate ambience—appropriate in being ambiguous enough to sustain her own character as

well as her partnership with the other. If the left-hand figure had at first appeared to be modeled in a contrasting naturalistic style, but on second sight, showed a playing-card flatness, she becomes on closer acquaintance more compound still. Only from the waist up does she seem volumetric; down below, the inlaid terrazzo effect of her trouser folds establishes an affinity with the kaleidoscopic mode of the Sleeper. And even at top, her solemn solidity, set off against a receding space, turns out to be borrowed splendor. It derives not from her own modeling, but from two rearward features: the ceiling above and the door at the back. The beams at the upper left, with their hint of receding perspective, pull the smooth sable ground behind the figure's head into the semblance of a retiring corner. And in the distant doorway the Odalisque, her denuded cousin, crouches before the aboriginal niche, here at last re-erected for its final appearance; niche, Odalisque, and foreground Smoker defining three clear spatial strata. Thus the Smoker's apparent three-dimensionality turns out to depend entirely on those two distant elements at the back: the beamed ceiling that radiates stylishly from her hat and the molded jamb of the door that runs into the trim of her shoulder.

Given this striking cooperation in her behalf between doorway and, ceiling, it comes as a shock to observe that these features positively refuse to cooperate with each other. The doorway jars so destructively with the ceiling's perspective that it cancels it out. It re-flattens the space toward the right to meet the different needs of the Sleeper.

Like the other "pink nudes" in the picture, the Sleeper displays the blue Matisse complexion, her color set off with a lemon sparkle of yellow. But most astonishing is the use of internal blacks. A black wedge had first appeared in Canvas H as a means of keeping the front and back aspects of the figure apart. Now again it appears in the same central position, a black stake separating contradictory views of belly and breast; but what had seemed like a desperate recourse in Canvas H becomes here the module of a structural system. The flat black repeats at once at the buttock, where it serves as a functional shadow; higher up, it doubles for the gaps between legs; then, spreading away from the woman's body, and with continuing change of signification, the black proliferates in similar angular shards uncoiling in spiral motion and forming a cavernous canopy, a sleeper's space. The Sleeper's body becomes the great

reservoir, her members discharge the energy that shapes her sur-
round. In a process of body-to-space conversion reminiscent of early
Cubism, the surrounding blackness evolves in continuous passage
from the fallout of her limbs. But if the formal principle here ap-
pears to be that of Cubist process, it is scotched by the fourth figure
in the design—the Servant. Her headlong rush into the cave, pre-
ceded by her beacon of coffee, pierces the Sleeper's surround as if,
ignorant of Cubist principles, she mistook this black ambience for
a literal rendering of deep shadow space.

The picture is built on a symmetry of cancellations. On the right,
Servant and coffee pot, together with the striped curtain *coulisse* at
the margin, restore to the Cubist space the suggestion of stage-like
depth. On the left, a stated perspective of depth is annulled by flat
contradiction. While the left half of the picture shows an essential
illusionism confounded by elements of forbidding flatness, the op-
posite half invites elements of disruptive illusionism to break up an
essential abstraction. A concord of contradictions; it is the principle
of reciprocal counterchange—now expanded to a symphonic scale—
which had been with Picasso ever since his composite front-and-side
faces, wherein the profile portion was charged with a facing eye,
and the *en face* with the eye in side view—a mutual exchange of
competences designed to make the parts lock.

Cubism here plays a powerful role—but a role assigned within a
scenario. It becomes one of the several space-determining forces
whose clash on the pictorial stage may be likened to the clash of
doom-determining forces in tragedy. Old fixed-point perspective is
another such force, and, finally, the simultaneous sighting of one
body from dispersed vantages is a third—a space-determinant whose
sheer possibility depends on the co-existence of the two others.

Cubism, in its original break-up of pre-faceted solids, had indeed
furnished the tools for Picasso's subsequent interweaving of aspects.
But that problem, and the goal it pursued, Cubism neither solved
nor confronted: the vision of a thing reappearing, as it were, suc-
cessively in the same contoured place; its incarnation in simultane-
ous aspects, each itself flat as a baroque brushstroke is flat, but in
combination, a record of sensuous perception.

Look at the Servant, compounded of a full backview behind and
a full front view before—as if we had stayed with her form as it
turned. And the Sleeper, whose repeated left side turning over we are
given to know with a kind of prolonged intimacy. As Picasso finally

renders the Sleeper's form—her body a coincidence of front and back within palpable contours—the familiar visual distinctions between right and left, between things here and hidden, between now and anon, settling and rising, all dissolve into forms of awareness whose affinities suggest both further abstraction and fuller possession. Such formal rendering implies neither a Cubist nor a perspective space, but a space already entered, inhabited by the eye as by a roaming caress.

The idea of such immediate knowledge as subject of representation furnishes one impulse for the conflation of aspects in the *Femmes d'Alger*. Servant and Sleeper, objects of a perfect possessiveness, occupy an invaded space, like the inside space of a pocket, like a cat's cradle.

But they represent also the opposite—a program as cerebral as any undertaken in twentieth-century art. Their physical simultaneities are evolved through tireless tries and adjustments to make their limited surface convey a maximum of three-dimensional fact; testing the capacities of the flat field for improved efficiency as a conveyor of data—to make it operate within the picture as would a chart, blueprint, or engineer's drawing—informative beyond the limitations of physiological sight. The quest embodied above all in the Sleeper is for the form which satisfies both the impulse of erotic possession and, at the same time, the most systematic investigation of the plane surface as a receptacle of information. In other words, to discover the unique coincidence which is at once diagram and embrace.

In Canvas O the unexpected coupling of that compound figure with another of iconic frontality comes to seem perfectly logical. The artist's two-natured vision is herewith externalized, induced by the contrast of representational modes. For it is the normal physiological vision which confirms itself in the waking woman, being fixed by her glance at a fixed point of view. And it is a vision released from fixity, a vision at large, which is mobilized by the simultaneities of the Sleeper. The pairing of the two figures in their respective modalities objectifies that powered sight whose realization had for fifty years engaged the artist's hand.

In this enterprise Picasso has had neither help nor companionship; nothing in modern art that encouraged it. The shared goals of painting since the mid-century lie elsewhere.

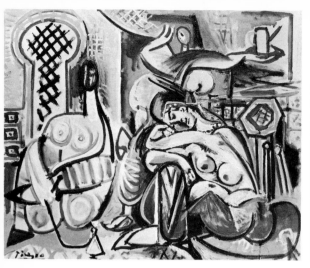

A (December 13, 1954)

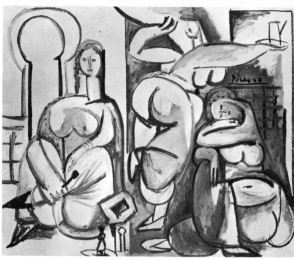

B (December 13, 1954)

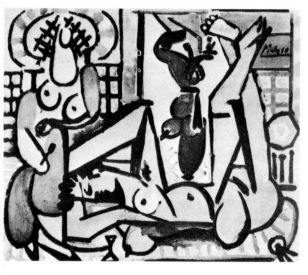

E (January 16, 1955)

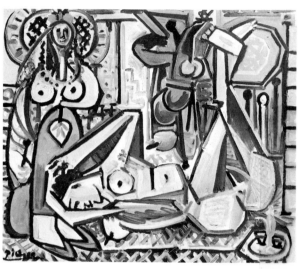

F (January 17, 1955)

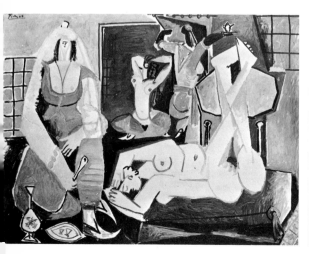

J (January 26, 1955)

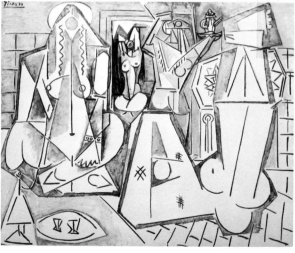

K (February 6, 1955)

Picasso, Variations on Delacroix's "Women of Algiers"

7 Monet's *Water Lilies*
(1956)

We read of the aging Monet that he lost confidence in his late works and thought of burning them. We have been told that "Monet's later pictures are not very successful . . . when he lost his precision of eye he could not compensate for this with a like precision in design."[1] And we hear from Monet himself: "I have taken up some things which it is impossible to do: clear water with grass waving at the bottom. It is wonderful to look at, but to try to paint it is enough to make one insane."

One of these paintings that were impossible to do has just been bought and hung by the Museum of Modern Art (Fig. 163). And it is wonderful to look at for an hour or so at a time, for you can do things to it with your eyes—tip it into a horizontal plane, then let it snap back to an upright sheet; gaze along placid surfaces, then look through them, five fathoms deep. Search opaque waters for diaphanous shrubs, and find a light source at its destination. You can invert the picture or yourself at will, lie cheek to cheek with the horizon, rise on a sinking cloud, or drift with lily leaves across a private sky. And yet this is no daydream; every part of it is true, so that one looks and stares with a sense of discovery.

The canvas—roughly eighty inches wide by twenty deep—forms one of the *Nymphéas*, or *Water Lilies*, series which occupied the septuagenarian painter during seven years, and of which the best known, thanks to Clemenceau's insistence, decorate two large oval rooms at the Orangerie behind the Place de la Concorde.

First published in *Arts* magazine, February 1956.

235

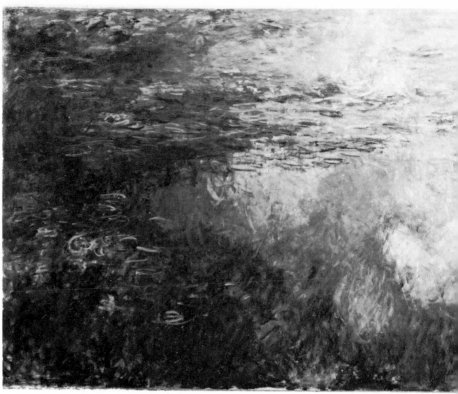

163. Claude Monet, *Water Lilies, ca.* 1925 (?)

Monet's immediate inspiration had been the lily pond in his own garden at Giverny. By 1914 he had decided to embark on a vast decorative cycle based on that theme, had ordered fifty enormous canvases and the building of a new studio; and while younger Frenchmen trained their sights on German trenches, Monet gazed at his lily pond through dimming eyes, and with a spiritual courage for which language has only physical analogies.

These scenes offer just enough of the lake to be inadequate for perfect orientation. They come close to a direct intuition of space, purposely suspending those locatable objects which our minds habitually use as resting points, markers for space calibration. Only now, after a lapse of thirty years, are we quite ready to accept these veiled, moist, unconfigurated ambiguities, and to perceive that the leap Monet made in his last years puts him closer to Mondrian than, say, to Corot.

Before seeing the Paris *Nymphéas* I had been wondering for some time at his *Poplars* in the Metropolitan Museum, painted in the early nineties (Fig. 164). Four tree trunks, slicing down the canvas, parts of them "real" and the rest in reflection, while a single horizontal, traced by the river bank, steadies the design and lends the scene a temporizing plausibility. But the river bank is a thinning

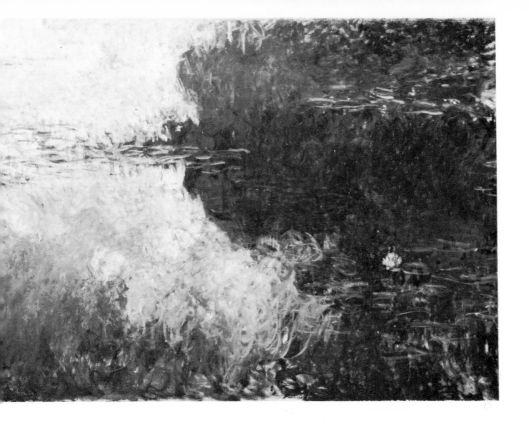

line, a last valedictory hint at that extended underprop of space which was Masaccio's gift to art, on which in former times all bodies had found rest, on whose gravitational pull you could count as on a reassuring constant. It means after all a great deal to a man to have ground under his feet, to know even in the rapture of a jump that such a ground exists, and preferably not too far away. In Monet's *Poplars* that base of certainty is in suspense; it promises the perils of a tightrope, and one-half its value is a watery illusion.

Most of his life the painter had been fascinated by reflections in water. Then, in his later years, he seemed to have found the cause of that fascination and to have faced what it implied: that a ground-line which arbitrates between the actual and its false mirror image separates two absolute equivalents, like the midline of a Rorschach blot; that the hierarchy of things more or less real is not determined by degrees of tangibility; that all those things are real which fully form the content of experience.

It is not only because the picture consists of vertical and horizontal lines that I invoke Mondrian's name. For the affinity goes further, further even than the shifting play of space between the bars of the resulting grid.

Both men were drawn to the painting of trees. And a tree, as ev-

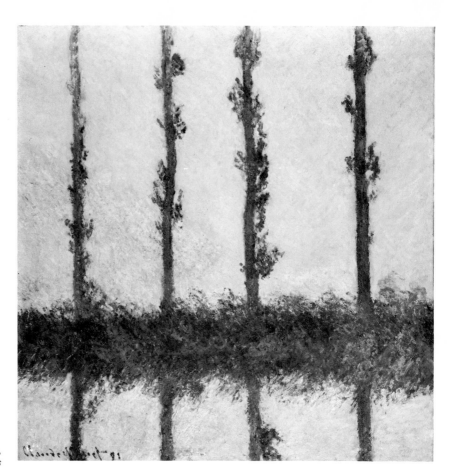

164. Claude Monet,
Poplars

erybody knows, is a rising vertical that spreads wide at the top. Mondrian suppressed the verticality and turned the tree into a total field. Monet, I believe, did the opposite, but for a similar purpose. He truncates the thing, leaving some shoots on it admittedly, but nonetheless chopping it down to a near-abstract vertical. He has disengaged such a fragment as will not tally with our concept—so that, as we faintly recognize a row of trees, we the more surely recognize a set of upright lines. The painting can still pass as a topographical portrait; but from the viewpoint of convincing likeness to a country scene it can, without loss, be turned upside down; only its pictorial balance will be shaken. So then the apparent rightsideupness of natural things is but a projection from our human posture. And the pictorial form arrogates to itself that meaningful necessity which used to belong to the objects depicted.

238

What could have led Monet to place his verticals over clear water? The effect is to make the recession of the horizontal water level little more than a transparent hoax. What we are more tangibly given is the continuity of verticals in a plane parallel to that of the picture. Just so, the acid shadows of his *Haystacks* at the Metropolitan Museum seem to dissolve the spreading ground in front, presenting once again a mirror image in plumb-line descent. But I suspect that there is more in the curtailment of his poplars than the picture's abstract self-assertion. For all his fabled and acknowledged realism, Monet now looks in nature for those fractions in which—torn from all mental moorings—the appearance becomes apparition. There is a vision here beyond the scope of finite forms, and we receive a glimpse of boundless extension. No clues are given as to when or where these beams will stop developing; no limits are set to their self-propagation—and the effect is infinite.

Which brings me back to the new picture at the Modern. Monet has found infinity in his back garden by the lily pond—and this is what I meant before when I said courage. Like Cézanne, he came to doubt whether his latest painting still made sense, and whether it might not as well be burned. He had set out to formulate a twentieth-century vision in the fine, cultivated idiom of the nineteenth—in his own words, "to produce an illusion of an endless whole, a wave without horizon, without shore."

And so, in the *Water Lilies*, the law of gravity—that splendid projection of the human mind lodged in its body—is abrogated, as in the underwater movies of Cousteau. The only horizontals are festoons of algae, leaves, and reeds placed very high. The bright, languid cloud in the lower center falls at a rate determined by its shape and hue alone, indifferent to any general law governing falling bodies. And near at hand grasses and rushes rise and levitate in full defiance of our experience of space. The whole world is cut loose from anthropomorphic or conceptual points of reference. Those points are still available, but they no longer constitute the world. If we must put them in, we may; for the picture is willing and the world pliant enough to accommodate any construction that will serve our needs.[2]

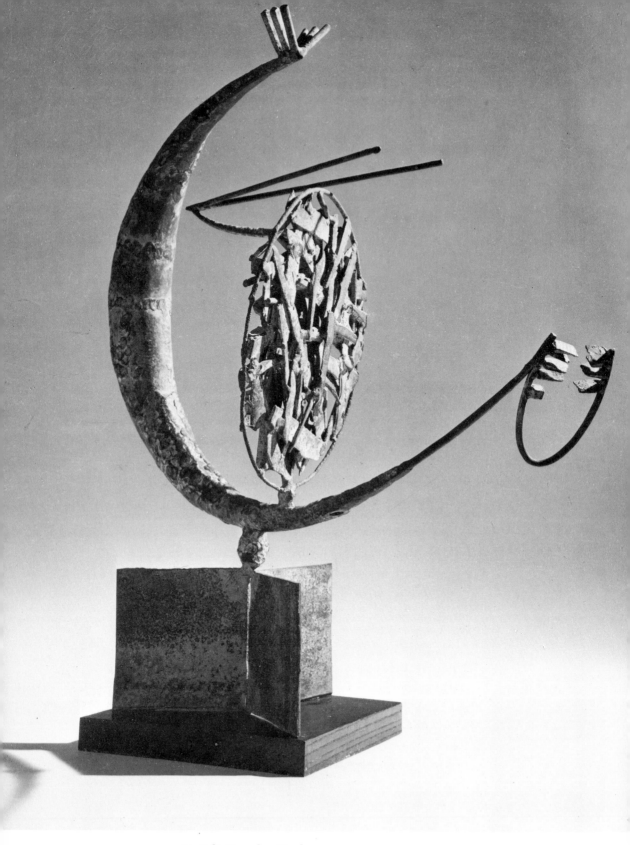

165. Julio Gonzalez, *Head, ca.* 1935

8 Gonzalez
(1956)

Julio Gonzalez died fourteen years ago in a suburb of Paris. Now for the first time his collected works in metal sculpture are being shown in this country (Museum of Modern Art, New York and Minneapolis).

At the time of his death, Gonzalez' work was scarcely known, except to brother artists. Some of his sculpture had been included in various Paris and Brussels exhibitions, and his name occurred in a few scattered articles. In 1936 the Museum of Modern Art was the first public institution to acquire a Gonzalez—an open construction of welded iron, called simply *Head* (Fig. 165), but of such originality and power that it was able to inspire a whole school of post-war sculpture in America. Then four years ago, a half-dozen of his major pieces turned up in the Museum's "Twentieth Century Sculpture" exhibition: whereupon the *Woman Combing Her Hair* (Fig. 166) passed into the permanent collection, giving New York two of Gonzalez' finest works.

Watching them over these past years I sometimes wondered at the old saw which declares beauty to be only skin-deep—and which thinks itself profound, whereas it is in fact particularly shallow. For the proverb acknowledges only the beauty of closed, compact forms as they reveal themselves in patent surfaces. It hails from a baby-stage of thought which relates to things by dabbling and paddling, and which cannot conceive without grasping.

There exists another order of bodily beauty which has nothing to do with the surfaced physique; it is the beauty which our body bor-

First published in *Arts* magazine, March 1956.

rows from the bend of a baroque staircase as it molds the path of
our climb; in which a driver participates as he rounds a well-banked
curve in the road. It is the beauty of a gesture which even a mis-
shapen limb might describe, or which a skater unfolds in the dura-
tion of motion. It is the beauty of the diagonal you make striding
into the wind; of the lean upright you draw when you stretch your
full height; of all those lines of force which traverse the felt interiors
of the body. And it is a beauty which flows more intimately from
the sources of freedom and life, depending little on accidents of
superficial structuration, and so much more on what we do.

This beauty is the theme of Julio Gonzalez—one of the great sculp-
tors of our time. His figures of sheet metal, iron rods, and strips are
insistently human, and as representational as empathy makes them.
Abstract they are only to those who seek their prototypes among
forms of external knowledge. But the kingdom of Gonzalez is within
you, and his types are the internal aspirations of your body and
mine.

It is said by healthful pagans that there is no living the good life
without pride of body. That pride had been restored to Western
man when the Renaissance (some would say the High Gothic)
sculptors recovered the classical form and posited man as self-
centered and self-motivated, and equipped for life in freedom and
efficiency. Thereafter, Narcissus gazed continually into the mirror
of his art—till he lost faith in the image. Turning from reflection to
introspection, he came to doubt whether it was truly he that was
being reflected, whether some less silvered surface might not yield
a truer portrait, and whether even that would be worth looking at.
By the time this century came around, the Narcissus in our art had
grown cold to the charm of its own figure. The great critic, Roger
Fry, once tried to account for the superiority of African statues over
Western figure sculpture by pointing out that, since the human
body is shaped much like a starfish, no realistic rendering of it can
hope to come to a good end. And a famous modern sculptor com-
plained of the gratuitous tyranny which requires an artist to put
exactly two eyes in a face when perhaps the rhythm of the piece
would be much better served by one or three. Gradually the human
figure drained out of Western art. Its symmetry had grown uninter-
esting, its vaunted beauty had become an irritant, and its alleged
autonomy, a mockery. In its classical mode the figure made its last
significant appearance in the work of Rodin and Degas; and there

that friendly form, as if submissive to a law of entropy, seems threatened with dissolution.

In Rodin's later work anatomy is no longer a fixed rule, anterior to each human body; it has become the fleeting figuration of a moment, always transient, accidental. Already in his *Head of Sorrow* the salient midline of the face is dislodged, shifting as flour shifts in a sack, and separating the head into odd halves. The energies that stir behind the classical facade are growing restive, and cannot be dammed up much longer.

As a concept of energy and form this is precocious, but as a body concept it is the late fruit of the Renaissance, touched by what wine growers in France call *pourriture noble*—the fine putrescence of the grape that is past ripeness.

For a better estimate of Degas we had an opportunity several months ago when Knoedler's, for the first time, showed over a hundred of the artist's wax originals—very different from the familiar bronze casts. Those unforgettable small figures of nude girls and horses were done by an old man who was fast losing his sight. He groped his vision into wax, and with such sensitivity, and from so deep a source, that the emerging bodies seemed to have sloughed, or not yet donned, some outer skin. Beyond all nakedness, they presented themselves in such utterness of physical surrender, such fresh, incredulous surprise at their own incarnation, that all their action, tubbing, scrubbing, and what not, seemed to say, This is my body. Against these little waxes, all the nude statuary I have seen looks almost exo-skeletal, the hardened, time-tempered integument of external anatomy hiding what is body beneath a harness of antique design. Degas' statues vibrated with the tremor of a nerve exposed, so gingerly were they in trying themselves out, so recent was their fall out of their author's brooding into flesh of their own. Their materiality appeared provisional and tentative, their surface vulnerable and untouchable, like a bird's body or an infant's skull held in the hollow hand.

In Degas, as in Rodin, the human form as a stable system seems doomed beyond hope of endurance.

What happened after that we know. Our body became not the hero, but the victim of life. If it survived in our art, it was by submitting to an inhuman rigidity, a demonic possession, or as the accident of impersonal physical forces. We got the dissections of the Cubist sculptors, the primitivist fetishes of one school, and the

glassy constructs of another. We admired the foetal biomorphs of Arp (to whom "Art that upholds the vanity of man is sickening") and the pebbled, ocean-worn anatomies of Henry Moore. In the hushed forms of Brancusi we watched the unexperienced purity of Platonic ideas; and in the figures of Lachaise a ballooning buoyancy which never appertained to man. Deprived of its own pride, the human body borrowed virtues from all alien things—much as primitive man, conscious only of his physical inadequacy, must appropriate the swiftness, potency, or antlered radiance of his totem animals.

Those sculptors who continued to present the figure in traditional classic array paid for indulging their nostalgia by losing significance. Why this should be we don't precisely know, but have seen it happen even to Maillol and Despiau—there is a drowsiness about their forms which fails to tax our sensibility where we are most awake.[1]

Within this century, then, Julio Gonzalez stands almost alone, the rare blend of an artist who is both modern and a humanist. Modern he is because his forms are vital, open processes in space. He is a humanist, firstly, because man is his lasting theme, and his works, when they seem least anthropomorphic, remain anthropo-kinetic. And secondly, because the kind of kinesis he imputes to man tends to be proud, free, energetic, eliciting not pity or recoil but admiration.

His irons sway with the *déhanchement* of a gothic madonna or lift themselves with an alerted swagger like Donatello's *St. George*. His life-size *Angel* (1933), for all its delicate allusion to the praying mantis and the dragonfly, is but the active principle sucked from the stone-carved angel who mounts guard by the New Tower of Chartres. The lithe metallic undulations of his *Woman Combing Her Hair* (Fig. 166; 1936) scaffold and imply the flesh of Aphrodite. And his *Femmes assises* (Fig. 167; 1935)—whose torsos are bare iron bars—are as triumphantly erected as the enthroned kings of Egypt.

It is this that is new in Gonzalez—to have seen the human body in its strength, while employing a contemporary, subcutaneous vision. He has, as it were, earned the right to use that theme again, because he has discovered it from a new vantage point. Like all modern artists, he knew that the world as it shows itself to sight and touch is a comparatively narrow sector of experience; that there are areas of awareness open, for instance, to our kinesthetic nerves. Tuned to their signals, Gonzalez' shapes seem determined by an

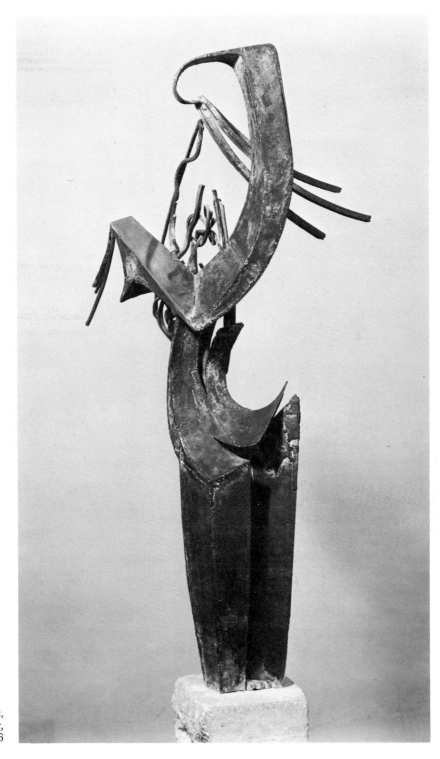

166. Julio Gonzalez,
Woman Combing Her Hair,
1936

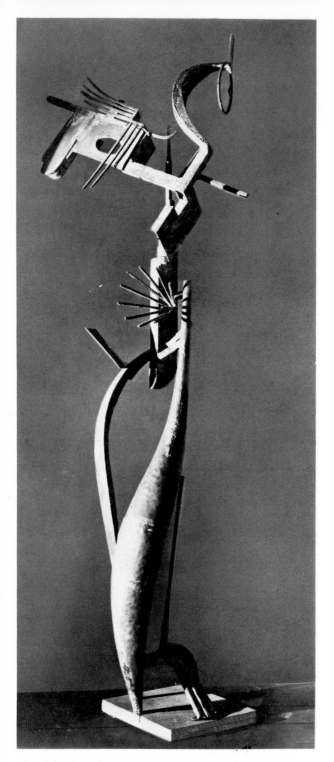

167. Julio Gonzalez, *Seated Woman*, 1935

168. Julio Gonzalez, *Woman with a Mirror*, 1936

inward apperception of dynamic functions, never by the look of
forms externalized and thingified. If a mounting horizontal projects
from the great verticals of his two seated women, it echoes the in-
trinsic sense that the braced body has of the chest cantilevered from
the dorsal region of the spine. A mouth in a Gonzalez head is ren-
dered as a tube, or a prehensile, dentured trap, depending on what
the mouth thinks it is doing. In the *Head* owned by the Museum of
Modern Art, the eyes are two darting prongs, a figure so native to
our sense of what sight is that it inhabits countless metaphors of
common speech. In the lovely *Woman with a Mirror* (Fig. 168;
1936) the leg-and-pelvic space is swept by a fertile shape which is
both seedpod and thigh, but more than either—the trajectory of a
caress.

Not that each element in these works can be parsed in this man-
ner. There are, as in contemporary verse, elisions and contracted
metaphors, and one yields ultimately to the sheer poetry of the
whole. Nor would I argue that its humanistic content represents the
whole meaning of Gonzalez' work. But so often when the subject
of the human form in contemporary art comes up, the alternatives
are posed in terms of a return, or a refusal to return, to the figure.
Gonzalez shows a modern art that does not go back to the figure, but
goes forward to encounter it at the next station.

More than the humanistic, the formal aspect of his sculpture has
aroused interest in recent years. Much of the openwork metal con-
struction both here and in Europe has sprung from his example. But
the interaction of solids and voids is realized in his work as in no
other man's. In some of his mature creations of the middle thirties,
the empty fields seem structured by magnetic tensions, so that an
entering object would, one feels, be drawn at once into some neigh-
boring orbit. In the Museum's *Head* the parabolic course of the
great crescent so defines the enclosed spatial intervals that they
seem filled with an elastic medium which moves and transmits mo-
tion, stores and releases energy as pressures are applied and with-
drawn. Suddenly the image moves off into astronomic space, so that
cosmos and head-of-man coincide in a fleeting equation.

Sometimes, as in the *Woman Combing Her Hair*, the enveloped
spaces seem filled with impenetrable matter—like the blank patch
of paper about which an Ingres traced the outline of a head. All

169. Julio Gonzalez, *Torso*, 1936

170. Julio Gonzalez, *The Montserrat*, 1936-37

emptiness is impregnated by this "drawing in space," which Gonzalez called the new art. "To project and design in space . . . to construct with it as though one were dealing with a newly acquired material—that is all I attempt," he declared.

And again: "The important problem to solve here is not only to wish to make a work which is harmonious and perfectly balanced—No! but to get this result by the marriage of *material and space*. By the union of real forms with imaginary forms, obtained and suggested by established points, or by perforation—and, according to the natural law of love, to mingle them and make them inseparable, one from another, as are the body and the spirit."

And there is the material aspect of his work—the semi-precious quality which his hand, by its deferential treatment, imparts to the iron. "The age of iron," said Gonzalez, "began many centuries ago by producing very beautiful objects, unfortunately for a large part, arms. Today, it provides as well, bridges and railroads. It is time this metal ceased to be a murderer and the simple instrument of a super-mechanical science. Today the door is wide open for this material to be, at last, forged and hammered by the peaceful hands of an artist."

Read in the wrong spirit—as an objective proposition—these words could sound naive; but they describe the transvaluation of a beggarly element, and I suspect that they reach up from the artist's soul. He was the son and grandson of Catalonian metal workers, and his hard rods and sheets are handled at a point of mastery where they seem eager to disavow their intractability. This is particularly striking in his late realistic work in welded sheet iron, the *Little Egyptian Torso* of 1934, the large *Torso* of 1936 (Fig. 169), and above all, the life-size *Montserrat* (Fig. 170). Here one hardly knows whether it is the sculptor who had the will of iron to impose, or the iron which assumed the leniency of a human intent.

In view of his unsurpassed craftsmanship and his gift and ultimate genius as a sculptor, it is a strange fact that Gonzalez did not recognize his vocation till well past his fiftieth year. His early life was misdirected into painting, and most of his sculptures before 1934 are of essentially biographic interest. A. C. Ritchie, who arranged the present exhibition, suggests in his catalogue introduction that the artist's deferred maturation may relate to the elastic and procrastinating time sense of the typical Catalonian. But the case of an artist who, late in life, discovers his true self close to his father's

occupation is better explained by individual than by national psychology.

Not that this matters in the end, for the sequence of Gonzalez' work has its own logic of growth. It begins in the late twenties with small-scale, occasionally clever variations on the work of the Cubist painters. Ideas are imported from Picasso, Lipchitz, and Gargallo, and the primitive arts they admired. In its stylistic indecision a bronze like the *Spanish Mask* of 1930 is painful to see. Roberta Gonzalez, the sculptor's daughter, has given us some hints of the self-doubt which racked her father during those long years.[2] But in the works of the early thirties, the new technique is explored and begins to point at expressive purpose—though they retain a gawky, virginal naiveté (like the *Woman with a Basket* of 1931 and the *Standing Figures* of the following year).

There comes a breath of confidence—and crudity—with the stick-figured *Prayer* and the *Dancer with Disheveled Hair;* and the first sign of an intense personal vision breaking through in the *Maternity* of 1933, the *Angel,* and the series of small heads. The greatness of Gonzalez rests finally on some dozen works produced during a four- or five-year spurt, works into which the man of sixty hammered his long-abeyant youth.

9 Recent Drawings, USA
(1956)

"Recent Drawings, USA," 150 works by as many artists, will show at the Museum of Modern Art from April 25th to August 6th (1956). Most of the works are of large size, and everybody will find at least ten among them which are very good. But first, as the French guidebooks say, *un peu d'histoire*.

Two years ago the Museum's Junior Council organized an exhibition of young American printmakers. At that time, 1400 entries were received, 110 were selected, and 381 prints sold to the public. Basing their expectations on these manageable figures, the Council sent its latest call for drawings coast to coast, and this time harvested 5000 entries from forty-six states. William S. Lieberman, Curator of Prints at the Modern and in sole charge of selection, eliminated 4850, the chosen remnant representing twenty-seven states and a wide range of non-professionals. It is consoling to discover that the professionals steal the show. The untutored genius is a fable after all.

Let me say as a first generalization that, regardless of quality, nearly all the works exhibited are complete and elaborate statements —not drawings so much as pictures in black and white. With few exceptions they exclude those exercises in which the artist, or the artist as student, merely probes some limited problem. Rare, too, is the drawing as *modello* for some larger piece. Even the sketch, the hasty notation, is barely represented.

In past times, when artists were working from nature, an exhibition of drawings would have felt different. While, in the process

First published in *Arts* magazine, May 1956.

251

of drawing, the artist's eye was fed by the visible world, there occurred an almost automatic translation, like a conversion of energy, by which the action of seeing became a movement on paper. The drawing took shape almost unchecked by the artist's eyes, which were too closely engaged in the visual field to take much time out for looking down at the page. The result was often a witty elision, and a constant discovering that more could be done with less.

At the Museum show, the artist's eyes are riveted to the sheet, and the hand is employed in subdividing and articulating forms already found in the large. With the world shut out, or only dimly remembered, the artist seems closeted with his drawing; and whenever inspiration lets up, the recourse is to repetitive ornamentation and patterning. In fact, one of the charms which one traditionally associates with drawings is made very little of in this show—the darting spontaneity, the reflex to a sudden observation, impulse, or thought.

Perhaps this is because these virtues of immediacy have lately migrated into easel painting. Most modern painters do their working out on the canvas itself, so that errors, feints, jilted alternatives, and false starts build up into a layered and historiated surface. The one-time excursions into separate sheets are telescoped upon one and the same canvas, whose upper skin comes to be charged with the record of displaced possibilities. As a result, the drawing as study no longer has meaning, and, like printmaking, draughtsmanship survives only as a self-fulfilling art. In this exhibition, at any rate, one feels that the traditional relation between drawing and painting is reversed, that when the artist wishes to assert the countervalues of deliberate design and careful execution, he turns to the lesser medium.

But if spontaneity is rare, there is, on the contrary, much punctilious detailing and texturing—the kind of work that suggests a watchmaker's care for precision. William C. Asman draws his *Reclining Figure* with monkish concern for each stippled mote. Jules Kirschenbaum's *Cape Cod Landscape* is precisely elegant, composed of millions of obedient molecules, and more than a little cold since not one of them dares move for fear of collision.

The *tour de force* in this class is Peter Takal's *Wood*, a dendrologist's dream. Subtly inventive in its range of textures, it suggests both the act of meticulous making and the state of prolonged contemplation. Its minutely worked surface is lightly borne by the

curve of the whole. The artist builds as though he had nature's own leisure.

One other drawing in this patient group stands out: Varujan Boghosian's *Village in the Storm* (Fig. 171). It is less a monument of perseverance than a genuine work of expression. And that expression is fairly disturbing, for it hints at the obsessive overinvolvement of the insane, as recorded in their fastidiously trivial drawings. I hasten to add that an artist who so knowingly controls his theme cannot be actually deranged, though he may be quite mad in the best sense of the word. Boghosian obviously knows a good deal, and one isolates some of his sources as one savors the ingredients of an

171. Varujan Boghosian, *Village in the Storm*, 1955

172. Clinton Hill,
Untitled, 1955

interesting dish. Thus his lines are produced in tiny punctuations, somewhat like Beardsley's; his whirls and eddies recall waters painted by a Chinese hand; others are isobars as from a weather chart. The circlets, wheels, and dragon's teeth at the storm centers —a kind of ornamental electricity—repeat the inlaid mother-of-pearl patterns found on the stiles and panels of Islamic doors. The vision as a whole may have a remote origin in Leonardo's *Storm in the Alps,* and a closer source in Klee's *Demon Above the Ships;* and a tang of madness or humor, of absurd pretence to meteorological veracity, infects every part. All of which adds up to saying that Boghosian is an original.

Strange to say, the abstract pictures on view number less than a score; obviously few of the better abstractionists cared to submit. But Clinton Hill offers one of the rare examples here of true draughtsmanship (Fig. 172). Its every line aims at its destination; each patch of tone vibrates with its neighbor; the open spaces work with energy. The drawing is done with such dash and decision that it is hard to believe the resulting pattern to be pure invention.

254

Another drawing outstanding in this collection, where much timidity, travail, and gaucherie are on display, is Jason Berger's *Landscape,* a brief statement that stops short once it has made its point. Here too, as in Hill's abstraction, the neutral paper becomes active brightness and light; the lines move with agility, and while they hold to the surface they contrive the third dimension dancingly, as if in play. Few other works here have a comparable radiance.

The Berger drawing is further remarkable for succeeding so effortlessly in the suggestion of plenitude between outlines. I raise this point because numerous figure drawings in the show strive for fullness, yet achieve only a superficial resemblance to older drawings. Those that use heavy chiaroscuro do of course evoke some illusion of volume, for the method is fairly foolproof. But I am now thinking of line alone, and I observe that the linear description of plasticity seems to be beyond the power of those who attempt it.

Now the evocation of volume through line is a feat which, during four hundred years, most self-respecting artists in the West could take for granted. When a Renaissance draughtsman, or even a Baroque master like Rubens, drew the contour of, say, a man's shoulder, he conceived it as a localized, small-scale horizon, which made an apparent line only because his vision was not periscopic. But he knew that this edge he was drawing was not a thing, that it stood for a process, for the event of a curvature turning out of his sight. And he symbolized this event by the dark trace of his medium, even though nothing dark showed at the contour observed.

In the drawing of contours as such there is of course nothing remarkable. Comics are drawn the same way; an outline is made and we are told that what's inside is a man. To which we assent from sheer habit.

But the miracle of great draughtsmanship in the past was not its conventional use of outlines, but what it compelled us to read around and between the lines. Whether or not shading was used, the contour itself was tensed in a transverse direction—like the edge of a full-bellied sail with the wind sitting in it. Where no mark was made on the paper, precisely there the form swelled to its summit. The drawn line, passing through thick and thin, pressing down heavy or light, sometimes breaking and leaping and doubling, became prodigiously descriptive. So that a Holbein could draw one faint, tremulous horizontal to the south of a nose, and from above and below, flourishing lips would bear down upon it. Surely this is

as close as man can come to spontaneous creation, or even to won-der-working. For of Moses' rod we are told that it parted a sea, and raised pressuring volumes of water on both sides of the line he had marked. Sometimes I think that Holbein, in a dry medium, did al-most as much.

But it was not Holbein alone, or Rubens, or Ingres. In varying degree this capacity of the contour—moving one way but controlling a region, like a battleship whose power is not in its course but in the range of its broadsides—in varied degree this strength of the contour was a near-universal possession, one of the chief stylistic traits of post-Renaissance art. And it is this possession which has gone by the board.

In the realistic figure drawings now shown at the Modern, the forms, even when coaxed with elaborate shading, remain un-achieved. Outlines are traced, but with no lateral span, and the paper won't rise in response. The indicated solids lack the expand-ing pressure. Somehow the wind has died in the sail, and the sheet is becalmed. What was common possession when it was part of a vigorous style seems now beyond reach.

But why should this be? Perhaps because it is possible, and at times necessary, to see the linear contour in a different light. It then appears that the contour intellectualizes what is given to sense. It evades the blunt bulk of a thing to flirt with its margin. It describes, implies, goes around it. It is, as the mystics say of rational thinking, knowledge *about*, not *of* a thing. It was Holbein's and Ingres' way, but as new aims were envisioned it had to be dropped.

You can see it happening in Delacroix who could, when he wanted to, draw as suggestive a contour as Ingres. But in his pen drawings of riders and lion hunters he prefers to take the full brunt of a form. Instead of trapping its substance in the outer fence of its edges, he likes to meet it head-on, where its mass has most density. He hatches away at the first fronting plane, then claws the averted planes with graining striations. He seems to grapple his forms in a close scuffle and only loosens his grip here and there to let the light in. Compared to him the classicists work with a hands-off gentility.

Van Gogh goes a step further. His later imagery is immersed in universal mottling, hatching and reticulation. One is reminded of Walter Pater: "That clear perpetual outline of face and limb is but an image of ours, . . . a design in a web the actual threads of which pass out beyond it." Sometimes Van Gogh does confirm his

outlines with deliberately crude, heavy strokes, but then they are schematically superimposed on a system whose real existence is without them. More often, his contours become incidental; and they suffer all kinds of distortion, for instead of containing their mass they are tossed by volcanic pressures.

In many more recent works the line of the draughtsman withdraws altogether from the surface of forms (which alone can yield contours). Now it identifies itself with the nerve of a thing, then with its inner construction, or with the strain of an action. The drawn line becomes vector. And then a form does not stop where its spurs are, but where its effectiveness is—far out into space. And that space must be shaped, being unique to each action.

What I am trying to say is that modern art has gained certain valid insights into an order of reality, and that these insights cannot be ignored when that same reality is under discussion. The reality of a closed solid in a passive space has been too intelligently challenged in recent art to be simply reaffirmed in the old terms by the old methods of delineation. If it is to be reaffirmed—as I imagine it will be, since it answers to a common human experience—it will be done only with new insight and a new passion for form.

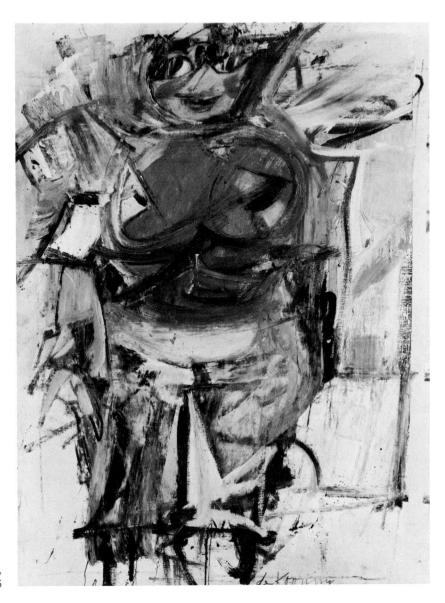

173. Willem de Kooning,
Woman—Ochre, 1954-55

10 De Kooning's *Woman*
(1955)

In the spring of 1953 Willem de Kooning shocked the New York art world with six enormous paintings at the Janis Gallery "on the theme of Woman." The present works at Martha Jackson's, most of them done last year, are still devoted to that theme (Fig. 173). How do they look now that we've caught our breath?

Two years ago a famous critic saw in them a "distortion of the figure to function in the overall design rather than to function in human appeal." This cannot stand, for de Kooning's name is not Matisse, and he is making no designs.

His *Woman* is distorted? Distorted from what norm?

She is no more distorted than a lightning bolt is a distorted arrow, or a rainstorm a distorted shower bath. She is a first emergence, unsteeped from a tangle of desire and fear, with some millennia of civilizing evolution still ahead of her.

Before this *Woman* can be educated into femininity men must first overcome the Amazons, make the world safe for patriarchy, repress their ancient myths, achieve an intellectual detachment from experience, observe the female form with a disinterest that is cool and unafraid, and, after ages of unruffled study in a stable world, produce the measured data of anatomy. De Kooning's *Woman* has a long way to go before she can become an Aphrodite of Praxiteles.

Does that mean that, in the words of the critic, she lacks "human appeal"? Not in the least. In fact she is disastrously erotic in some

First published in *Arts* magazine, November 1955, reviewing the de Kooning show at the Martha Jackson Gallery, November 7 to December 3, 1955.

remote, paleolithic way. Like the Venuses of Willendorf and Men-
tone she is all vulgar warmth and amplitude; like them she stands
huge, stupid, and receptive, without arms or feet, innocent of that
acquired grace which is bred into the girls we think we know. Grace
may be woman's second nature, but de Kooning is not concerned
with nature once removed. His *Woman* is at once more old and
young than the beauty whose appeal is to our waking taste. She is
the fluid, touch-determined image of the newly-born; the remem-
bered flesh that yielded at all points to the lover; the succubus that
lies too heavy on the drifting consciousness of sleep. She is shame-
less and innocent, as yet too female to be feminine, part witch, part
farmer's daughter, part mother and part whore; a power too com-
prehensive and immediate to be watched and rendered with con-
trolling skill.

Some have seen hatred or a caricature's gibe in this de Kooning
apparition. I have been told that she looks ugly. I am unable to see
ugliness or hate in these marvelous paintings. To me they suggest,
on the contrary, a fierce generosity. For the capacity to love only the
prettiest chorus girl in the line bespeaks a finical emotion, one so
narrow and so niggardly, there is in it as much of lacklove as of love.
It takes a manly heart, like that of Rubens if you like, to stake the
bounds of lovability more wide, and to love Helen for all her silly,
puckered knees.

Perhaps this is the Netherlander in de Kooning (who came to this
country at the age of twenty-one). For the Northerners alone had
the stomach to love real flesh, to accept men and women without
idealizing, Platonizing, and Italianizing them.

It is an interesting question how de Kooning's *Woman* relates to
the abstractions that have made him a leading exponent of New
York's *avant-garde* almost since his first one-man show in 1948. Two
years ago it seemed to some that his "return" to the figure marked
a retreat from more advanced positions, or a change of heart. Per-
haps it is too early to argue the point on the strength of this limited
display; the big, authoritative showing of his work is not due at the
Janis Gallery until next spring.

Yet it seems to me that already the logic and grand rhythm of his
growth become apparent. I would point to his *Queen of Hearts* of
1943 (Fig. 174), an early work as de Koonings go, which despite
some Cubist dislocation in the body and some elegant speed-writing
in the drawing of the face, still belongs to the peaceable kingdom
of pre-World War II. The figure here is still a solid, placed in, or

174. Willem de Kooning,
Queen of Hearts, 1943

against, a vacant and inactive space. She is held together still by a
sentimental and a plastic integrity. And she remains an impediment
to the free flow of energy through the pictorial space. From her to
the de Kooning *Woman* of the 1950's there was no direct transition.
Her solid contours had first to be dismembered, blasted, and atom-
ized; and the upshot was to be a violent discharge of subhuman,
even suborganic, energies.

Accordingly, by the late 1940's de Kooning's *Paintings* had shed
every trace of the familiar image. His new subject matter dealt with
the vicissitudes of pure mobility, abstracted from the things that
move as numbers are abstracted from the things we count.

Much of the power of those abstract paintings derived from the compelling force with which his forms sped through a hindering medium, not merely gliding across unresisting canvas. The artist's method of constant revision and adjustment—but with each correcting stroke applied at the same blinding speed—built up his ground in deposits of stratified color, deep as the shimmer of mother-of-pearl, and suggesting, between lines of stress, the sudden baring of some split-second geology.

We saw not things here but events—a darting, glancing, evading, overlapping, and colliding; a grammar of forms where all nouns were held in abeyance; systems of turbulence whose rate of motion was so flickering fast that the concretion of a "thing" became unthinkable.

And yet it has occurred—as the foetus occurs in the swarming of massed cells. The agitated worlds of de Kooning's abstract canvases were scenes of germination. And within these worlds—the fastest and most urgent ever put on canvas—de Kooning has descried a familiar shape, a form that even Adam would have recognized as from an ancient knowledge.

11 Pollock's First Retrospective
(1955)

Jackson Pollock's work has been shown every year since the early
1940's. This month, at the Sidney Janis Gallery (through Decem-
ber 31), brings the first opportunity to see the artist whole, from
The Flame of 1937, before he joined the WPA, to the *White Light*
of 1954, the only picture finished in the last two years. It is therefore
as good a time as any for stock-taking.

More than any other living artist's, Pollock's work has become a
shibboleth; I have heard the question "What d'you think of Jackson
Pollock?" shouted from the floor of a public gathering in a tone of
"Are you with us or against us?"

His supporters and detractors share a common vehemence of con-
viction—which is not necessarily a point in Pollock's favor. For the
detractors are not galled by the pictures themselves, but by the
claim that they are art. What annoys them is extrinsic to the work
and throws no light on its quality.

It would be a mistake to regard the division of opinion as running
simply between highbrow and low, between Bohemian and Philis-
tine. Today's alignments are more complex than those that con-
fronted the Armory exhibitors. Arrayed against the sheer validity
of Pollock's work are the views of most art historians, of most lit-
erary men, and of many brilliant painters not in the *avant-garde*.
Pollock's champions are a few critics and museum men, abstract
painters who recognize in him a superior power, and, above all,

First published in *Arts* magazine, December 1955.

those who know the man himself. Thus Pollock dramatizes the question—"For whom does the artist paint?"

I recall a conversation I once had with Paul Brach, himself an abstract painter. I suggested that the type of person who becomes an artist is not necessarily the same in every culture. Granted that artists in primitive societies, or in our Middle Ages, were men who expressed a communal myth, what does the man whose temper moves him to express such a myth choose to become in our time? Is he not likely to become a movie-maker, a writer of science or detective fiction, or an advertising man? Brach agreed and said, "Yes, and the sort of man who now becomes a painter would, in the Middle Ages, have become an alchemist."

But who in the Middle Ages understood what alchemists were doing? Only the other alchemists, while patrons were content with hazy notions of their general objectives. Note also that a modern painting tends to be spoken of today as an experiment, not as a thing of terminal validity, but as a step in some mysterious progression impelled by a final cause. If the analogy will be allowed to hold for the length of a paragraph, then we are dealing today with a wholly esoteric art, and Pollock is a *cause célèbre* precisely because more than anyone he symbolizes a radical change in the social role of art.

To support this esoteric theory of contemporary painting there is this further point, already hinted at: "You've got to know the painter to appreciate and understand his work." I have heard this phrase repeatedly, most often in regard to Pollock. I have been puzzling over what it means, since obviously it flouts some very basic and traditional ideas about the autonomy of the art work.

It seems to me to mean surprisingly much. It could mean, for instance, that modern-art appreciation is a sanctificationist cult, where the initiate can get himself into a private state of grace through the appropriate sacrament, to wit, the handshake of the painter.

Or else it can mean this: just as a full understanding of, say, Indian art is denied to one who is not steeped in India's religious lore, and who ignores the myths of which that art is a prime carrier, so a Pollock painting, charged with his personal mythology, remains meaningless to him for whom Pollock himself is not a tangible reality. As Indian sculpture is related to Vedic and Upanishadic

thought, exactly so are Pollock's canvases related to his self. Ignore that relation and they remain anonymous and insignificant.

All the above has been excogitated in an armchair, with a few reproductions at my elbow. And the reader who has stuck it out this far may have observed that it ignores the fact of the exhibition at the Janis Gallery. Now the effect of that exhibition is utterly overwhelming. Questions as to the validity of Pollock's work, though they remain perfectly good in theory, are simply blasted out of relevance by these manifestations of Herculean effort, this evidence of mortal struggle between the man and his art. For the man mortifies his skill in quest for something other than accomplishment. From first to last the artist tramples on his own facility and spurns the elegance that creeps into a style which he has practised to the point of knowing how. Thus the *Masked Image* of 1938 is a strong, well-knit Cubist work, perfectly realized; but it gives way to the scattered paleography of *Magic Mirror*, 1941. His *Gothic* (1944) is a new synthesis—which breaks apart again in the levitating Miroid forms of *Totem II* (1945). How good these pictures are I cannot tell, but know that they have something of the barbarism of an ancient epic. Does anybody ask whether the Song of Gilgamesh is any good?

Then come the celebrated "drip" paintings on huge canvas or board, like *Cockatoo* of 1948, and the red-figured *Out of the Web* from the following year. Such tangled skeins have not been seen in art since Kells and Lindisfarne, but in the Celtic manuscripts one marvels most at the magic of artifice by which the labyrinthine coils are managed; whereas, in the comparison, the Pollock looks as every Van Gogh looked fifty years ago—something that you and I could do as well. But this is surely what the artist means. He has no love for conspicuous diligence; and if it comes to that, have we? The Middle Ages gave high rank to the artifact as a symbol of perfection; the thing of cunning workmanship stood near the top in their hierarchy of values. For us who think in terms of function, the artifact *per se*, though of multiplied ingenuity, is no longer in the order of ideal things. And so the artist, in the excellent words of Parker Tyler, "charges the distance between his agency and his work with as much *chance* as possible, the fluidity of the poured and scattered paint placing maximum pressure against conscious design."

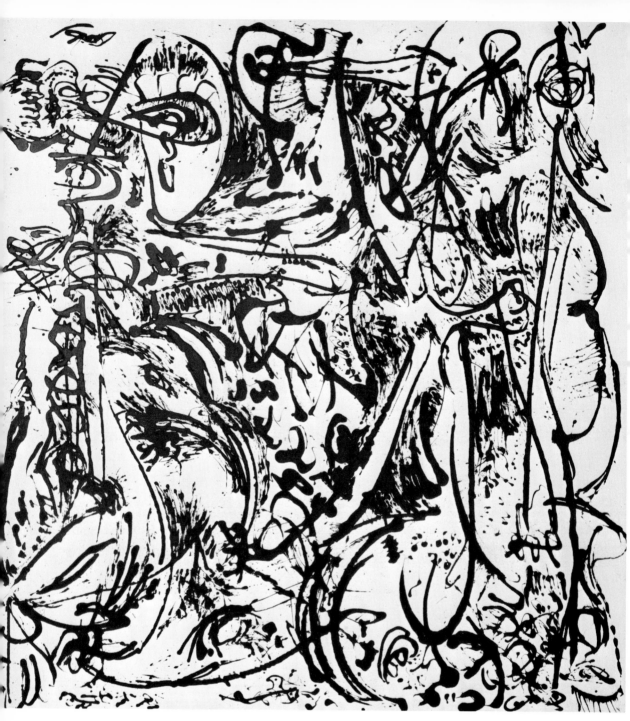

175. Jackson Pollock, *Echo*, 1951

Of course it is possible to carp at such painting, and not from any lack of taste or sensitivity to art, but from a love for humanistic values. Where we get stupefaction instead of enlightenment; where the mind is not confirmed in authority but rather scandalized; where, instead of rationality and freedom, we confront the apparent sport of mindless ferocity and chance—there it becomes legitimate to waive the question of the artist's merit and to enquire what it might signify for our entire culture if such work as his is indeed our best.

His last painting, called *White Light*, turns away, as one would expect, from the facility of the developed mazes of the early fifties. They had perhaps become too beautiful. *White Light* presents again that labored stammer on the surface, as if the artist could not think but against heaped resistance. It looks like the end-stage of the "Unknown Masterpiece" in the Balzac story that drew tears from Cézanne. The clogging pigment seems to choke, bleach out of visibility, some kinder picture underneath.

To me the most hypnotic picture in the show is *Echo*, done in 1951 (Fig. 175); a huge ninety-two-inch world of whirling threads of black on white, each tendril seeming to drag with it a film of ground that bends inward and out and shapes itself mysteriously into a molded space. There is a real process here; something is actually happening. Therefore the picture can afford to be as careless of critique as the bad weather is of the objections of a hopeful picnicker. With all my thought-sicklied misgivings about Pollock, this satisfies the surest test I know for a great work of art.

12 Pascin
(1955)

The "artistic temperament," in the romantic sense, is not character-
istic of artists. Yet, since artists are not of one type, but represent
every psychological type at its creative power, their ranks, once in
a while, include men whose private life traces a tragic pattern.

Jules Pascin (1885-1930) was one such, and if the facts of his
biography are unfamiliar, most of its stuff is there in the twenty-six
paintings which form his current retrospective exhibition at the
Perls Galleries (November 14–December 24).

Pascin's personality in all its phases haunts those canvases with a
peculiar immanence: the precocious satirist whose studies of brothel
life in a Bulgarian town got him an invitation from the editor of
Munich's *Simplicissimus*—which was declined on the grounds that
his father would not let him go, he being but fifteen at the time; the
cocky youth who lived it up in Munich, Berlin, Vienna, Budapest,
and Prague; the intellectual who studied mathematics, architecture,
engineering, and philosophy, and, in the judgment of a tutor, would
have made a first-class scientific brain; the man who spent his nights
in the stews and his days painting some regrettable aspect of vice—
or of toil; who sought roisterous company and restless travel from
Greece to Louisiana to forget the want of intimacy and affection;
the aging alcoholic with the full lips and the ruined liver and the
unslept eyes, whose protracted dying drew from him a melancholy
swan-song art of young girls wilting; the anti-classicist who said *"ce
sont des morts"* of the old masters in museums, but could draw like

First published in *Arts* magazine, December 1955.

176. Jules Pascin,
Le Modèle à l'atelier, 1909

the best of them; the celebrated painter and mad, lavish host of Montmartre who at the last, at forty-five, opened his veins, then hanged himself impatiently because the blood was slow.

His artistic development coincides with his rake's progress, as appears from a comparison of two works in the show, the *Modèle à l'atelier* of 1909 (Fig. 176), and *La Rousse,* done within a year or two of the end. The former is magnificently fauve, painted in bold, loaded strokes, with a burst of purple in the upper right, and the mirrored artist, self-portrayed, on the far left. The girl stands forth in strong contrasting light; drawn in resilient curves and modeled in consistently warm tones, she stands defiantly in the exuberant possession of her body, cut off below the knees, because such bounce as hers is not contained by the conventions of a frame.

And then *La Rousse,* another nude, as young as the first, but with a life chilled by two decades of the artist's past. The pigment is laid on in thin, ascetic washes, as if the artist's palate shrank from the oily glut of common paint. The background space is of a wan, ice-colored luminosity with shifts of blue and green and gray-to-mauve.

269

177. Jules Pascin,
Les Amies, 1928-30

The girl is seen in almost the same stance as the other; her feet also are cut at the frame, so that the compositional device seems much the same as in the early version. But the psychological implications are the reverse, suggesting here something misfitted. Almost transparent, too, is the body, the weak flesh showing the gray shimmer of the bone within; and where, in the delicate modeling, the skin tones softly lift themselves into color, they subside into ashes at the next modulation. There is the general sense of a body unfit to sustain the rigors of physical existence.

In the 1909 version the color was warm, the forms were strongly marked to suggest solids resistant to touch; the late picture presents a characteristic inversion: the prevailing color is cold, but the lambent forms behave as things do when they melt and fuse; they are cold to the eye, ostensibly—but with a furtive, fading warmth in the texture, as of sheets recently occupied.

Which of the two is the better painting is hard to say. If the one verges on sentimentality, the other breaks just short of coarseness— and I feel safer with the latter, with the work of 1909.

It is, however, the soft, slighter, opalescent, and more lyrical pro-
duction of the late phase which supports Pascin's reputation—the
young models, sad and dispirited, who, in their personal charm and
the shamelessness of their undress, present so strange a blend of
sweetness and depravity—like *Les Amies* (Fig. 177) and the *Jeune
Fille à la bouteille de vin.*

These pictures impress one at first sight as of an exceeding sen-
suality. But the impression soon corrects itself. For if the artist
wanted to project his melancholia, that soul's gloom which the
Middle Ages condemned as *acedia*, his dramatic instinct led him to
find his symbols in moments of near-pornographic tension, where
sloth lives at the edge of outrage. In situations that normally call for
responsive action—even if the action required is no more than the
redeeming of a fallen stocking or the closing of immodest knees—
the failure to act can become a poignant symbol of paralysis. The
world of the late Pascin is one in which the force of gravity that dis-
locates the strap of a bra is always greater than the energy available
to pull it up again. In the artist's poetry of decadence, the disrobing
of those weary bodies reads as a dismantling of the will.[1]

13 Torsos and Raoul Hague
(1956)

One approach to the remains of Greece and Rome has been to mend the damages of time as if time had not been. From the mid-sixteenth century to 1900, the restorations grafted upon broken marbles express fundamental attitudes. A rescued statue was a witness, and it was the obligation of Renaissance culture to convert its survival into a rebirth. But ancient statuary was to be raised to a new life, not to the half-life of a cripple. Hence an armless Satyr gets new limbs to manipulate castanets; found heads are mated with beheaded trunks; if the Mars Ludovisi extends the stump of a leg, Bernini himself fits him with a new foot; and the Hermes of Olympia is given back his lost shins and his bunch of grapes. Why not? They were full-bodied gods; to leave them otherwise would be collusion with hateful destruction.

Unfortunately, each restoration, as the years go by, starts to betray its date. You can tell whether those marble hands were clenched in Rome or groomed at Versailles. That pallid group, those reconstructed members, are the chaste dreaming of a Munich neoclassicist who dreams of Greece to endorse Winckelmann's taste. Reluctantly, modern museums strip away the restored parts and acquiesce in the torso—defined in *Funk and Wagnalls* as "a fragmentary or defective thing."

But there is another line of thought, also voiced in the sixteenth century. Michelangelo, the legend has it, refuses to lay hands on the Belvedere Torso—as though no restored limbs could perfect it.

Originally published, before minor adjustments, in *Arts* magazine, July 1956.

His own maquettes abide in the same state, and his deposed Christ at Florence is left short of a leg, which tells the more cruelly of the body's collapse.

In the Grotte des Pins at Fontainebleau, Primaticcio, in 1543, attaches four atlantes to the piers, un-armed and without feet; and the divided muscles of their fronts swell like great rusticated building blocks, so that these sculptured giants cease to be figures of men, but become sculptures representing sculptures which are weather-beaten and old as the hills. Shortly thereafter, Goujon installs caryatids in the Louvre, and at their deltoids the stone is sliced away to make them look like antiques that have lost their arms.

A direct line runs from these Mannerist conceits to the decorative, half-bodied caryatids Rodin had to make in his youth. But the most personal statements of Rodin's maturity are again partial anatomies—the headless, armless *L'Homme qui marche* (Fig. 212); or the *Earth* (Fig. 263)—a male nude lying prone, its rough chine rolling like a range of hills, and lower legs sheared off and slipped like a rift valley, leaving a fissured cleft at the knees; there are no hands, and the feet chopped away condemn the trunk to immobility. A year later, lopping the arms off Victor Hugo's *Inner Voice*, Rodin explained that arms imply action, and that action is the enemy of meditation (Fig. 239).

The dark brooding of Raoul Hague's abstract sculptures strikes me as similar; it too is the effect of felt amputations, of a center maintained and withdrawn.

Hague is a native of Constantinople who has lived in this country since 1921, and, since 1941, in Woodstock, New York. Except for occasional single exhibits in group shows, his work is now being seen (at the Museum of Modern Art) for the first time. Hague does not work in metal, and apparently no longer in stone. His mature medium is wood. The titles of his pieces are precise and evasive: *Ohayo Wormy Butternut, Log Swamp Pepper Wood* (Fig. 178), *Sawkill Walnut,* and so on. I am told that Hague himself scours the country for materials. Presumably the finding of a stump or fallen log releases the initial idea. Then Hague hauls the timbers back to his studio, and the finished sculptures are named for the sites and the original blocks which had fathered the thought.

Like his revered teacher Flannagan, Hague believes in direct

178. Raoul Hague, *Log Swamp Pepper Wood*, 1951

carving. His undulant, ovoid shapes seem at first sight to suggest much that was seen before. But they are more concretely physical, far less involved with ideal essences than Brancusi's. And unlike Arp's or Viani's biomorphs they do not seek to imply forms in transition. They are stilled and collected and content in their own mass, without attempting to suggest the dynamics of growth, or potentials of space penetration. This in itself, given the dominant concerns of modern sculpture, makes them unusual.

All of them, I believe, refer to the human body, especially the elegant *Mount Marion Walnut* and *Log Swamp Pepper Wood*—both of them torsos, and both female, to judge from the warm lifted swell of their surface. But they are depersonalized by their headlessness; by their lack of limb, inactivated; and by their catastrophic breaks, denatured.

In view of their partial humanity, the abrupt breaks that define the ends of his forms are at first vaguely disturbing. Thoughts of

mayhem are quickly dispelled, for these knifed terminations were present at the work's inception. What they do is to italicize, to put the chosen form in quotes. And so it dawns on one that these are not in fact images of human bodies, but of sculptures of bodies. And their inspiration is a novel form of classic revival, another way of imitating the antique.

Hague's "imitation" is obviously not typological—as it was through the Middle Ages, when a Hercules or Mithra dispatching a wild animal was carved again in medieval style to stand for a Samson. Nor is it restorative in the manner of Renaissance and baroque taste. Hague's type of imitation is foreshadowed at that moment when recovered antique statuary is not re-imagined for how it had once looked, or what it had once represented, but when perfection is projected into its actual truncated state. His two most engaging works embody a specific response, as it were, to the products of excavation.

The look of ancient ravaged sculpture, disinterred and bronze-diseased, or mottled by internal rust, has charmed many contemporary sculptors. Marini daubs his newest bronze with acid so that a look of eons of endurance may lend prestige to the form. Germaine Richier erects figures that seem eaten and rotted away, as if retrieved from cobwebs of millennial neglect. Picasso has made sculptures and incised pebbles whose message comes across in a sort of muffled Sumerian, as from an ancient habit of speaking through ten feet of silt. Even Gonzalez' *Torso* suggests bare survival in the teeth of time—like fragmentary sheets of rare Greek bronze that curve on one side into body, and then gape into nothing.

The mutilated fragments of Greek art permeate all our culture, but never before now—except perhaps during the Mannerist age—have artists been specifically moved by their mutilations. And they *are* moving, these escaped odds and ends. Ignoring the base struts that profess to support them, the torsos stand up proud in all our museums. Despite their embrowned stone, they refuse to age, to give way, to admit the need of restoratives. If only a square foot or two of carved surface remains, the rest of the rock converges upon it, nourishes it, and an arm, a straight thigh, or a buoyant pelvis remains charged with sufficient health. It is here that Greek humanism and anatomical perfection contrast most poignantly with the present condition. The organism, broken in mid-body by some mindless

chance, yet clinging to its task, becomes a symbol of humanity whose goal is not the good life but precarious survival.

Classical sculpture as such has rarely been usable inspiration for the modern sculptor. It was disqualified for being too illusionistic, too proudly human, too sanguine about the validity of man's predilections. But none of this holds for Greek sculpture that has come to grief, whose skin is scarred, whose terminations are not shapely toes but grotesque accidents, whose self-will, in short, has outlasted an agony.

I think it is this sense of the valiant fragment which lies behind most of Hague's work. His *Log Swamp Pepper Wood* of 1951 is an extended torso—but most emphatically not reclining, like a piece by Henry Moore. It is a fallen torso, the sculpture of a sculpture that lies on its side. What makes it moving is precisely the juvenescence which persists. And its wood grain serves to emphasize that this is but a distillation of its motive power, that the theme is not the superficial look of antique art, but the great surge and sinuous torsion of a stub of body.

The torso called *Mount Marion Walnut*, 1953-54, is even more daring. Doubled and slightly turned at the waist, its female shape has real nobility; and attached to its whole length is some indefinable Siamese form—perhaps an extra thigh, or fragment of related figure —but clearly something that shares its own circulation and pulse. The image seems to me that of a fragmentary sculptural group, reconceived as a self-contained symbol.

In *African Mahogany*, and in one other work, the principle still holds, though the pieces are not recognizably figurative. Heavy chunks they are, with disappointed projections, but with not enough articulation given to complete them in anthropomorphic terms. Potent relics, nevertheless.

Hague's last work, *Marbletown Walnut*, 1955-56, is the most tantalizing fragment. Circling it counterclockwise, one suddenly discerns the remains of a large seated figure, preserved up to the middle; but as one continues walking, the mirage fades; one is left again with a form rendered abstract by deduction. And here, for once, the form's contentment is disturbed; its flattened stumps and ax-like clefts—exactly like classical remnants—send waves of regret into space. This is his latest work, and one cannot say in what direction Hague will go from here. One can only be certain that his first show reveals an artist of confident strength and originality.[1]

14 Fritz Glarner and Philip Guston at the Modern
(1956)

Curves are too emotional, said Mondrian, and banished them from his art. This was some years ago, but in Fritz Glarner's work, now showing at the Museum of Modern Art, the sentence is still in force. Ruled by the doctrines of *de Stijl*, the world of Glarner is one of absolute, unbending rectilinearity.

Consider now what manner of judgment this is—that curves are emotional. Mondrian could not have arrived at it from a consideration of their essence *a priori;* the proposition had to be empirical, generalized from the emotional effect which certain curves of his acquaintance had on him. Curves were weighed in their typical contexts and found guilty by association.

Now suppose we apply an equally empirical test to straight lines; our enquiry will lead to the following findings: that a straight edge on a wooden surface indicates lumber, or furniture, but never a tree; that a straight line limiting a flow of water defines an embankment or canal, never a river; that a batch of fish surfacing in a flat plane betrays, not a fresh haul, but a new-opened can of sardines. A straight line, then, is the mark of human purpose, human cunning, enterprise, success. And it is a fine example of unconscious human self-congratulation that the word "straight," in our language, takes on connotations of superior virtue.

I would have liked to think that in China the word for straight might exist without implying trueness and rectitude. The old Chinese had such belief in the superior wisdom of nature, in the su-

First published in *Arts* magazine, June 1956, as "Fritz Glarner and Philip Guston among 'Twelve Americans' at the Museum of Modern Art."

perior beauty of organic, ever-changing curves, in the superior strength of the yielding, pliant, and adaptive bend, I hoped that their vocabulary would reflect a different, more pantheistic ethic.

But alas, China has let me down. According to Giles' Dictionary, the word *chih*, which means straight, means also upright and honest. For which information my grudging thanks are due to Mr. Alan Priest of the Metropolitan Museum.

I hope this point about the rectilinear as a sign of human craft is not dismissed as abstruse theorizing. But lest it is, let me invoke Paul Bunyan, the mighty logger. Paul, you remember, had sworn that he would tame the Whistling River—"or bust a gallus tryin'." And tame it he did, by freezing it and then yanking it straight to take out the kinks. This from the cracker-barrel bards of our backwoods is proof enough. And I propose to use their insight as an index to one meaning level in the work of Glarner.

Glarner's work is of the kind that makes one highly conscious of his process. A Glarner painting is a puzzle solved, with the rules slightly varied in each play. In the recent *Relational Painting, 74* (Fig. 179), the painter has set himself to manipulate and fit together some two hundred units, all quadrilateral with one side slanted at 15°. But the shape occurs in infinite mutations; no two may be identical, their proportions ranging from the squat and square to the short narrow strip. The function of these last is slightly ambiguous: they seem too thin to qualify as areas and never come independently of the plane whose edge they enforce. Yet areas they are, since, by the rules of the game, nothing but area is admissible. Then again, these smallest units almost dispense with the slant margin, not being large enough to become deviant; i.e., the irregularity of the oblique is the price which a shape pays for being too aggressively expansive, or else it is the freedom which only size can command. For the acute diagonal is that factor of unrest by which Glarner attempts to animate his geometry. Nor is it to be taken lightly, and only those who once have violated a religious code will appreciate the Glarnerian obliquity in its perfect defiance. In the dogmatics of *de Stijl*, that slant is 15° of heresy—as the artist knows; but, says he, "the slant or oblique which I have introduced in my painting . . . liberates the form."

You must look to the colors to see orthodoxy restored. These are laid on according to the absolutes imposed by *de Stijl:* the primary red, yellow, blue; the antipodal non-colors black and white, and

179. Fritz Glarner,
Relational Painting, 74

three intermediate grays. In this picture the rules require a strict inverse correlation between color value and size. By a principle of compensation, the larger the area, the lighter its tone. Thus each of the units has a sort of equivalence, and the result—in this case the solution of a very tricky problem—is an equitable uniformity, a society of shapes wherein each is held in a balance of fitting relations.

Line, in Glarner's work, can hardly be detached as a separate value; yet its conduct too obeys definite rules. It must of course move straight, looking, like Orpheus in the abode of the dead, neither to right nor left, no matter how sharp or distracting the impingements of abutting shapes. Only when another edge finally blocks its path may it turn at right angles.

279

As to the total pattern, there is a faint sense of a central vortex and a hint of spiraling rotation. But such motion is given in its fossil stage, as if it might once have existed, before the present freezing and arrest.

There are other solved problems in this work—like the shallow advance and recession conveyed by the colors. But further analysis would only confirm the bewildering complexity of Glarner's chosen assignment and the fine workmanship implied in its solution. It is perhaps not irrelevant to recall that the artist hails from Switzerland, the land where small-scale precision industry was brought to perfection.

But it was in Naples that he received his early training as a painter, and in Paris, where he joined the Abstraction-Creation group of the 1930's, that he came under the spell of that movement which was called Neoplasticism by Van Doesburg, Morphoplasticism by Mondrian, and has passed into history as *de Stijl*, the movement which claimed that perfect purity and universal states were expressible in the absolute polarities of color and the alleged "neutrals" of rigid verticals and horizontals.

Glarner himself makes no such claims for his work—which is as well, for they were never easy to maintain. Why the rectangle should be a shape more universal than the triangle, the circle, or the egg never became compellingly clear; nor in what sense the coveted "appearance of a machine or a technical product" (Mondrian) could at the same time approach some transcendental absolute; nor why submission to the elements of Euclid should make art more autonomous than submission to any other extraneous discipline; nor why the ruled precision of Mondrian's lines should be more purely painting than a stroke of Titian's—or of luck; nor why it should be logical to permit intermediate grays but disallow intermediate angles. Many of Mondrian's paintings seem to me marvelous despite his pretentious mystique—at any rate they have a suddenness of presence which is unforgettable. And except for superficial similarity of means, they seem to me to differ radically from the work of Glarner.

Where Mondrian creates the abstract of a momentary equilibrium, Glarner contrives a concrete jig-saw of specific shapes in tenon-and-mortise or some similar contact. Where Mondrian makes radiant open spaces that draw us like the potent emptiness of a Sung

painting, Glarner presents a tight-clenched and excluding surface. Where Mondrian disencumbers us of body and lets us assume whatever size we want to be, a Glarner, if one tries to enter it at all, makes one feel confined and reduced. And lastly, Mondrian achieves simplicity where Glarner labors with the intricate.

Therefore, in the work of Glarner, I feel justified in discounting his resemblance to *de Stijl*, asking instead what one should ask of any abstract painting—what its content is.

And this takes me back to my beginning and the signification of straight lines. A Glarner is a world of straight-yanked commodities and standardized items.[1] And to reduce a world to packaged rectangles is not to achieve symbols of universality, but to manipulate an abstract image of mechanical production methods, where the history of every form is not a life but a process of fabrication.

But perhaps this applies only to the component shapes within a Glarner painting. What of the whole? Here surely is a wizard complexity which passes beyond the immediate sense of deliberate purpose. There seems to be a conflict here. And yet, not so, for there exists in our experience a prototypical form which bridges the gap: I mean the city.

It is in the great modern city that the man-made, the rectilinear, the devised, goes beyond any power of man to will or comprehend. In the city the man-made overgrows the human purpose to restore for man a jungle of cross purposes which are not his.[2]

I do not mean, of course, that Glarner paints city plans. Nothing so primitive as a grid will you find on his canvas. I suggest rather that a kinesthetic intuition of city routine, the motor pattern of rush-hour scurries, furnishes the substrate of his image. It is the city with its stoneweb of inflexible intersections, its staccato pulse, its tempo of abrupt stops and turns, which jerks our course into an angular beat; the city with its ever-changing grain and density, where every block is similar but no two are the same as we experience them at different paces; it is the city which, like Glarner's painting, keeps us small, running the maze; which offers an equivalent to Glarner's strident, heartless gaiety; and which, above all, keeps its populace perpetually excluded, to walk the endless gauntlet of cold shoulders.

What I find in Glarner's painting is a high-styled formalization of the urban rhythm. It is idealized and even beautiful. But I find no

place in it to which my eye will cling; no line in it so moves that it and I could swing along together. The picture, like a sterile beauty, is everyman's exile.

A Philip Guston is Glarner's opposite in every sense. While Glarner's public elegance is quick and efficient, a Guston is pondered and slowed and hauled up from unspeakable depths of privacy. A Glarner picture is all externality, display; Guston's abstractions are exposures of nerve-threaded flesh. It is as if the hollow of man's body—scarred and stained with sin and hunger, pain and nicotine—were flattened like an unrolled cylinder and clothes-pinned to the sky.

You remember those early lines of Eliot which used to be so disturbing in their brain-straining leap:

> Let us go then, you and I
> When the evening is spread out against the sky
> Like a patient etherised upon a table . . .

Guston's new image is that recondite.

He has journeyed a long way in search of his center. By the mid-1940's he had evolved a personal style; behind him lay the *Martial Memory* of 1941, *If This Be Not I* of 1944-45, and the *Night Children* of 1945, wherein the space-form equation of Cubism had been finally assimilated to become integral with his own symbolic imagery. These paintings, in their strength of structure, their subtlety of color, and the melancholy of their childhood themes, remain among the masterworks of American art.

Thereafter, Guston's work became freer in handling, his figure drawing more emancipated from anatomical norms and more pliant to his own pictorial and expressive ends; depth was progressively reduced as each portion of space closed in on the surface; and the symbolism became more arcane. In Guston's spiritual growth, the whole evolution of modern art seemed to be recapitulated. And it was still a personal compulsion that moved him, in the early fifties, to cross the threshold of abstraction. He had reached it on foot, pacing out every inch of the way.

His earliest work in the present Museum show is an untitled abstract *Painting*, dated 1952. In general disposition it faintly echoes the firm structure of his figurative work. But everything here is hushed and softened; the tender strokes of the brush are barely

afloat; color is weightless, like odor; the picture is the after-image of a flower garden fading on the inside of closed lids.

And now the painter seems to reverse the direction of his sight; his in-turned eye seeks incommunicable self-recognition. His canvases expand in size as they focus more narrowly.

Two themes—Whatness and Whereness—dominate all his last paintings. The What is given by the color and the slow motion of its track. A narrow range of shades of red heaves back and forth between pale rose and scarlet. Color of blood; not of blood spilled or smeared, but still investing the live tissue, lying bare here like a universe expanded from a surgeon's cut. And then—in confrontation with glut reds and membrane pinks—the streaks of gray, color of ashes, of fasting, of senectitude and privation.

The red-gray forms the central interlock. Within it, and all around, almost unnoticeable, are vagrant dabs of orange, azure, celadon, giving the paint surface an unpredictable depth and vibration. Then an ebbing away towards the edges where the cold, nacreous surface is haunted by a graying purple, still strangely organic, like the color of chilled human skin.

The other theme is that of localizing what is going on. Yes, the red proclaims itself clearly enough, but the gray drifts and swims in the tissue, and you seek it—or rather its precise relation to the more organic hues—like a doctor tapping, trying to locate a pain. At the same time, it is the grays which function as defining elements, give a more measured statement to the space, and, by setting off the reds, bestow on them a sort of self-realization. The blind, red, windowless organic interiority gains self-awareness by virtue of the foreign body, the intruding gray. The gray pain, the gray hunger, twining with red-roaring guts, becomes the agent of awareness—I am in pain, therefore I am.

But I would not give the impression that these paintings are cries of pathological distress. Far from it. For their last effect—when the initial shudder over these thick smears has passed—is a remote and radiant joy, the very quality which tempts one to locate these worlds of entrails in the sky. In their slow, tempered breathing there is no shred of conflict, and no violence. The intrusive grays are linked and latched to the organic fiber, the two sustain each other like a warp and weft; the grays, for all their otherness, become a necessary and a welcome presence, and the picture smiles with ashes in the mouth.

A feature which sets Guston off most clearly from other New York

180. Philip Guston,
Beggar's Joys, 1954-55

abstractionists is the slow pace of his pictures. We are accustomed
to paintings whose elements move at the speed of more than human
performance. But in a Guston the brush is drawn hither and back
like a sleeper's breath.

Its effect on the observer is to slow down his own visual opera-
tions—not in fact, not in the way assembly lines determine a piece-
worker's speed—but in imagination, turning us momentarily into
contemplatives and thereby giving us a fleeting consciousness of a
disused capacity in ourselves.

One of the means by which Guston's new paintings impose a
slower tempo of perception is compositional. In *Beggar's Joys* (Fig.
180; 1954-55) the red-gray nucleus propagates itself over the canvas

by a comparatively simple process of radiation. In *The Room* of the same year, no such clear principle of structure is perceptible. And in *Bronze* (1955) the uncertainty of placement with respect to the picture limits is brought to a new extreme. Sensation is intense, but diffused like a nervous inflammation. The sense of center is abandoned; what is left is a weary drag from left to right. Composition, at this point, is furthest removed from any reliance on structuring clues. Every tried picture-building device seems eliminated, as though the artist were determined to avoid whatever has been known to make paintings successfully. One is reminded of Cézanne's impatient dismissal of master examples: "They were making pictures, and I am attempting a piece of nature."

To arrive at these works the artist has gone the hard road of relinquishment. The somewhat blatant melancholy of his early figure compositions is left far behind. But this new serenity in anguish, which one faintly suspects, is expressed in terms no longer of communication. His latest image is the end-stage of a slow farewell to externals, to those mediating screens of knowledge that shield his center from himself.

15 Paul Brach's Pictures
(1963)

They are very near invisibility.

Invisibility is of various kinds, and to list its varieties while the pictures are up helps to focus attention.

Invisibility by disappearance. An object absent, remote or indistinct leaves a leftover emptiness and a straining to see. This seems relevant to Brach's pictures. Their vacant geometry suggests depleted voids, voided containers. Their huge suspended circles can look like extinguished suns. Solar cult emblems snuffed out. Empty icons.

Then, invisibility by extinction of light. This too seems relevant. Not actual darkness—which conveys a specific degree of reduced illumination—but a consistency or opacity that can be neither brightened nor deepened.

And invisibility due to dimmed vision; whether through blindness or the sightlessness of inattention. Brach makes his pictures easy to resist. They court unseeing indifference or disinterest, as if to remain invisible to the averted mind.

And there is one further mode of invisibility which comprehends the others. I mean the invisibility of an encompassing undifferentiated homogeneity. Obviously, where all differentiation is lacking, nothing will show. Oneness too is invisible.

Can it be painted, this ineffable metaphysical One? Not by leaving the picture blank, for that simply leaves the canvas an object in a worldful of objects. Paint it then: dispel its physicality to make a

First published in *Toward a New Abstraction*, The Jewish Museum, New York, 1963.

181. Paul Brach,
Riddle, 1962

symbolic allusion to wholeness; then imply oneness by sacrificial negations—as Brach does—asking, and making me ask, How close to all-one can multiplicity come?

Ask how much is renounced:—Color, composition, incident, movement, focus, style, signature, painterliness—all drained in romantic renunciation, until even the figure-ground differential, the first and last requirement of figuration, is at the vanishing point. And there, at the threshold of invisibility, your eye toils to see.

They are difficult paintings. Their color is a grey-blue monochrome—cerulean and white, with a little umber lending imperceptible warmth and weight, and sometimes minute variations from

287

added violet or reduced white. What varies most is the pigment's density and the pressure of buried color below.

The color was not picked for charm but for efficiency. It evolved in trial and error as the best value to make the painted surface ambiguously solid and void. And it works when you play the game (or read the language). Witness the stately conversion dance of his circles: ashen disks in a strafing light, then hollows or portholes in a dark field as you change position; and under overhead lighting, dense massy globes. And they move forward and inward and remain unlocatable, like a coin and a moon at arm's length seen with one eye. And this is the painter's irony: to reap uncertainty from the centered symmetry of monochrome circles and squares. But they need the good will that accepts them on their own terms as totalities. Else they become blue pictures, blue surfaces plainly visible—and you may not even care for that shade. But Brach has felt no inclination so far to change color. His cerulean gives him in the space of a diagram the blueprint of a worldspace.

They are beautiful pictures, solitary and serious.

16 The Eye Is a Part of the Mind
(1953)

We begin with the interrogation of witnesses. Two men are called to defend the reversal of esthetic values in their time. The first is Giorgio Vasari, the tireless biographer to whose *Lives of the Painters* we owe half the facts and most of the figments current on the artists of the Renaissance. The other, Vasari's junior by four centuries, is André Malraux, whose *Psychology of Art*[1] forms a brilliant brief for the moot values of a neo-mystic, modern taste in art.

Speaking of Masaccio, the great initiator of the naturalist trend in Western art, Vasari states: "The things made before his time may be termed paintings merely, and by comparison his [Masaccio's] creations are real."

And Malraux, hailing Manet as the initiator of the modern trend in art, asks: "What then was painting becoming, now it no longer imitated or transfigured?" And his answer: "Simply—painting."

A startling coincidence—the "painting merely" of Vasari and the "simply painting" of Malraux. Strange also that the selfsame epithet should come as scorn from one man and as praise from the other, and yet for both bear the same connotation.

For what exactly did Vasari have in mind? That Masaccio's work, and that which flowed from his influence to make the mainstream of the Renaissance, was a true representation of the external world; whereas earlier icons, mosaics, and frescoes were pictorial patterns

First published in *Partisan Review*, 20, 2 (March-April 1953); revised and reprinted in Susanne K. Langer, ed., *Reflections On Art*, Johns Hopkins, Baltimore, 1958, and Oxford University Press, New York, 1961.

whose forms were not determined by reality. Being undetermined by nature, he called them "paintings merely"—just as he might have called scholastic metaphysics "thinking merely," since it too formed a speculative system adrift from experience. Vasari's point was that medieval pictures implied no verifiable referent outside themselves. Renaissance painting, on the contrary, was valid because in it every element corresponded with its prototype in nature.

And Malraux? What does *he* mean when he pits the "simply painting" of Manet against the styles of other ages? Why, precisely the same thing. Representational art for him is weighted with extraneous content and transcribed appeal, with reference to things and situations that exist outside the picture frame in general experience. Manet pries art loose from the world. "Modern art," says Malraux, "has liberated painting which is now triumphantly a law unto itself." No longer must a painting borrow its validity from natural analogues. Its meaning—if self-significance can be called meaning—lies wholly within itself. Wherever art is seen with modern eyes—seen, that is to say, as "a certain compelling balance in colors and lines"— there, says Malraux, "a magic casement opens on another world . . . a world incompatible with the world of reality." It was for this incompatibility that Vasari spurned medieval art; it is on this very account that Malraux exalts contemporary painting.

Thus juxtaposed our authors confess that what is here involved is not a difference in esthetic judgment, nor even in the definition of art. We are dealing rather with two distinct valuations set upon reality, and the overt gap between the Renaissance and the modern esthetician is evidence of a rift far more deeply grounded.

We will ask later whether either Malraux or Vasari was justified in seeing "merely painting" anywhere. For the moment we may say that Malraux speaks the mind of his generation when he declares that the representation of external nature has nothing to do with art. "Creating a work of art is so tremendous a business," says Clive Bell, "that it leaves no leisure for catching likenesses." As long ago as 1911, Laurence Binyon wrote with satisfaction: "The theory that art is, above all things, imitative and representative, no longer holds the field with thinking minds." Albert C. Barnes reminds us that only painters "unable to master the means of plastic expression, seek to awaken emotion by portraying objects or situations which have an appeal in themselves. . . . This attraction, though it is all-important in determining popular preference, is plastically and aes-

thetically irrelevant." And, as Sheldon Cheney insists: "It can hardly be too often repeated that the modernist repudiates the Aristotelian principle 'Art is Imitation.' "

But this position presents a serious quandary, for the first glance at art through the ages shows unmistakably that most of it is dedicated precisely to the imitation of nature, to likeness-catching, to the portrayal of objects and situations—in short, to representation. Now there are three possible formulas by which this contradiction between evidence and creed may be resolved. The first asserts that representation has always been an adventitious element in art—a concession to state, populace, or church. Modern art, then, differs from historic art not in essence but in degree of purity. This is the view put forth by Roger Fry and by most later formalists. The second choice is to concede that representation did function essentially in the arts of the past, and that modern art, by suppressing the outgoing reference, constitutes something radically different and new. This is the implication of such continental critics as Ortega y Gasset and Malraux, who endorse the meaning elements in the historic styles, yet claim for modern art exemption from associated values. It is also (esthetics makes strange bedfellows!) the view of the bourgeois who repudiates all modern art as an unfunny and too long protracted hoax.

The third alternative is to suggest that modern art has not, after all, abandoned the imitation of nature, and that, in its most powerful expressions, representation is still an essential condition, not an expendable freight. It is this third view which this essay will seek to establish. It will try to show that representation is a central esthetic function in all art; and that the formalist esthetic, designed to champion the new abstract trend, was largely based on a misunderstanding and an underestimation of the art it set out to defend.

II

We have said that most historic art is vitally concerned with representation. And lest the word be thought to offer too much latitude, we will commit ourselves further to say that about half the great art generated by mankind is dedicated to the accurate transcription of the sensible world.[2] This is as true of the best paleolithic art as of Egyptian at its finest moments. It applies to the entire Hellenic effort down to third-century Rome.[3] It applies equally to the great

Western wave that lies between Giotto and the Postimpressionists. Nor is it any the less true of Chinese painting—so self-conscious that it operated for a thousand years within six explicit canons; of which the third called for "conformity with nature," or "the drawing of forms which answer to natural forms." All of these schools—and there are as many more—strove for the mastery of nature by convincing imitation.

Perhaps it will be said that artists closer to us in time would not have subscribed to this quest. Here is a sampling of their depositions: Manet declared (Malraux notwithstanding) that he painted what he saw. Van Gogh's avowed aim was to be "simply honest before nature." Cézanne exclaims: "Look at that cloud! I would like to be able to paint that!" And he says: "We must give the picture of what we see, forgetting everything that has appeared in the past." Even for Matisse "the problem is to maintain the intensity of the canvas whilst getting near to verisimilitude."

Such quotations, given a collector's leisure, could be amply multiplied. They are adequately summarized in Constable's dictum which defines the goal of painting as "the pure apprehension of natural fact."

Yet artists and critics, for half a century and more, have been denouncing the representation of nature as a fatal side-stepping of artistic purpose. And whoever has the least pretension to esthetic culture speaks with condescension of "that power which is nothing but technical capacity in the imitation of nature."[4] This famous slur, reverberating in the prejudice of almost every modern connoisseur, has become standard critical jargon. The picturing of overt nature is written off as mere factual reportage, worthy only of the amateur photographer, a mechanical skill, patently uncreative and therefore alien to the essence of art.

The objection to this view is not far to seek. To begin with, "technical capacity in imitation" implies what no one seriously believes: that nature confronts man with a fixed, invariant look. For what else does it mean to speak of "mere skill in copying the model" (the words are Malraux's), but that the model's appearance is an objective fact susceptible of mechanical reproduction? We know better than that. Appearances reach us through the eye, and the eye—whether we speak with the psychologist or the embryologist—is part of the brain and therefore inextricably involved in mysterious cerebral operations. Thus nature presents every generation (and every

person who will use his eyes for more than nodding recognitions) with a unique and unrepeated facet of appearance. And the Ineluctible Modality of the Visible—young Dedalus's hypnotic phrase—is a myth that evaporates between any two works of representation. The encroaching archaism of old photographs is only the latest instance of an endless succession in which every new mode of nature-representation eventually resigns its claim to co-identity with natural appearance. And if appearances are thus unstable in the human eye, their representation in art is not a matter of mechanical reproduction but of progressive revelation.

We can therefore assert with confidence that "technical capacity in the imitation of nature" simply does not exist. What does exist is the skill of reproducing handy graphic symbols for natural appearances, of rendering familiar facts by set professional conventions. We have cited a canon from the beginning phase of Chinese painting; here is another from nearer its dead end:

There are ten ways, say the Chinese academicians, of depicting a mountain: by drawing wrinkles like the slashes of a large axe, or wrinkles like the hair on a cow's hide; by brush-strokes wrinkled like a heap of firewood, or like the veins of lotus leaves. The rest are to be wrinkled like the folds of a belt, or the twists of a rope; or like raindrops, or like convoluted clouds, etc.

With rigorous training the Ming painters could, and did, acquire a dazzling proficiency in drawing the right wrinkles so as to evoke some long-assimilated and familiar facts about natural panoramas. They had mastered the skill of applying certain academic tricks for the drawing of mountains—but this is most emphatically not the same as skill in drawing actual mountains. The mechanical, the uncreative element lies not therefore in imitating nature, but in academicism, which is the passionless employment of preformed devices. Representation in art is the fashioning of graphic symbols to act as analogues for certain areas of visual experience. There is every difference between this fashioning of symbols, this transmutation and reduction of experience to symbolic pattern, and the use of symbols ready-made. In works that seem to duplicate a visible aspect of nature we must therefore distinguish between the recitation of a known fact and the discovery thereof, between the dexterous use of tools and their invention.

This distinction must be upheld for all representational art. Seen in this light it becomes quite absurd to charge Victorian academi-

cians with too fastidious an eye for natural forms. Their fault was not, as Roger Fry maintained, "the fervid pursuit of naturalistic appearances," but that they continued to see and represent the facts of nature in spent conventional terms. The so-called naturalism of certain nineteenth-century academicians was worthless because it was impelled by precept and by meritorious example, instead of by pure visual apprehension. These men never imitated nature; they copied earlier imitations and applied those formal principles which, they believed, had made their models so effective. That they sometimes painted from life is, of course, beside the point; for they still saw life in the aspect which their vision was conditioned to expect.[5] Thus the malady of Victorian art (and of some lingering official art today, notably in Soviet Russia) is not naturalism, nor literal representation, but the presumption to create living art out of impulses long dead and mummified; which ailment is not confined to realistic art. For academicism will blight non-objective figurations and abstractions as readily as illustrative, anecdotal pictures.

This is not to say that a convention invariably chokes artistic creativity. It does so only when too fully conned and understood, when the uphill drive of aspiration is relaxed and the professors of the brush can settle down to mass production. An artist searches for true vision, but having found it, leaves in his successors' hands the blueprint of a new academy. Almost anyone with a modicum of talent and sufficient application can appropriate another man's mode of representation. (Were this not so, the forger's craft would not exist.) But he cannot discover it. He can learn after one lesson in perspective how to give an illusion of depth to a design (an illusion, by the way, based largely on our habit of routine consent). But this lesson will not arm him with the passion of an early Florentine who first ventures through the picture plane and, like daydreaming Alice, finds a wonderland beyond. The same rules of perspective mean one thing at the Beaux Arts; in Mantegna's studio, in Uccello's workshop, they meant quite another. Space, that had congealed into a solid crust during the Middle Ages, was here pierced and vaporized. Bodies were inserted and, against resisting pressure, as on reluctant hinges, pivoted into depth. There is in Uccello's work a tensity which springs directly from his craving to know how bodies will behave in the *terra incognita* known as the third dimension. And the reports of his discoveries, such as the bold foreshortenings in *The Battle of San Romano*, are proclaimed in tense and urgent gestures.

And what is true of perspective applies equally to anatomy. The gulf that separates a Pollaiuolo nude from one by Bouguereau is not all a matter of significant design. The one was born of nature's union with an avid sensibility; the other makes a parade of a habitual skill. One says, pointing to the array of anatomic facts—"Here lies the mystery"; the other says—"Here lies no mystery, I know it all."

The modern critic who belittles all representational concerns, because he sees them only as solved problems, underrates their power to inflame the artist's mind and to intensify his vision and his touch. He will fail in appreciation if he cannot relive the artist's will to formulate his found reality. Nor need he know how much of anatomic ignorance prevailed in Pollaiuolo's time to judge the measure of the artist's revelation. For Pollaiuolo's effort to articulate each muscular inflection is permanently sealed in the form. Like all works connected with discoveries of representation, his pictures lack the sweet ease of accomplishment. His images are ever aborning, swelling into space and taking life, like frozen fingers tingling as they warm. It is not facts they purvey; it is the thrill and wonder of cognition.

But is this sort of cognition relevant to esthetic value? To be sure, it is. We are told that the artist's design seeks to impose enduring unity and order on the undifferentiated content of experience. To bring his organizing powers into fullest play, the painter must haul his perceptions out of confusion and annex them to his plan. A young Michelangelo, busying himself in anatomic studies, knows that the apparent turbulence of a man's muscles must become in his design as inevitably ordered as was the long, unswerving contour of Masaccio. A score of muscles newly differentiated, a new vocabulary of expressive gesture, a newly seen relation between motion and shape, these become part of that living diversity to which unification is the victorious response. They are the stuff of the esthetic program. And in bringing novel visual experiences to his art, Michelangelo, so far from abandoning Masaccio's ground, is doing precisely what his forerunner had done. For he is still engaged in the "pure apprehension of natural fact." The mannerist, on the other hand, he who displays Michelangelo's musculature over again, is not at all repeating Michelangelo, since what he arranges on the canvas lives already in the domesticated state. It had been won for art already.

In realistic art, then, it is the ever-novel influx of visual experience which incites the artist's synthesizing will, summons his energies, and so contributes to the generation of esthetic form. And this per-

haps explains why periods of expanding iconography, of deepening observation and growing imitative skill so often coincide with supreme esthetic achievement. When the limits of the depictable in nature suddenly recede before the searching gaze, when earlier works come to seem inadequately representative of truth, then the artist's power multiplies. Hence the beauty of those Fifth Dynasty reliefs in Egypt, when, almost suddenly, all life comes to be taken for the artist's province; or the unsurpassed grandeur of Middle Kingdom heads, when the uniqueness of the human face is first perceived. Hence the upsurge of esthetic force in sixth- and fifth-century Greece, when new insights into human nature find embodiment; or in Quattrocento art when the untamed reality of space has to be disciplined and reduced to the coordinate system of the plane canvas or wall.

The Impressionists formed another group of passionate investigators into natural fact. Was it accident that these same men evolved powerful new formal conceptions? Malraux chooses to see no connection between the significance of their forms and their representational pursuits. "That the banks of the Seine might look more 'lifelike' in Sisley's than in Théodore Rousseau's work was beside the mark," he says. Beside the mark, possibly, for the modern doctrinaire, but obviously not so for Sisley.

And Cézanne? Nowadays every schoolboy knows that Cézanne was interested in picture construction. We incline to forget that he was just as concerned with the construction of Mont Sainte-Victoire and the vibration of sunlight; that he studied the subterranean geologic energies which had rolled up the landscape of Provence, and pondered those pervasive unities of nature in which forms are compacted despite their apparent edges. Today's fashionable cant ignores Cézanne's obsession with reality, "the spectacle that the Pater Omnipotens spreads before our eyes." When he warns his friend, Emile Bernard, to "beware of the literary spirit which so often causes painting to deviate from its true path—the concrete study of nature—to lose itself all too long in intangible speculations," he seems to be speaking not so much of the critics he knew, as of those more recent who profess to know him. The truth is that Cézanne's work embodies profound insights into nature. And the logic of his form is unthinkable without his ardent apprehension of natural fact.

By what hazard do these moments of whole-hearted nature-imitation synchronize so often with unforgettable art? In the for-

malistic system of ideas the recurrent coincidence of significant form with deepened observation remains unexplained. To avoid perversity we do better to grant that nature-imitation in art is neither mechanical skill nor irrelevant distraction. The most that can be said in its disfavor is that we of this century happen to have turned our interest elsewhere.

III

Where your treasure is, there (dropping the h) will your art be also. Every picture is to some degree a value judgment, since you cannot represent a thing without proclaiming it to be worthwhile.

Now the arts discussed in the foregoing section pertained to those schools whose purpose was, at least in part, to depict the open sights of nature. One and all they endorsed Constable's plea for the pure apprehension of natural fact.

But natural fact can be purely apprehended only where the human mind has first endowed it with the status of reality. Only then is the act of seeing backed by a passion, being focused on ultimate truth. From Masaccio to Cézanne men prized overt nature as the locus of reality, and to it they directed their capacities of apprehension. But if we invoke a civilization for whom nature was a pale and immaterial reflection of ideal types, we shall expect to find it careless of the outer shapes of things. Its art will strive to incarnate those forms which are the permanent exemplars behind the drift of sensuous appearances. This indeed is the course taken by Christian art after the fall of pagan Rome.

We can now modify Constable's dictum and propose that art seeks the pure apprehension of natural fact wherever natural fact, as registered by the senses, is regarded as meaningful reality. Where it is not so interpreted we shall find some form of anti-humanist distortion, of hieratic stylization or abstraction. But—and this is crucial—such abstraction will continue to apprehend and to express reality. Though it rejects the intimations of mere sense perception, it does not thereby cease to be representational. Only the matter that now calls for representation is drawn from a new order of reality.

Let us list briefly some of the formal features governing Early Christian and Byzantine art. Comparing it to the preceding style of disenchanted Hellenism, we are struck by a rigid frontality in the

disposition of figures, by a minimum of variation in gesture, and the replacement of individual likeness by canonic type. We note that movement is arrested, that the natural bulk of things is flattened and all forms are gathered in a single plane; distance is eliminated in favor of ideal space, purple or gold; color becomes pure, unmodulated, and the shadow—that negating spirit who haunts only the art of the West—vanishes in the diffusion of an unremitting light.

These devices sound, as indeed they look, other-worldly. Yet we can say without paradox that their employment proves how deeply involved was the art of Byzantium, and of the Western Dark and Middle Ages, in the effort at truthful representation. This is readily verified by reference to Neo-Platonist esthetics.

The most valuable source here is Plotinus, whose thought, by way of Dionysius and Augustine, shaped the spirituality of the first Christian millennium. What, asks Plotinus, speaking of the plastic arts, are true distance and true size? And his answer is a philosophic premonition of the Byzantine manner.[6] If we see two men, the one close by, the other far away, the latter will appear ridiculously dwarfed, and the interval between the two will seem absurdly shrunken. A given distance, therefore, is so many measures of falsification. Since deep space is the occasion of delusion, true distance can exist only within the nearest facing plane; true size is the dimension of each form within that plane.

The argument is extended to true color. If the red of a red object fades in distance, this effaced, degraded color is not "true." The truth must be an even red in the proximate plane. Furthermore, shadows are to be shunned for doing violence to truthful color, for there can be neither truth nor reality where there is not illumination. Thus to Plotinus the proper rendering of a red sphere would be a disk of pure, ungraduated hue. It is the chiaroscurist—a pander to the sense of sight—who mistakes the nature of reality and therefore sins against the light. "We dare not keep ourselves set toward the images of sense," Plotinus says.[7]

Do Byzantine images seem incorporeal? How else should they represent the truly real? "The body is brute," says Plotinus; "the true man is the other, going pure of body." And he proceeds to reprove those who on the evidence of thrust and resistance identify body with real being.

Do Early Christian figures seem monotonously like, immobile and unchanging? We are forewarned by Plotinus that "bodies live in

the species, and the individual in the whole class; from them they derive their life and maintenance, for life here is a thing of change, but in that prior realm it is unmoving."

Finally, do the eyes in medieval faces seem excessively prominent? The eye sees the sun, says Plotinus, because it is itself sun-like. Window of the soul, it bespeaks the presence in the body of that radiant emanation which sustains matter in being. Should not the artist therefore mark the eye's true nature rather than its physical size? Values having more reality than facts, it is they that determine the ethos and technique of medieval art.

Clearly, then, the formal conventions of this Christian art came into being in the interest of representational truth; not, to be sure, of direct visual facts, since such facts were metaphysically discredited, but of an ideal, extra-sensory reality.

Obedient to its mystic vision, Christian art proceeded to erect a system of representation by abstraction. Here a certain limited affinity with our own contemporary art suggests itself. There is indeed striking resemblance between the repudiation of naturalism in our time and in Plotinus' day. Plotinus wrote that "the arts give no bare reproduction of the thing seen but go back to the ideas from which nature herself derives." Compare this with Paul Klee's "The modern artist places more value on the powers that do the forming, than on the final forms (of nature) themselves." And even Roger Fry, who had no stomach for mystical speculation, says of Cézanne—who was all modern art to him—that he rendered "not appearances, but the causes of appearance in structure."

As the greatest apostle of the modern esthetic faith, the case of Roger Fry is a rewarding study. And it is noteworthy that he was unaware of his own implications. He fervently believed that the prime business of art, in fact its sole legitimate concern, was "abstract unity of design." "Painting," he exclaimed, "has thrown representation to the winds; literature should do the same and follow suit!" Yet, gazing at an academic portrait, he passed this elegant quip (quoted in Virginia Woolf's *Roger Fry*): "I cannot," he said, "see the man for the likeness."

This went far deeper than Fry intended. He had meant to say that he could not see the essential man beneath the clutter of external traits. But he unwittingly confessed that he did want to see this inner man. While affirming that the valuable image did not manifest itself in mere visibility, he also admitted that the truth which lay

concealed behind the model's mask could and should be represented by some graphic symbol. It will be seen at once that Fry was speaking from a philosophic premise for which his formalistic theorizing left no room. He mistook for an esthetic doctrine what was actually a shift in philosophic orientation. And he was not calling for the end of representation in art, but for the representation of a different content, to be tapped from a new order of reality.

Fry's sensitive recoil from Victorian academicism—or naturalism, to give it his preferred misnomer—was therefore based on two objections, neither of which he acknowledged. First, that it substituted standard commonplaces for pure vision, and second, that it continued to portray an aspect of nature which in the philosophic conscience of his age had lost reality and meaning. For the inversions of modern psychology and the iconoclasm of contemporary physics have once again, as in the Middle Ages, subverted our faith in the reality of palpable appearances. And it is right and proper for the modern artist who is worthy of his time that he should turn his back on the apparent, since he holds with Plotinus that "all perceptible things are but signs and symbols of the imperceptible." Thus the relevance of naturalistic representation to art depends on no esthetic doctrines, but on prior metaphysical commitments. And the argument for and against representation, which has agitated critics for so long, has rarely been fought at its proper level.

IV

Has modern art, then, like Byzantium, broken with the sensible world? Is it true that art, having paid its debt to nature, is now finally at liberty? Let us consider first those modern works which still maintain natural forms at some degree of recognizability. To the formalist their distortions seem sufficiently justified as serving the higher needs of design. Yet in these works the illustrative element is there, and—no matter how abstracted—takes its point from its residual resemblance to familiar sights. "The deformation of natural forms" of which Klee speaks in his journals presupposes in us the expectation of natural forms undeformed. Meyer Schapiro, speaking of Picasso's *Girl Before a Mirror,* points out that "Picasso and other moderns have discovered for art the internality of the body," that is, the inner image of the body as conjured up by fear and desire, pleasure and pain. But this inner image is communicable

only as related contrast to the outer. Everyone knows how clumsy one's human feet feel when pursuing a bird. The mammoth foot in Miro's *Man Throwing a Stone at a Bird* is thus an eloquent hyperbole, a piece of graphic gigantism. It makes its point not as largeness—a pure, abstract value—but as enlargement, which implies an external referent. The distance which the form has traveled in the way of distortion is apprehended by the beholder and becomes a vital element of the narrative structure. Familiar nature is not, after all, ignored. It survives as the distanced, but implicit, norm.

Exaggeration for expressive ends is found, of course, throughout the history of art. It is the common device of all caricatures. No matter how remotely they may venture into fantasy, it is the stretch and span between norm and distortion that constitutes their wit. The same is true of expressionism and of much so-called abstract art. A term of reference still lies outside the picture frame in human recollection and experience, as it does for the most clinically realistic pictures.

To an eye still immersed in the visual habits of the nineteenth century, the abstract way often seems willful and arbitrary. To a mind indoctrinated with formalist theory, it often looks like—"simply painting," a manipulation of the medium itself. Both judgments, I believe, are failures of appreciation, since abstraction *from* nature is still a telling mode of representation, whose hyphen with common reality is stretched but never snapped, except in the most thinly decorative works.

There is another feature in contemporary abstract art which ties it to the world of sense and separates it from all anti-naturalistic styles of the past—its boundless freedom of selection from natural sights. The conceptualism of ancient Egypt or Byzantium had constrained itself to show every form from a preferred angle, convinced that one aspect alone could reveal its essential nature. Thus the Egyptian foot appears persistently in profile, as though the human foot in essence were a profile form, all other postures being accidentals. Domiciled in eternity, the Egyptian or Byzantine foot is not susceptible of change.

Modern abstraction brooks no such restraints. Six centuries of arduous research into the changing nature of appearance are not so easily dismissed. Accordingly, in modern art, a difficult, foreshortened front view of a foot is met head-on, and finds its abstract formulation as readily as the diagrammatic profile. The modern painter,

if caught in the orbit of Picasso or Paul Klee, discovers a formative principle not in the foot as such, but in the foot in every possible predicament. He sees not one transcendent, universal formula for man, but a distinct abbreviation for man in every pose, mood, situation. Klee himself finds a symbolic cipher not for Woman, the Eternal Feminine, but for a middle-aged lady coming home loaded with packages.

It is quite true that Klee probes into the form-giving principle behind the thing, and strips it, like the mystic, of its superfluity; his representations rest upon his vision of a world whose surface forms conceal an occulted reality. In his own words, he seeks "a distant point at the source of creation, a kind of formula for man, earth, fire, water, air, and all the circling forces." Klee here seems to repeat a commonplace of mysticism. And yet his work, one of the potent influences behind modern abstraction, is of devastating originality, utterly destructive of the mystic premise that there is one immutable reality available to detached contemplation. For Klee finds his occult reality incarnate in each fleeting, perjured gesture of this world. In his intuition the nature of man is not to be found in any timeless essense, soaring like Byzantine man above vicissitudes. Man, to Paul Klee, is what he does and where he is—a *Juggler in April*, an *Omphalocentric Lecturer*, an *Old Man Figuring*, a *Mocker Mocked*. Vainly you scan these works for any single pictographic type; in every sketch the symbol is freshly apprehended and invented anew. If this is mysticism it is certainly not of the medieval, contemplative kind. It is a restless, existential mysticism, peculiarly our own.

Or watch Picasso's *Three Musicians* in the Philadelphia version. Despite an apparently remote cubist formalism we can say with confidence that the three men in the picture are equipped with six hands. But saying this we have already said too much. Having availed ourselves of the non-visual concept of *the human hand*, we have implied that Picasso here deals with a six-fold repetition of a single item. But he does nothing of the kind. He knows, or knew in 1921, that a man's hand may manifest itself as rake or mallet, pincer, vise, or broom; as cantilever or as decorative fringe; that it is a nubile and unstable element, contracting easy marriages with other forms to build up into compound entities. In actual vision the hand is an infinity of variegated forms. Its common factor is not any ontological handshape, but a protean energy with only a positional and functional relation to the arm, and to the object handled. Thus,

in the *Three Musicians*, a fist hugging a fiddle's neck is one sort of efficient force expressed by one decorative shape; four digits flat upon a keyboard are of another sort entirely. Picasso here dispels the *a priori* vision which must ever find conceptual permanence despite visible change. His manual formulae stand not for Being, but for function, operation. Adaptability and change are the sole measure of reality. And it is on behalf of such reality, as well as of design, that his sleights of hand are wrought. To describe the *Three Musicians* as a finely patterned abstraction of invented anatomies is an injustice to the matter of Picasso's revelation.

It follows that the modern abstractionist does not necessarily write off the "accidents" of visual appearance. He welcomes their occurrence, but pictures them as the negotiable shapes assumed by transient energy. And in this adaptability to every optic impulse modern art is more closely linked to its naturalistic ancestry than to the unworldly stylizations of the past. Its affinity with medieval art remains, after all, purely negative. Modern and medieval art agree that reality is not so much revealed as masked by surfaces. But as, at a carnival, the choice of a mask may betray the reveler's characteristic nature, so surfaces bespeak something as to the truth below. And the truths inferred by modern and by medieval artists lie at opposite poles of interpretation.

v

It remains to speak of so-called non-objective art. Here surely all connection with the outer world is cut. The forms that here emerge mean nothing, we are told, but private states of feeling; and, for the rest, they are pure form, a music for the optic nerve. The following passage from Ortega y Gasset ("On Point of View in the Arts," *Partisan Review*, August 1949) may serve as an example of the common view: "Painting," Ortega writes, "completely reversed its function and, instead of putting us within what is outside, endeavored to pour out upon the canvas what is within: ideal invented objects. . . . The [artist's] eyes, instead of absorbing things, are converted into projectors of private flora and fauna. Before, the real world drained off into them; now they are reservoirs of irreality."

This seems to me an open question still. For we are forced to ask: by what faculty of mind or eye does the artist discover and distill the forms of his private irreality? Whence come the plastic symbols

of his unconditioned subjectivity? Surely no amount of introspection will yield shapes to put on canvas. And if this is so, from what external quarter proceed those visual stimuli which the artist can identify as apt and corresponding to his inner state?

Obviously, any attempt to answer such questions is pure speculation. Yet it seems worth considering the testimony of those artists and critics who have pointed to the impact of science on contemporary art.

The impact operates on several levels and takes various forms. There is, first, the original stream of suggestion issuing from the laboratories. Wittingly, or through unconscious exposure, the non-objective artist may draw permissions for his imagery from the visual data of the scientist—from magnifications of infinitesimal textures, from telescopic vistas, submarine scenery, X-ray photography. Not that he renders a particular bacterial culture or cloud chamber event. The shapes of his choice are recruited in good faith for their suggestiveness as shapes, and for their obscure correspondence to his inner state. But it is significant how often the morphology he finds analogous to his own sentient being is that which has revealed itself to scientific vision. It is apparently in these gestating images, shapes antecedent to the visible, that many abstract painters recognize a more intimate manifestation of natural truth. On these uncharted realms of form they must impose esthetic purpose; from them they wrest new decorative principles—such as the "biomorphic" motif. Nature they imitate no less than did Masaccio. But where the Renaissance had turned to nature's display windows, and to the finished forms of man and beast, the men of our time descend into nature's laboratories.

But the affinity with science probably goes further still. It has been suggested that the very conceptions of twentieth-century science are finding expression in modern abstract art. The scientist's sense of pervasive physical activity in space, his intuition of immaterial functions, his awareness of the constant mutability of forms, of their indefinable location, their mutual interpenetration, their renewal and decay—all these have found a visual echo in contemporary art; not because painters illustrate scientific concepts, but because an awareness of nature in its latest undisguise seems to be held in common by science and art.

The question is, of course, whether nature as the modern scientist conceives it can be represented at all, except in spectral mathemati-

cal equations. Philosophers of science concur in saying it cannot. Even such divergent thinkers as A. N. Whitehead and Bertrand Russell join hands when they declare that the abstractions of contemporary science have irrevocably passed beyond man's visual imagination. "Our understanding of nature has now reached a stage," says J. W. N. Sullivan, "when we cannot picture what we are talking about."

But this utterance of the philosophers contains an unwarranted assumption, to wit, that whereas man's capacity for intellectual abstraction is ever widening, his visual imagination is fixed and circumscribed. Here the philosophers are reckoning without the host, since our visualizing powers are determined for us not by them but by the men who paint. And this our visual imagination, thanks to those in whom it is creative, is also in perpetual growth, as unpredictable as the extension of thought.

Thus the art of the last half-century may well be schooling our eyes to live at ease with the new concepts forced upon our credulity by scientific reasoning. What we may be witnessing is the gradual condensation of abstract ideas into images that fall within the range of sensory imagination.[8] Modern painting inures us to the aspect of a world housing not discrete forms but trajectories and vectors, lines of tension and strain. Form in the sense of solid substance melts away and resolves itself into dynamic process. Instead of bodies powered by muscle, or by gravity, we get energy propagating itself in the void. If, to the scientist, solidity and simple location are illusions born of the grossness of our senses, they are so also to the modern painter. His canvases are fields of force; his shapes the transient aggregates of energies that seem impatient to be on their way. In the imagery of modern art waves of matter have usurped the place of tangible, visible things.

The representation of the trajectory in art has its own history, like the representation of the visage of Christ. Emerging in certain Rembrandt drawings as a scribbled flourish in the wake of a volatile angel, it comes in the late work of Turner to invade painting itself. And in Brancusi's *Bird in Space* the path of motion at last claims the full sculptured dignity of mass. It is senseless to call such a work non-representational, for there is no ignoring here of nature. The trail of a projectile is, after all, as real as the object flung. And though it wants tangibility, it is as surely part of the natural world.

So much then for the dissolution of the solid in contemporary art;

the substantial object has been activated into a continuing event. As for space, it is no longer a passive receptacle, wherein solid forms may disport themselves, as once they did in Renaissance or nineteenth-century art. In modern paintings—barring those which are nostalgic throwbacks to the past—space is an organic growth interacting with matter. There is a painting by Matta Echaurren, entitled *Grave Situation*, in which long tensile forms stretch through a space generated by their motion—a space which at the same time inflects the curvature of their path.

It takes some effort to concede the heroic creativity of such envisionings. Granted that they do not depict what we normally see. But to call them "simply painting," as though they had no referent outside themselves, is to miss both their meaning and their continuity with the art of the past. If my suggestion is valid, then even non-objective art continues to pursue art's social role of fixating thought in esthetic form, pinning down the most ethereal conceptions of the age in vital designs, and rendering them accessible to the apparatus of sense.

17 Objectivity and the Shrinking Self

October 1967

Dear James Ackerman,

I am putting down some of the thoughts that occur to me as I ponder your proposed topic, "The Condition of the Humanities." The word "condition" is not mine; in fact, it embarrasses me. Not only does it suggest a pathological state, but it implies that the speaker comes armed with diagnosis and cure; and I want to make no such claims. I will even confess that my field (the study of Renaissance and Baroque art) appears to me sometimes to be in a fairly interesting condition. There is far more good work coming out than I get to read. On the other hand, the bulk of what is now being published, especially by young scholars, seems tedious beyond endurance without being exactly bad; it is all based on A-papers—the sound, unimpeachable output of academic art history. And if this output leaves some of us disappointed, the fault probably lies in our own obsolete expectations. It is *retardataire* to demand traditional humanistic rewards from art historical studies whose concern is the kind of data that should only be scanned, processed, and indexed for convenient retrieval.

Two questions suggest themselves: first, whether this new professionalism should usurp the whole field; and, second, why it should be the work of young scholars and recent graduates that turns out to be especially tame and conventional. Presumably, our discipline is

Written in response to an invitation from Professor James Ackerman, Harvard University, to participate in a conference, held 1967-68 at the American Academy of Arts and Sciences, on "The Condition of the Humanities." For the results of the conference, see *Daedalus*, Summer 1969.

not now attracting, or holding on to, those younger people who might approach problems with imagination and courage. We prefer on the whole to nurture the other kind. We introduce them to the technology of research and teach them the proper set of questions to ask with respect to art.

A few years ago the new Graduate Center of the City University of New York undertook to redesign some of the university's undergraduate freshman courses. Those of us who were charged with the art historical end of the project began by asking what one should show and tell a group of incoming college freshmen, most of whom might never again be exposed to a formal presentation of art. Our answer in part called for breaking up the regular lecture sequence with talks by young scholars. But we would invite only those who had once asked a new question, evolved a way of pursuing it, and come up with a novel insight. It was part of the plan that this new insight contrast with the traditional interpretation which the student would have found in his book. We wanted the irony; the textbook itself was to be put in a new, somewhat dimmer light. What we were hoping to celebrate was a marriage of art scholarship and adventure.

We got off to a splendid start. Our first guest speaker unfolded a revolutionary interpretation of one of the key monuments of Western art, and the students could be seen holding their breaths in the excitement of seeing it done. The speaker indeed had met all but one of our requirements—that of youth. Her opening remark explained that the first fertile question that had started her on the track of discovery occurred to her during a seminar she took in Hamburg in 1928. Two more guest speakers followed, both passing forty, and then that part of the project collapsed. During scores of professional talks delivered at the annual national conferences of art historians, we listened for new questions asked by young scholars— and gave up at last. It seems that we were trying to sell art history to our freshmen for its pioneer spirit; whereas a pioneer spirit characterizes neither the condition nor even the aspiration of institutionalized art history at this moment.

Institutions cannot, of course, teach people to ask new questions or make them imaginative beyond their gifts. But they do cheer and check. They create a climate of encouragement or disapproval for one set of qualities or another. And to a large extent they predetermine who shall survive the rigors of the environment they create.

The value structure of our great graduate schools is familiar. They may still reserve first place for the genius, but lacking genius, they promote the methodical archivist, while the leaper with the unproved hypothesis is encouraged to seek his fortune elsewhere.

The great immigrant European scholars who taught most of us what to teach could afford to lay every stress on objective historical discipline because their humanism was bred in the bone. What the field needed when they were entering it was the corrective of a more rigorous scientism than had ever before been applied to art. And it is because they succeeded that the correctives we need are no longer the same.

Can objectivity be made too much of? When I was a student, a great art historian advised me never to tell my readers or listeners how I came to a problem, or by what steps I proceeded, but to come clean with my findings. His advice has remained so much alive with me that it has urged me ever since to pursue the opposite course. I admire the art historian who lets the ground of his private involvement show. Though we all hope to reach objectively valid conclusions, this purpose is not served by disguising the subjectivity of interest, method, and personal history which in fact conditions our work.

Recently, in a public talk, I heard a senior scholar demonstrate that an important sixteenth-century fresco gained new dimensions of meaning by being referred to an actual site in Rome. Later, in private, he described the circumstances of the first observation that eventually led to his findings. He had climbed a steep Roman hill, had stopped to recover his breath, and turned around with his eyes open. But the ensuing epiphany was censored out of his formal talk, leaving the objective evidence to stand alone. And yet, in this case, the subjective experience pointed to an overwhelmingly important objective fact—namely, that the meaning newly found in the picture had been always accessible, and not only to research scholars, but to every footloose pilgrim in Rome. I suspect that if this excellent scholar had found his own experience of hill-climbing and revelation anticipated in some old traveler's diary, he would have cited it as objective evidence.

The finest among modern art historians seem at times somewhat confused in assessing the historical significance of subjectivity in our field. Let me cite another example taken, as all my examples are, from work that is truly exemplary: John Shearman's *Mannerism*.[1]

Its second paragraph introduces the author's methodological credo as follows:

> The contradictions in contemporary meanings for the word "Mannerism" are to a great extent due to the fact that most of them are too contemporary and not sufficiently historical. In the attempt to rescue sixteenth-century art from the ill repute that much of it enjoyed in the nineteenth century, it has been endowed with virtues peculiar to our time—especially the virtues of aggression, anxiety and instability. They are so inappropriate to the works in question that some pretty odd results are bound to follow. . . . My conviction is that Mannerist art is capable of standing on its own feet. It can and ought to be appreciated or rejected on its *own* terms, and according to its *own* virtues, not ours.

Can one quarrel with such a program? Yes, on one point; because Shearman's historical sense fails to apply itself to his immediate parent generation. His "conviction that Mannerist art is capable of standing on its own feet" is itself unhistorical, unrelated to Mannerism's known afterlife, during which it suffered ridicule and eclipse. Whatever feet of its own it may have had, Mannerism proved incapable of standing on them. A handful of early twentieth-century scholars at last restored it to consideration and admiration, apparently by endowing it with a wrong set of virtues. Mannerism was rehabilitated in a passionate recognition of kinship by men who were experiencing modern European Expressionism. The inappropriateness of the virtues they projected upon this sixteenth-century art sprang from their felt affinity with another age of anxiety. And it was this subjective intuition of kinship that lent motive, energy, and excitement to their explorations. In the end, their subjectivity constitutes nothing less than the historical precondition for the rediscovery of the subject. Therefore it seems both ungenerous and unhistorical to dismiss as mere error and hindrance the subjective projections of these earlier discoverers. An error which discovers a continent is at least as valuable as any later correction.

With the disdain of subjectivity goes the demand that value judgments be eliminated from serious investigations of art since they cannot be objectified. Needless to say, much of the work art historians do is well done only in the objective mood, as in the physical examination of monuments, the searching of archives and texts, or tracing the provenance of an altarpiece by identifying its local saints. No one doubts that value judgments would be a frivolous interference in this sort of work. The point about the general dis-

dain of such judgments is that it tends to bar or belittle any work that is not of this sort. It is not that objectivity is ever misplaced; but that the restriction to objective criteria simply rules out certain interests. Since objective criteria are the given criteria, we are faced with a bid to confine research to the filling out of preformed questionnaires. In protecting art history from subjective judgments, we proscribe the unpredictable question into which value and personality may surely enter, but which pertains to art because of art's protean nature. Our probity in always excluding the speaker resembles, even as it inverts, the piety which in the Middle Ages always included God—as in the equation $2 + 2$ (God willing) $= 4$.

The artistic universe is so thoroughly value-structured that the objectivity claims, were they to be taken seriously, would amount to mere cant. We still operate with the primitive categories "good," "mediocre," and "best." And we constantly make "objective" conclusions flow from the application of these categories, as when we decide that a certain medieval manuscript is of sufficiently superlative quality to be localized in an imperial scriptorium.

A refusal to suspend value judgments may be realistic in its own way. It reminds one that the world of art works is not self-existent, like the animal kingdom, but that the objects of our enquiry depend for their sheer existence on admiration.[2] Art is cherished, or it does not survive. A succession of value judgments, embodied in acts of neglect or preservation, largely determines what we receive from the past. And it is esthetic judgment that largely structures the world of artistic forms at their inception: It was the *best* artists who got the big royal commissions; the *best* architects who came to St. Peter's. Whenever this sureness of valuation breaks down, as in the nineteenth century—when the knighthood bypasses Turner to settle on Sir Edwin Landseer—then the failure to choose what we now regard as the greater value becomes itself the material of history.

To say it in other words, the record of past valuations is integrally part of art history, and that record is meaningless without present revaluation. We know it as an "objective fact" that in the Rome of 1510 the *best* artists enjoyed the greatest acclaim; that in the Paris of 1870 the *best* were passed up; that at the time only the *best* critics knew it; and that the artistic consciousness of our own century rests largely on the universal acknowledgment of those former *misjudgments*. We review and judge all past opinions with more of our own, the process being simply the life and afterlife of all art. If

Manet did not seem greater to us than Leon Gérome, then a history of nineteenth-century painting in France would not even be possible; only an incomplete index of paintings produced.

The professional plea to suspend value judgments is neither wholly honest nor practical, and the pretense that this has ever been done is not realistic. This is self-evident if one considers recent phases of art that have yet to become history, or better still if one thinks of the whole phenomenon of film, in which, at this moment, an entire history of art can be seen foreshortened. The process of structuring the field by constant evaluation has of course been going on steadily, while the historian had his back turned. When he finally turns to confront it, the material he receives will have been qualitatively structured already. He may modify that structure over and over, but he will never unstructure it.

Similarly, in the study of older art forms, we can insulate our discipline against subjective judgments only because we safely enjoy a rich and unrepudiated inheritance of such judgments. "Objectivity" leaves it to others to say why the matter in hand is being studied at all. But who are these others? This is precisely the present challenge to every humanistic curriculum.

An eminent scholar teaching in one of the great universities of Western Europe describes a new low of irreverence attained by his students. "Raphael stinks," they declare. Here then is an occasion to reconsider why Raphael should be in. But how? To what objective data do you appeal? Can his inclusion in the curriculum be justified without admiration, on objective grounds alone, by expounding the power and wealth of his patrons, his fame, his innovations and influence—that is to say, without again choosing him, without passionate reaffirmation of his genius today?

In the light of these considerations, the one-sided professional caution against value judgments and subjectivity in scholarship seems like a strangely perverse assimilation of a humanistic field to alien standards.

I remember a conversation I had with Mr. Philip Pouncey some years ago in the Print Room of the British Museum. Mr. Pouncey is universally recognized as the surest eye in the field of Italian drawings. He was criticizing the normal process of art history education which, he thought, hitched cart to horse in wrong order. Students were taught Raphael before they had learned to tell in a given drawing what made it a Raphael rather than a work of Perino or Giulio.

Would it not be wiser, he asked, to start students off with the simple elements of connoisseurship? Should not this be the foundation of all other studies, since it can hardly make sense to study an artist's style, development, or iconography before you have learned how to distinguish the object of your studies? Mr. Pouncey was of course recommending his own kind of connoisseurship as preparation for all other studies in the field. He was doing it with that offhand air that well-bred Englishmen use to deprecate their own skills. It was the merest ABC he was talking about, the trivial but necessary exordium to more ambitious and sophisticated pursuits.

Obviously, Mr. Pouncey deserved better than to have me agree. I therefore suggested that one introductory course in connoisseurship would not produce connoisseurship enough. The sort of perceptiveness in attribution which he had in mind was—as he knew perfectly well—not an elementary attainment, like that of any army recruit who has a course in aircraft recognition behind him. It was rather an ultimate virtuosity, compounded of many gifts and long practice. At this point, the great attributionist, warming to the subject but hushing his voice, confessed that this must indeed be the case, for he had felt again and again how his own sensitivity to distinct drawing styles could be blunted by an absence of even one or two weeks during vacations; how any interruption of his continuous exposure to Italian Renaissance drawings would make him feel—I am quoting his very words—"as if some vital power had departed from me."

Is it conceivable that a Linnaeus, or any scientific taxonomist, would describe his ability to differentiate within his field in the language of magic?

Of the late Richard Offner it was said (by Panofsky, summarizing the achievements of "Three Decades of Art History in the United States") that he "developed connoisseurship in the field of the Italian Primitives into the closest possible approximation to an exact science." How close is that? Offner had summoned all his resources to distinguish between non-Giotto and Giotto. Inconclusively: for in the end, it is not scientific exactitude which determines the issue, but an idea about human freedom. The question is how far Giotto, or any trecento artist, or any artist at all, can move willfully from one style to another. No criteria that science lends answer that sort of question.

The question also involves our ideas about the self-consciousness of the creative process. That artists can work in diverse styles simul-

taneously is a fairly recent discovery. For an older scholar, a stylistic divergence within, say, a Titian altarpiece would have been evidence of interference by studio hands, of incompleteness or of later rework, restoration, etc. Whereas we may read this same variable as evidence that Titian chose to distinguish donors from saints by rendering the adoration of the former in a stiff archaic manner.

Phenomena of stylistic simultaneity are now being reported from every art historical area; and, no doubt, every responsible scholar feels that he finds them in the given evidence. But it seems to me that it is the *style* of mid-twentieth-century scholarship to be finding this evidence, or rather, to interpret the data in terms of simultaneity.

Now, by a curious coincidence, simultaneity of divergent styles—to an extent never dreamt of before—is the outstanding trait of the most powerful artistic *œuvre* of our century—that of Picasso. Irrelevant? It does indeed sound preposterous to suggest that the question of what Titian could or could not have painted depends, in some remote sense, on the Picasso experience. Such a suggestion would make havoc of our objectivity claims! And yet, if a historian studying an earlier age were to discover in it a formal correspondence between its creative output and its own scholarly methodology, he would surely point to that correspondence as a significant symptom of period character.

The objects of our attention differ from the concerns of physical science in being existential human creations; and they differ from the concerns of social science because (in the cases that interest us the most) they are remarkable feats, never repeated. We do not expect them to demonstrate regularities; to the extent that works of art are subjectively structured by personalities formed in the total experience of both art and life, no one orthodox method at any one time can comprehend them. And any exclusive scientism in our discipline has the negative side effect of screening out forces of unpredictable relevance that continually feed into the art of the past as well as the present. The attempts to cope with more private or more freely metaphorical and evasive aspects of art become professionally suspect. They tend to be left to art writers, popularizers, critics, psychologists—that is, to men who have neither the habits nor the responsibilities of the historian's hard-won methodology, so that their contributions to the literature of art serve to confirm the discredit of the whole enterprise.

Sexuality is a case in point. A few exceptions apart, the disciplined history of art remains to this day coy and chaste. We still breathe the moral climate of the nineteenth-century esthetes who staked out our field, and the head of a major American art history department claims to plead "in the interest of privacy and human dignity" when he writes: "Michelangelo's sex life is, quite frankly, none of our business. We cannot treat him, try him or confess him. His physical pleasures, whatever they may have been, have no importance for his art."

What is astonishing in these forthright words is a modern scholar's assurance that a great artist's sexual life could be so divorced from his personality as to remain irrelevant to his art and therefore to us. This can only mean that whatever attention the matter has received in the past was amateur and misguided, and that academic art history at this moment is not coping with it. Yet a man's sex life —even if mocked in the phrase "physical pleasures" and arranged under the heads of sin, crime, and sickness—is no less formative in his personality than his faith or his Neo-Platonist thought. And in that case, how shall it be put out of bounds before its irrelevance is established by trial?

As for violating a privacy, who can say where an ultimate privacy lurks? Centers of privacy shift, as does the public status of sex. There are moments, individual as well as collective, when the sense of the obscene shifts from food to sex, and from sex to death. (In some periods—today, for example—a religious experience is harder to discuss socially than a sexual one, and even a minister finds it easier to preach about birth control than about "dying well.") And suppose that Michelangelo's deepest private anxiety were the fear of entanglement in Lutheran heresy. Would the probing theologian be violating his privacy?

Certain problems inevitably tend to remain outside the scope of our approach—some, like sex, of permanent human relevance, others given immediacy by contemporary developments. Such problems are hard for specialists to lay hold of. It is difficult for the specialist to pose novel questions, to expand the criteria of interpretation. Lifting a subject to a new plane may require a fulcrum outside. The goal now being set before our students in the great graduate schools is, in the late Walter Friedlaender's phrase, the "conquering of a province." This ideal of mastery in a circumscribed field is only partly positive, for it draws much of its strength from the rejection of dilettantism. But in the present phase of American graduate edu-

cation the developing threat resides less in dilettantism than in the constriction of viewpoint that comes with consistently specialized studies. And the ideal of the specialist may already be losing appeal, becoming less heroic than the phrase "conqueror of a province" suggests. "The specialist is by definition the Dependent Man," I read in a remarkable article by David Lyle.[3] "He cannot provide the essentials of life for himself. He is dependent upon others to provide, to create opinion, to know what must be done. Dependent Man, properly fed and educated, is Acquiescent Man . . . programmed for Conformity."

Some years ago an interesting difference developed in the pages of the *Art Bulletin* between two eminent medievalists. It concerned the interpretation of the figure of an archer on an eighth-century monument known as the Ruthwell Cross. In 1944 Meyer Schapiro had called it "one of the oldest medieval examples of secular imagery at a terminal point of a religious monument." Sixteen years later the late Ernst H. Kantorowicz adduced theological, legendary, and visual material on the subject of Ishmael, showing that it was Ishmael as symbol of asceticism and desert life who appeared in the Ruthwell Cross archer. Schapiro, he believed, had under-interpreted the image since he "seemed to think of a hunting scene of more or less ornamental character . . . a purely decorative configuration, having no religious meaning at all."[4] Three years later, Schapiro returned to the fray, bringing visual evidence of similar medieval bowmen in contexts that could in no way be related to Ishmael. He gently parried his colleague's charge that by denying symbolic status to the archer's figure, he had reduced it to ornament. Between the exclusive alternatives of either religious meaning or none, either symbolic content or pure decoration, he inserted a "content of force," motifs "laden with affect . . . like metaphor in poetry . . . a means of dwelling in an enjoyed feeling or desire."[5] Few authorities will be bold enough to arbitrate between these two scholars. But whether or not Schapiro is right, his conception of the medieval motif which is neither explicit symbol nor decoration owes much to his simultaneous awareness of contemporary and medieval art. Purists may even object that Schapiro's near-abstract terms (such as "content of force") are not homegrown medieval, being furnished perhaps by a modern esthetic experience that here seems acknowledged as a means of potential insight into past art.

The legitimacy of retrojecting from our immediate experience to remote fields of study touches on the issue of relevance. No one imagines that relevance attaches to particular subject matter. Making things relevant is a mode of seeing.

How relevant is the large Geometric Greek vase at the Metropolitan Museum to contemporary American culture? America has been recently shaken by three political assassinations, and each time we were forced into an awareness of some of our ritual forms. It became suddenly clear that all our rites of mourning—I mean what we actually do during mourning with our bodies—demand either total inertia or a slow funereal gait that is best adapted to the pace of the very old. The physical rhythm of mourning constricts and punishes the normal physical energies of young men. Their need to assert feelings in their own physical mode, in exertion and speed, is choked and repressed in all conventional obsequies. Hence—and I mean literally from our position in afflicted America—one looks back in envy and admiration at the geometric kraters erected at their hero tombs by the Athenians of the eighth century—the great vases with the prothesis scene and, in the band below, the chariot race in honor of the dead man. Their rituals of mourning provided the outlet of vigorous contest for the overflowing energies of their youth. I am not recommending physical exercise or athletic contests as a response to political assassination. It is enough to record that the institution of the Greek funeral games now reveals a dimension of humane wisdom which never before struck home with such accusative power.

Even the "holy pictures" of conventional religiosity can become relevant to our world, given a change of focus. For example: A group of students studies the "American Christ," that is to say, the visualization of the Christ figure in American paintings and popular arts from, say, 1840 to 1910. It is found that the image becomes increasingly cloying, effeminate, and effete—the result, I think, of reducing the Christ to the single specialized function of loving-kindness, with every other dimension suppressed. Meanwhile, another student group assembles visual documentation for the evolution of the American ideal of manhood during that same span of years. It is our hypothesis that the two, the Christ and the ideal man, diverge ever more widely—and as never before in Christian history. No earlier Christ conceived in the Christian universe had been so deficient, so disqualified in terms of values actually held. The Amer-

ican Christ image in 1900 is at the furthest remove from what in a man is felt to be worthy. The he-man who admires himself for being rugged, self-reliant, self-made, red-blooded, two-fisted, etc., visualizes a Christ whom he rejects in his guts. I submit that this progressive emasculation of Christ in nineteenth-century imagination is the visual precondition for the post-Christian civilization of modern America. And the study of this development, or devolution, which only historians of art can pursue, is one which gives immediate access and relevance to a range of historical imagery normally spurned by developed taste—diluted repeats of Murillo and Reni, the art of Carlo Dolci, the Nazarenes and Pre-Raphaelites, and, above all, the sanctimonious *bondieuserie* of religious supply stores. They all become part of our formative history.

Let me attempt two further examples of ancient things rendered relevant through contemporary experience. At Expo '67 in Montreal, where every major pavilion was celebrating the triumph of film, what was most noticeable was that the familiar form of it, projected upon a single inert rectangular screen, no longer satisfied. The old non-participant screen was becoming as obsolete as the passive stage-space of nineteenth-century Salon painting had become under Cubism. In addition to multiple projections on clustered screens, the screens themselves seemed to split and proliferate, and the split screens could move, releasing showers of visual data, discontinuous systems in perpetual fluctuation. For deliberate complexification of the optical field, it seemed that nothing comparable could have appeared before—at least not outside pure decoration, not in the context of a narrative, dramatic, didactic, or representational art. But the next time I have occasion to think about the development of the Italian altarpiece in the thirteenth and fourteenth centuries, I will look with a new surprise at its curious multiplication of panels, at its iconic saints and scattered anecdotes shown in different systems and on different scales, yet so juxtaposed that no single narrative or symbolic form can be read without interference from adjacent images. I will wonder, perhaps, how it is that an icon —designed, one would think, to *focus* devotion—could evolve into so complex an aggregate of non-simultaneous events. The suggested analogy between the movies' split screen and the medieval polyptych may in the end prove gratuitous and superficial. But even then I will have redefined the peculiar esthetics of the polyptych in an

investigation for which the shock of a relevant contemporary experience provided the impulse.

The experience of film might even induce those European students who had declared against Raphael to look again. It is at least thinkable that their tastes were less offended by Raphael's works (which they can hardly have looked at much) than by certain long-enshrined concepts of Raphael held in our culture. Film can make other concepts available, concepts more relevant to twentieth-century thought and not necessarily less relevant to Raphael than were the concepts of Bellori or Wölfflin.

Susanne Langer's *Feeling and Form* contains a brief appendix on film from which I quote these conclusions:

> The artistic potentialities [of the film] became evident only when the moving camera was introduced. . . . The straightforward photographing of stage action, formerly viewed as the only artistic possibility of the film, henceforth appeared as a special technique. [In the mode of its presentation, cinema] creates a virtual present, an order of direct apparition, [which Langer calls the dream mode]. The most noteworthy characteristic of dream is that the dreamer is always at the center of it. . . . [In film] the camera is in the place of the dreamer. But the camera is not a dreamer. . . . It is the mind's eye and nothing more. . . . The percipient of a moving picture sees with the camera; his standpoint moves with it, his mind is pervasively present.[6]

It is not my concern now to argue the merits of Miss Langer's theory with regard to film. But I suggest that the terms of her analysis can be directed to one modality of Raphael's art, especially in its final phases. Raphael's conception of narration-in-space (in the designs for the Vatican Logge, for instance) is tantamount to the invention of a new art, comparable to the new art that was born when the camera first put on wheels and began to roll through the space of the esthetic illusion. In those Raphael compositions—especially as they were endlessly republished in series of prints—it is immediately evident that the viewer's standpoint moves unhindered to post itself anywhere in the field of action. We move in from cineramic overviews of the *Creation* to intimate close-ups. In *God's Promise to Abraham*, the Patriarch appears from the back, God from the front, approaching in middle distance. Then, in *God's Command to Isaac*, it is the Patriarch who appears from the front, while the backview of God dollies in, half foreshortened, as though it had just passed the camera. And in the *Pillar of Cloud* fresco, the view

from between two foreground tents into the Israelites' circular camp is a random transition "shot"—like that from a rolling camera wheeling about the circle of covered wagons in an American Western. These compositional innovations are radical. What Raphael invents is a mode of fluid positioning which is most accurately described in contemporary cinematic terms.

Finally a few words on the danger of projecting the modern experience of ambiguity upon the art of the past. In a lecture some years ago on Michelangelo's *Holy Family* tondo (Fig. 32), I suggested that the picture worked on several levels of meaning and that its father figure especially was conceived as a compound personification. The artist's *concetto,* frequently criticized for its artificial complexity, seemed to support so many possible readings, so much had converged in his final form, that one came away overawed by its simplicity. After the talk, a friendly colleague, who was well disposed toward my attempt, suggested that "of course, when you come to publish this, you will narrow the possibilities down."

What interests me here is the assumption that multiple interpretations for a single image or feature are self-defeating. Two meanings are fairly safe, given the tradition of typological exegesis. But if meanings multiply, even though they should all seem equally plausible and equally compatible with a given appearance, then it is advisable to settle on one alone or on one analogical pair. For three or four meanings cannot be right at the same time, and to be right is after all the objective. This at least is how I understand my colleague's advice, since he was not questioning any of the proposed interpretations, but was disturbed only by their proliferation. His model of "rightness" derived from classical mechanics, or logic, from conceptions of truth evolved in times other than our own.

But I am conscious of belonging to a generation brought up on Freud and James Joyce. *Ulysses* and *Finnegans Wake* were the pabulum of my teens, and I am always ready to welcome another artist who conceives his symbolic forms multi-storied. This means that I am perpetually in danger of projecting my contemporary artistic experience upon the past—which every respectable art historian knows is reprehensible. But there is another way of putting the matter. If there ever were earlier artists who conceived multi-storied symbolic forms, then ours is the generation equipped to detect it, being trained, so to speak, in the reading of Joyce. And then it be-

comes our duty (and pleasure) to announce, at the risk even of be-ing wrong, what we are the first to see. And furthermore, if Michel-angelo's *Holy Family*, for example, should indeed be such a multiple symbolic structure, then it is the simplistic reading imposed on it by earlier scholars which will turn out to have been the distorting pro-jection, an imposition from the age of positivism. It is naïve to im-agine that you avoid the risk of projecting merely by not interpret-ing. In desisting from interpretation, you do not cease to project. You merely project more unwittingly. For there is no escape from oneself and little safety in closing art history off against the con-temporary imagination.

18 Rodin

PREAMBLE, 1971

I had turned ten when Rilke's *Rodin* fell into my hands, and I still have the book, now held together by a rubber band. The text, which I read word by word, did not strike me as out of the ordinary; it was, I judged, the way grown-ups write about art. But the pictures at the back of the book—the sculptor's works in sepia-toned photographs, some of them signed across the bottom "Aug. Rodin"—these were pored over in delicious disquiet hours on end, for they seemed to be of men and women, and the pictures let me in, allowing me to peer into dark adult privacies. You still get a sense of this suggestiveness of Rodin's work watching young visitors to the Musée Rodin in Paris, those especially who wander by themselves, whose gaze transforms each of these dingy exhibition rooms into a theater of passions.

That was before my art education began. I was soon taught that passion is one thing and theater another and art something else again. Esthetic judgment has responsibilities. Thanks to the infallible guides of my adolescence, above all Roger Fry, the English formalist critic, I learnt that taste in art is not a surrender to every interesting stimulus. A taste truly concerned with quality had, I gathered, its own moral stance. It must be pure, uncompromising, and ascetic, armed not only to resist the second-rate, but every seductive interference from disturbing content.

Having at last reached seventeen, it became clear to me, as it had long been to my elders in the avant-garde, that Rodin's work did

First published as Introduction to *Rodin: Sculptures and Drawings*, exhibition catalogue, Charles E. Slatkin Galleries, New York, May, 1963.

not pass the test of a disciplined taste. It failed by those criteria which alone addressed themselves to the essential formal quality of art. And as the emotions Rodin liked to represent were too sentimental and accessible, so their form was too loose to qualify as serious sculpture. Roger Fry, the revered mentor, had passed the final sentence: "His conception is not essentially a sculptural one. Rodin's concern is with the expression of character and situation; it is essentially dramatic and illustrational."[1]

It seems to me that formalism as a gauge of quality is rarely, if ever, what it claims to be. Rather than a means of isolating the esthetic factor from all styles and manifestations of art, it is, at least in its historic record, a taste preference for certain styles against others. Formalist criticism is nearly always engaged and passionate in its championship of a particular constellation of works. Thus between 1920 and 1950, the sculpture that appealed to formalists had to be unencumbered by expressive or symbolic content, and it tended to be monolithic. It was everything Rodin was not—solid and simple, undemonstrative and imperturbable—like the art of Brancusi, or of the Cyclades.

Growing up you take your place in the world, in the world of taste as in every other. At seventeen, vacationing in Denmark, I discovered the most beautiful of all possible sculptures in Copenhagen's Ny Carlsberg Glyptotek—a male head with a broken nose, Amenemhet III, Egyptian, Middle Kingdom (Fig. 182). The stone, the label said, was quartzite, and its hard crystalline shape was a revelation of infinite density. And that look it had of serious reserve seemed to hold other values implicit: you could tell it had been carved and polished with steadfast determination; and it was all "direct carving," all "honesty" with respect to material. Could Rodin's nervous, hasty, over-eager output stand comparison with this?

When an artist goes into eclipse, the œuvre itself by which he is known undergoes alteration. And it changes in a way that increasingly justifies the aversion of taste. As Rodin's reputation receded, the objects left behind to represent him to our minds were either such proverbial clichés as the *Kiss* and the *Thinker,* or else the expensive marbles marketed by Rodin's atelier during his final years.

Where, in those days, would you have gone for his best? Much of Rodin's boldest thought remained cellared and closeted at Meudon, where the sculptor in 1897 had acquired a modest estate. Until his death twenty years later he commuted between his Meudon studio,

186.

built out on the terrace in front of the bedroom, and the one in Paris, installed since 1908 at the Hôtel Biron. But the Meudon atelier was demolished in 1925, and though an exhibition space was subsequently raised through the enthusiasm of the Philadelphian Jules E. Mastbaum, Meudon remains to this day one of the most desolate of unvisited public museums in the world. "Rodin is still an unknown man," wrote the sculptor Jacques Lipchitz in 1954. "At Meudon there are some 1500 molds never cast; some extremely daring representations; some, almost automatic expressions."[2] As late as 1962, when I first penetrated that inexhaustible Meudon basement, I remember the exhilaration upon first catching sight, atop a tall vitrine, of a forest of Clemenceau busts—not spare casts but all different, thirty-four of them—one serial portrait, continuous as Monet's *Rouen Cathedrals* or *Water Lilies*, yet to this day unpublished and unexhibited.

Meanwhile, back in Paris, in the once elegant Hôtel Biron, where posthumous Rodin bronze casts were offered for sale at depressed prices year after year, the Musée Rodin was running down. Its spiritless debilitation well into the 1960's seemed to confirm its obsolescence—while modern art burgeoned around the world.[3]

Until 1955, New York's Museum of Modern Art possessed not one of Rodin's sculptures. To see Rodin during those years, New Yorkers would have gone up to the Metropolitan Museum. But there, during the 1930's and forties and fifties, it was the glossy marble copies that were on display, serving as decorative centerpieces in the painting galleries. The Museum's great Rodin bronzes were in storage until 1957. And the unique, astonishing small plaster and terra-cotta fragments, which the Museum had received as a gift from Rodin himself—these have not been exposed again since their arrival in 1913. It was the same in Paris' Petit Palais, where a masterpiece of French art, Rodin's bronze *Torso* of 1877 (Fig. 186), was kept in the basement. In Philadelphia, the Rodin Museum created by Jules E. Mastbaum and opened in 1929 was, by the mid-1930's, in full decline. "Now only a handful of persons, and only an occasional Philadelphian, visit the beautiful Rodin Museum," runs a newspaper report of 1936.[4] In San Francisco's California Palace of the Legion of Honor much of the magnificent Spreckels collection of early casts and original plasters was found in storage in 1963. And in the basement of the Boston Museum of Fine Arts, Rodin's bronze *Iris* (Fig. 187) was labeled "unexhibitable" until 1953, when it was traded to the late Curt Valentin in return for six small maquettes.[5]

Rodin's real self had gone underground, and the part of him that was left showing did not seem to deserve reappraisal. In step with my generation, I could assume that my childhood susceptibility to Rodin was well outgrown.

The revision of judgment set in during the 1950's. Early in 1953 Andrew Carnduff Ritchie mounted a major show of twentieth-century sculpture at the Museum of Modern Art, New York. His gateway to the twentieth century was Rodin. In reviewing the catalogue of the exhibition (for *Art Digest*, August 1953) I posed the question of the legitimacy of Rodin's inclusion and decided in favor:

187.

> What is it that sets modern sculptures apart from their predecessors? . . . To suggest that modern sculpture shows a greater preoccupation with plastic first principles is not enough. . . . Modern sculpture is not merely more concerned with plastic form, but with a different kind of form, one answering to a radically new awareness of reality. The forms of contemporary sculpture are unstable and dynamic things; every transient shape implies a history, a growth, an evolution. . . . The question can be stated in another way. On what grounds does Mr. Ritchie claim Rodin for our century? Classifying his works as "conceived in relation to light" only relates Rodin's flickering "lumps and holes" to Monet's fleeting specks of color. It only establishes him as an impressionist. . . .
>
> And yet Rodin does belong to us; not by virtue of his light-trap modeling, but because in him, for the first time, we see firm flesh resolve itself into a symbol of perpetual flux. Rodin's anatomy is not the fixed law of each human body but the fugitive configuration of a moment. . . . And the strength of the Rodinesque forms does not lie in the suggestion of bone, muscle and sinew. It resides in the more irresistible energy of liquefaction, in the molten pour of matter as every shape relinquishes its claim to permanence. Rodin's form thus becomes symbolic of an energy more intensely material, more indestructible and more universal than human muscle power. And it is here, I believe, that Rodin links up with contemporary vision.

Within the Western anatomic-figure tradition, Rodin is indeed the last sculptor. Yet he is also the first of a new wave, for his tragic sense of man victimized is expressed through a formal intuition of energies other than anatomical.

His first masterwork, created when he was twenty-three, was the portrait of a man whose nose had been mashed to pulp—the *Man with the Broken Nose* (Fig. 183). But the sculpture was itself a product of breakage, since the terra-cotta Rodin submitted to the Salon of 1864 was the mask that survived when the full head he had mod-

182. *Amenemhet III,*
ca. 1860 B.C.

183. Rodin,
Man with the Broken Nose,
1863

184. Daniele da Volterra,
Bust of Michelangelo

185. Rodin,
Man with the Broken Nose,
1882

eled was accidentally broken. Decades later, Rodin remarked that
he had "never succeeded in making a figure as good as the *Broken
Nose.*" The image which, he insisted, "determined all my future
work," was a visage defaced by a blow. It was a face whose central
feature arrests what the young Michelangelo felt when the fist of a
fellow art student made his nose "go down like putty" to disfigure
him for the rest of his life. An artist of Rodin's susceptibility could
not have been unaware that the paragon of sculptors had been him-
self a man with a broken nose (Fig. 184); as are most ancient
sculptures—damaged nose first. It is as if the battered prow of the
human face were the token and stigma of the sculptor's art.

Twenty years later, Rodin repeated the *Broken Nose* in little for
use on the *Gates of Hell* (Fig. 185); and the revision reveals the
trend of his thinking: the nose made malleable by an act of ill-
chance has become the all-determining pattern. Now the entire face
is a medium in fluctuation, a churning sea.

In May 1954, Curt Valentin installed a Rodin exhibition in his
relatively small gallery on New York's 57th Street. The collection
of forty-four sculptures contained only one marble; the rest were
early bronze casts and original plasters. This show marked a turning
point in Rodin's posthumous fortune. For me it meant a loyalty re-
newed, and being restored to my childhood enthusiasm.

The essay that follows was written at Meudon and Paris during
the summer of 1962. It was intended as a limited effort, not a full
presentation, but a bid to reinsert Rodin in the stream of modern
consciousness.

But that consciousness was already turning. Two European schol-
ars, Joseph Gantner and J. A. Schmoll gen. Eisenwerth, were re-
thinking the meaning of Rodin's partial figures; Albert E. Elsen's
work on the *Gates of Hell* appeared in 1960. In December 1962 the
Louvre opened a *Rodin inconnu* exhibition, followed in 1963 by a
similar showing at the Galerie Claude Bernard, Paris. In May 1963
the Charles E. Slatkin Galleries, New York, launched a Rodin ex-
hibition which during the following two years toured twelve major
museums in Canada and the United States. Cresting this new wave
of appreciation was the great Rodin retrospective at the Museum of
Modern Art, 1963. The Rodin revival was in full swing.[6]

A few words must be said on the question of Rodin's share in the
marble carvings that carry his name, a question on which there is

still uncertainty and disagreement. My exordium failed to distinguish between the single heads—*La Pensée* and some of the late portraits in which Rodin seems to have been closely involved—and the multiple marble groups. I would still disattribute the latter almost entirely. There is of course ample evidence that Rodin throughout his life employed assistants to transfer his conceptions to stone. His own genius was that of a modeler. On the other hand, there can be no doubt that in some corner of his large nature Rodin clung to the romantic stereotype of the sculptor as a wielder of hammer and chisel, a Michelangelesque titan who imposes his will upon stone. A heroized portrait of him, modeled for bronze by his disciple Bourdelle (Hôtel Biron, Chapel), shows him with mallet and chisel —there being nothing heroic about the spatula and the thumb.[7] In exactly this spirit romantic admirers have called Rodin "the greatest thinker in stone of modern times,"[8] though Rodin's thinking is not in stone but in pliant matter. "The most picturesque detail of his method," wrote George Bernard Shaw who had sat at length for his portrait, "was his taking a big draft of water into his mouth and spitting it onto the clay to keep it constantly pliable."[9]

Whatever his actual practice and preference, Rodin surely wished to project himself on the world as a creator of works in stone. He may have remained over-impressed by the memory that the *Broken Nose* in its original terra-cotta was rejected by the Salon of 1864, but accepted eleven years later in a cold marble replica.

The discussion of the subject in Athena Tacha Spear's *Rodin Sculpture*[10] remains inconclusive. Though the book is a mine of valuable information, the "eyewitness" description she quotes of Rodin actually carving is too transparently stereotyped and journalistic to be creditable. It appeared in the *New York Times Magazine* in a piece called "The Model of 'The Kiss' Talks on Rodin": "Oh, he worked very fast. Chip-chip-chip and the marble flew everywhere. . . ."[11]

More serious are the criticisms sent to me at my request by my friend Albert E. Elsen in a letter of August 21, 1969. In fairness to him, and perhaps to Rodin, Elsen's words deserve to be quoted:

> I cannot agree that to know Rodin we must forget his stones. We know that there are marbles of very high quality, also marbles whose making he worried about, suffered over, and finally delivered with pride. I cannot agree that he had no feeling for stone or carving. . . . Admittedly the marbles are not his best. Much of the stone carving is hack work. We know that there has been no editing

of his marbles on view in Paris. At least eighty per cent of them are either uncompleted or rejected pieces; many were made without his consent, and some were posthumous. (At his death, Judith Cladel reported that it was scandalous to see a number of carvers working in their own studios—without Rodin's authorization, carving from his plasters. She was responsible for the law putting a stop to this.) But can we dismiss them—can we amputate this part of Rodin? Conceiving for stone, overseeing their making and finishing them was very much a part of him. Today, when so many artists don't touch their works, not even making models, but are only giving verbal directions, can we still deny to Rodin what he was so extensively and enthusiastically involved in for so long?[12]

Perhaps indeed my original case against Rodin's marbles was overstated. I wanted them out of the way because they obscured Rodin's genius. "Move them aside," I wrote, "if only for now." "Now" was ten years ago.

Rodin's posthumous place remains unsettled. The approval he sought in his youth was withheld till he was a man in his forties; no major artist served so long a period of hiddenness. When fame finally came, it came in the midst of polemics, the astonished sculptor finding himself a storm center of controversy, pitted against an official academy from whom he had asked only acceptance and fellowship.

Then the admirers came, the few and the many; the champions, disciples, assistants—and the beautiful worshippers, offering fashionable adulation and festooning the aging master in glory. By 1914, at the outbreak of World War I and three years before his death at seventy-seven, Rodin's rank as First Since Michelangelo seemed assured. Since then his greatness has rarely been questioned—only his taste, his good judgment, and his significance in the present. For while modern art was in the making Rodin seemed irrelevant. And now, forty-five years after his death, it is his relevance that astonishes us as we look again.

But it means learning to disregard. Begin by shelving the famous marbles and stones. Having signed them, the master is legally responsible for them; and of course morally, since he ordered, supervised, and approved them for sale. But he did not make them. Marbles such as the *Hand of God*, the *Cathedral* (Fig. 228), *Eternal*

188.

Idol (Fig. 188), *Eternal Spring* (Fig. 189), *Fall of an Angel* (Fig. 233), or *The Kiss*—of which no less than four over-life-size versions exist—they are dulcified replicas made by hired hands. We can bring them back for special studies of Rodin's influence, of his esthetics, his sources of income, his role as entrepreneur. But for his sculpture, look to the plasters, the work in terra-cotta and wax, and the finest bronze casts. Rodin himself rarely drives his own chisel; he kneads and palps clay, and where a surface has not been roughed and shocked by his own fingering nerves, it tends to remain blind, blunted, or overblown by enlargement; rhetoric given off by false substance.

Of course, much of Rodin's own-fingered work is rhetorical too. It seeks to appeal, to afflict, to persuade—always to stir the heart up into fellow feeling. And it is on these programmatic works, with their charge of pride, craving, contrition, defeat, that Rodin's fame largely rests.

Degas has had better luck. His posthumous reputation as sculptor is not founded on what he showed during his life—the "frightful realism" (as Huysmans called it) of the *Petite Danseuse* of 1880; it rests rather on some eighty unfinished, uncompletable wax figurines, formed in profoundest privacy and never exhibited during his life. Degas even left them uncast, so that a working hive of bathers, dancers, and horses swarmed always about him like thoughts astir.[13]

You can, as an artist, try to say something big about life; or be content to make the stuff in your hands come to life. And this humbler task is the greater, for all else merely follows.

Or this other distinction: there are objects an artist makes because he wants to be seeing them, and there are themes he invents which, in Rodin's own phrase, "awaken the spectator's imagination." Our own sympathies—I mean those of the post–World War II present—are flatly anti-rhetorical. They lean towards the object an artist makes simply to make its acquaintance, to find it out. Modern minds are repelled by the kind of advertisement which Rodin's famous works, in their impatience to rouse our feelings, give to emotion.[14]

It is the diminished status of emotionalism as such which puts the declamatory Rodin at a disadvantage with us (and us with him, which amounts to the same but sounds better; for instead of arrogantly rejecting half his work, we merely confess our incapacity to relate to it). A modern consciousness cannot endure the heroics of

189.

190. Rodin, *Gates of Hell*

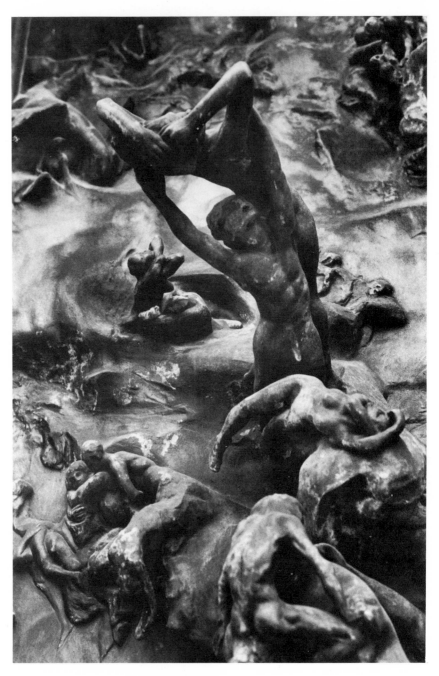

191. Rodin, *Gates of Hell*, right panel detail

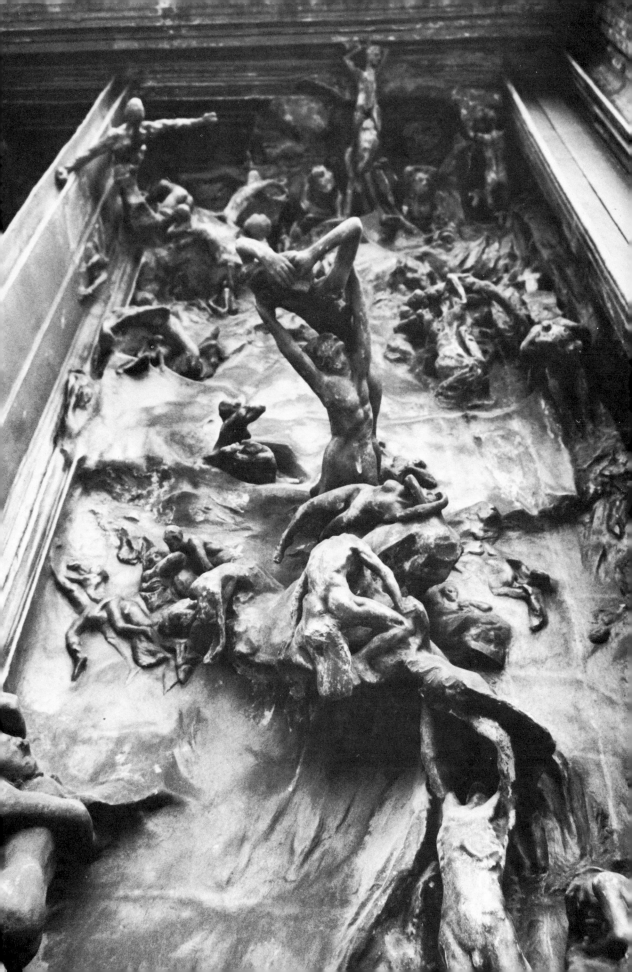

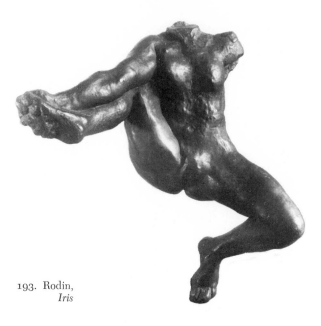

193. Rodin,
Iris

a contemporary without automatic suspicion. Our commitment to irony is far too serious to enable us to suffer and judge an art of Rodin's demonstrative, humorless pathos.

But Rodin too left a private creation, richer and more daring than that of the sculptor Degas. For half a century it has been sequestered, or simply obscured by the renowned exhibition pieces. Move these aside—if only for now—and it is marvelous to see Rodin's art stride into the present.

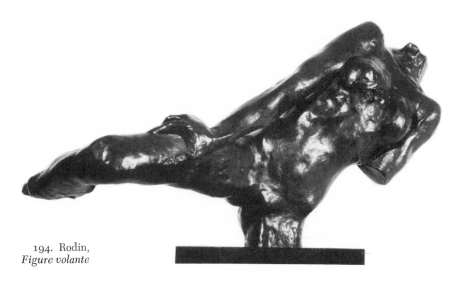

194. Rodin,
Figure volante

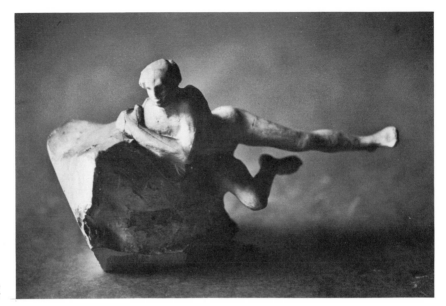

195. Rodin,
Figure Study

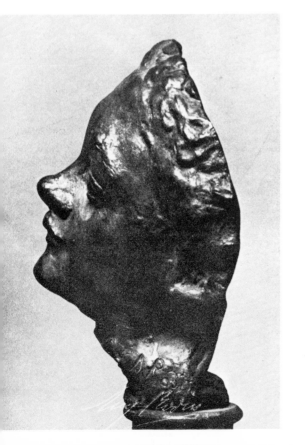

5. Rodin, *Head with Upturned Nose*

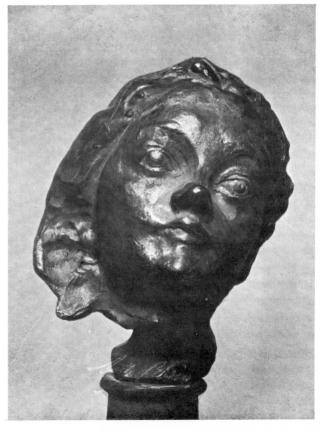

197. Rodin, *Head with Upturned Nose*

IMMERSION IN SPACE

To begin with the space he creates. Rodin's intuition is of sculptural form in suspension. He finds bodies that coast and roll as if on air currents, that stay up like the moon, or bunch and disband under gravitational pressures. He seeks to create, by implication, a space more energetic than the forms it holds in solution.

This is the impossible concept behind the *Gates of Hell* (Figs. 190-92), the project of Rodin's best twenty years, his great source work, his dumping ground and "Noah's Ark," wherein 186 figures drift and writhe like leashed flying kites. A vision of energetic immersion is also the inspiration of *Iris* (Fig. 193)—a woman unfurled, headless, lodged in mid-air; of the listing *Figure volante* (Fig. 194), whose home base is not any ground below but some vanishing pole of attraction; of that cantilevered, rock-clinging plaster *Figure Study* (Fig. 195), so floated that all the surrounding air turns buoyant to keep it up.

Even Rodin's heads can look tossed and sudden—as Rilke saw when, in his great prose poem on Rodin (1903), he described the head of the *Balzac* as "living at the summit of the figure like those balls that dance on jets of water." It is in their aerial detachment from body and gravity that Rodin's heads (whether portraits or not) differ from, say, Bernini's great marble busts. Bernini's portrait of Louis XIV astonished the French by the commanding posture which its mere head and shoulders conveyed; they felt it showed the King marching at the head of his troops.[15] For Bernini's busts, by their imperious suggestion of stance, imply the whole man, and through the man's implied body, the ground. Rodin's unbodied heads—the masks mounted off base, tipped and angled (Figs. 196 and 197), the alert *Mrs. Russell* (Fig. 198), and scores of others—they seem not poised but propelled, discharged into space by the abstracted energy of gesture alone.

Like Monet, with whom he exhibited in 1889, Rodin evolved within an unquestioned tradition of representation. Both men therefore taught themselves to project some of their most secret intuitions through choice of subject; Monet by looking deep into a lily pond, where the familiar clues of up-and-down and near-and-far watered away (Fig. 163); Rodin by isolating restless fragments of body, such as hands—more familiar in their absolute motion than for their moorings at the nearest anatomical joint.

198.

In the human hand Rodin discovered the only familiar existence which has no inversions, no backviews or atypical angles; which can never be seen upside down. Because hands, weightless and tireless, live in perpetual adaptation and transit, unlike the hard-bottomed space that supports our bodies, the space in which hands exert themselves is as fluid, as musical, as that of Monet's sky-replete water.

Rodin made some 150 small plaster hands, two to five inches long, for no purpose but to be picked up and revolved between gingerly fingers (Figs. 199–201). Their modeling is of such tremulous sensibility that, by comparison, Rodin's own hand, preserved in a plaster cast at the Paris Museum, looks stiff and clodden—as would the cast of any real hand keeping still. But a living hand is in motion, and Rodin's little plasters simulate motion in two ways at least: first, by multiplied surface incident, which makes the light on them leap and plunge faster than light is wont to do; and again by the ceaseless serpentine quiver of bone and sinew, as if the sum of gestures which a whole body can make and all its irritability had condensed in these single hands; and their fingertips so earnestly probing that one credits them with total awareness and a full measure of life. There is in sculpture no surrender of privacy more absolute than when two of these small plaster hands lie together (Fig. 202).

Bronze casts of these hands unfortunately have to be mounted. Now they stand flat-footed on platformed wrists, fingers skyward in prophetic pretentiousness. Rodin himself did not usually mount them, but left them lying loose in chests of drawers. "He would pick them up tenderly one by one and then turn them about and lay them back," writes an English sculptress recalling a visit in the year 1901.[16] In other words, Rodin made some 150 sculptures which were not conceived to stand with their weight bearing down.

And not hands only. Among the gifts received by the Metropolitan Museum, New York, in 1912 from Rodin himself, is a flexed plaster leg, about four inches long. The toes point and the sole twists inward and up, so that the leg cannot stand, nor lie at rest, nor suggest any specific orientation. It is a typical Rodinesque form dislodged from the ground. To experience it as sculpture we must pick it up and "turn it about," restoring it to that same spatial medium within which Rodin conceived it—the mindspace of conception —the space in which most of his forms turn and return. For they have to be seen in their successive recurrences, the same figures

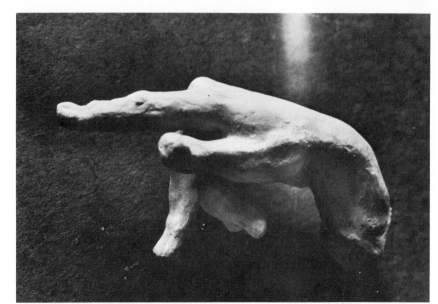

199. Rodin,
Hand

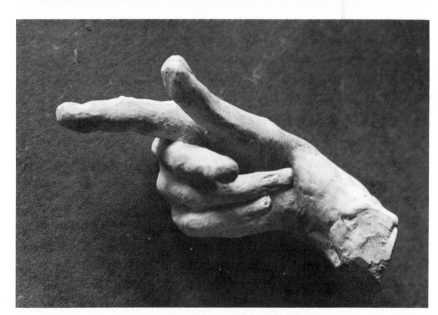

200. Rodin,
Hand

201. Rodin,
Hand

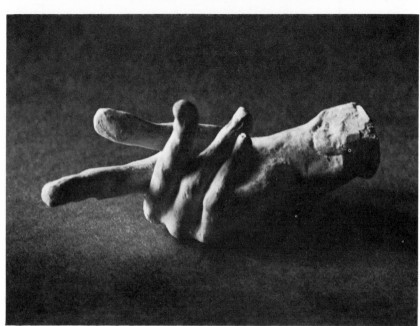

202. Rodin,
Hands

again and again, with new roles, new titles, new partners, a new limb or two, and always a new orientation, reclaiming their affinity with a swimmer's bottomless, all-accessible space. And it is this native invertibility of his figures that enables Rodin to recast them.

His figure of the *Prodigal Son* is best known to us kneeling. Thrusting his hands up to the sky, he leans over backwards in the standard large version (Fig. 203); plunges forward in the reduced model. Then, in the group called *Fugit Amor*, the same figure is laid back to back upon a prone, drifting female, and they glide on together trailing his kneeling legs (Fig. 204). In the right-hand panel of the *Gates of Hell*, you may find this group twice, coursing in different orbits (Figs. 191, 205).

Rodin makes a playful group, representing a seated girl-mother and child. He then breaks it up and, in a new version, a new child with its back to the girl drifts unsupported athwart her closed legs, the title changing to *L'Amour qui passe* (Figs. 206 and 207).

Or *The Martyr*, originally a small upright female figure in the *Gates of Hell*. Enlarged to near life-size in 1885, tilted ninety degrees, and cast in bronze, it becomes a recumbent corpse pressed down on a twisted shoulder, and the legs stiffly out. Ten years later, this same figure, hugely winged, reappears, with no change of sex, as a *Fall of Icarus;* but now the body descends headlong at thirty degrees to touch ground with the face alone. Finally, fourteen years

341

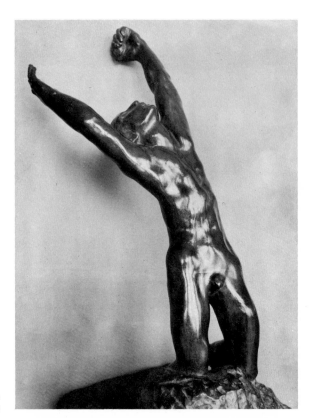

203. Rodin,
Prodigal Son

204. Rodin,
Fugit Amor

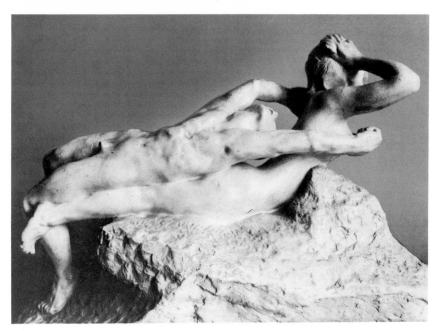

205. Rodin,
Gates of Hell

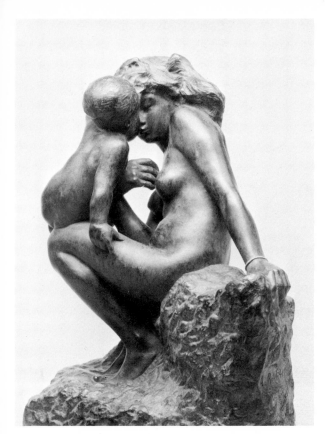

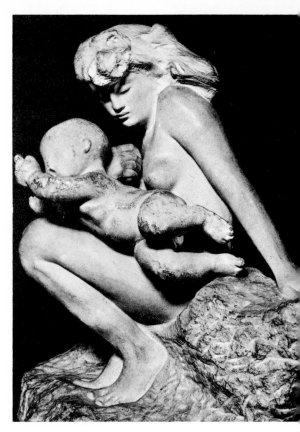

206. Rodin, *Mother and Child* 207. Rodin, *L'Amour qui passe*

later, it returns in relief on a tomb slab, upright again and entitled *Le Lys brisé*, or *Resurrection*.[17]

How many of Rodin's inventions take to the air?

The well-known *Eternal Idol* (Fig. 208), shows a youth, with both arms to his back, kneeling before a hesitant girl to plant his lips under her breast: while she fingers the toes of a retracted foot so that her body's profile forms a triangular silhouette. Observe the pair of them again, this time in echelon as an Adam and Eve—levitating in the embrace of a God-figure that began as a dancer but now seems materialized from Michelangelo's *Creation of Sun and Moon* (Fig. 209).

The point is not so much that Rodin puts his sculptures through these revolutions, but that they lightly lend themselves to inversions, as most figurative sculpture, conceived to rest on a supporting base, does not. His figures' compliance with ever-new angulation

344

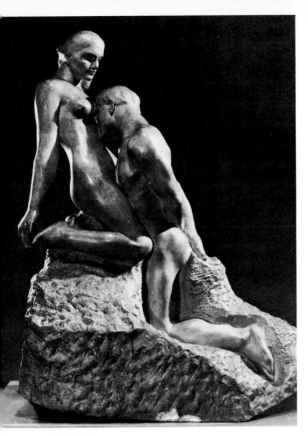

8. Rodin, *Eternal Idol*

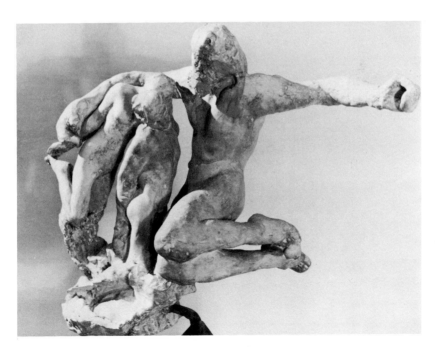

209. Rodin,
The Creation

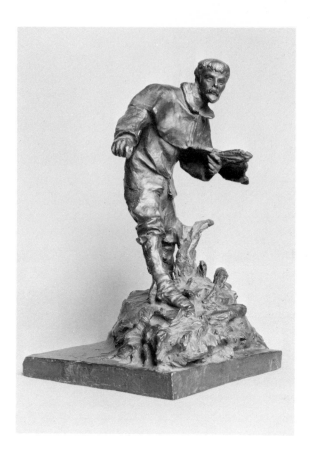

210. Rodin,
Bastien Lepage

implies that their given postures result less from volition than from
strains imposed by the medium. So that what enlivens Rodin's forms
is not only the vibration of surface modeling and the quickened
light, but the implication always of some pressure or spatial turbu-
lence to which these forms are exposed.

Many of his figures are precariously balanced or hoisted, like the
Bastien Lepage (Fig. 210) and the *Claude Lorrain* on their respec-
tive monuments. Many have to do with falling—*La Chute d'un Ange*
(Fig. 233), *Icarus* in several versions, *L'Aiglon, Le Rêve, L'Homme
qui tombe* (Fig. 244, top), etc. And then *La Belle Heaulmière*, the
Large Shades (Fig. 223 and 224), and the *Petit Ombre*, called also
The Precipice (Fig. 211)—figures that gaze into abysmal depths, as
if the ground at their feet were a nether sky.

This evasive relationship to a supporting ground marks a good
half of Rodin's conceptions, his casual doodles, and even his failures,

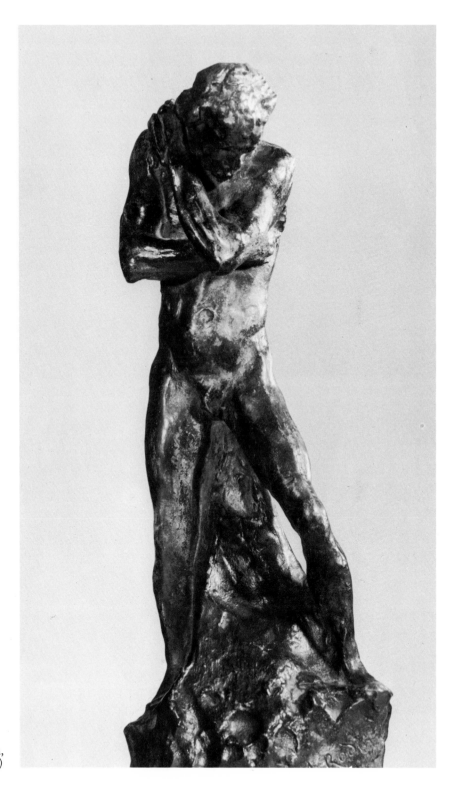

211. Rodin,
Le Petit Ombre (The Precipice)

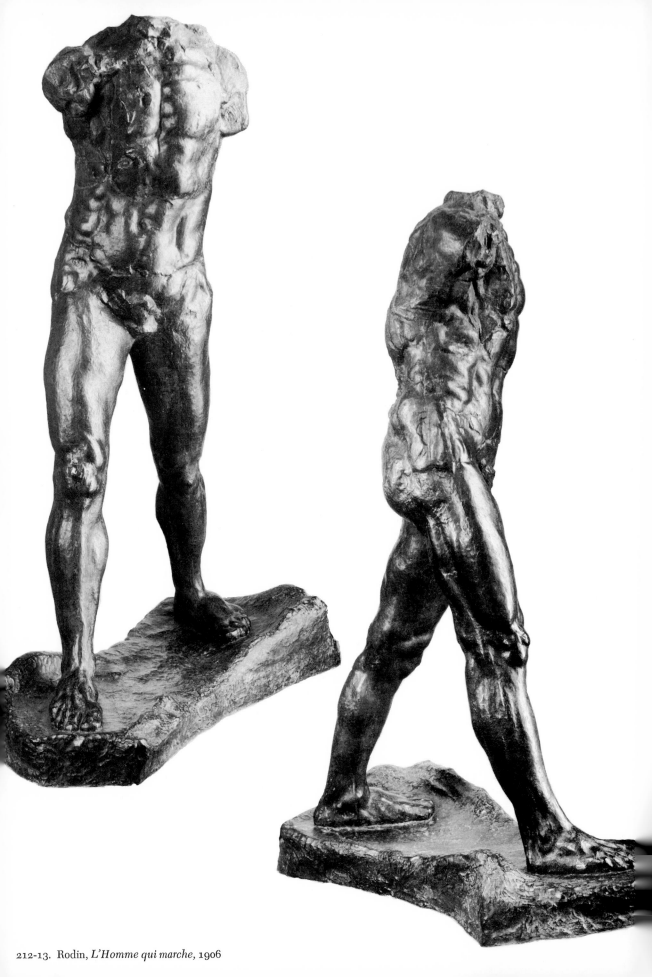

212-13. Rodin, *L'Homme qui marche*, 1906

as much as his great, humble masterworks. They share the disturbed equilibrium, or the vain drift to find the void at its center.[18]

And then the opposite: the monumental statues that stand planted and rooted. The *Walking Man* (*L'Homme qui marche*) of 1900 and its grand version of 1906 (Figs. 212 and 213), the life-size nude study for the *Jean d'Aire* (the Burgher of Calais with the key—perhaps Rodin's greatest work, Fig. 214); the *Balzac* (Figs. 267-69) and the striding nude *Victor Hugo* (Fig. 215). For these figures it is the fierce grip on the earth that becomes the whole enterprise. They stand or take one step as if they were driving piles for foundations.

L'Homme qui marche is not really walking. He is staking his claim on as much ground as his great wheeling stride will encompass. Though his body's axis leans forward, his rearward left heel refuses to lift. In fact, to hold both feet down on the ground, Rodin made the left thigh (measured from groin to patella) one-fifth as long again as its right counterpart.

The resultant stance is profoundly unclassical, especially in the digging-in conveyed by the pigeon-toed stride and the rotation of the upper torso. If the pose looks familiar, it is because we have seen news photos of prizefighters in the delivery of a blow. Unlike the balanced, self-possessed classical posture with both feet turned out, Rodin uses the kind of step that brings all power to bear on the moment's work.[19]

For the *Jean d'Aire*, standing his ground is an ultimate effort. His huge feet do not rest flat but turn in like a grasping ape's, clutching their clod of earth (Fig. 214). Such actions are hard to see in a photograph, hard to see anywhere if they are not re-experienced internally; one must do it oneself and perform every one of these poses to realize how desperately these statues act out the drama of powerful bodies giving their whole strength to the labor of holding on. As though standing still were the utmost that could be asked of a man.

There is only one major work which stands effortlessly on both feet: the early so-called *Age of Bronze* (1876; Figs. 216–18). It was to become Rodin's point of departure in every sense. For his mature works depart in opposite directions from the common waking experience of equilibrium: they are either disturbed, unsettled, adrift; or else they hold the ground with rapacious tenacity, as if they would lose their limbs one by one, rather than loosen their grip. And both these extremes share in the power of suggesting that the surrounding emptiness is energetic.

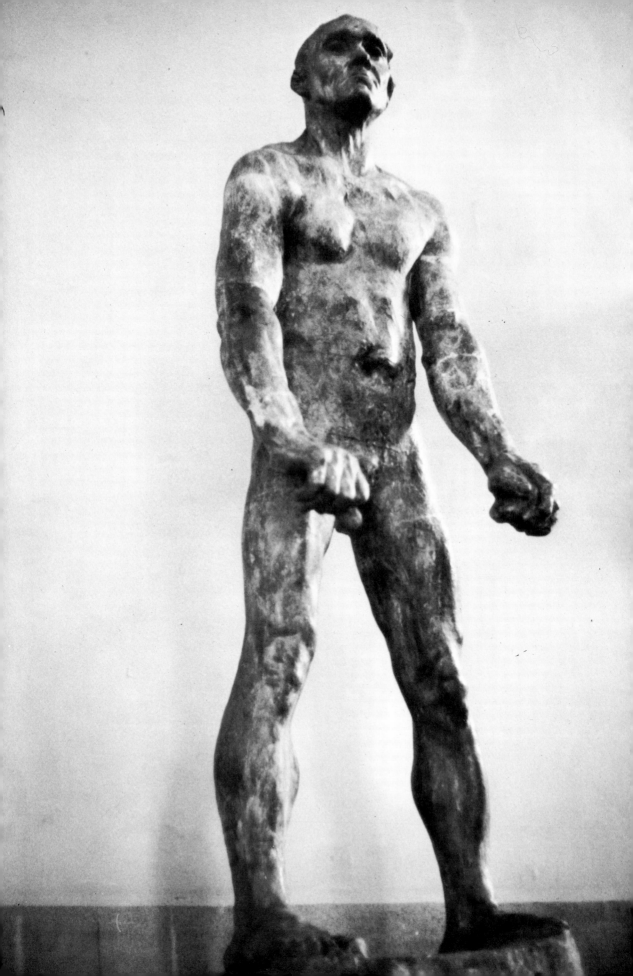

Rodin, *Jean d'Aire*

Rodin's implied space equips sculpture in three distinct ways for the modern experience. Psychologically, it supplies a threat of imbalance which serves like a passport to the age of anxiety. Physically, it suggests a world in which voids and solids interact as modes of energy. And semantically, by never ceasing to ask where and how his sculptures can possibly stand, where in space they shall loom or balance, refusing to take for granted even the solid ground, Rodin unsettles the obvious and brings to sculpture that anxious questioning for survival without which no spiritual activity enters this century.

And there are assumptions more fundamental even than the ground underfoot which Rodin puts to the question.

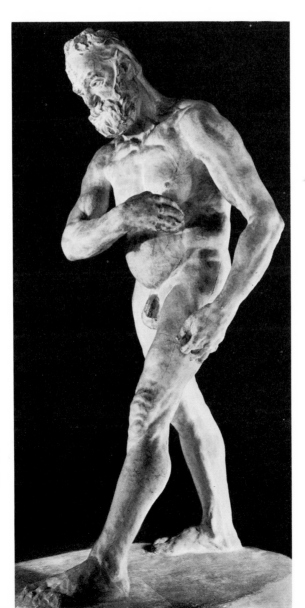

215. Rodin,
Study for
Victor Hugo Monument,
1897

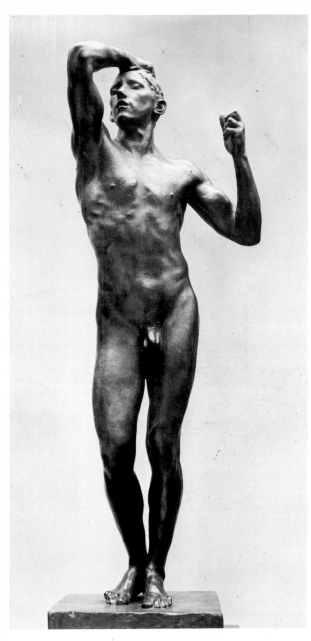

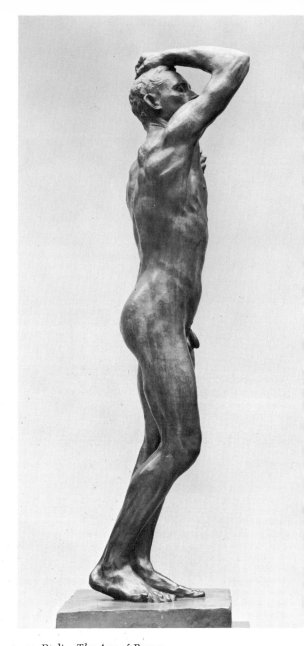

216. Rodin, *The Age of Bronze*

217. Rodin, *The Age of Bronze*

ALLOCATION OF BODY

To all men one body each. Artists who represent figures in action tend to respect the natural rule of one to one. But not Rodin. In his work, the singleness of man's body allotment succumbs to three kinds of action—to multiplication, fragmentation, and random graft.

352

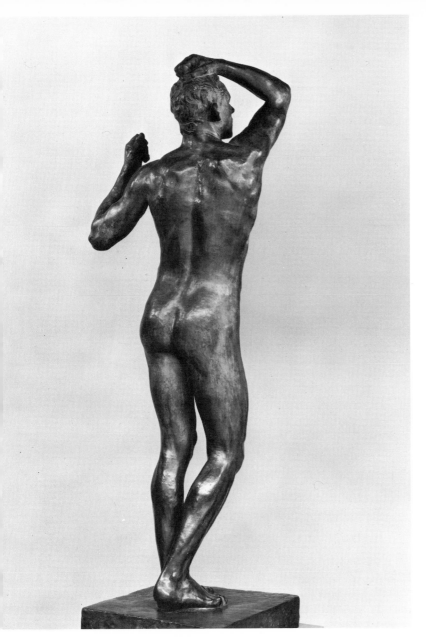

8. Rodin, *The Age of Bronze*

MULTIPLICATION

At Meudon, Rodin's estate near Paris, there are still many unfamiliar small plaster groups. One such, tucked away in a dim corner and long listed as lost, consists of two naked crones—seated, confronted, poring over the ground; a hollow backdrop behind suggests the

353

219. Rodin, *Les Sources taries*

mouth of a cave (Fig. 219). The figures are two identical casts of a reduced version of the celebrated *La Belle Heaulmière*, so named in allusion to a ballad by François Villon, but known also as *Winter* and *The Old Courtesan*. The double exposure was exhibited in 1889 under the rationalizing title, *Les Sources taries*. But the title is afterthought, for the figure's confrontation with its own body's self suggests something which, unlike dry springs, is not found in nature—as if a departed mirror had left a congealed reflection behind.

The opposite corner of the same exhibition hall displays a compound even stranger, and, I believe, so far nameless (Fig. 220). It consists of two casts of Rodin's *Eve* (of 1881), again in reduced scale. Here the self-identity of the figures is masked by the fact that one Eve has a new set of arms; and on her back, pressed down on her like a *cauchemar*, crouches the famous *Femme accroupie*. (Fig. 221). Like most of Rodin's pieces, the group is evocative enough for his literary friends to have found it a title. But the titles always came after the fact, that is to say, after the sculptor had discovered the combination.

The twinning theme runs through the *Gates of Hell*. Looking

354

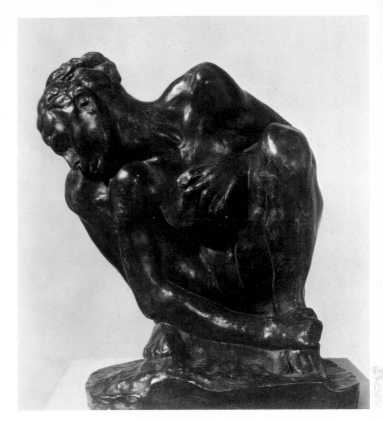

o. Rodin, Group with two Eves 221. Rodin, *Femme accroupie*

sharply at lintel and cornice, you discover the *Man with the Broken Nose* staring out at once from two points in space. The Gate's left panel contains the two prominent incidents from Dante's *Inferno*, the *Ugolino* group and *Paolo and Francesca* (Fig. 222). One body, duplicated, is shared by both groups; for Ugolino's dying son re-embodies the languishing Paolo. Their angulation in space is decep-tively different, but their juxtaposition is close enough to compel the recognition of twinship. Doubles meet again in the right-hand panel where the *Prodigal Son* and the *Fugit Amor* group are adjoined (Figs. 191 and 205).

Why did he do it? Not because he was out of ideas or short of fig-ures; for among the scores of figures excluded from the final *Gates* project, many were put away to make room for these repetitions; of which the most spectacular is the *Three Shades*, the triple yoke and crown of the *Gates of Hell*, one form in three bodies (Figs. 223 and 224).

Such multiplications are Rodin's constant recourse, and if we do not know how they were prompted, we at least recognize the effect, which is always a redoubling of energy. Multiplication generates

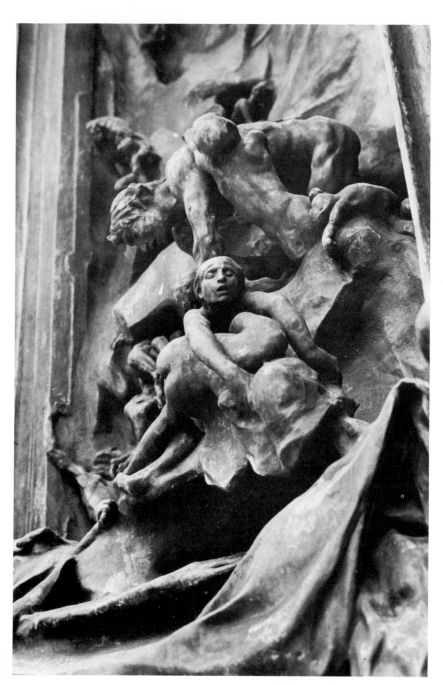

222. Rodin,
Gates of Hell,
left panel detail

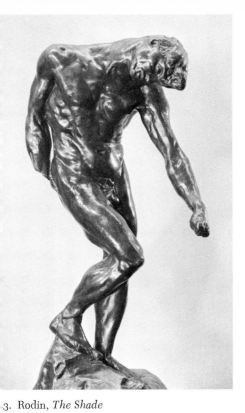

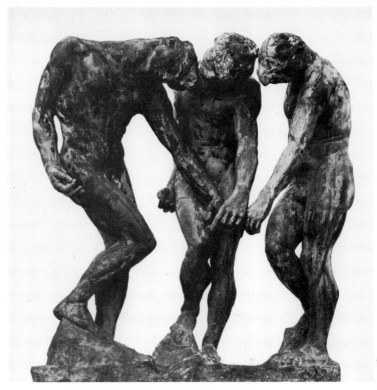

223. Rodin, *The Shade*

224. Rodin, *The Three Shades*, 1880

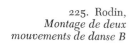

225. Rodin,
*Montage de deux
mouvements de danse B*

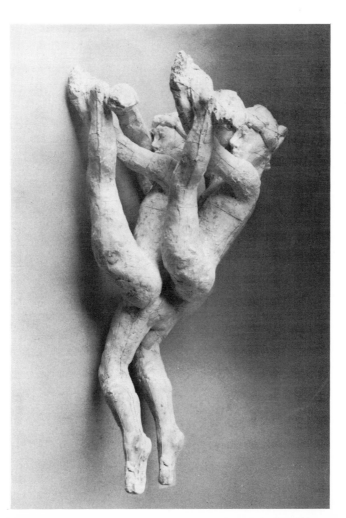

new and more intricate rhythms of solids and intervals, as in the late montage of high-kicking dancers in echelon (Fig. 225), or in the *Trois Faunesses* of 1882 (Fig. 227). The silhouette of one standing *Faunesse* alone (Fig. 226) suffers like all free-standing sculpture; the exterior shapes made or implied by its contours are surrendered to air. By assembling three casts of the figure, Rodin prevents dissipation. The exterior shapes become engaged intervals, and the repeat of this one irregular body yields infinite rhythmic amplification.

Sometimes the duplications reflect Rodin's avowed interest in expressing a succession of moments; for the repetition of identical or similar poses may suggest—as the carvers of the Parthenon Frieze must have known—uninterrupted duration, or a single form evolving in time. What the sculpture gains is the potency of prolonged states.

Elsewhere, the repeats hint at subtler mystification. The famous *Cathedral* (Fig. 228) is not formed by a pair of pious hands joined in prayer, but by two right hands that lend each other their tips to explore.[20] The *Secret* is a complicity of doppelgängers whose encounter expresses the privacy of complete self-absorption. And when Rodin lays together two casts of one tiny hand, the suggestion arises of narcissism, of the sculptures forever caught in marveling reciprocal self-contemplation.

These strange replications, which can be read either as one figure proliferated in two or three bodies, or as one body in several roles or places at once, compel an instinctive reconsideration of what actually is represented. If it occurs more than once, the sculptural form cannot be a direct representation of nature. It must be either an artifact in mechanical multiplication, or a thought obsessively thought again. It can be both. Only one thing it cannot be: the simple analogue of a natural body whose character it is to be unrepeatable.

Rodin's double-takes thus serve to check the ostensible naturalism of his art. The official nineteenth-century notion of the sculptural image as an analogue representation—analogous to some actual or imaginable body in nature—breaks down. And the breakdown is not achieved by simplification of form or depletion of content, but by visual enrichment and amplification.

Again the *Age of Bronze* (Figs. 216–18) is Rodin's point of departure. For that earliest statue, a young Belgian soldier, Auguste Neyt, had posed in "interminable sessions" through eighteen months, the sculptor transposing his shape with virtuoso exactitude. It does not much matter what adjustments Rodin actually made. Perfect

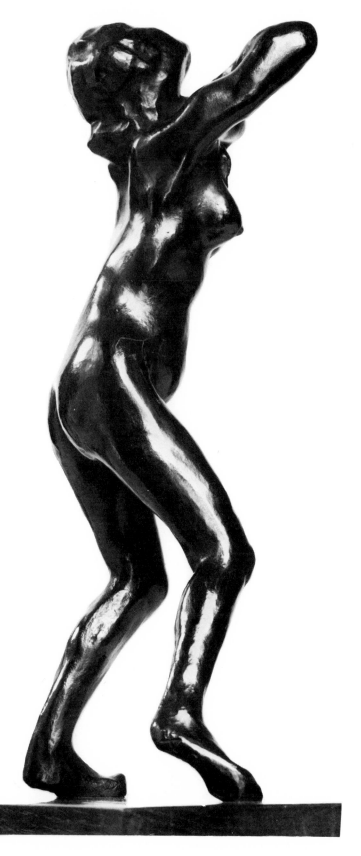

226. Rodin, *Faunesse*

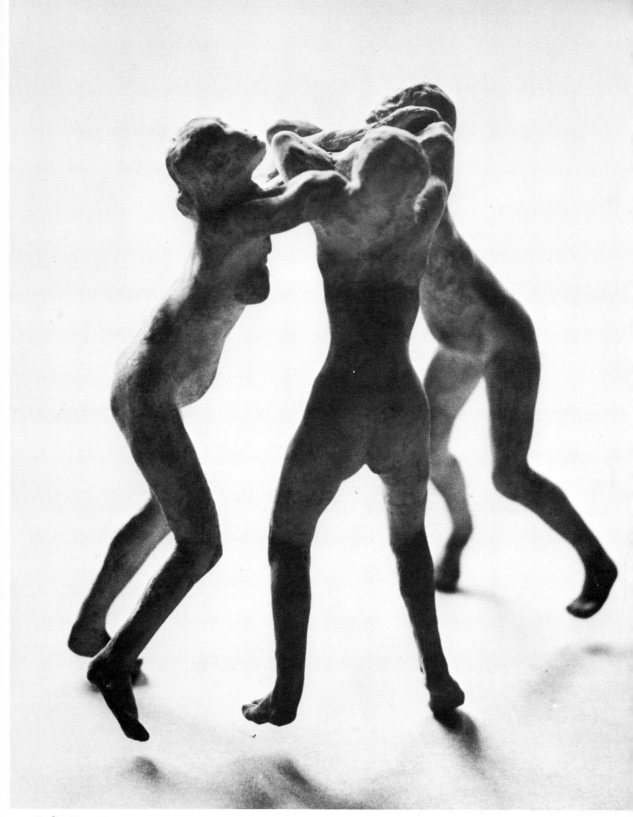

227. Rodin, *Trois Faunesses*

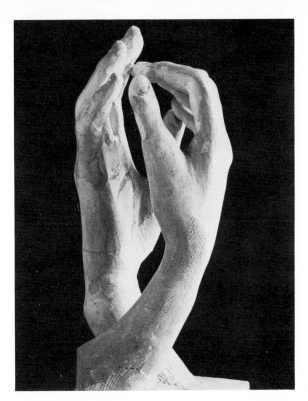

parity was the hoped-for illusion: no nuance of M. Neyt's body surface was to lack in his bronze double, and every turn of the bronze
must follow the young man's physique. The result is a frustration, almost aggressively boring. But it took the earnestness of a genius to
pursue the reigning cant about objectivity to this end. The *Age of
Bronze* was a paradigm of the esthetics of analogues, and the scandalous charge that the sculptor had merely taken a cast from the live
model, though unjust in fact, was esthetically justified.

In Rodin's maturity the constant multiplication of identical forms
again helps to remove his art in two directions from the position of
the *Bronze Age*: towards the work of art as an industrial object,
made and makable again and again; and towards art as the inside-
out of a private obsession. Only by such departures could the art of
sculpture be reconstructed into a potentially modern art form.

FRAGMENTATION

The traffic in anatomical fragments had long been legitimized.
Roman sculptors had introduced the detached portrait bust. The
Middle Ages exhibited sacred bones in reliquaries shaped around the
saint's head, arm, or finger. Sixteenth-century sculptors and amateurs cherished the *Torso Belvedere*, etc. French Rococo sculptors
invented such winning trifles as *Le Baiser donné* and *Le Baiser rendu*

—pendants wherein paired heads alone became tell-tale situations.[21] And by the late nineteenth century, the habit of admiring excavated debris had established the torso as an academic typeform. Rodin draws upon all precedents and enlists further the suggestiveness of mutilated cathedral sculpture and of Michelangelo's abandoned maquettes and stones. And yet, beyond all precedent, his fragmentations trace an original path.

La Terre, for example—a mountainous skyline formed by the spine of a prone human body (Fig. 229). Its undulant contour climbs up to the nape, then drops sharply to let the head fall. The omission of arms and feet is clearly justified by the theme: we understand at once that extremities entail potentials of action and locomotion, whereas what is here conveyed is an activity wholly identified with keeping still.

It is not enough to observe that no feet are present, for, as the base indicates, no feet were ever intended; nor arms from the deltoid down. And this betrays the novelty of the approach. Unlike the arms of the Venus de Milo, the limbs here are not conceivable as missing or as replaceable in imagination. The hulk of *La Terre* allows no fringe forms; it is finished without them because what Rodin represents is not really a human body, but a body's specific gesture, and he retains just so much of the anatomical core as that gesture needs to evolve.

The drift of it becomes wonderfully explicit in the streamlining of the *Figure volante* (1890; Fig. 230). Touching down only at the stump of a thigh, the other leg (calf-length) trailed like a streamer, the figure's headless trunk ascends at forty-five degrees, while its single arm heaves close to reduce wind resistance. Not the body's shape but its transit determines its stringent economy.

229. Rodin, *La Terre*, 1884

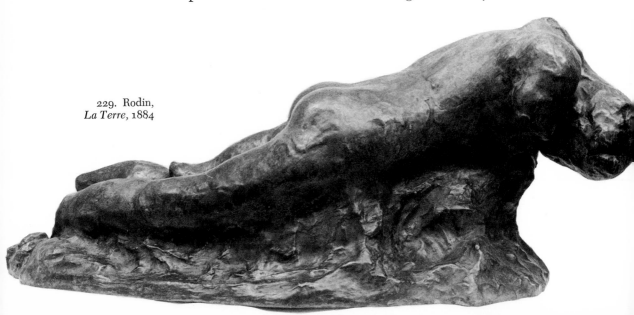

230.

There is a powerful shift here away from traditional ground. Rodin has not so much modeled a body in motion, as clothed a motion in body, and in no more body than it wants to fulfill itself.

Whence it is no paradox to nominate Rodin's figure the precursor of Brancusi's *Bird in Space*—where the sculpture gives form to a trajectory. Rodin takes the enormous step that precedes the abstraction. Compare any flying figure from Baroque sculpture, say, a Virgin of the Assumption: a massy body of preformed anatomy is uplifted and put in motion. Brancusi's *Bird* is at the opposite pole: no body at all, but a movement projected in sculptural form. Between these two, Rodin's *Figure volante* occupies an exact middle position: the sculpture represents an energy—like an electric discharge in a lightning rod—which has found a conductor body.

It is because of the comparative primacy given to movement, gesture or act, that any unmoved part of the body becomes dispensable. Rodin himself said as much when he explained to Degas why his *Walking Man* had no arms—"because a man walks on his legs."

This principle of dispensability determines the limits of fragmentation. An anatomy can be stripped down so long as it yields a clear gesture. But the dispensability rule also hands us a criterion of judgment. Rodin tends to spoil a work when, in obedience to the anatomical norm, he makes a partial figure "complete." This occurred especially during the 1880's, which produced some of his prettiest idyls, and before the sum of his attitudes had caught up with the courage of his imagination.

In 1878[22] he had made a small female torso, one of his most moving works, named *Torse d'Adèle* after his favorite model (Fig. 231). The overlapping thighs break off at the knees, the head is lost in the crook of a lifted elbow, the right arm abandoned just below shoulder. Rodin loved this figure and attached it like a coralline structure to the uppermost corner of his *Gates of Hell* (Fig. 244, top left). Soon after, in 1884, the figure entered a lover's embrace known as *Eternal Spring*—one of Rodin's best-selling works of those years and among his outstanding esthetic failures (Fig. 232).

In both these reappearances—in the *Gates* lintel and in the *Eternal Spring*—the *Torse d'Adèle* has been "finished" by the addition of a right arm (in two variant forms) and lower legs. Both additions are unconvincing, and so they remain in 1895 when the "completed" *Torse d'Adèle* is used once again in a maudlin group known as *Fall of an Angel* or *Illusions Reclaimed by the Earth* (Fig. 233 compounded with 234).

231. Rodin,
Torse d'Adèle, 1882

A modern Rodin admirer finds it painful to see one of Rodin's finest sculptures compelled to serve in such mawkish tableaus. These works are failures not only because the translation of scale and material has botched Rodin's surface; not only because much of this mollified marble looks like damp soap; or because the extended appendages sadly outscale the back-bending torso; but because in all these variants, whether bronze, plaster or marble, the consummate rightness of the original abbreviation has been sacrificed to an extraneous appeal. For the addition of these anatomical members negates one of Rodin's profoundest convictions about sculptural form—about what he called *le modelé*.

"*Le modelé* . . . I know what that means," wrote Rilke to his sculptress wife in 1902, after first meeting Rodin: "It is the science of planes as distinct from contour, that which fills out contours. It is a law governing the relationships between these planes. You see, for him there is only the *modelé*."[23]

And Rodin himself to Paul Gsell:

> I am going to tell you a great secret. The impression of real life . . . do you know what it is that gives this impression? It is *la science du modelé*. These words will strike you as commonplace but

232. Rodin,
Eternal Spring, 1884

233. Rodin,
Fall of an Angel, 1895

234. Rodin,
Caryatid

you will soon judge their full import. This *science du modelé* was taught to me by a certain Constant who worked in the decorative sculpture shop where I first started out as a sculptor.

One day, seeing me model a Corinthian capital in clay, he said, "Rodin, you are going about it badly. All your leaves appear flat. That's why they don't look real. Make them so that they shoot their points towards you."

I followed his advice and was amazed at the result I obtained.

"Remember well what I am telling you," Constant continued. "From now on when you model, never look at your forms in extension, but always in depth. Never regard a surface as anything but the outermost point of a volume, as the broader or narrower summit which it directs towards you. That's how you will acquire *la science du modelé*."[24]

In no work by Rodin is this founding principle of his art embodied with greater power and subtlety than in the *Torse d'Adèle*—its every surface a summit point, the peak of an elevation more or less rounded. And it is the absolute want of exactly this quality which makes the parallel limbs added to the *Torse d'Adèle* look so soulless. Even in the *Gates* lintel, the addition of arms and legs converts the figure, unlike every other figure within this field, into a flat silhouette. And in the marble groups, the surrender of the original *Torso* to honeyed sentiment is matched by the compromise of its sculptural integrity, Rodin's *modelé*.[25]

It is hard to know whether the vulgarity of such finishings is due to a failure of taste, some residual immaturity of feeling, or to a falling back on his early commercial manner prompted either by a genuine need of money or by a more or less cynical exploitation of public taste. At any rate, Rodin's insipid marble groups are the expression of Rodin in his audience-oriented aspect.

In his vast privacies he makes no compromise. There is a small bronze of 1889 which Rodin first called *Danaide accablée*, then *Nymphe pleurant*—another of the hundreds of little figures with which he peopled the *Gates*. This one represents a nude crouched, knees up and face cupped in both hands, yielding a fairly explicit demonstration of grief or shame. But the sculptor's questioning fingers keep asking how much body a weeping nymph needs for contrition. And he cuts away at the arms and legs until he finds a sufficiency—an accident of breakage, of apparent negligence or partial casting. What remains is a collapsed gesture, a shape so

knotted and to modern eyes so abstract that it takes a reluctant effort to spell out the pose (Fig. 235).[26]

I do not claim that abstraction in the modern sense was intended. And yet, in some late private moments, Rodin may have recognized in his work a potentiality to which his fragments bore the most eloquent witness. Brancusi, passing through Rodin's influence in 1906–7, and beginning then to lop off anatomical portions, discovered himself in the process and continued thence to the formulation of abstract twentieth-century form. Rilke (in the letter of 1902 quoted above) had already spoken of Rodin detaching from all things and bodies the *modelé*, "the law governing the relationship between planes," then "making of it an independent entity, that is, a work of sculpture." And proceeding at once to relate this "secret" of Rodin's art to the esthetics of fragments, the poet continued: "For this reason a piece of arm and leg and body is for him a whole, a unity, because he no longer thinks of arm, leg and body (that would seem to him too thematic, you see, too *literary*, as it were), but only of the *modelé* which is self-contained and which in a certain sense is ready and rounded."

235. Rodin, *Nymphe pleurant*

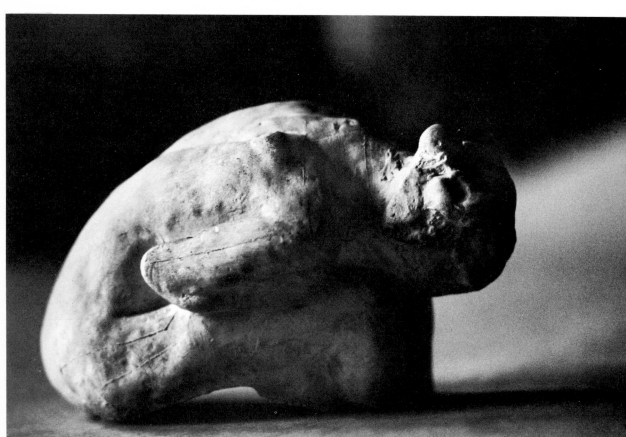

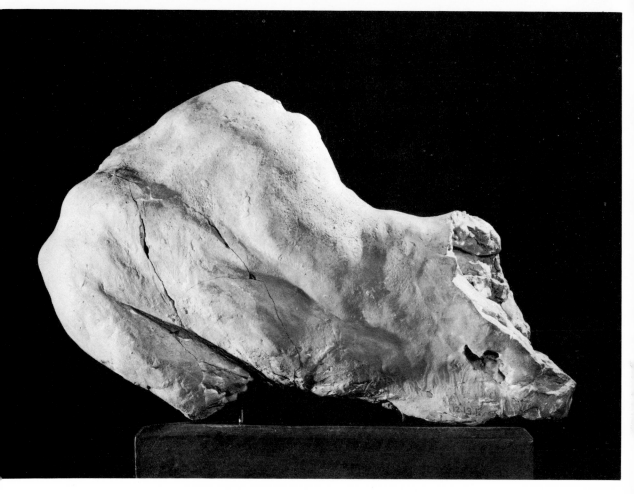

236. Rodin, *Fragment of a Torso*

Surely, the sculptor too came to see his fragments as values which owed nothing to the display of emotion, little to the pathos of gesture, and not very much even to the identification of human shape. In the Meudon cellar one still finds terra-cotta fragments, mounted on wooden slabs by Rodin himself, which pass beyond any test of meaningful gesture to become almost pure sculptural energy. A chunk of female thorax, for instance—mounted like a geological specimen. A somewhat larger fragment, more explicitly human, is at the Metropolitan Museum, New York, a gift from the sculptor in 1912 (Fig. 236). Or at Meudon again: a girl's lower body, some eight inches long—weirdly attenuated and rigid from waist to ankles, feet crossed. It lies on its side, not as a pliant woman would lie, but as one mounts a precious blade or carved ivory tusk.

Some of these pieces have never been shown, or even photo-

graphed, as if by extension of Rodin's own reticence. For he was cautious about exhibiting his fragmentations. He knew, as every revolutionary mob knows, that the mangling of a representative statue reads as an act of aggression against its prototype; that the deletions and cancellations of his own sculptured anatomies would strike home as amputations and acts of mayhem;[27] that connoisseurs would allow a beheaded figure only if it could pass for a "study," or if, being called "torso," it recalled some venerable antique. The criteria which today make Rodin's partial figures acceptable as total entities —criteria which these same figures would help call into being—did not then exist in official art.

As they gradually entered the public domain, Rodin's wrecks and fragments again forced a reconsideration of the nature of sculpture. Of portrait busts it had always been understood that they were not decapitations; not commemorative of beheaded men, but a *pars pro toto*, the representation of a part signifying a whole. Rodin's work demanded the extension of this simple logic to any anatomical cluster —and more than that: not a part *for* the whole, but the part *as* a whole, and its wholeness wholly immanent in the fragment.

Perhaps he was asking too much. Hence his timidity. So his masterly early *Torso* (Fig 260), made before 1877, remained unexhibited. His plaster of *La Méditation* (Fig. 239), produced in 1885 as part of the Victor Hugo monument project, was not exhibited in its definitive armless state until the Salon of 1897. *La Terre*, completed by 1884 (Fig. 229), was not shown until Rodin's great retrospective of 1900, that is to say, when his long battle for recognition seemed about to be won.[28] And even at that late moment, the concessions he made reveal inner conflict. He exhibited the *Three Shades* (Fig. 224) from the finial of the *Gates of Hell*, but not in their original rightness with their forearms tapering into blind stumps; for the Exhibition he added six hands—terminations so disappointingly weak that we understand better than ever why they had been left off. And while the Exhibition of 1900 included his *L'Homme qui marche*, the man walking without head or arms, the master fudged on the title. He entered it as "a study" for his *St. John the Baptist* of 1878, though in fact the work was a new conception, assembled from the *Torso* (Figs. 260 and 261) produced twenty-five years before and a new pair of legs, and the sculptor knowing full well that this proud masterpiece was no "study."

But Rodin's public relations lacked the boldness of his creativity. Prudence may have dictated restraint, for he felt "defeated" by the official rejection of his *Balzac* in 1898 and dared not meet another financial reverse. And there may have been deeper anxieties. Perhaps the traditionalist in him was dismayed by the enormity of the step his art had taken during the decades of hidden labor. Though he heard himself speak of the human body as "a temple walking," he saw himself treating it like a potsherd. He, Rodin, had shattered its indivisible oneness. While avowing the glorious traditions of Greece and of Gothic France, he saw that his own hands, unlike those of the ancients or the cathedral carvers, had made the human body—the image of God, no less—come unstuck. Now both "atom" and "individuum"—the two ancient names for irreducible monads— had become comparable misnomers. But Rodin saw day after day how much sculptural energy could be released by splitting the "individual" figure and launching its particles on unpredictable paths.

ASSEMBLAGE AND GRAFT

Rodin modeled incessantly. Energy—that excess flowing out at the fingertips, which drives some hands to drumming the table—kept him proliferating his race of figments till a thousand plasters lined and littered his ateliers. His studio practice, described by assistants, suggests a shop of ceaseless large-scale production.

It is as if the labor only began after a figure was done. Rodin had modeled it whole, loosely, as if by improvisation. Then his custom was to multiply it in a score of casts from the same mold, most of which he dismembered. Or else he cast the figure in sections and repeated some of the sections alone.[29] Each operation fed into the quarry of fragments around him, and he spent his maturing years amidst the heaping accumulation of varisized figures, limbs, torsos, and heads—his giblets he called them—a reservoir of readymades and self-made *objets trouvés*, which worked for him as the idioms and syllables of a language work for a poet: they envelop him, invade his mind, and begin to think in his stead.

One figure from the lintel of the *Gates of Hell* (1882)—a stocky nude dragged on by her own falling head—places herself behind the seated Victor Hugo as the *Inner Voice* (1885–86). Released from his

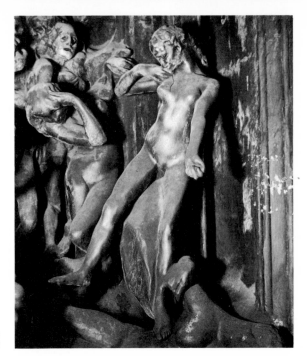

237. Rodin,
Gates of Hell, 1882

238. Rodin,
Study for
Victor Hugo Monument

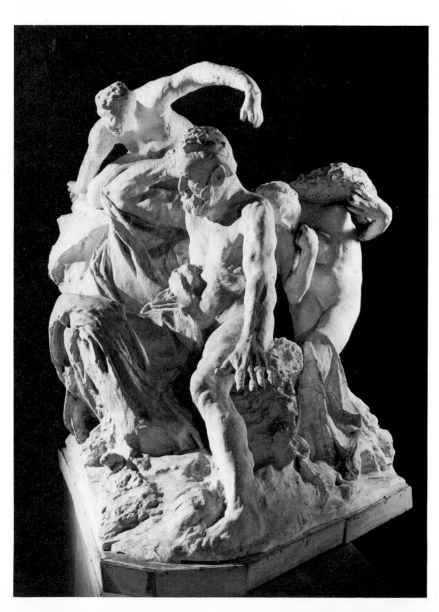

239. Rodin,
La Méditation

240. Rodin,
Beauty

241. Rodin,
La Sirène

243. Rodin,
Constellation

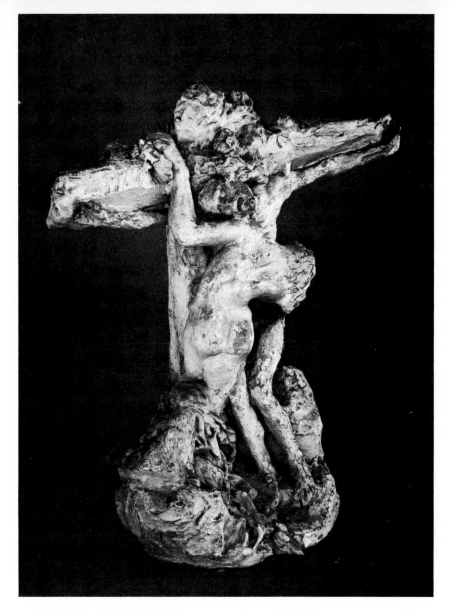

242. Rodin,
The Magdalen, 1894

monument, with cradled arms that suggest self-concealment, and
finally without arms at all, she becomes *Meditation.* The same fig-
ure, still bereft of arms, appears as "Beauty" in a drawing for Bau-
delaire's *Fleurs du mal* (1888). Carved in stone (by an assistant),
with legs turned to fishtail, she becomes *La Sirène*; pressed against
a crucifix, the *Magdalen* (1894). Finally, free-standing again, with
arms opened and another nude floated against her, she enters a
bronze group (in marble by 1902) called *Constellation* (Figs. 237–
43).

375

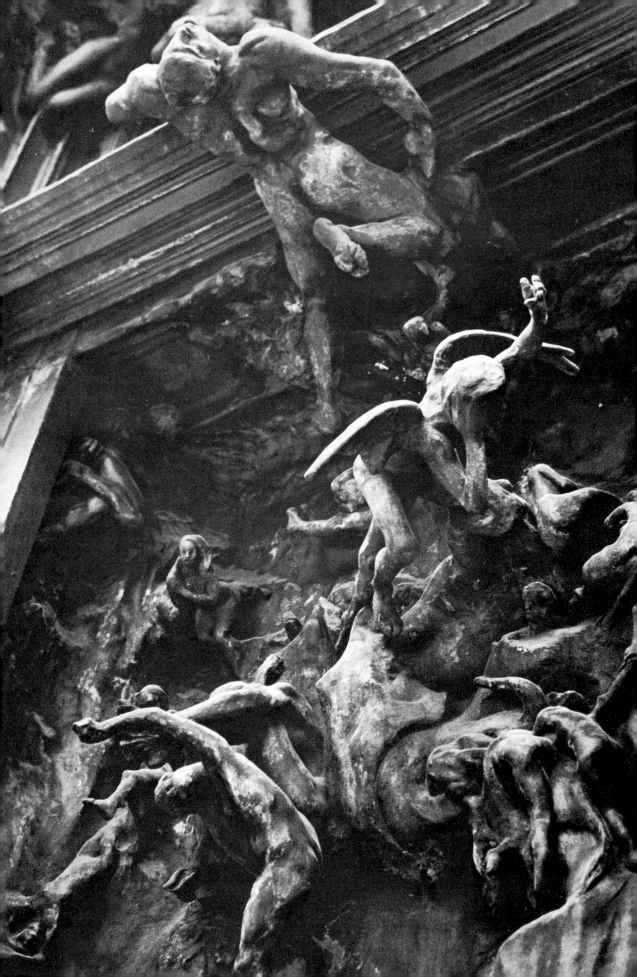

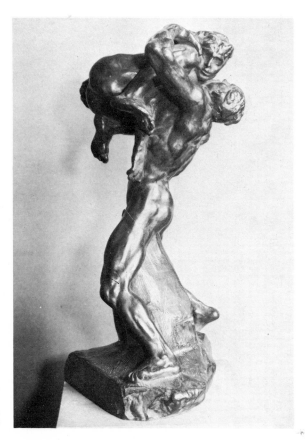

245. Rodin,
Je suis belle, 1882

No Rodin sculpture is known until it is known in its adaptability. Most of his works are constellations of interchangeable parts; and within his enormous output you can play endlessly spotting the vagrants. The *Chute d'un ange* is only the *Torse d'Adèle* mourned by the *Caryatide* (Figs. 231, 233, and 234). *Je suis belle* (or *The Abductor*) is *L'Homme qui tombe* hoisting the *Femme accroupie* in his arms (Figs. 244–46). The *Centauress* unites the androgynous torso of Orpheus—himself an uneasy graft—with the mount of the equestrian *General Lynch*. At Meudon you may notice several dozen casts in various sizes of a single stiff arm—thrust out with palm down and splayed fingers.Wherever that arm is bolted to a human shoulder, its owner freezes in a gesture of imperious command or rejec-

44. Rodin, *Gates of Hell* (showing *L'Homme qui tombe*), top of left panel

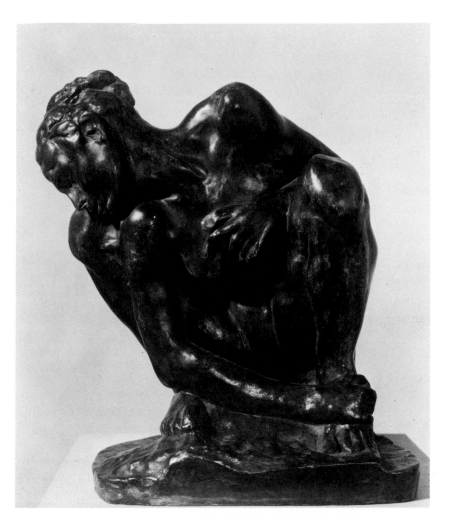

246. Rodin,
Femme accroupie

tion. It ends up on the Victor Hugo monument as the poet's left arm stilling the ocean as he bends his ear to his "Inner Voice" (Figs. 238, 247). Rodin even toyed with the monstrous notion of making *La Terre* raise its drooping head—to become the body of the *Man with the Broken Nose*. And there is no reason, this side of reverence, why the game of cross-breeding his sculptures, which Rodin played with his friends, should not be resumed. Given his readymades, original Rodin hybrids can still be bred.

More interesting than the compounding of figures in groups is the constellation principle working in the individual body.

248.

Again the *Bronze Age* is a point of departure (Figs. 216–18). In that showpiece Rodin achieved a continuous modulation of surface, transitions smooth enough to become imperceptible, so that the body seems to have no divisions. That whole antique armature of clarified articulations which, since ancient Greece, had made male anatomy thinkable as an art object dissolves in the skinflow of continuity. What makes it seem appallingly real is not simply that the imitation is close, but that conceptual distinctions are blurred; nameable parts melt in an organism possessed only of its own molten unity.

Thereafter, Rodin's most serious work imports mechanism into the body; or rather, the sentient, organic element is stunned by the intrusion of the mechanical, the uncooperating, the alien.

The *Prodigal Son* throws arms up to heaven, and the load upon his frail body is crushing because those uplifted arms are not organically his own, but oversized and a burden to lift (Fig. 248).

Ugolino's dying son in the lifesize group at Meudon lies on his back, and his groin shows the jarring misfit of an alien leg. In the

247. Rodin,
Study for
Victor Hugo Monument

249.

definitive version for the *Gates* (lifesize bronze in the park of the Paris Museum) the figure turns over so that this harsh maladjustment is lost to sight. But the misfit principle is retained for the groping arms. They are wrongly plugged in at the joints, so that paralysis creeps down from their very shoulders; the strength of gesture in them suffices only for dying away (Fig. 249).

The great nude *Jean d'Aire* clasps the key of Calais, but his pronated left hand is not tuned to a corresponding rotation of arm. The left arm intrudes rigidly between hand and shoulder; it suggests a separation of will and body, or a breakdown in nervous transmission (Fig. 250).

Balzac, in one awesome standing nude study, plies his right hand like an unruly tool; it is not his body's hand, of course, but a crude graft (Fig. 268).

The limb wrongly fitted is one of Rodin's devices for looking it in its task. The arm of the *Tragic Muse* in the Victor Hugo monument (Figs. 238 and 249) is so wrenched at the shoulder, and hence so incapable of potential play, that it can only twist itself, as it does here, into a canopy for the poet's head. To such an arm, the prerogative of organic limbs to exercise varied functions seems forever denied. The effect is an equation of body with one instant exertion, an intensified suddenness, and a hint of piston-rod specialization in the function of limbs.

All these inorganic intrusions, though no more than a hint, draw their poignancy from the sharp discord they throw into the general illusion of life.

Is it possible that these misfits are due only to impatient haste, that they reflect no positive artistic intention?

Hardly. The same *Tragic Muse*, for instance, has two superposed necks of decreasing diameter, of which the upper supports a distinctly small head. Were this no more than a trial sketch, such an accident could be written off. But Rodin had the figure cast in this form; then enlarged in this form; and finally, still with its goitered look, carved in stone. The question is not whether he noticed these miscarried grafts but, since he took pains to preserve them, what role they play.

One of the anecdotes told of Rodin's working methods describes his using three successive models to pose for one statue. "So great was his quest for perfection," concludes the report. A naive conclu-

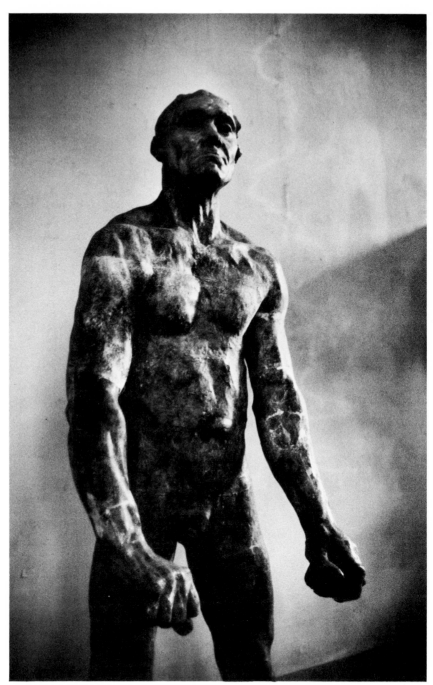

250. Rodin,
Jean d'Aire

sion; it refers Rodin's model change in midstream to an old academic tradition, to Zeuxis or Raphael who, we are told, used to combine the best parts of various models since no one body in nature seemed perfect enough.

Rodin very probably felt the reverse. The natural body before him was altogether too perfect, too coherent and simple to give a true reflection of what it is to be human.

Rodin's human body may be a fissured whole, or an agglutination of disparate, even incongruous parts. An unpredictable alternation of organic joints and abrupt disjunctions lends his great original works a charge of desperate, jerky energy, or suggests tragic exposure to forces both outside and within to which the will has no access. And, as a corollary, those works which, like the nude Balzac studies, express a triumphant will—for them to maintain their body's cohesion is work all-absorbing, the kind of intrinsic work that goes on perpetually in a closed fist.

From an old humanist point of view, Rodin's figures suggest loss of wholeness, of classic serenity or self-possession. From a political viewpoint they are plainly unfit to serve as public monuments. They are too troubled, too private, and too perilously exposed to uncertainty. They imply that all cohesion is hybrid; that the association of a hand with a wrist, of an ill-fitting thigh with a loin, of a figure with its supporting base, a body with a repeat of itself, a child with its mother, or a man with a maid—that all are equally provisional and episodic.

But they imply also that a sculptor's themes, whether or not derived from the human, are the stuff of imaginative manipulation. It is now becoming apparent that the reign of the classic anatomical figure in our sculptural tradition was more effectively subverted by the onslaught of Rodin's art than by the abstractions that followed. Or, to put it another way, the implications of Rodin's work, misunderstood by his would-be disciples, Desbois and Bourdelle, were fully grasped only by Brancusi and the sculptor Matisse.

SCULPTURE ITSELF

Rodin's ability to recreate the semblance of elastic flesh never left him; witness some of his later portraits, the *Hanako* (Fig. 251) or the Mrs. Russell (Fig. 252). But these are of wax, and the illusion they convey of a lucent skin surface is the quality of the wax used.

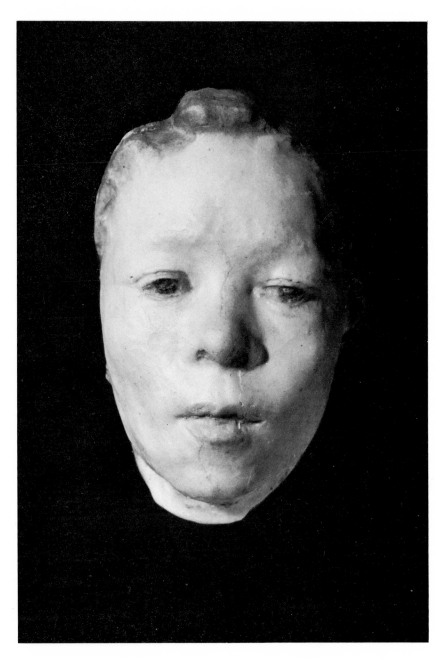

251. Rodin,
Mask of Hanako,
the Japanese Actress

There are also a number of marble portraits which are better than mechanic translations from the original plaster or bronze. They seem to have been conceived both for the stone and for execution by a chosen assistant, a *praticien* who excelled in smooth carving. Such are the *Puvis de Chavannes*, the *Lady Warwick*, and the *Lady Sackville-West* of 1914 (Figs. 253–56). In these carvings the definitions are softly veiled so as to suggest things seen through a haze. In so far as the aim of these carvings is portraiture, their treatment invests the sitters with remoteness and reverie. But no one can escape

252. Rodin, *Mrs. Russell*

the impression that the true aim is to trace the affinity of white marble for light, so that even in the averted planes shadows seem to slip from surfaces too smooth to retain them. These works seem to be about marble as those others are about wax.

Rodin's preferred material is bronze. But after the scandal aroused by the *Age of Bronze*, with its outright illusion of nakedness, his bronzes tend increasingly to forbid the analogy with smooth human flesh. Thenceforth, though they refer to humanity, they refer as intensely to the metal in its cold or heated state.

Beginning with the *St. John* (Fig. 257), Rodin's modeling grows more emphatic, male flesh is treated as a rutted terrain, the leaps from elevation to trough become steeper, the transitions metal-edged. In his greatest work, for example the head of Jean d'Aire (Fig. 258), the abrupt crags and hollows give a palpable materiality to the substance—somewhat as the deeply embrasured portals of Romanesque churches gave perceptible depth and density to the mass of the wall.

Flesh of augmented hardness is one departure; another is the flesh resolved into flux. Form, for Rodin, is conceivable as a viscous flow that melts and reconstitutes itself before our eyes. He makes the musculature of a torso seethe like blistering lava, so that the strength conveyed is not in the likeness of muscle, nor in athletic movement alone, but in the more irresistible material energy of liquefaction.

Solid or molten—these are the modes of bronze and plaster, not those of flesh. Henceforth, Rodin's best sculpture is about the materials of which it is made.

It is also about the process of making them. In the *Age of Bronze* no part of the sculpture varied from any other in perfection of finish. In most of his subsequent works Rodin straddles the state of perfection by leaving them either unfinished or damaged.

He is the first whose sculpture deliberately harnessed the forces of accident. It began, he tells us, with the mask of the *Man with Broken Nose*, his early masterpiece of 1863, which became a mask only by accident (Fig. 259). The jury of the 1864 Salon rejected it. But for Rodin it predicted an eventual pattern of partnership with disaster and chance, of watching the accidental and letting accident write the work's story. "Chance," he wrote in *Les Cathédrales*, "is a great artist." And again: "More beautiful than a beautiful thing is the ruin of a beautiful thing."

His most beautiful ruin is the early torso, less than life-size, pre-

259.

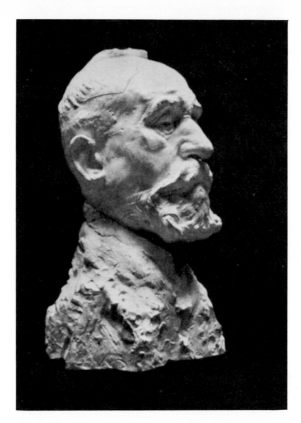

253. Rodin,
Puvis de Chavannes, 1891

254. Rodin,
Puvis de Chavannes, 1892

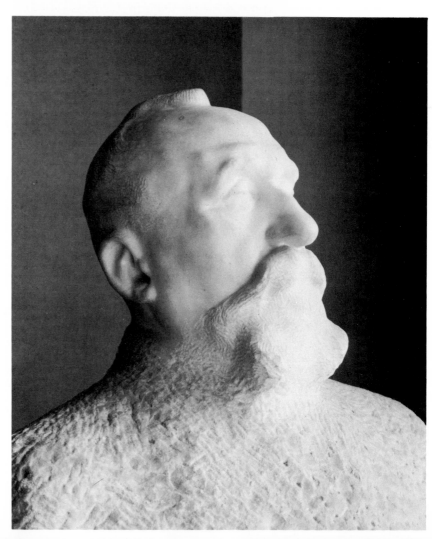

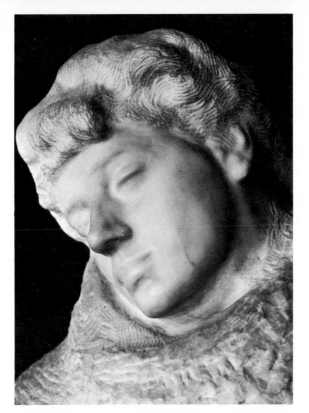

256. Rodin,
Lady Warwick, 1908

255. Rodin,
Lady Sackville-West, 1914

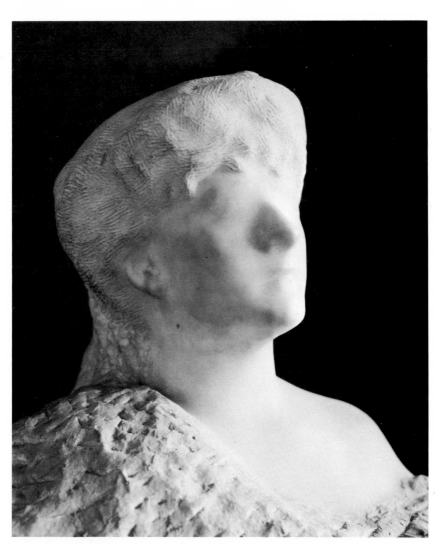

served in magnificent bronze at the Petit Palais, Paris (Figs. 260 and 261). It is the crucial source work from which grew the *St. John* of 1878, then the first *Walking Man* of 1900, finally the monumental *L'Homme qui marche of* 1906.

At first sight the torso is a piece of nostalgic neo-antiquity. But it was made by one who sees antique art in two places at once—that is, in its own orbit, invested with native athletic pride; and in our world, as a scarred relic. Rodin's torso, marvelously straight and compact, meets the highest test of sculptural genius—to make the mere abiding in form a form of wild motion.

But the torso is also a wreck, with tears at the shoulders made when the clay was damp, with gouged areas left by broken-off chunks of plaster, and with searing scars and bubbles caused at the foundry. The body's muscular stance ends up as metallic hardness, its compactness as fossilization. Rodin cast the wreck for himself alone, for he never exhibited it. But the pattern of its material ravages, such as the huge square gash at the right pectoral, he preserved like stigmata throughout his life, transplanting them faithfully to his *Walking Man*. The respect which his contemporaries accorded to the laws of anatomy, Rodin bestowed on the fatality of accidents.

257. Rodin,
St. John the Baptist, detail

258. Rodin, *Jean d'Aire*, detail

Catastrophe is perversely welcomed again in the *Figure volante* (Fig. 262). The entire backview of this near-life-size sculpture is one ghastly contusion, as if some large flat-faced object has scraped the clay while it was wet. It is remarkable enough to see that Rodin, instead of repairing the damage, perpetuates it in bronze (1890). It is more remarkable to discover in the Meudon basement the small terra-cotta original of the figure with its back identically bruised. In making the large definitive version, Rodin restaged the disaster.

A preserved "accident" in *La Terre* is stranger still (Fig. 263). Intending to cut the legs away below the knees, Rodin sank a knife into the clay. But, having cut halfway through the calves, he stopped, finding apparently that the gashes just made were worth keeping. The operation must have occurred upon one of two slightly different small terra-cotta studies for *La Terre* kept at Meudon. Both show the same knifed fissure above the calves. And the monumental version received the same trial cut, as though this had become part of *La Terre's* irrepressible geological record.

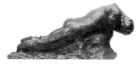

263.

389

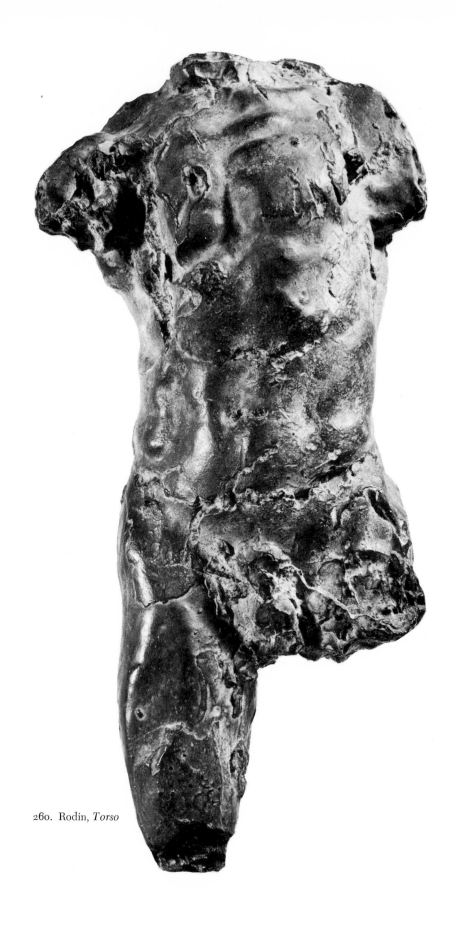

260. Rodin, *Torso*

261. Rodin,
backview of
L'Homme qui marche

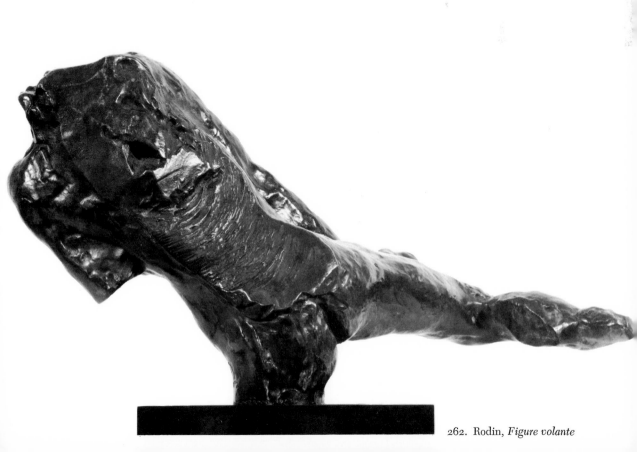

262. Rodin, *Figure volante*

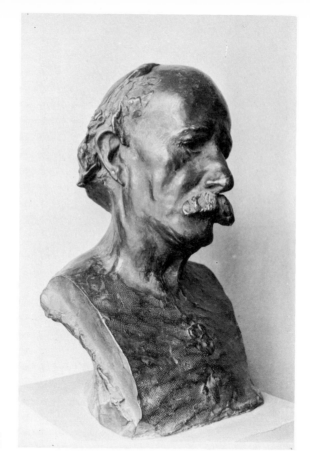

264. Rodin,
Marcelin Berthelot

265. Rodin,
Baudelaire, 1898

Accident is one of Rodin's resources for doubling the energy charge of his work. Breaks, cracks, and losses are violent. They imply the intractable and unforeseen, and that the artistic will drives its decisions against the brutal nonchalance of insensate matter.

The incorporation of accident is also a way of holding the sculpture down in a private world. The objective anatomy of the hale human body is a public thing, after all, like the constitution or civil code. But the story of one figure's progress through chance, error, discovery, damage, and salvage—this story, which tends to become the chief theme of Rodin's art, is all confessional and more unashamedly private than any manifest erotic content. And perhaps Rodin's ultimate significance for our time is simply that he turned the direction of sculpture around. Nineteenth-century sculpture was Baudelaire's "tiresome art," dedicated chiefly to conventional communal goals. Rodin restored to inward experience what had been for at least a century a branch of public relations.

His real theme then is the intimacy of gestation, every available means being used to maintain a given figure as a telescoped sculptural process. Whatever vicissitudes a work in progress can undergo are sealed into the form. The wet rags that are wrapped around clay to keep it moist leave their textures imprinted on the bare chest of the great *Marcelin Berthelot* bust (1906; Fig. 264). The little clay pellets or trial lumps which a sculptor lays down where he considers raising a surface—even if the decision is no, they stay put and, in a dozen portraits of the mature period, get cast in bronze. (Compare the portraits of Gustave Geffroy, 1905; Eugène Guillaume, 1903; Baudelaire, Fig. 265; Balzac, Fig. 270; Camille Claudel in the Victoria and Albert Museum; etc.)

To deny no part of the working process, temporary wooden struts (e.g. against the Achilles tendon of the *Walking Man*, Fig. 213) may be preserved in the final bronzes. Casting seams are not chased away. On the contrary; Rodin cultivates carelessness—or admits impatience—even in freeing a plaster cast from its mold, leaving this process, too, incomplete, so that some of his exquisite modeling remains smothered under clods of unshaped plaster. Hence, for instance, the excrescences at the hips of the beautiful *Young Woman's Torso* (1909, Fig. 266).

And since this practice of preserving portions of clinging mold combines with the habits of fragmentation and graft, it follows that Rodin never really knows beforehand how many limbs a particular

266. Rodin,
Young Woman's Torso, 1909

figure, when finished, will have or lack; how many rough chunks of redundant plaster that he refused or neglected to chip away will encumber it; how much the figure's shape will reflect a preformed anatomy, and how much will be owed to automatism and accident. The anatomy of the schools is no longer the privileged determinant of human form since what is exhibited is not the likeness of human bodies but the process of their transformation in art.

What he avoids above all is the finishing touch, his secret dream being to keep every work going like a stoked fire—forever, if possible. Twenty years on the *Gates of Hell*—left unfinished; twenty-three years of involvement with the image of Victor Hugo, and the commissioned monument abandoned in 1906—though unfinished; as his last-conceived *Tower of Labor* would have been, had he lived to bring his project forward to incompletion.

The word "unfinished" is wrong if it suggests a "block." With Rodin it refers to an outpouring of effort so identified with the act of living that it hates to turn itself off. Why else the thirty-four different busts for one portrait of Clemenceau? To have finished sooner would have meant choking off a lifeline.

Hence, though he constantly applies for, and receives, public commissions, he surrenders the products reluctantly—hating the finality of casting and delivering the *Burghers* to the city of Calais; and perhaps he left their individual bases showing in the final assembly to imply that they could always be taken apart again and regrouped.

In 1891 Rodin undertook the commission to make a statue of Balzac, then forty years dead (Figs. 267–70). After his long broodings on hell and hopelessness, he wanted this artist's image to embody a triumphant creative will. He was to spend seven years on the project, reading Balzac and the writings about him, and collecting every available picture of him, including the caricatures; he made trips to Touraine to study the physiognomic type of Balzac's countrymen; ordered a suit from Balzac's tailor who still had the old measurements; made a plaster cast of Balzac's dressing gown and a precise portrait bust of a young farmer who happened to have similar features; and produced all in all twenty-two studies for the head, seven for the nude body, two of the figure in dressing gown, and at least sixteen for the clothed statue. Do all these exertions fall under the head of research? They seem more like external motions to rationalize an obsession; and they flow from a conception of art whose end result is not one statue, one artifact, but a stretch of autobiography.

267. Rodin, *Balzac*

268. Rodin, *Balzac,* nude, headless

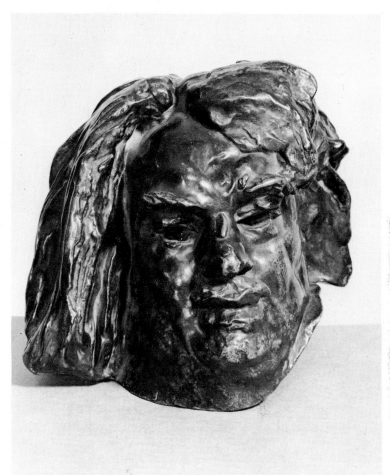

270. Rodin, *Head of Balzac*

9. Rodin, *Balzac*

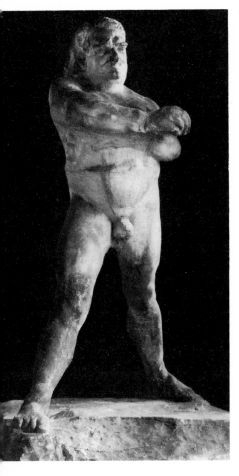

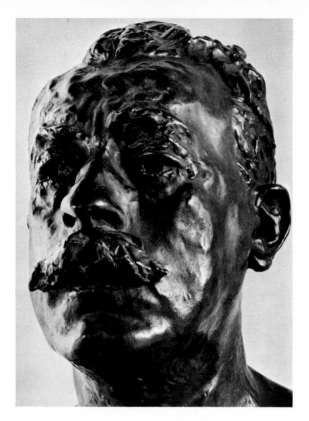

271. Rodin,
Etienne Clémentel, 1916

To ask which of Rodin's Balzacs is "definitive" is like asking a runner to pinpoint the definitive footprint in the track he has left behind. For Rodin a work of art is no longer the sort of work that can be finished. It can only be abandoned, whether through distraction, discouragement, boredom, or competing calls. Indeed, Rodin himself came to suspect that he should perhaps have abandoned the Balzac some two years sooner.

According to older criticism, his final phase, that is to say, after he stopped work on the Balzac in 1897, coincides with a decline of his creative powers. It is a matter of preferences. True, his last years were spent largely in reaping worldwide admiration and enjoying the role of a sage who pronounces on the nature of art and the delinquency of the times. Much of his working day went into supervising his *praticiens* as they made grandiose enlargements of earlier inventions, or furnished marble translations and bronze reductions for the mantelpiece.

But Rodin's artistic personality was a complex affair. A susceptible part of him craved official acceptance and wished to please. Overly conscious perhaps of his humble stock, he lacked the aristocratic sureness of taste of a Degas or Lautrec, and the intellectual sophistication to resist established Beaux-Arts pretensions. His con-

tinual quest after monumental public commissions bespeaks ideas which to us seem painfully vulgar—that sculpture, to be significant, must be large; that to be noble it must be in marble; and that its supreme role is to stand in the civic square and provide uplift for the public. Yet the other Rodin, whose hands knew how to obey the *voix intérieure*, continued uninfluenced to work small, to model in clay, and to forget more and more that civic zeal needed boosting.

He touched two new peaks during these later years: a series of busts which rank with the greatest portraiture of all time (Figs. 271 and 272); and—even more significantly for our age—a reduced mode of modeling which propels the septuagenarian Rodin into this century's avant garde.

In many of his late figurines, such as the *Jugglers*, the *Nijinsky*, the *Mouvements de danse*, Rodin's modeling blinds itself to external anatomy (Figs. 273–77). His subtle acquaintance with human surface is set aside for a deepening, inward-turned acquiescence. One feels, as never before, an acceptance of the condition and shape of the material worked on; and a new willingness to let surface be no more than the track and passage of his own working hands. His little *Dance Movements* must have looked gauche indeed in 1911 when they emerged. They are so frankly made of crude rolls of clay of nearly uniform thickness; their modulations are so naively the im-

272. Rodin, *Clemenceau*, 1911

273-77. Rodin, *Mouvements de danse*

print of Rodin's thumb and the pinch of his fingers. And the marvel is that they too, the figures, their clay irradiated by movement, consent. For they dance. Accepting perfunctory surfaces and awkward limbs, they are oblivious of self and body, of style and beauty—to be only what the dance is.

POSTSCRIPT, 1971

Two men I will always associate with my work on Rodin. One is the sculptor Jean Tinguely, with whom I first drove out to Meudon in the summer of 1962. We spent six hours there, wandering singly about the house, the museum, the gardens, and occasionally crossing paths to exchange a few words.

At one point I was looking at Rodin's *Adam*, his most Michelangelesque figure (Fig. 278). It had long been observed that the right hand, with its extended, quivering index, alludes to the life-giving moment in Michelangelo's fresco of the Creation of Man. But I stared at the corresponding arm, curiously twisted from the shoulder down and turning the elbow out as it gropes towards a raised knee. Imitating the pose, I felt myself absorbing the impotency which that gesture imposes upon one's body, and I realized that it must be an ancient indicator of death, for the gesture occurs in antique relief representations of Niobids dying, their arms similarly pronated.

I have since learned that the meaning of this "pronated dead arm," as I decided to call it, is understood by intuition. In the film *Bonnie and Clyde* (1967) it is the gangster's concluding gesture as he rolls over for the last time. Gunned down and riddled with bullets, Clyde dies like a Niobid. But that day in Meudon it occurred to me that Rodin's immediate model for the pronated dead arm must be the dead Christ in Michelangelo's *Florentine Pietà*—which Rodin describes looking at with deep emotion. And in that case, the arms of Rodin's First Man span a symbolic passage from birth to death.

It was at this moment that Tinguely passed and so, pointing to the ungainly pronation of the *Adam*'s left arm, I said: "Jean, what do you make of that movement? It's incapacitating. Why is it we can twist an arm in that way? What is it for, anatomically?"

He halted and tried it. "It's not a gesture of work," he said.

Tried it again: "It's not a gesture of sport."

And again: "It's not a gesture of love."

278. Rodin,
Adam, 1880

Then, straightening up, he said with finality: "Ce n'est pas dans la vie."

The other man's name I do not know. He was the waiter on the night shift in the small Paris café where I did most of the writing.

"Always writing," he said one night. Then added, "I never learned. Never had much education."

Did he miss it, I asked—expecting, like a good American, to receive invaluable first-hand information about relative earning capacities.

"Of course I miss it," he said. "Because it's interesting."

Notes

Jasper Johns: the First Seven Years of His Art

1. *Newsweek*'s sole editorial comment (March 31, 1958): "Dada, it seems, rides again." Michel Ragon, reporting on American art in *Cimaise* (January 1959, p. 28) wrote: "Jasper Johns est une explosion dadaïste un peu comparable à Yves Klein à Paris." Pierre Schneider, reporting in *Art News* (March 1959, p. 48) on Johns's first show in Paris, observed that the subjects were "alienated from their meaning by being represented in an unctuous 'painterly' manner. It is a sign of the times: Dada, like everybody else, has gone to art school." *Time* (May 4, 1959), in a piece entitled "His Heart Belongs to Dada": "Like Johns, the Dadaists deliberately tried to strip art of all sentiment and all significance." "Dada's the Disease," diagnosed Emily Genauer and belied her name by informing readers of the New York *Herald Tribune* (April 3, 1960) that Johns "likes to attach empty coke bottles to his canvas"—a mistaken reference to a painting by Rauschenberg.
2. *Art News*, March 1959, p. 60.
3. *Arts*, February 1959, p. 49.
4. June 5, 1960, p. 38.
5. "The Audience as Subject," introduction to *Out of the Ordinary*, Exhibition Catalogue, Houston, Texas, November 1959.
6. *Art News*, January 1958, p. 20.
7. *Evergreen Review*, March-April 1960, p. 78.
8. *Art International*, September 1960, p. 75.
9. *Arts,* January 1958, p. 54.
10. *Charm*, April 1959, p. 85. Cf. Ben Heller in *School of New York: Some Younger Artists*, ed. B. H. Friedman, New York, 1959: "Primarily, their importance is less as flags or targets than as means of forcing the viewer to focus upon the canvas itself, to react to it as an immediate and direct painting experience." Similarly William Rubin (see text, below): "For Johns the image is meaningful in its meaninglessness."
11. Cf. Irving H. Sandler in *Art News* (February 1960, p. 15): "In his flag, target, number and letter pictures Johns tried to make the invisible (the familiar) visible and then to make it invisible again."
12. The exception is Robert Rosenblum, who responded at once to a "visual and intellectual impact." Johns's work, he wrote, "assaults and enlivens the mind and the eye with the exhilaration of discovery" (*Arts*, January 1958, p. 54). And again *Art International*, September 1960, p. 77): "In general, Johns establishes a spare and taut equilibrium of few visual elements whose immediate sensuous impact is as compelling as the intellectual jolt. . . ."
13. *Arts*, March 1960, pp. 57-58.
14. *Art International*, January 1960, p. 26.
15. *Cimaise*, September 1961.
16. *Art News*, February 1959, p. 39.
17. 1971: I was writing as of December 1961. The observation does not hold for some of Johns's more recent work.

18. The *Map* reproduced in Figure 19 is the second version of 1962; the first, considerably larger, version of 1961 (Museum of Modern Art, New York) does not show up well in black-and-white reproduction.

Other Criteria

1. "Fifty-seventh Street" (unsigned), *Fortune,* September 1946, p. 145, and Eric Hodgins and Parker Lesley, "The Great International Art Market," *Fortune,* December 1955, pp. 118 ff.
2. See Fairfield Porter, *Thomas Eakins,* New York, 1959, p. 26: "Eakins was one of the first American artists to adopt . . . what James Truslow Adams called 'the mucker pose.' He was the first American artist—as distinct from craftsman or folk-artist—to make his paintings out of what was there instead of relying greatly on tradition. He was the first of consequence to study in France instead of England. . . . The rhetoric he despised was inapplicable to the world he both accepted and chose. . . . Truth precluded the formality of 'picture-making' as well as the spontaneity of accomplishment. . . . The intellect was no organizer, but a protector of the purity of fact against the wind of affectation . . . there is almost no formality to his paintings, but an investigation of form . . . that prefers no one aspect of nature to another."
3. Ibid., p. 28. Sloan's comment is quoted in Barbara Rose, *American Painting Since 1900,* New York, 1967, p. 214. Cf. the following from Angiola R. Churchill, *Art for Pre-Adolescents,* New York, 1970, p. 2: "In keeping with our original pioneer mores, American educators have traditionally had a bias against the arts. In a utilitarian culture, art is play, and play is sinful and weakening. What Leonard calls the 'Dionysian spirit' has been kept out of learning" (George B. Leonard, *Education and Ecstasy,* New York, 1968).
4. Cf. the poem "Work" by Kenyon Cox (1856-1919), the most vocal of American academicians before World War I: ". . . Who works for glory misses oft the goal;/ Who works for money coins his very soul./ Work for the work's sake, then, and it may be/ That these things shall be added unto thee."
5. Letter to his father datelined Madrid, December 2, 1869, published in Margaret McHenry, *Thomas Eakins, Who Painted,* Oreland (Pa.), 1946, p. 17.
6. James T. Flexner, *American Painting,* New York, 1950, p. 65.
7. *New York Times,* September 12, 1967, p. 12.
8. *Life,* February 23, 1968, p. 27.
9. Robert Henri, *The Art Spirit,* paperback ed., New York-Philadelphia, 1960, p. 56.
10. See Joseph Masheck, "The Panama Canal and Some Other Works of Work," *Artforum,* May 1971, pp. 38-39.
11. From an interview of August 1970, quoted in *Oldenburg,* Sidney Janis Gallery Exhibition Catalogue, New York, November 1970.
12. *Art News,* December 1952.
13. "An Interview with Hans Haacke," by Jeanne Siegel, *Arts,* May 1971, p. 18 f.
14. "Une figure bien dessinée vous pénètre d'un plaisir tout à fait étranger au sujet. Voluptueuse ou terrible, cette figure ne doit son charme qu'à l'arabesque qu'elle découpe dans l'espace. Les membres d'un martyr qu'on écorche, le corps d'une nymphe pâmée, s'ils sont savamment dessinés, comportent un genre de plaisir dans les éléments duquel le sujet n'entre pour rien; si pour vous il en est autrement, je serai forcé de croire que vous êtes un bourreau ou un libertin." *L'Œuvre et la vie d'Eugène Delacroix,* Paris, 1927, pp. 27-28.
15. Baudelaire's mind was of course too subtle and generous to make his observation dogmatic. Elsewhere (as in his essay, *Le Peintre de la vie moderne*) he calls for an art that captures the characteristic look of modernity, and with no reference to arabesques.

16. Published posthumously, New York, 1939, p. 150.

17. Albert C. Barnes, *The Art in Painting*, New York, 1925, p. 408.

18. Clement Greenberg, "Picasso at Seventy-Five," in *Art and Culture* (1961), Boston, Beacon paperback, 1965, p. 62.

19. See Greenberg, "Modernist Painting," in *The New Art*, ed. Gregory Battcock, New York, 1966, pp. 101 ff. The essay first appeared in *Art and Literature*, Spring 1965.

20. Greenberg, "Abstract, Representational, and so forth," in *Art and Culture*, p. 136.

21. Betty Friedan, *The Feminine Mystique*, New York, 1963, p. 37. Cf. her analysis (pp. 29-30) of the ideal American woman as presented in an issue of *McCalls* (July 1960)—"pared down to pure femininity, unadulterated."

22. "Modernist Painting," p. 102.

23. "Cézanne," *Art and Culture*, p. 53.

24. "Modernist Painting," pp. 103-4.

25. *Art News*, October 1971, p. 60.

26. "Modernist Painting," p. 107.

27. Greenberg, "Collage," in *Art and Culture*, p. 72.

28. "Collage," pp. 73-74.

29. The deliberate exploitation of surface-to-depth oscillation characterizes all major painting. It is the inexhaustible resource of the art. But the degree to which the resultant duality registers on the viewer's attention depends on the culture and the set of expectancies he brings to his appreciation. He mistakes the goal of the Old Masters if he imagines them aiming for that near-absolute dissolution of the picture plane which distinguishes late nineteenth-century academic painting.

 To take an outstanding example of illusionist Old Master art—Velázquez' *Menippus:* the heavy impasto that molds the scrolls and books in the foreground tells you explicitly where the paint is. But the jug and bench in the "background," where the raw canvas appears barely stained by a thin wash of pigment, says—"this is where the canvas is." And the palpable mystery of the painting is the old Cynic's material presence inserted in the non-dimensional film between canvas and paint. No painting was ever more self-defining than this.

30. On this question of content: during the 1960's many American sculptors made boxes, some of them highly impressive. By some marvelous coincidence, the moment when this plain box, cube, or die first emerged as a sufficient sculptural statement was also the moment when the Black Box of the computer entered the general consciousness, sometimes with fateful meaning. Remember Senator Morse of the Senate Foreign Relations Committee interrogating Secretary of State Rusk in March 1968 (*New York Times*, March 12, 1968, p. 16). The Senator was referring to the Tonkin Gulf incident, when the North Vietnamese attacked the American destroyer *Maddox*. The vessel was claimed to be on a routine patrol in international waters, but, according to Morse, was engaged in an act of deliberate provocation. "Why didn't the Administration tell this committee on August 6, 1964," he asked, "that the Maddox . . . was completely equipped with spy equipment, including the big black box . . . that that big black box on the Maddox had made possible to stimulate the electronic instruments of North Vietnam? . . ."

 It may well be that the electronic black box, the faceless housing of invisible functions, is to the modern imagination what muscular strength was to Cellini and mechanical energy to the generation of the Futurists. As the aged Thomas Hart Benton said in a recent interview (*New York Times*, June 5, 1968, p. 38): "Look at that train! The machines of that day really had something for an artist. They weren't afraid to exhibit their power. Today's machines enclose it, cover it up." Cf. Derek J. de Solla Price, "Gods in Black Boxes," in *Computers in Humanistic Research*, ed. E. Bowles, Englewood Cliffs, 1967, p. 6: "Although the concept of a 'black box' has now become commonplace in such diverse fields as computers, cybernetics, and psychology, the historical origin of the phrase is not . . . clear. . . . So far as I know, the black box was first used as a pedagogic device in the 1880's

when it entered teaching laboratories of physics, particularly the Cavendish Laboratory in Cambridge, as a box containing a network of resistances, inductances and capacitances which were led out to a set of terminals mounted on the box. . . . Such boxes were actually used, and in the late 1930's some of them had been painted black, presumably to go along with the symbolism of the dark nature of their interior. . . . I do not know who publicized the term, . . . I understand the term to mean a piece of apparatus with known input and output properties but unknown interior mechanism."

31. Barnes, *op. cit.*, p. 408. For the author's insistence on synthesizing the elements of design, see pp. 55, 61, 67 f.

32. "Quality in Louis," *Artforum*, October 1971, p. 65.

33. The fact that some Louis paintings may actually hang upside down is immaterial. Their space will still be experienced as gravitational, whether the image suggests falling veils or shooting flames.

34. "Frankenthaler as Pastoral," *Art News*, November 1971, p. 68.

35. Quoted in Eila Kokkinen, review of *Claes Oldenburg: Drawings and Prints*, in *Arts*, November 1969, p. 12.

36. "Warhol: The Silver Tenement," *Art News*, Summer 1966, p. 58.

Picasso's Sleepwatchers

1. Picasso's mistress of those years, Fernande, writes in her memoir (1933): "I was, or so people said, the very essence of health and youth: tall, full of life, optimistic, cheerful and confident: with my head in the clouds, in fact. A perfect contrast to him!" (Fernande Olivier, *Picasso and His Friends*, English trans., New York, 1965, p. 16.

2. *A Portrait of the Artist as a Young Man*, in *The Portable James Joyce*, New York, 1947, p. 481.

3. Françoise Gilot and Carlton Lake, *Life with Picasso*, New York, 1964, p. 42.

4. Statement by Picasso, 1935; see Alfred H. Barr, *Picasso: Fifty Years of His Art*, New York, 1946, p. 274.

5. Cf. the characteristic question in Leonardo's Notebook (British Museum 263, Ar. 278v): "Why does the eye see a thing more clearly in dreams than the imagination when awake?"

6. Cervantes, *Don Quixote*, Chapter 68.

7. Painting by the Pre-Raphaelite Simeon Solomon; see Alfred Werner in *Arts*, May 1966, p. 51. The subject of sleep occurs in the most academic as well as the most advanced art of the period. It is the theme of Stephan Sinding's *Night*, 1896, hailed as the "consummate symbol of sleep"; and of numerous recumbent heads produced by Brancusi from 1906 to 1910 (see Sidney Geist, *Brancusi*, New York, 1968, pp. 31-35).

8. Jorge Luis Borges, *Labyrinths*, New Directions Paperback, New York, 1962, p. 10. The Quevedo quotation is from a poem discussed by Borges in *Other Inquisitions*, Washington Square Press, New York, 1965, p. 41. The line from the Calderón play is from Act II, sc. 19.

9. Gilot, *op. cit.*, p. 85.

10. David Duncan, *Picasso's Picassos*, New York, 1961, p. 145.

The Skulls of Picasso

1. The fantasy of the sexual skull has a history yet to be written. One of Morgenstern's *Songs of the Gibbet* (Christian Morgenstern, *Galgenlieder*, 1905) opens on these eery lines:

Sophie mein Henkersmädel (Sophie, my hangman's moll
Komm, küsse mir den Schädel! Come up and kiss my skull!
zwar ist mein Mund My mouth, it's true,
ein schwarzer Schlund— Is a black flue—
doch du bist gut und edel! But you are kind and noble!)

A fine seventeenth-century Dutch *Vanitas Still Life* in Indianapolis displays two skulls, unmistakably male and female, and unmistakably affectionate, as if to belie the platitudinous Latin legend below: "All that is human is smoke. . . ." The work may be a personal statement of the artist himself—one J. Falk, otherwise unknown. It recalls L. Furtnagel's famous double portrait in Vienna of the painter Hans Burgkmair and his wife, where the couple's elderly faces are reflected in a hand mirror as two death's heads.

2. Eli Marcovitz, M.D., "Man in Search of Meaning," *Bulletin of the Philadelphia Association for Psychoanalysis*, 20, 3 (September 1970), p. 178.

3. Cf. *Jeux de pages*, oil, 1951, reproduced in Christian Zervos, *Picasso, Œuvre Catalogue*, Editions Cahiers d'Art, Paris 1932 ff, XV, 184.

4. Cf. Roland Penrose, *Picasso, His Life and Work*, New York, 1958, p. 298.

5. I am indebted to William S. Rubin for first telling me of this drawing. A painstaking study of it, with verbatim transcription of text, was made by Margit Rowell, to whom I wish to express my sincere gratitude and admiration.

6. Penrose, *op. cit.*, p. 311.

7. Cf. Robert Rosenblum, "Picasso and the Anatomy of Eroticism," in *Studies in Erotic Art*, ed. Theodore Bowie and Cornelia v. Christenson, New York, 1970.

The Algerian Women and Picasso At Large

1. Françoise Gilot and Carlton Lake, *Life with Picasso*, New York, 1964, p. 193. Hereafter cited as Gilot. Picasso's early interest in the *Femmes d'Alger* is attested by four remarkable drawings, based on the Delacroix painting, in the Royan sketchbook of January 1940 (published in C. Zervos, "Confrontations de Picasso avec des œuvres d'art d'autrefois," *Cahiers d'Art*, 1960, pp. 42-43). The article was kindly brought to my attention by Judith L. Wolfe.

2. For the Sleeper's posture, cf. the following illustrations in Christian Zervos, *Picasso, Œuvre Catalogue*, Editions Cahiers d'Art, Paris, 1932 ff. (hereafter cited as Z. followed by volume and figure number): Z. XV, 215; Z. XVI, 111, 115, 316, 317, 344. Cf. also Fig. 67 in this volume.

 The pose is an antique type that recurs frequently in Picasso's work—the left leg grounded and flexed; the other, with the raised knee, perpendicular to it so that the ankles cross at right angles.

3. For the drawings, see Z. XVI, 344, 350, 351, 370. For the lithographs see Fernand Mourlot, *Picasso lithographe*, 5 vols., Monte Carlo, 1949-70, No. 266; cf. also No. 265 for another variation. The earliest dated account of the genesis of the paintings is contained in D.-H. Kahnweiler, "Entretiens avec Picasso au sujet des Femmes d'Alger," *Aujourd'hui*, No. 4, September 1955, pp. 12-13.

4. Gilot, p. 130.

5. Gilot, p. 93.

6. Roland Penrose, *Picasso, His Life and Work*, New York, 1958, p. 351.

7. This important connection with Cézanne's series (see L. Venturi, *Cézanne*, Paris, 1936, especially Nos. 223 and 224) was pointed out to me by Miss Melissa McQuillan of the Institute of Fine Arts, without whose timely reminder the ancestry of Picasso's Algerian series would have remained incomplete.

8. For the Archaic Greek runners, cf. G. M. Richter, *The Sculpture and Sculptors of the Greeks*, revised ed., New Haven, 1950, figs. 84-86.

9. Cf. Poussin's *Bacchanale* in the London National Gallery, No. 62. It is another ex-

ample of the consistency of Picasso's vocabulary that the posture of the figure with offered bowl and back-kicking leg occurs as early as 1902 in the painting called *Soup* (Collection of Mrs. J. H. Crang, Toronto).

10. The canonic positions of sleep: that of the recumbent sleeper with one or both arms overslung—the commonest antique formula, resumed in the Renaissance (Giorgione) and handed down to Ingres, Courbet, etc.; and that of the sleeper prone, belly to ground, cheek resting on arms—like the familiar sleeping Hermaphrodite (Hellenistic). Both postures are part of Picasso's inventory from the beginning.

11. Paris, Louvre, and the smaller preliminary version in the London National Gallery. Picasso's variation, *Young Ladies on the Banks of the Seine,* is in the Öffentliche Kunstsammlung, Basle.

12. Gilot, p. 43.

13. See James Hillman, "First Adam, then Eve," in *Art International,* September, 1970, p. 33, with abundant citation of literature.

14. Told to me by William S. Rubin of The Museum of Modern Art, New York, recalling his talks with Picasso during the summer of 1971.

15. The outstanding example of this Picasso pun in earlier work is the *Girl Before Mirror,* 1932, Museum of Modern Art, New York. Cf. also the drawing of a lower body (May 19, 1941; Z. XI, 121), where this punning coincidence becomes the turning hinge that converts a frontal view into its reverse aspect.

16. The colorful Canvas N (Fig. 97) was not available to me for study in time to be included in this discussion. For Canvas O see the final section of this essay.

17. Meyer Schapiro, Introduction to Eugène Fromentin, *The Old Masters of Belgium and Holland,* New York, 1963, p. xxxix (first published, *Partisan Review,* 1949).

18. Edward Fry, *Cubism,* New York, 1966. Hereafter cited as Fry.

19. The above quotes are from Fry, pp. 57, 60, 70, 78, 82, 62, and 66.

20. Lecture delivered at Leyden University, December 9, 1908 on "Die Einheit des physikalischen Weltbildes," in *Wege zur physikalischen Erkenntnis,* Leipzig, 1933, p. 5: "Die Signatur der ganzen bisherigen Entwicklung der theoretischen Physik ist eine Vereinheitlichung ihres Systems, welche erzielt ist durch eine gewisse Emanzipierung von den anthropomorphen Elementen, speziell den spezifischen Sinnesempfindungen."

21. Further drastic reinterpretations of Cubism are imminent. Above all, I believe that Picasso's Cubist pictures will dissociate themselves increasingly from those of his colleagues and be better recognized as a phase of Picasso's own continuing thought.

22. The quotations are from *The Sculpture of Picasso,* Museum of Modern Art, Exhibition Catalogue, text by Roland Penrose, New York, 1967, p. 19; and Douglas Cooper, *The Cubist Epoch,* Exhibition Catalogue, Los Angeles County Museum of Art and the Metropolitan Museum of Art, New York, 1970, p. 25. See also John Golding's definition of "what the Cubists called 'simultaneous' vision—the fusion of various views of a figure or an object into one coherent whole" in *Picasso and Man,* Exhibition Catalogue, Montreal, 1964, p. 12. Cf. Marshall McLuhan, *Understanding Media,* New York, 1964, p. 13: "Cubism, by giving the inside and outside, the top, bottom, back and front and the rest, in two dimensions, drops the illusion of perspective in favor of an instant sensory awareness of the whole." McLuhan seems to confuse the totality of the picture with the supposed wholeness of the object depicted. His description of the alleged effect of Cubist rendering is of course based on his reading, and there hardly exists a more eloquent tribute to the power of the printed word. In the very act of propounding the superior effectiveness of immediate sense stimuli, he succumbs to a verbal message diametrically contradicted by the sensory reality of the medium.

23. Harold Rosenberg in *The New Yorker,* May 8, 1971, p. 104.

24. Fry, p. 82.

25. Cf. Gilot, pp. 130-31: "Pablo had always liked to surround himself with writers and poets, beginning with the day of Guillaume Apollinaire and Max Jacob. That is one reason, I think, why he was always able to talk very articulately about his painting. At each period the poets created around him the language of painting. Afterwards Pablo, who—for things like that—was an extremely adaptable, supple person, always talked very perceptively about *his* painting because of his intimacy with those who had been able to discover the right words."

26. Cf. Figure 92 and pp. 123 and 147.

27. That ambiguity cannot be *seen* is a central thesis of E. H. Gombrich's *Art and Illusion*, New York, 1960. His Figure 2, "Rabbit or Duck," a drawing from a humorous magazine, is designed to prove "that we cannot experience alternative readings at the same time (p. 5)." On page 238 the argument is resumed and illustrated by a blank outline trace of a human hand (his Fig. 201):

 Few people realize that the outline drawing of a hand is ambiguous. It is impossible to tell whether it is a right hand seen from the front or a left hand seen from the back. . . . more likely than not, we will have to use our own hands for guidance, trying to match them against the image and to project the alternatives until we are convinced of the ambiguity. It is only then we will come to realize that it was a matter of sheer accident which of the readings we adopted first. To detach the projection, once it was made, we must switch to the alternative one. There is no other way for us to see ambiguity.

 Fortunately the task of challenging Gombrich does not devolve upon me, since Picasso has spent his life challenging it. Gombrich's conviction that alternatives cannot be seen in simultaneity is argued on the evidence of trivial diagrams. It ignores the fact that the most powerful visual imagination of our century has labored precisely to make ambiguity visible, to create the illusion of simultaneous alternative readings.

28. Full composition studies for the *Demoiselles d'Avignon* are published in Z. II, 19-21, 632-44 and Z. VI, 980-81.

29. Alfred Barr, *Picasso: Fifty Years of His Art*, New York, 1946, pp. 56-57. Hereafter cited as Barr.

30. Barr, *loc. cit.*, makes no attempt to reconcile this development towards formal abstraction with what he calls the work's "sheer expressionist violence and barbaric intensity."

31. Fry, p. 82.

32. Edward Fry, "Cubism 1907-08: an Early Eyewitness Account," *Art Bulletin*, 48 (1966), p. 71.

33. The phrase "que je les possède" was used by Picasso explaining his figure drawing in a recent conversation with William S. Rubin.

34. See the drawing of 1933 in the Art Institute of Chicago, Z. VIII, 112. Cf. also the impressive series of etchings of the same year (Georges Bloch, *Pablo Picasso: Catalogue de l'œuvre gravé et lithographié*, Vol. I, Berne, 1968, Nos. 28-31, and Bernhard Geiser, *Picasso: Peintre-Graveur*, Berne, 1955, Nos. 339 and 372.) The drypoint here reproduced is Bloch 31.

35. The violence of these "embraces" has misled some to regard them as scenes of rape. But one must look at these women's hands, which never claw or repel; and at their faces, which never show signs of fear, pain, or revulsion. In fact, the action is never a rapist-victim, subject-object relation. So strong is the indication of bilateral sexual fulfilment, that the image may as well represent the woman's fantasy of transverberation.

36. The secret is lifted in several etchings of the "347" series, such as the plate dated September 8, 1968/II, which equates the act of painting with coitus. The painter appears to be Raphael and recalls the theme of Ingres' *Raphael and His Mistress* (formerly Riga, Museum; cf. the versions at the Fogg, Cambridge, and the Gal-

lery of Fine Arts, Columbus, Ohio). Visually the Picasso etching is closer to Ingres' *Paolo e Francesca*: cf. particularly the upper half of the version sold at Sotheby's on November 30, 1966.

37. The Boston ivory led Stephanie Golden of Oxford University Press to recall Wallace Stevens' "Thirteen Ways of Looking at a Blackbird." In the poem, one of the bird's symbolic values is death, as in the stanza:

> A man and a woman
> Are one.
> A man and a woman and a blackbird
> Are one.

38. Later graphic folk art popularized the moral antithesis of front and back in the image of *Frau Welt*, or personified worldliness—a fine woman's face to the fore and a Death's Head behind. Broadsheets of the sixteenth and seventeenth centuries symbolize the front/back dichotomy by bisecting the figure along a central divide: the well-dressed right half depicting the worldly state, the other half, the bare bones of death, understood as lurking behind. The analogy is with Janus and Annus, the new year, both of whom are commonly represented with a face fore and aft—as is the figure of Prudence. But commonest in the late Renaissance is the personification of two-faced Fraud whose hidden hag's face belies the young face in front.

 We may add that, according to an ancient Hebrew myth, God originally created Adam androgynous with a male face forward and a female face looking back. But "He changed His mind, removed Adam's backward looking face, and built a woman's body from it." See Robert Graves and Raphael Patai, *Hebrew Myths*, New York, 1966, p. 66.

39. See pp. 202-6, below.

40. The full text is given in Stefano Ticozzi, *Vite dei pittori: Vecellj di Cadore*, Milan, 1812, p. 512.

41. "Its shrine is completely open, so that it is possible to observe the image of the goddess from every side; she herself, it is believed, favoured it being made that way. Nor is one's admiration of the statue less from any side. They say that a certain man was once overcome with love for the statue, and, after he had hidden himself (in the shrine) during the nighttime, embraced the statue and that there is a stain on it as an indication of his lust." Cf. J. J. Pollitt, *The Art of Greece, 1400-31 B.C.* (Sources and Documents in the History of Art), Englewood Cliffs, N.J., 1965, p. 128.

42. "Giorgione is said to have once engaged in an argument with some sculptors. . . . They maintained that sculpture was superior to painting, because it presented so many various aspects, whereas painting only showed one side of a figure. Giorgione was of opinion that a painting could show at a single glance, without it being necessary to walk about, all the aspects that a man can present in a number of gestures, while sculpture can only do so if one walks about it. He offered in a single view to show the front and back and two sides of a figure in painting, . . . He accomplished this in the following way. He painted a nude figure turning its shoulders; at its feet was a limpid fount of water, the reflection from which showed the front. On one side was a burnished corselet which had been taken off, and which presented the left profile, its shining metal revealing every detail. On the other side was a looking-glass, showing the other side of the figure, a beautiful and ingenious work to prove that painting . . . shows to a single view more than sculpture does." G. Vasari, *The Lives of the Painters*, . . . Milanese ed., Florence, 1906 I, 101, and IV, 98.

43. For the genesis of the work as a demonstration piece for the theories of Giovanni della Casa, see Vasari, *op. cit.*, VII, 61: "Avendo monsignor messer Giovanni Della Casa . . . cominciato a scrivere un trattato delle cose di pittura, e volendo

chiarirsi d'alcune minuzie e particolari dagli uomini della professione, fece fare a Daniello il modello d'un Davit di terra finito; e dopo gli fece dipignere, o vero ritrarre in un quadro, il medesimo Davit, che è bellissimo da tutte due le bande, cioè il dinanzi ed il dietro, che fu cosa capricciosa."

44. Antonio Federighi, *ca.* 1420-90. The drawing is inscribed in the artist's hand: "These women are in the house of the Cardinal of Siena; they are three, I copied them from the front and from the back. They are called the Three Graces."

45. Cf. the *Three Dutch Women* of 1905, Musée de l'Art Moderne, Paris.

46. Bartolommeo Fazio (Facius) in *De viris illustribus,* 1456, discussing Joannes Gallicus (Jan van Eyck). The lost painting was in the possession of Cardinal Octavianus. For the full text and the Latin original see L. Baldass, *Jan van Eyck,* London, 1952, p. 84 and note 1.

47. Cf. the Picasso drawings of February 5, 1935 (Z. VIII, 248, 250, 252), where a metamorphic nude, drawing before a mirror, tries to portray herself from her own realistic reflection; the point being precisely that each is unlike the other.

48. Delacroix, *Journal,* ed. Yves Hucher, Paris, 1963, p. 203.

49. E.g. the *Salomé* drypoint or *Les Saltimbanques,* National Gallery, Washington, D.C., both of 1905; the *Minotauromachy* etching, Bloch 111, and the *Blind Minotaur,* aquatint, Bloch 97, both of 1935.

50. Picasso's great *Seated Bather* of 1929 has been cited for the similarity of its open-work anatomical structure. But the comparison also reveals how much more spatial recession Picasso demands in 1937, and how much his distanced witness contributes to the volumetric effect.

51. See the *Lettere sull'Arte di Pietro Aretino,* ed. Ettore Camesasca, Milan, 1957-60, I, No. CVII, p. 175.

52. Outstanding examples of Renaissance jack-knifing figures are Michelangelo's *Brazen Serpent* Spandrel on the Sistine Ceiling and Tanzio da Varallo's *Defeat of Sennacherib* (Novarra, Museum). The type is anticipated in the Christ figure of Butinone's *Descent from the Cross* (Chicago, Art Institute, 33.1004). Cf. also Rosso's early drawing *Christ on the Cross* (Haarlem, Teyler Museum). For an intermediary type between jack-knifing and spiralling serpentination, but still designed to display front and back at the same time, cf. Rosso's *Moses and the Daughters of Jethro* (Uffizi) and Mabuse's woodcut *Hercules and Dejaneira,* reprod. in H. Pauwels, *et al.,* exhibition catalogue, *Jan Gossaert genaamd Mabuse,* Rotterdam, 1965, Cat. 73.

53. An almost pure Mannerist figure, represented as part of a sculptural group, occurs in Picasso's etching of March 30, 1933, from the Suite Vollard, *Sculptor, Reclining Model and Sculpture of Horse and Youth* (B. 55). More personal explorations of the jack-knifing type occur in Picasso's numerous drawings, from 1938 to 1944, of women bending over to wash feet. (E.g. Z. IX, 200, 322, 331, 338, 382, 383; also Z. XIII, 291). These bending figures are, so to speak, the reverse of Picasso's back-bending bodies developed around his studies for the *Crucifixion* of 1930. There the Magdalen's stricken figure is given as the jack-knife reversed into a backbend, with no body landmarks left out of sight.

54. Cf. Z. XVI, 249 ff.

55. Bertrand Russell, *Our Knowledge of the External World,* Chicago-London, 1914, p. 89.

56. Alfred H. Barr (in *Cubism and Abstract Art,* Museum of Modern Art, New York, 1936, p. 31) wrote of Picasso's *Arlésienne* of 1911-12: "The profile of the face is superimposed upon a frontal view illustrating the principle of 'simultaneity'—the simultaneous presentation of different views of an object in the same picture."

The effect is more explicitly rendered in Metzinger's Cubist Portrait of 1911 at the Chicago Art Institute. But nowhere in Cubism does this device become a substantive feature.

57. Its immediate forerunners, growing directly out of Synthetic Cubism, are such works as *Harlequin*, 1915 (Pierre Daix, *Picasso*, New York, 1965, p. 101) and the drawing *Femme debout*, 1916 (artist's collection, Z. II, 906). The type appears fully developed in *Harlequin*, 1918 (collection of Mr. and Mrs. Joseph Pulitzer, Jr., St. Louis).

58. Other examples: *Woman*, 1922-23, etching on zinc, G. 99; *Seated Woman*, 1926-27, Museum of Modern Art, New York.

59. In imitation of Picasso's distortions, photographers have repeatedly tried to create images "in the round" by splicing disparate aspects together, or by keeping the shutter open while the model or the camera moved. It seems to me that these attempts fail because the problem here is to shape "nothings" as if they were real entities, and the photographer is unable to impose shaped necessity on the intervals between displaced features.

60. Otto Demus, *Byzantine Mosaic Decoration*, Boston, 1955, p. 8.

61. Cf. Braque on the single viewpoint of the Renaissance, which "never allows one to take full possession of the things. . . . It is as if someone had spent his life drawing profiles and ended by believing that man was one-eyed." Quoted in John Richardson, *Georges Braque*, New York, 1961, p. 10.

62. A similar effect occurs in a figure from a Spanish eleventh-century Beatus manuscript, reproduced in Anthony Blunt, *Picasso's Guernica*, New York, 1969, pl. 29A. It seems, however, to be unique. Picasso's solution is generated in its own ground, just as his doubled and tripled faces are unrelated to representations of Hecate or to those condemned fifteenth-century Trinity symbols that display three faces upon one head.

63. Cf. Barr, p. 59. For Picasso's copies from and variations on Egyptian motifs, see especially the drawings of 1903 and 1904, Z. XXII (Supplement), 31 and 69. Picasso's most precocious instance of an "Egyptianized" eye seems to be a pastel, *Scene of Bohemian Life*, dated 1898 (Z. I, 12). In 1901 Picasso drew his self-portrait wearing an Egyptian crown (O'Hana Gallery, London).

64. An exception is the front-and-back pun in the 1907 drawing of a *Standing Nude* (Fig. 103), where the duplicity succeeds by suppression of data. The images here discussed succeed by conflating positive evidence of front and back aspects.

65. For similar four-way multiplication of aspects, cf. also the drawings of the following year, Z. XI, 268, 270.

66. Richard Ellmann, *James Joyce*, New York, 1959, p. 559. For helping me trace this quotation, and for much else, I am indebted to my friend and colleague, the Joyce scholar Leonard Albert.

67. Cf. *Three Nude Women*, 1938, drawing, Meric Collection, New York, Z. IX. 200, and Fig. 79.

68. Anatomic inversions occur on several Archaic Greek gems and small bronze statuettes. A scarab in Leningrad represents a winged horseman whose frontal torso descends to a pair of buttocks. (See John Boardman, "Three Greek Gem Masters," *Burlington Magazine* 111 [1969], Fig. 12). On a small (3″ high) East Greek bronze in the British Museum, the head is reversed in relation to trunk and limbs (D. E. L. Haynes, "A Group of East Greek Bronzes," *Journal of Hellenic Studies*, 72 [1952], No. 9, Pl. IIc.). Karl Neugebauer has collected figures in which various parts of the body are reversed. In his catalogue of bronzes in Berlin he cites another example where head and legs face in one direction, the torso in another (*Die minoischen und archäisch griechischen Bronzen* I, Berlin, 1931, No. 163). He lists others, including a lead statuette whose head and crossed arms are twisted around to the back of the body (Athens; cf. also S. Reinach, *Répertoire de la statuaire grecque et romaine* III, Paris, 1904, 262, 3). A more complex, probably Etruscan piece, noted by both Haynes and Neugebauer, is reproduced by C. Q. Giglioli ("Curiosità archeologiche," *Studi Etruschi* 3 (1929), p. 529,

Fig. 1; also Reinach, *op. cit.*, II, 442, 2; the work is in the British Museum). Here the head, right arm, and legs face forward, while the trunk and the other arm are turned around.

These rare, mostly provincial pieces have not been sufficiently studied and remain almost unknown. The authors cited above believed them to have been cult objects, perhaps serving as amulets or for some occult purpose (e.g. Neugebauer, *op. cit.*, p. 67 and note 2), for they saw such anatomic inversions as possible only in the realm of the supernatural. An inscription recently found upon one such statuette seems to confirm this view (Haynes, *op. cit.*, p. 75).

69. There had of course been earlier attacks on the problem of rendering furniture seen from multiple angles, e.g. the sensitive drawings of tables produced in 1915. But these show superimposed diagrammatic views of the object in a manner derived from Synthetic Cubism; they relate to the schematic assemblage principle of, say, *L'Italienne* (Fig. 128). By contrast, a table of the 1940's, such as that in *Nature morte à la cafétière* (April 6, 1947; Z. XV, 45) is neither diagram nor assemblage, but one tightly organized object seen in full density from left and right, above and below, simultaneously.

70. Barr, p. 242.

71. For the above references cf. Barr, pp. 231-36.

72. The eye-witness-lamp in the *Guernica* mural occupies the apex of the main structural pyramid. In the first state of the mural (May 11, 1937) that position is taken by the clenched fist of a vertically upraised arm. The same fist in the second state is vastly enlarged and grasps ears of wheat while a great sun or sunflower circles it like a halo. Finally, in the third state the blatant symbols of raised arm and fist are abandoned and the sun disc assumes the ambiguous almond shape of lamp and eye. The sequence, however, suggests that the eye-lamp is still for Picasso the symbol of power.

73. See Ernst H. Kantorowicz, *The King's Two Bodies*, Princeton, 1957, *passim*.

74. Gilot, *passim*. Compare James R. Mellow in the *New York Times*, October 24, 1971, Section II: "My reading of Picasso's treatment of women over the years . . . is that it has been characterized by a rich vein of hostility. . . ."

75. Penrose, *op. cit.*, p. 298, quoting Antonina Valentin.

76. Cf. the interpretations of the *Nude Dressing Her Hair* as a picture of war given by Picasso's friends Paul Eluard and Pierre Daix (Daix, *op. cit.*, p. 180).

Monet's *Water Lilies*

1. Alan Clutton-Brock, *An Introduction to French Painting*, London, 1932, p. 119.

2. The *Nymphéas* here discussed perished in the fire at the Museum of Modern Art in 1958.

Gonzalez

1. The omission of Matisse from the above passage seems to me in retrospect regrettable (1971).

2. See *Arts*, February 1956.

Pascin

1. This article drew the following comment from the American painter Ernest Fiene who had been Pascin's personal friend in the late 1920's (see *Arts*, February

1956, "Letters," p. 4): "Too much has been said of Pascin's addiction to brothels and liquor and not enough about his passion for art, life and good fun. . . . The story that at fifteen he was engaged on the strength of his studies in brothels to work for *Simplicissimus* is unfounded. Pascin told me that at fifteen he won the cartooning competition of a Viennese newspaper. He left home in the dark night and was greeted at the railroad station in Vienna by the editor—Pascin was small and slight like an 11-year-old boy. The editor was disgusted and would not have him. He returned home and it was some years later that *Simplicissimus* engaged him. . . ."

Torsos and Raoul Hague

1. August 1971: I am no longer sure that the above observations are the most relevant things to be said about Hague. But I continue to feel that this fine sculptor has been unjustifiably ignored. In 1963 when René d'Harnoncourt installed an exhibition of contemporary American sculpture in the garden of the Rodin Museum in Paris, where every piece had to stand up to the natural grandeur of trees, Hague's powerful forms were almost alone in not losing stature.

Fritz Glarner and Philip Guston

1. Having straightened the offending stream, Paul Bunyan finds that "all the miles and miles of extra river that used to be in the kinks are running wild out on the prairie. So . . . he sends a crew to camp to bring his big cross-cut saw and a lot of baling wire. He saws the river into nine-mile lengths and the men roll it up like linoleum and tie it with baling wire. Some say he used these later when he logged off the desert, rolling out as many lengths as he needed to float his logs."
2. That the city rather than some "universal appearance" is relevant even to Mondrian is suggested by some of his titles—*Trafalgar Square, New York City, Broadway Boogie-Woogie.* Did he realize that his final theme was not the eternal but the very now?

The Eye Is a Part of the Mind

1. Bollingen Series XXIV, 1949; later revised as *The Voices of Silence.*
2. It would be missing the point to include here only such art as looks convincingly lifelike to us. What matters is the artist's intent to push the truth of his representation to the limits of what is felt to be depictable. The changing pattern of these limits is the preoccupation of the history of art.
3. "The story of Greek art is the story of a step-by-step discovery of the true nature of appearance by the liberation of vision from its conceptual bonds," wrote Roger Fry (*Last Lectures*, New York, 1939, p. 187).
4. The words are taken from Alois Riegl (died 1905).
5. Even Sir Joshua Reynolds, in his first Discourse, laments that students "make a drawing rather of what they think the figure ought to be than of what it appears."
6. See A. Grabar on *"Plotin et l'esthétique médiévale"* in *Cahiers Archéologiques,* Vol. I, 1945.
7. See, for this quotation and those following, *The Essence of Plotinus,* compiled by Grace H. Turnbull from the translation by Stephen MacKenna, Oxford, 1948.
8. In his *Art as Experience* John Dewey writes: "Nothing that man has ever reached by the highest flights of thought, or penetrated by any probing insight is inherently such that it may not become the heart and core of sense."

Objectivity and the Shrinking Self

1. John Shearman, *Mannerism*, Baltimore, 1967.
2. 1971: The contrast with the animal kingdom strikes me in retrospect as problematic, since the surviving world of animals is likely to become as value-structured as our art. Cattle and chickens survive because their produce is wanted; cockroaches and rats because we tolerate slums. It is the lion and the eagle that perish, to survive only in the zoological equivalent of the art gallery.
3. David Lyle, "The Human Race Has, Maybe, Thirty-Five Years Left," *Esquire*, September 1967, p. 183.
4. Ernst H. Kantorowicz, "The Archer in the Ruthwell Cross," *Art Bulletin*, 1960.
5. Meyer Schapiro, "Bowman and the Bird on the Ruthwell Cross and Other Works: The Interpretation of Secular Themes in Early Mediaeval Religious Art," *Art Bulletin*, 1963.
6. Susanne K. Langer, *Feeling and Form*, New York, 1953.

Rodin

1. See "London Sculptors and Sculptures," in *Transformations* (1926), Doubleday Anchor Books, 1956, p. 198. Fry preferred Dalou and Frank Dobson.
2. *Auguste Rodin*, Curt Valentin Gallery, Exhibition Catalogue, New York, May 1954.
3. For a recent appraisal of the lamentable condition of "Rodin in Paris and at Meudon," see *Burlington Magazine*, November 1967.
4. Robert Reiss in the *Philadelphia Record*, June 14, 1936.
5. *Art Digest*, August 1953, cover and p. 12.
6. The publications relevant to the foregoing paragraph are: Joseph Gantner, *Rodin und Michelangelo*, Vienna, 1953; J. A. Schmoll gen. Eisenwerth, *Der Torso als Symbol und Form, Zur Geschichte des Torso-Motivs im Werk Rodins*, Baden-Baden, 1954; cf. also the contribution of the above authors in *Das Unvollendete als Künstlerische Form: ein Symposion*, ed. J. A. Schmoll gen. Eisenwerth, Berne, 1959. The catalogue of the Galerie Claude Bernard exhibition contains a thoughtful introduction by Jacques Bornibus. My own essay was written for the Slatkin Gallery catalogue. The exhibition at the Museum of Modern Art was accompanied by what has become a standard work on the subject, Albert E. Elsen's *Rodin*, New York, 1963.
7. Cf. Jules Dalou's *Nude with a Mallet, ca.* 1891, an ideal self-portrait of the sculptor as carver, even though the work itself is that of a modeler. It was designed as one of four statues for the base of the monument to Baron Haussmann's civil engineer Adolphe Alphand; the terra-cotta model is in the Petit Palais, Paris.
8. Sommerville Story, *Auguste Rodin*, London, 1939.
9. Quoted in Elsen, *Rodin*, p. 126.
10. The Cleveland Museum of Art, 1967, pp. 67 f.
11. July 6, 1930, p. 17. This kind of reporting belongs to exactly the same order of journalistic mythology as the once-famous "eyewitness" description of Rodin producing one of his partial figures (quoted in Elsen, p. 180). An American woman visited Rodin's studio in 1910 to purchase a sculpture: "How much?" "Forty thousand francs." "All right, I'll buy it." "Wait!" Rodin, armed with a hammer, broke the legs, crushed the arms, smashed the nose and knocked off the ears. "Voilà!" "Never have I seen such a quick worker!"
12. Cf. the following in Elsen's *Rodin*, p. 138: "Rodin's works in marble do not today ignite the imagination nor challenge the eye as do his bronzes, . . . but the better marbles, such as the women's portraits, *The Danaïd* and *Beside the Sea*, are gen-

erally suffused with good taste. Frequently they will reveal superb passages of finesse in modeling that compensate for the triviality and lack of inspiration in many of his other marbles. For better or worse, Rodin's marble mode was one that came honestly to him."

13. Degas' reason for not casting his figures in bronze: "It's too great a responsibility. Bronze is for eternity. You know how I like to work these figures over and over. When one crumbles, I have an excuse for beginning again." Quoted in Victor Frisch and Joseph T. Shipley, *Auguste Rodin, a Biography*, New York, 1939, p. 312.

14. Cf. Anatole France's reading of Rodin's *Gates of Hell:* ". . . These couples . . . cry to us: 'Our eternal torments are in ourselves.' We bear within us the fire that burns us. . . ." etc.

 Objections to the excessive emotionalism of Rodin's work were of course voiced before. Henri Rochefort exclaimed at the end of a perceptive critique of the *Balzac:* "For the love of art, let the sculptor spare us his commentaries" (quoted in Story, *op. cit.,* p. 22). Still in the same spirit, Henry Moore favors Rodin's *Walking Man* "over other works, such as the series of embracing couples, (because of the) absence of the sentimental and the literary" (Elsen, "Rodin's 'Walking Man' as seen by Henry Moore," *Studio*, July-August, 1967, p. 30). Cf. finally Sidney Geist's authoritative statement in discussing an early Brancusi bust: "The lack of emotion expressed on the face . . . announces a sensibility that, since Manet, we recognize as modern" (Geist, *Brancusi*, New York, 1968, p. 23).

15. Diary of M. de Chantelou, entries for August 17 and September 9, 1665 (ed. Hans Rose, Munich, 1919, pp. 116, 183).

16. *Self-Portrait of an Artist: From the Diaries of Kathleen, Lady Kennet*, London, 1949, p. 42.

17. For this and similar transmigrations, see now Athena Tacha Spear, *op. cit.,* Cat. XI.

18. Baudelaire's space metaphors tend towards similar visions of drift and suspension, as in *Les Plaintes d'un Icare*—". . . de l'espace trouver la fin et le milieu."

19. Since this was written, Elsen has published Henry Moore's observations on the *Walking Man*, of which the artist owns a cast (see note 14). The figure's feet, in Moore's words, "clench the earth . . . gripping the ground." Elsen continues: "Imitating the position of the figure with the right foot turned in, Moore showed how one could not possibly walk in this manner. The toeing-in is for him the result of the model 'striking a pose.' "

 Rodin's own recollection of the genesis of the *Walking Man* confirms his non-walking—though the description as given by Dujardin-Beaumetz is not verbatim: "The peasant undressed, mounted the model stand as if he had never posed; he planted himself, head up, torso straight, at the same time supported on his two legs, opened like a compass. The movement was so right, so determined, and so true that I cried: 'But it's a walking man!' I immediately resolved to make what I had seen. . . . It was thus that I made 'The Walking Man' and 'John the Baptist.' I only copied the model whom chance had sent me." (*Auguste Rodin: Readings on His Life and Work*, ed. Albert Elsen, Englewood Cliffs, 1965, p. 166.) Note that it was the pose of a man "determined" and "planting himself" which inspired the image of a man walking "copied from nature."

20. Cf. the misleading fiction: "The idea came to him one day in 1908 of representing the high-pointed naves by two tapering hands joined in a gesture of prayer" (Story, *op. cit.,* pp. 18 and 149). The *Cathedral*, like the *Secret*, should be seen in the small original plaster at the Musée Rodin, not in the vulgar marble enlargement (Cf. *Rodin inconnu*, Louvre exhibition catalogue, 1962, Nos. 185, 186).

21. Cf. versions at the Morgan Library, New York, and the Wallace Collection, London, attributed to Houdon, whom Rodin rightly admired. For Rodin's affinity with Rococo sculpture, compare also the stance of the *Age of Bronze* and the *Eve* with such works as Houdon's *La Frileuse*, Metropolitan Museum, New York.

22. Not 1882, since, according to A. E. Elsen, the *Torso* inspired the *Sirens* Rodin carved in 1878 for the Villa Neptune in Nice. (Letter to author, October 4, 1971.) Rodin's almost forgotten caryatids for the Villa Neptune represent the first of his unsuccessful attempts to "complete" the *Torse d'Adèle*. They are to be published shortly by Mr. John Tancock, director of the Rodin Museum, Philadelphia, who kindly showed me the photographs.

23. *Letters of Rainer Maria Rilke*, New York, 1954, p. 83.

24. Auguste Rodin, *L'Art, Entretiens réunis par Paul Gsell*, Paris, 1912, pp. 63-64.

25. It must be understood that Rodin's failures are relative to his own standards. If one compares his *Eternal Spring* or *Eternal Idol* with a work of nearly identical subject, say, the *Adoratio* by the successful Salon sculptor Stephan Sinding, Rodin's authentic poetic sense and superior sculptural imagination leap to the eye even here.

26. See Georges Grappe, *Catalogue du Musée Rodin*, Paris, 1931 (3rd edition), Nos. 263-65.

27. Elsen (*Rodin*, p. 180) quotes the following from a book written in 1925 by Fred Wellington Ruckstull, an organizer of the National Sculpture Society in the United States: "Why any man should, today, *deliberately model* a human body and then *mutilate it* and then *hack it*, and exhibit it, except as a revelation of his sadistic soul, passes our comprehension. The first man . . . to do this was Rodin. In his 'Walking Man' . . . we have a glaring example. . . . To deliberately produce such a cadaver and sell it, perhaps is proof of the working of a mind tainted with sadism."

 Similarly, though half in jest, George Bernard Shaw, describing Rodin's working method in making Shaw's portrait (Elsen, p. 126): "If the nose of the bust was too long he cut off a section and pressed the end to close the wound with no more emotion or affectation than a glazier replacing a window. If the ear was not in its place he would cut it off and lay it on correctly, these mutilations being executed coldbloodedly in the presence of my wife (who almost expected to see the already terribly animated clay begin to bleed)."

28. Professor Elsen reminds me that Rodin, in 1888, allowed his early *Torso* (Fig. 260) to be reproduced in a periodical. But the context of an appreciative magazine article—where the torso appears as something the writer found in the studio, an unfinished or injured piece, perhaps awaiting repair—such a context, of a limited magazine readership, is vastly different from that of a public showing. Cf. the preceding note for the extra margin of outrage felt over the fact that symptoms of Rodin's perverted sadism were actually exhibited and offered for sale!

29. Victor Frisch, his assistant from Munich, describes the process as follows: ". . . he had several plaster casts made. One was kept intact, the others were cut apart and the sections numbered and catalogued, so that they might be drawn out of their cupboards to serve in other figures, perhaps years later. Thus dissected, limb from torso, they would be set, again and again, in new arrangements and further considerate groupings . . ." (Frisch and Shipley, *op. cit.*, p. 113).

Illustrations

All dimensions are in centimeters. Unless otherwise specified, works of sculpture show dimensions for height only.

All works by Picasso are reproduced by permission of SPADEM 1971, by French Reproduction Rights, Inc.

All works by Gonzalez are reproduced by permission of ADAGP 1971, by French Reproduction Rights, Inc.

1. Henri Matisse, *Joy of Life*, 1906. The Barnes Foundation, Merion, Pennsylvania.
2. Jasper Johns, *Liar*, 1961. Encaustic, pencil, and sculpmetal on paper, 53.9 x 43.2. Collection, Mr. and Mrs. Victor W. Ganz, New York.
3. Johns, *Flag Above White*, 1954. Encaustic on canvas, 55.9 x 48.3. Collection, Mr. and Mrs. Michael Sonnabend, Paris.
4. Johns, *White Flag*, 1954. Encaustic and fabric on canvas, 182.9 x 365.8. Owned by the artist.
5. Johns, *Three Flags,* 1958. Encaustic on canvas—raised canvases, 77.3 x 115.6 x 12.7. Collection, Mr. and Mrs. Burton Tremaine, Meriden, Connecticut.
6. Johns, *Flag*, 1960. Sculpmetal, 30.5 x 50.2. Collection, Robert Rauschenberg, New York.
7. Johns, *The Canvas*, 1956. Encaustic on canvas, 76.2 x 63.5. Owned by the artist.
8. Johns, *The Drawer*, 1957. Encaustic, canvas, and wood, 76.2 x 77.5. Brandeis University Art Collection, Gevirtz-Mnuchin Purchase Fund.
9. Johns, *Gray Numbers*, 1958. Encaustic and collage on canvas, 170.1 x 120.7. Collection, John Powers, Colorado.
10. Johns, *Coat Hanger,* 1958. Black conte on white paper, 61.2 x 54.3. Collection, Mr. and Mrs. William Easton.
11. Johns, *Bronze,* 1960-61. Bronze, 29.2 x 15.9 x 8.9. Collection, Mr. and Mrs. Robert C. Scull.
12. Johns, *Painted Bronze,* 1960. Painted bronze, 11.4 x 20.2 x 12. Collection, Mr. and Mrs. Robert C. Scull.
13. Johns, *Target with Four Faces,* 1955. Encaustic and collage on canvas with plaster casts, 76.2 x 66. The Museum of Modern Art, New York.
14. Johns, *Target with Plaster Casts,* 1955. Encaustic on canvas with plaster casts, 29.5 x 11.7 x 9. Owned by the artist.
15. Johns, *Gray Painting with a Ball,* 1958. Encaustic on canvas, 80 x 62.3. Private collection.

16. Johns, *Device Circle*, 1959. Encaustic and collage on canvas with wood, 101.6 x 101.6. Collection, Mr. & Mrs. Burton Tremaine, Meriden, Connecticut.

17. Johns, *Tennyson*, 1958. Encaustic and canvas on canvas, 185.7 x 123.2. Des Moines Art Center, Des Moines, Iowa.

18. Johns, *Flag Above White*, 1954. Encaustic on canvas, 55.9 x 48.3. Collection, Mr. and Mrs. Michael Sonnabend, Paris.

19. Johns, *Map*, 1962. Encaustic and collage on canvas, 152.4 x 236.2. Collection, Mr. and Mrs. Frederick Weisman, Beverly Hills, California.

20. Johns, *Shade*, 1959. Encaustic on canvas with object, 132.1 x 99. Private collection, New York.

21. Johns, *Target with Plaster Casts*, 1955. Encaustic on canvas with plaster casts, 29.5 x 11.7 x 9. Owned by the artist.

22. Johns, *The Drawer*, 1957. Encaustic, canvas, and wood, 76.2 x 77.5. Brandeis University Art Collection, Gevirtz-Mnuchin Purchase Fund.

23. Johns, *NO*, 1961. Encaustic, collage, and sculpmetal on canvas with objects, 172.7 x 101.6. Owned by the artist.

24. Johns, *o Through 9*, 1960. Charcoal on paper, 73.7 x 58.4. Owned by the artist.

25. Johns, *o Through 9*, 1961. Charcoal on paper, 137.2 x 114.3. Collection, Mr. and Mrs. Robert C. Scull.

26. Johns, *Construction with a Piano*, 1954. 27.9 x 22.9 x 5.1. Collection, Mr. and Mrs. Robert C. Scull.

27. Johns, *Target with Four Faces*, 1955. Encaustic and collage on canvas with plaster casts, 76.2 x 66. The Museum of Modern Art, New York.

28. Jean Léon Gérome, *Pygmalion and Galatea*. Oil on canvas, 88.9 x 68.6. The Metropolitan Museum of Art, gift of Louis C. Raeger, 1927.

29. Thomas Eakins, *William Rush Carving His Allegorical Figure of the Schuylkill River*. Oil on canvas, 91.3 x 121.3. Courtesy of the Brooklyn Museum, Dick S. Ramsay Fund.

30. Rembrandt, *A Woman Reading, ca.* 1639-40. Pen and bister, 6.7 x 8.7. The Metropolitan Museum of Art.

31. Niccolò di Pietro Gerini (?) *Crucifixion*. Florence, Sta. Croce.

32. Michelangelo, *Doni Madonna*. Florence, Uffizi.

33. Early fifteenth-century Florentine (?) manuscript. Courtesy Speed Art Museum, Louisville, Kentucky.

34. Kenneth Noland, *Coarse Shadow* and *Stria*. Installation photograph, André Emmerich Gallery, 1967.

35. Dubuffet, *Olympia*, 1950. Oil on canvas, 88.9 x 116.2. Collection, Mrs. Victor M. Leventritt, New York. Photo courtesy Pierre Matisse Gallery.

36. Morris Louis, *White Series* II, 1960. Acrylic on canvas, 241.8 x 363.2. Collection, Mrs. Philip Lilienthal. Courtesy André Emmerich Gallery.

37. Robert Rauschenberg, *White Painting with Numbers*, 1949. Oil on canvas, 101.6 x 61. Collection, Mr. and Mrs. Victor W. Ganz, New York.

38. Robert Rauschenberg, *Winter Pool*, 1959. Combine painting, 219.6 x 147.9. Collection, Mr. and Mrs. Victor W. Ganz, New York.

39. Robert Rauschenberg, *Third Time Painting*, 1961. Combine painting, 213.4 x 157.5. Harry N. Abrams Family Collection, New York.

40. Pablo Picasso, *Contemplation*, 1904. Watercolor. Collection, Mrs. Bertram Smith, New York.

41. Picasso, *Sleeping Nude*, 1904. Watercolor, 36 x 26. Collection, Jacques Helft, Paris. Z. I. 234.

42. Picasso, *Reclining Nude with Figures*, 1908. Oil on wood, 63 x 36. Owned by the artist. Z. II. 688.

43. Picasso, *The Family*, 1923. Charcoal drawing. Thannhauser Collection, courtesy of the Thannhauser Foundation, New York.

44. Picasso, *Youth and Sleeping Girl*, September 24, 1931. Pencil drawing, 47.4 x 61.7. Z. VII. 350.

45. Jan Saenredam, *Jael Slaying Sisera*. Engraving. Bartsch III. 107.

46. Boldrini after Titian, *Satyr and Sleeping Nymph*. Woodcut.

47. Annibale Carracci, *Jupiter and Antiope*. Etching. Bartsch XVIII. 18.

48. Picasso, *Minotaur and Woman Asleep*, June 18, 1933. Drypoint, 29.9 x 36.8. Bloch 261.

49. Jacob Matham, *Cimon and Iphigenia*. Engraving. Bartsch III. 59.

50. Picasso, *Faun and Sleeping Woman*, 1936. Etching and acquatint, 33.8 x 41.7. Suite Vollard 27.

51. Picasso, *Girl Seated by a Sleeping Minotaur*, May 18, 1933. Combined technique, 18.6 x 26.7. The Museum of Modern Art, New York. Suite Vollard 86.

52. Picasso, *Vigil*, 1936. Etching and aquatint, 25.3 x 29.4. Suite Vollard 26.

53. Picasso, Study, February 10, 1946. Pencil drawing, 32 x 50. Z.XIV. 137.

54. Picasso, Study, February 10, 1946. Pencil drawing, 32 x 50. Z. XIV. 142.

55. Picasso, Study, February 10, 1946. Pencil drawing, 32.5 x 50.

56. Picasso, Study, February 10, 1946. Pencil drawing, 32 x 50. Z. XIV. 143.

57. Picasso, Study, February 10, 1946. Pencil drawing, 32.5 x 50. Z. XIV. 144.

58. Picasso, Study, February 10, 1946. Pencil drawing, 32.5 x 50. Z. XIV. 146.

59. Picasso, Study, February 10, 1946. Pencil drawing, 32.5 x 50.

60. Picasso, Study, February 10, 1946. Pencil drawing, 32.5 x 50. Z. XIV. 151.

61. Picasso, *Two Nude Women*, November 1945–March 1946. Lithograph, 31.3 x 43. Mourlot XVI.

62. Picasso, *Two Nude Women*, November 1945–March 1946. Lithograph, 31.3 x 43. Mourlot XVI.

63. Picasso, *Two Nude Women*, November 1945–March 1946. Lithograph, 31.3 x 43. Mourlot XVI.

64. Picasso, *Two Nude Women*, November 1945–March 1946. Lithograph, 31.3 x 43. Mourlot XVI.

65. Picasso, *The Artist's Bedroom*, December 29, 1953. Oil on canvas, 130 x 97. Z. XVI. 100.

66. Picasso, *The Artist's Bedroom*, December 29, 1953. Oil on canvas, 130 x 96. Z. XVI. 99.

67. Picasso, *The Dream*, 1942. Ink and pencil, 50 x 65. Haubrich Collection, Cologne.

68. Picasso, *Sleeping Man and Standing Woman*, October 13, 1946 (VII). Pencil drawing, 50 x 65. Z. XIV. 258.

69. Picasso, *Satyr and Sleeping Woman*, November 1, 1946. Pencil drawing. Zervos, *Dessins*, 187.

70. Picasso, *Skull and Pitcher*, 1945. Oil on canvas, 73 x 92. De Menil Family Collection, Houston, Texas.

71. Picasso, *Skull and Leeks*, 1945. Oil on canvas, 89 x 130. Galerie Louise Leiris. Z. XIV. 96.

72. Picasso, *Death's Head*, 1944. Bronze, 28.9 x 21.3 x 26. Owned by the artist.

73. Picasso, *Death's Head*, 1944. Bronze, 28.9 x 21.3 x 26. Owned by the artist.

74. Pablo Picasso, 1944. Photograph by Robert Capa, Magnum Photos Inc.

75. Picasso, *The Women of Algiers, A,* December 13, 1954. Oil on canvas, 60 x 73. Private collection, New York.

76. Picasso, *The Women of Algiers, B,* December 13, 1954. Oil on canvas, 60 x 73. Private collection, Nevada.

77. Eugène Delacroix, *The Women of Algiers,* 1834. Oil on canvas, 227 x 177. Musée du Louvre, Paris.

78. Delacroix, *The Women of Algiers,* 1849. Oil on canvas, 111 x 84. Musée Fabre, Montpellier.

79. Picasso, *The Women of Algiers, C,* December 28, 1954. Oil on canvas, 54 x 65.1. Collection, Mr. and Mrs. Victor W. Ganz, New York.

80. Picasso, *The Women of Algiers, D,* January 1, 1955. Oil on canvas, 46 x 54.9. Private collection.

81. Picasso, Studies of reclining nudes, 1905. Ink drawing, 15.5 x 33. Owned by the artist. Z. XXII (Supplement), 201.

82. Henri Matisse, *Hindu Pose,* 1923. Collection, Donald S. Stralem, New York.

83. Picasso, *The Women of Algiers, E,* January 16, 1955. Oil on canvas, 46 x 54.9. Private collection, Nevada.

84. Picasso, *The Women of Algiers, F,* January 17, 1955. Oil on canvas, 54 x 65.1. Collection, Mr. and Mrs. Daniel Saidenberg, New York.

85. Picasso, *The Women of Algiers, G,* January 18, 1955. Oil on canvas, 65.1 x 54. Saidenberg Gallery, New York.

86. Picasso, *The Women of Algiers, H,* January 24, 1955. Oil on canvas, 129.8 x 161.9. Collection, Mr. and Mrs. Victor W. Ganz, New York.

87. Picasso, *The Women of Algiers, M,* February 11, 1955. Oil on canvas, 130.2 x 194.9. Collection, Mr. and Mrs. Victor W. Ganz, New York.

88. Picasso, Study of nudes, 1905. Ink drawing, 32 x 27. Owned by the artist. Z. XXII (Supplement), 171.

89. Picasso, *Three Nudes and a Satyr Playing the Flute,* July 21, 1932. Drypoint etching, 29.7 x 36.7. Suite Vollard 11.

90. Picasso, *The Women of Algiers, A,* with overlay.

91. Picasso, *The Women of Algiers, A,* with overlay.

92. Picasso, Study for *The Three Women,* 1908. Charcoal drawing, 62 x 16.5. Private collection, New York. Z. II. 707.

93. Picasso, *The Women of Algiers, I,* January 25, 1955. Oil on canvas, 97 x 130. Galerie Beyeler, Switzerland.

94. Picasso, *The Women of Algiers, J,* January 26, 1955. Oil on canvas, 114 x 46. Private collection, New York.

95. Picasso, *The Women of Algiers, K,* February 6, 1955. Oil on canvas, 129.8 x 161.9. Collection, Mr. and Mrs. Victor W. Ganz, New York.

96. Picasso, *The Women of Algiers, L,* February 9, 1955. Oil on canvas, 130.2 x 96.8. Collection, Mr. and Mrs. G. I. Kass, Washington, D.C.

97. Picasso, *The Women of Algiers, N,* February 13, 1955. Oil on canvas, 113.9 x 146. Washington University Gallery of Art, St. Louis.

98. André Lhote, Cubist drinking glass, 1952. Reproduced from Herschel B. Chipp, ed., *Theories of Modern Art,* Berkeley and Los Angeles, 2nd ed., 1968, p. 197.

99. Picasso, *Grand Nu de femme,* 1962. Linoleum cut, 64.1 x 53.4. Bloch 1085.

100. Picasso, *Woman with Mandolin,* 1910. Oil on canvas, 100.3 x 73.7. Private collection, New York.

101. Picasso, *Head of a Man,* 1907. Watercolor. The Museum of Modern Art, New York, A. Conger Goodyear Fund.

102. Picasso, *Head of a Woman,* 1907. Oil on canvas, 46 x 33. Z. II. 12.

103. Picasso, *Standing Nude*, 1907. Drawing, 65 x 48. Owned by the artist. Z. II. 685.

104. Picasso, *Les Demoiselles d'Avignon*, 1907. Oil on canvas, 243.8 x 233.6. The Museum of Modern Art, New York. Acquired through the Lillie P. Bliss Bequest.

105. Picasso, Study for *Les Demoiselles d'Avignon*, 1907. Drawing, 20 x 13.5. Owned by the artist. Z. II. 629.

106. Picasso, *The Sculptor*, August 4, 1931. Drawing, 31.7 x 25.4. Seattle Art Museum, LeRoy M. Backus Collection.

107. Gonzales Cocx, *The Sense of Sight*, *ca.* 1650. Oil on wood, 18 x 14. Royal Museum, Antwerp.

108. Picasso, *The Embrace*, 1933. Drypoint etching, 29.7 x 37.1. Suite Vollard 31.

109. Ivory bead from a rosary, French or Flemish, *ca.* 1500. Courtesy Museum of Fine Arts, Boston.

110. Ivory bead from a rosary, French or Flemish, *ca.* 1500. Courtesy Museum of Fine Arts, Boston.

111. Picasso, *Head of a Woman*, June 26, 1940. Ink drawing. Z. XI. 54.

112. Picasso, *La Lola*, 1905. Drawing, 38 x 27.5. Owned by the artist. Z. XXII (Supplement), 189.

113. Master P. M., *The Women's Bath*. Engraving, 19.6 x 16.3.

114. Antonio Federighi, *The Three Graces*. Pen drawing. Graphische Sammlung, Munich.

115. Picasso, *Nudes in an Interior*, September 18, 1941. Ink drawing, 21 x 27. Z. XI. 298.

116. Picasso, *Nudes in an Interior*, September 18, 1941. Ink drawing, 21 x 27. Z. XI. 301.

117. Picasso, *Nudes in an Interior*, September 19, 1941. Ink drawing, 21 x 27. Z. XI. 306.

118. Picasso, *Girls with a Toy Boat*, February 12, 1937. Oil and charcoal, 129.8 x 194.9. Collection, Peggy Guggenheim, Venice.

119. Paolo Farinati, *Perseus and Andromeda*. Drawing. Collection of Her Majesty The Queen, Windsor Castle.

120. Jan van Hemessen, *Judith*, *ca.* 1560. Oil on panel, 99.7 x 77.7. Courtesy Art Institute of Chicago, The Wirt D. Walker Fund.

121. Picasso, Study of a nude, 1939-40. Pencil drawing, 15.5 x 10. Z. X. 234.

122. Picasso, Study of a nude, 1939-40. Pencil drawing, 15.5 x 10. Z. X. 235.

123. Picasso, *La Puce*, 1942. Aquatint, 36.5 x 28.6. *Venus Callipyge*, National Museum, Naples.

124. Picasso, *La Ronde*, December 6, 1953. Ink drawing, 44.5 x 50.5. Z. XVI. 32.

125. Picasso, *Nude Girl Asleep*, February 28, 1954 (VII). Pencil drawing, 24 x 32. Z. XVI. 249.

126. Picasso, *Nessus and Dejaneira*, 1920. Pencil drawing, 20.9 x 26. The Museum of Modern Art, New York. Acquired through the Lillie P. Bliss Bequest.

127. Picasso, *The Bather*, 1908. Oil on canvas, 130 x 97. Private collection. Z. II. 111.

128. Picasso, *L'Italienne*, 1917. Oil on canvas, 149 x 101. Collection, E. G. Bührle, Switzerland. Z. III. 18.

129. Picasso, *Head of a Woman*, 1925. Lithograph, 12.7 x 11.4. Mourlot XX.

130. Picasso, *Nude Woman in an Armchair*, 1932. Oil on canvas. The Tate Gallery, London.

131. Agnolo Bronzino, *Panciatichi Madonna*. Pitti Palace, Florence.

132. Picasso, *Portrait of a Lady*, 1937. Oil on canvas, 92.1 x 64.7. Owned by the artist.

133. Picasso, *Femme assise*, April 23, 1943. Oil on canvas, 100 x 81. Z. XIII. 101.

134. Picasso, *The Faun*, August 30, 1946. Ink drawing, 65 x 50. Z. XIV. 230.

135. Picasso, *Nude Dressing Her Hair*, June 19, 1940. Page from the Royan sketchbook (postscript to Fig. 158), ink drawing, 40.5 x 30.5. Z. XI. 13.

136. Picasso, *Head of a Woman*, May 20, 1941. Pencil drawing, 27 x 21. Z. XI. 119.

137. Picasso, *Head of a Woman*, June 12, 1941. Ink drawing, 27 x 21. Z. XI. 168.

138. Picasso, *Reclining Woman*, May 19, 1941. Ink drawing, 21 x 27. Z. XI. 113.

139. Picasso, *Head of a Woman*, June 26, 1940. Ink drawing. Z. XI. 54.

140. Picasso, *Heads*, July 30–August 9, 1942. Ink drawing, 18.2 x 9.5. Z. XII. 97, 98, 101, 102.

141. Picasso, *Woman in a Mirror*, July 13, 1940. Ink drawing. Z. XI. 70.

142. Picasso, *Sleeping Nude*, 1941. Oil on canvas, 92 x 65. Z. XI. 198.

143. Picasso, *Three Nudes*, detail of lower figure, January 8, 1942. Gouache on paper. Z. XII. 2.

144. Picasso, Study for head of a horse (*Guernica*), May 2, 1937. Oil on canvas, 64 x 34.5. Owned by the artist, on loan to the Museum of Modern Art, New York.

145. Picasso, Study of a lamb, August 26, 1942. Ink drawing, 27 x 21. Z. XII. 130.

146. Picasso, Study of chairs, December 8, 1942. Ink drawing, 27 x 21. Z. XII. 175.

147. Picasso, *Still Life with Fruit Basket and Flowers*, August 2, 1942. Oil on canvas, 73 x 92. Z. XII. 109.

148. Picasso, *Still Life with Fruit Basket*, 1942. Oil on canvas, 73 x 92. Z. XII. 110.

149. Picasso, *Still Life*, August 12, 1942. Oil on canvas, 89 x 116. Z. XII. 105.

150. Picasso, *Still Life with Thorns*, August 13, 1943. Oil on canvas, 92 x 73. Z. XIII. 92.

151. Picasso, *Furnished Room*, August 25, 1941. Pencil drawing, 21 x 27. Z. XI. 248.

152. Picasso, *Furnished Room with Sleeping Nude*, September 1, 1941. Pencil drawing, 21 x 27. Z. XI. 262.

153. Picasso, *Furnished Room*, September 1, 1941. Pencil drawing, 21 x 27. Z. XI. 266.

154. Picasso, *Reclining Nude*, study for *L'Aubade*, May 3, 1942. Pencil drawing, 21 x 27. Z. XII. 64.

155. Picasso, *Reclining Nude and Seated Woman*, study for *L'Aubade*, May 3, 1942. Ink drawing, 17 x 26. Z. XII. 64.

156. Picasso, Study for *L'Aubade*, May 5, 1942. Ink drawing, 10 x 13. Z. XII. 65.

157. Picasso, *Women on the Beach*, 1934. Ink and brush, 24.8 x 34.3. Saidenberg Gallery, New York.

158. Picasso, *Nude Dressing Her Hair*, 1940. Oil on canvas, 130.2 x 96.8. Collection, Mrs. Bertram Smith, New York.

159. Picasso, *La Ronde*, December 6, 1953. Ink drawing, 44.5 x 50.5. Z. XVI. 32.

160. Picasso, *Nude Dressing Her Hair*, March 7, 1954. Pencil drawing, 32 x 24. Z. XVI. 254.

161. Picasso, *La Coiffure*, March 7, 1954. Oil on canvas, 130 x 97. Z. XVI. 262.

162. Picasso, *The Women of Algiers, O.*, February 14, 1955. Oil on canvas, 113.9 x 146. Collection, Mr. and Mrs. Victor W. Ganz, New York.

163. Claude Monet, *Water Lilies, ca.* 1925 (?). Oil on canvas, 199.4 x 560.7. Formerly, The Museum of Modern Art, New York, Mrs. Simon Guggenheim Fund.

164. Claude Monet, *Poplars*. Oil on canvas, 81.9 x 81.6. The Metropolitan Museum of Art, The H. O. Havemeyer Collection. Bequest of Mrs. H. O. Havemeyer, 1929.

165. Julio Gonzalez, *Head, ca.* 1935. Wrought iron, 45.1 cm. The Museum of Modern Art, New York.

166. Julio Gonzalez, *Woman Combing Her Hair,* 1936. Wrought iron, 132.1 cm. The Museum of Modern Art, New York, Mrs. Simon Guggenheim Fund.

167. Julio Gonzalez, *Seated Woman,* 1935. Iron, 87 cm. Collection, Roberta Gonzalez, Paris.

168. Julio Gonzalez, *Woman with a Mirror,* 1936. Iron, 208.3 cm. Collection, Roberta Gonzalez, Paris.

169. Julio Gonzalez, *Torso,* 1936. Iron, 61.6 cm. Collection, Roberta Gonzalez, Paris.

170. Julio Gonzalez, *The Montserrat,* 1936-37. Iron, 165.1 cm. Stedelijk Museum, Amsterdam.

171. Varujan Boghosian, *Village in the Storm,* 1955. Pen and ink on cardboard, 66.1 x 56.8. The Museum of Modern Art, New York, Blanchette Rockefeller Fund.

172. Clinton Hill, *Untitled,* 1955. Chalk.

173. Willem de Kooning, *Woman—Ochre,* 1954-55. Oil on canvas, 76.2 x 58.4. The University of Arizona Museum of Art, The Gallagher Memorial Collection.

174. Willem de Kooning, *Queen of Hearts,* 1943. Oil on board, 116.9 x 68.6. Joseph H. Hirshhorn Foundation.

175. Jackson Pollock, *Echo,* 1951. Oil on canvas, 234.9 x 217.2. The Museum of Modern Art, New York. Acquired through the Lillie P. Bliss Bequest and the Mr. and Mrs. David Rockefeller Fund.

176. Jules Pascin, *Le Modèle à l'atelier,* 1909. Oil on canvas, 72.7 x 60. Perls Galleries, New York.

177. Jules Pascin, *Les Amies,* 1928-30. Oil on canvas, 99.7 x 81. Perls Galleries, New York.

178. Raoul Hague, *Log Swamp Pepper Wood,* 1951. 57.8 x 149.9. Owned by the artist.

179. Fritz Glarner, *Relational Painting, 74.* Oil on canvas, 104.2 x 111.8. Collection, Mr. and Mrs. Armand P. Bartos, New York.

180. Philip Guston, *Beggar's Joys,* 1954-55. Oil on canvas, 182.9 x 172.7. Collection, Mr. and Mrs. Leo Castelli, New York.

181. Paul Brach, *Riddle,* 1962. Oil on canvas. Private collection, New York.

182. *Amenemhet III, ca.* 1860 B.C. Quartzite. Copenhagen, Ny Carlsberg Glyptotek.

183. Auguste Rodin, *Man with the Broken Nose,* 1863. Bronze, 19.7 cm.

184. Daniele da Volterra, *Bust of Michelangelo.* Florence, Casa Buonarroti.

185. Rodin, *Man with the Broken Nose,* 1882. Bronze, 12.7 cm.

186. Rodin, *Torso.* Bronze, 53 cm. Paris, Musée Petit Palais.

187. Rodin, *Iris.* Bronze, 95 cm.

188. Rodin, *Eternal Idol.* Marble, 74 cm. Paris, Musée Rodin.

189. Rodin, *Eternal Spring,* 1884. Marble. Paris, Musée Rodin.

190. Rodin, *Gates of Hell.* Bronze, 680 cm. overall height.

191. Rodin, *Gates of Hell,* right panel detail.

192. Rodin, *Gates of Hell,* right panel.

193. Rodin, *Iris.* Bronze, 95 cm.

194. Rodin, *Figure volante.* Bronze, 21.3 cm.

195. Rodin, Figure Study. Plaster. Paris, Musée Rodin.

196. Rodin, *Head with Upturned Nose.* Bronze, 11 cm.

197. Rodin, *Head with Upturned Nose.* Bronze. 11 cm.

198. Rodin, *Mrs. Russell.* Wax, 47 cm. Stanford University Museum.

199. Rodin, *Hand.* Plaster, approximately 8.9 cm. long. Meudon, Musée Rodin.

200. Rodin, *Hand.* Plaster, approximately 8.9 cm. long. Meudon, Musée Rodin.

201. Rodin, *Hand*. Plaster, approximately 8.9 cm. long. Meudon, Musée Rodin.
202. Rodin, *Hands*. Plaster, approximately 8.9 cm. long. Meudon, Musée Rodin.
203. Rodin, *Prodigal Son*. Bronze, 140 cm.
204. Rodin, *Fugit Amor*. Marble, 57 cm.
205. Rodin, *Gates of Hell*. Bronze, 680 cm. overall height.
206. Rodin, *Mother and Child*. Bronze, 39 cm.
207. Rodin, *L'Amour qui passe*. Marble. Paris, Musée Rodin.
208. Rodin, *Eternal Idol*. Marble, 74 cm. Paris, Musée Rodin.
209. Rodin, *The Creation*. Plaster. Paris, Musée Rodin.
210. Rodin, *Bastien Lepage*. Bronze, 175 cm.
211. Rodin, *Le Petit Ombre* (*The Precipice*). Bronze, 32 cm.
212. Rodin, *L'Homme qui marche*, 1906. Bronze, 225 cm.
213. Rodin, *L'Homme qui marche*, 1906. Bronze, 225 cm.
214. Rodin, *Jean d'Aire*. Plaster, life-size. Paris, Musée Rodin.
215. Rodin, Study for *Victor Hugo Monument*, 1897. Plaster, 190 cm. Paris, Musée Rodin.
216. Rodin, *The Age of Bronze*. Bronze, 175 cm.
217. Rodin, *The Age of Bronze*. Bronze, 175 cm.
218. Rodin, *The Age of Bronze*. Bronze, 175 cm.
219. Rodin, *Les Sources taries*. Plaster. Meudon, Musée Rodin.
220. Rodin, Group with two Eves. Plaster. Meudon, Musée Rodin.
221. Rodin, *Femme accroupie*. Bronze, 84 cm.
222. Rodin, *Gates of Hell*, left panel detail. Bronze.
223. Rodin, *The Shade*. Bronze, 192 cm.
224. Rodin, *The Three Shades*, 1880. Bronze, 98 cm.
225. Rodin, *Montage de deux mouvements de danse B*. Plaster, 33 cm. Meudon, Musée Rodin.
226. Rodin, *Faunesse*. Bronze, 16 cm.
227. Rodin, *Trois Faunesses*. Plaster, 16 cm.
228. Rodin, *Cathedral*. Plaster, 14.5 cm. Paris, Musée Rodin.
229. Rodin, *La Terre*, 1884. Bronze, 46 cm.
230. Rodin, *Figure volante*. Bronze, 21.3 cm.
231. Rodin, *Torse d'Adèle*, 1882. Plaster, 15 cm. Paris, Musée Rodin.
232. Rodin, *Eternal Spring*, 1884. Marble. Paris, Musée Rodin.
233. Rodin, *Fall of an Angel*, 1895. Marble. Paris, Musée Rodin.
234. Rodin, *Caryatid*. Bronze, 44 cm.
235. Rodin, *Nymphe pleurant*. Bronze, 20 cm. Meudon, Musée Rodin.
236. Rodin, *Fragment of a Torso*. Plaster. Metropolitan Museum of Art, New York.
237. Rodin, *Gates of Hell*.
238. Rodin, Study for *Victor Hugo Monument*. Plaster, 190 cm. Paris, Musée Rodin.
239. Rodin, *La Méditation*. Bronze, 140 cm.
240. Rodin, *Beauty*. Drawing. Paris, Musée Rodin.
241. Rodin, *La Sirène*. Plaster. Paris, Musée Rodin.
242. Rodin, *The Magdalen*, 1894. Plaster, 102 cm. Meudon, Musée Rodin.
243. Rodin, *Constellation*. Bronze, 73 cm.
244. Rodin, *Gates of Hell* (showing *L'Homme qui tombe*), top of left panel.
245. Rodin, *Je suis belle*, 1882. Bronze, 75 cm.
246. Rodin, *Femme accroupie*. Bronze, 84 cm.
247. Rodin, Study for *Victor Hugo Monument*. Plaster, 190 cm. Paris, Musée Rodin.
248. Rodin, *Prodigal Son*. Bronze, 140 cm.
249. Rodin, *Gates of Hell*, left panel detail.

Index

References to figure numbers are in italics.